STUDIO PAPERBACK

Luigi Snozzi

Claude Lichtenstein

Birkhäuser Verlag
Basel · Boston · Berlin

Translation German-English:
Bruce Almberg, Katja Steiner, Ehingen

A CIP catalogue record for this book is available from the
Library of Congress, Washington D.C., USA

Deutsche Bibliothek – Cataloging-in-Publication Data

Snozzi, Luigi:
Luigi Snozzi / Claude Lichtenstein. [Transl. German-Engl.: Bruce
Almberg ; Katja Steiner]. - Basel ; Boston ; Berlin : Birkhäuser, 1997
 (Studiopaperback)
 ISBN 3-7643-5439-9 (Basel ...)
 ISBN 0-8176-5439-9 (Boston)

NE: Lichtenstein Claude [Mitarb.]; HST

This work is subject to copyright. All rights are reserved, whether
the whole or part of the material is concerned, specifically the rights of
translation, reprinting, re-use of illustrations, recitation, broadcasting,
reproduction on microfilms or in other ways, and storage in data
banks. For any kind of use, permission of the copyright owner must
be obtained.

© 1997 Birkhäuser – Verlag für Architektur, P.O.Box 133,
CH-4010 Basel, Switzerland
Printed on acid-free paper produced from chlorine-free pulp. TCF ∞
Layout/page layout: Christoph Kloetzli, Basel
Printed in Germany

ISBN 3-7643-5439-9
ISBN 0-8176-5439-9

9 8 7 6 5 4 3 2 1

Inhalt

Contents

7 Entwerfen und Erkennen, Entwerfen als Erkennen
7 Design and Recognition, Design as Recognition

Bauten und Projekte / **Buildings and Projects**

			
16	Entwurf für ein Hochhaus	16	Design for a High-Rise Building
18	Haus Lucchini, Faido	18	Lucchini House, Faido
20	Haus Rotalinti, Bellinzona	20	Rotalinti House, Bellinzona
21	Sozialwohnungen, Locarno	21	Social Housing, Locarno
24	Reihenhäuser Taglio, Orselina	24	Row Houses Taglio, Orselina
26	Bürogebäude Fabrizia, Bellinzona	26	Office Building Fabrizia, Bellinzona
30	Haus Snider, Verscio	30	Snider House, Verscio
34	Wohnbau, Carasso	34	Housing Development, Carasso
36	Ecole Polytechnique Fédérale, Lausanne	36	Federal Polytechnical School, Lausanne
38	Überbauung Al Rabissale, Minusio	38	Development Al Rabissale, Minusio
40	Apartmenthaus Martinelli, Lugano	40	Apartment House Martinelli, Lugano
42	Wohnbau und Bootshafen Foce Sacromonte, Brissago	42	Apartment Building and Boat Harbor Foce Sacromonte, Brissago
45	Wohnbauten, Celerina	45	Apartment Buildings, Celerina
48	Wohnbebauung Verdemonte, Monte Carasso	48	Housing Development Verdemonte, Monte Carasso
50	Gemeindehaus und Primarschule, San Nazzaro	50	Community House and Primary School, San Nazzaro
52	Haus Kalman, Minusio	52	Kalman House, Minusio
58	Haus Bianchetti, Locarno-Monti	58	Bianchetti House, Locarno-Monti
62	Restrukturierung des Klosters Madonna del Sasso, Orselina	62	Restructuring of the Madonna del Sasso Monastery, Orselina
66	Brücke, Golino	66	Bridge, Golino
68	Psychiatrische Klinik, Münsterlingen	68	Psychiatric Clinic, Münsterlingen
70	Sportzentrum, Tenero	70	Sports Complex, Tenero
73	Haus Cavalli, Verscio	73	Cavalli House, Verscio
76	Geschäft Costantini, Minusio	76	Costantini Store, Minusio
78	Primarschule, Montagnola	78	Elementary School, Montagnola
80	Erweiterung des Hauptbahnhofs, Zürich	80	Central Railroad Station Extension, Zurich
82	Richtplan für Monte Carasso	82	Guide Plan for Monte Carasso
86	Braunschweig: Eine Utopie für die Stadt	86	Braunschweig: a Utopia for the City
88	Piazza del Sole, Bellinzona	88	Piazza del Sole, Bellinzona
90	Klösterli-Areal, Bern	90	Klösterli Area, Bern
92	Kunstmuseum und Bibliothek, Chur	92	Museum and Library, Chur
96	Raiffeisenkasse, Monte Carasso	96	Raiffeisen Bank, Monte Carasso
98	Bibliothek und Museum, Thun	98	Library and Museum, Thun
100	Turnhalle, Monte Carasso	100	Gymnasium, Monte Carasso
104	Telecom-Gebäude, Bellinzona	104	Telecom Building, Bellinzona
106	Hauptbahnhof, Bologna	106	Central Railroad Station, Bologna
109	Pfarreizentrum, Lenzburg	109	Parish Center, Lenzburg

112	Friedhofserweiterung und -verdichtung, Monte Carasso	112	Expansion and Condensation of the Cemetery, Monte Carasso
114	Haus Guidotti, Monte Carasso	114	Guidotti House, Monte Carasso
116	Reihenhäuser Büchel, Brione	116	Büchel Row Houses, Brione
118	Haus Barbarossa, Minusio	118	Barbarossa House, Minusio
120	Apartmenthaus Bianchini, Brissago	120	Apartment Building Bianchini, Brissago
124	Regierungszentrum des Département du Bas-Rhin, Straßburg	124	Government Center of the Département du Bas-Rhin, Strasbourg
126	Regierungsviertel, Vaduz	126	Government Quarter, Vaduz
130	Restrukturierung und Umbau des Convento, Monte Carasso	130	Restructuring and Conversion of the Convento, Monte Carasso
136	Haus Bernasconi, Carona	136	Bernasconi House, Carona
138	Restrukturierung der Ecole Polytechnique, Lausanne	138	Restructuring of the Polytechnical School, Lausanne
140	Architekturmuseum, Rotterdam	140	Museum of Architecture, Rotterdam
144	Haus Rapetti, Monte Carasso	144	Rapetti House, Monte Carasso
146	Haus Diener, Ronco	146	Diener House, Ronco
150	Häuser Cerri/Joppini, Roveredo	150	Cerri/Joppini Houses, Roveredo
152	Dopppelhaus Guidotti, Monte Carasso	152	Guidotti Double House, Monte Carasso
154	Wohnquartier Morenal, Sementina/Monte Carasso	154	Housing Quarter Morenal, Sementina/Monte Carasso
158	Pfarreiheim St. Florin, Vaduz	158	Parish Center St. Florin, Vaduz
160	Geschäfts- und Wohnhaus, Sursee	160	Business and Apartment House, Sursee
162	Bahnhofplatz und Volkshochschule, Pforzheim	162	Station Square and Adult Evening School, Pforzheim
165	Masterplan für Le Bouveret	165	Master Plan for Le Bouveret
168	Lido, Brissago	168	Lido, Brissago
170	Neustrukturierung Sulzer-Quartier, Winterthur	170	Restructuring of the Sulzer-Quarter, Winterthur
174	Häuser Giannini/Salzborn, Cureglia	174	Giannini/Salzborn Houses, Cureglia
176	Stadtviertel Ticosa, Como	176	Town Quarter Ticosa, Como
179	Haus d'Andrea, Monte Carasso	179	D'Andrea House, Monte Carasso
181	«Céramique», Maastricht	181	«Céramique», Maastricht
184	KNSM-Insel, Amsterdam	184	KNSM Island, Amsterdam
187	Bürohaus mit Wohngebäude am Pariser Platz, Berlin	187	Office Building with Apartment House at Pariser Platz, Berlin
191	Biographie	191	Biography
192	Ausstellungen	192	Exhibitions
193	Werkverzeichnis	193	List of Works
196	Auswahlbibliographie	196	Selected Bibliography
201	Mitarbeiterinnen und Mitarbeiter	201	Collaborators
202	Bildnachweis	202	Illustration Credits

Entwerfen und Erkennen, Entwerfen als Erkennen

Design and Recognition, Design as Recognition

Längst hat das Phänomen, das in den siebziger Jahren als ‹Neue Tessiner Architektur› weltweit ein Zeichen für eine scharf konturierte Entwurfshaltung geworden war, an Homogenität verloren; naturgemäß interessieren heute die Unterschiede in den Haltungen mehr als das Verbindende. Ein Unglück ist dies nicht. Denn was die angebliche Einheitlichkeit der Interessen ausmachte, war zwar die gemeinsame Entscheidung für die ‹Form› und gegen die (vulgär)funktionalistische Ideologie von Architektur als einer nützlichen, im übrigen aber begrenzt-belangvollen Dienstleistung. Die Tessiner ‹Gruppe› lehnte die selbstsichere Saloppheit ab, mit der die vielbeschäftigten Architekturbüros während der langen Boomjahre ihre Schwächen offensiv kaschierten; sie selbst bekannten sich zur Legitimität der ‹Form›, wobei diese dabei als Anspruch statuiert wurde, der sich nur mit hoher Disziplin erfüllen läßt. Einig waren sie sich deshalb in der entschiedenen Absage an die üblichen Prägungen – wie etwa die Selbstabsolution vor der Verantwortung durch die vermeintlich rücksichtsvolle ‹Anpassung› an das Vorhandene. Doch vor dem Hintergrund dieser Gemeinsamkeiten haben sich unter den namhaften Tessiner Architekten dieser Generation längst unterschiedliche Interessen herauskristallisiert.

Luigi Snozzi ist unter ihnen jener, dessen Bauten und Entwürfe kaum mehr ohne das Bewußtsein vom besonderen Wert des Denkens, dem sie sich verdanken, betrachtet werden können. Snozzi handelt innerhalb der Architektur und durch sie, aber die Impulse dazu gewinnt er auch von außerhalb. Seine Bauten bringen in ihrer Eigenart zum Ausdruck, daß sie in einem Begründungszusammenhang stehen, der über ihre Materialität hinausweist.

Aber was ist es denn, was dies ausmacht? Die Aussage, Snozzi sei das ‹soziale Gewissen der Schweizer Architektur›, wie das gelegentlich zu lesen ist? Kaum, denn aus erfüllter Gewissenspflicht entstünde schwerlich eine Ausstrahlung, wie Snozzis Architektur sie hat. Diese setzt

The ‹New Ticino Architecture› phenomenon, which had become a worldwide signa for a sharply contoured design attitude during the seventies, has long since lost its homogeneity. As a matter of course, the differences in the attitudes are of greater interest today than are the unifying aspects. This is not such a great misfortune. What determined the supposed unity of interests may have been the common decision for ‹form›, and against the (vulgarized) functional ideology of architecture as a useful but otherwise insignificant service. The Ticino ‹group› rejected the self-confident casualness with which the well-occupied architectural studios offensively covered up their weaknesses during the long lasting boom years; they themselves acknowledged the legitimacy of ‹form›, while the latter was decreed as an expectation which could only be fulfilled with a high degree of discipline. Therefore, they agreed in the decisive refusal of the usual impressions, such as the self-absolution from responsibility through the supposedly considerate ‹adaptation› to the existing. However, given the background of these common traits, different interests have crystallized among the famous Ticino architects of this generation.

Luigi Snozzi is the one among them whose buildings and designs can hardly be observed any longer without the consciousness of the special value of thinking to which they owe their existence. Snozzi acts within architecture and through it, but he gets the impulses for this also from without. His buildings express through their individuality that they are placed into a context of reasoning which points beyond their own materiality.

But what is really causing this? Is it because Snozzi is ‹the social conscience of Swiss architecture› as is occasionally written? I think not. Because results originating from a mere moral or social ‹obligation› could not equal the radiant expression that can be found in Snozzi's architecture. The latter infers the willingness to ask more deeply than usual – and the unusual talent to perceive the es-

doch wohl die Bereitschaft voraus, tiefer nachzufragen als üblich – und die ungewöhnliche Fähigkeit, die wesentlichen Fragen dort zu wittern, wo sie noch verschüttet sind.

Auch ohne das Denken zu kennen, das hinter Snozzis Gebäuden und Entwürfen steht, ließe sich aus seinen Bauten wohl eine spezifische Qualität herauslesen; es ist jedoch fraglich, ob dieser auf die bloße Objekterscheinung reduzierte Blick den Bauten gerecht würde. Im Vergleich mit den Werken anderer Tessiner Architekten seiner Generation erscheinen seine Bauten ruhig, bescheiden, unaufgeregt. Daß sie gerade dadurch auch als ‹überlegen› wahrgenommen werden können, darf nicht ohne weiteres vorausgesetzt werden. Denn es gibt keine Exerzitien raffinierter Materialverwendung, keine virtuose Handwerklichkeit, keine Inszenierung geometrischer Ordnungen, kein Spiel mit Sinnestäuschungen, ja nicht einmal die ungebrochen zur Schau gestellte Begeisterung über das weise und wunderbare Spiel starker Primärformen unter dem Licht (um das bekannte Wort Le Corbusiers zu paraphrasieren). Snozzis Bauten sind bisweilen lapidare Gehäuse, oft aus Sichtbeton – der für Snozzi ein ‹natürliches› Material ist («Wasser und Sand!»), und ‹lapidar› bedeutet ja: in Stein gehauen. Die Silhouetten sind klar und zusammenhängend: Architektur mit bündigen Konturen und sparsamen Linien. Große Komplexe drücken immer wieder so etwas wie Indifferenz aus, eine Irritation, die durch die unmodulierte Reihung gleichartiger Elemente entstehen kann (Snozzi hat die Nerven, zu wiederholen, wo sich bei andern längst der Variierungszwang durchgesetzt hätte). Das bauliche Detail bleibt unter Snozzis Hand immer diskret, wird nie zelebriert: nie mehr Detail als nötig – fast immer weniger als üblich unter Architekten von Rang. Das Auge folgt den Linien und wird selten aufgehalten, wird kaum je wider Willen durch theatralische Effekte beansprucht.

Im Vergleich mit all den imponierenden Gesten, denen man an Straßenrändern und in Publikationen begegnen kann, mangelt es Snozzis Architektur an Aufmerksamkeit heischender Präsenz. Mag sein, daß dies in einer Art von Verweigerung begründet ist, wahrscheinlicher ist wohl schlicht Snozzis Desinteresse gegenüber der Charaktermaske des Hochleistungsarchitekten. Dafür hat er seine guten Gründe, und, was entscheidend ist, das Desinteresse wird durch ihn überzeugend in andere Fragestellungen umgewandelt. Deshalb ist Snozzi ein bedeutender Architekt unserer Zeit. Wer sich mit seinem Werk beschäftigt, kann an solchen Umwandlungen teilhaben, zu neuer Bewertung kommen und die Dinge in einem anderen Licht sehen. So zeigt sich etwa das, was bei Snozzi

sential questions in places where they are still hidden.

Even without knowing the thoughts behind Snozzi's buildings and designs, a specific quality can be recognized in his architecture. It is only questionable whether the perception, reduced to the mere appearance of the object, would do them justice. In comparison with the works of other Ticino architects of his generation, his buildings seem to be calm, modest, unexcited – it may not be taken for granted that, just because of this, they can be perceived as ‹superior›. There are no exercises of clever material utilization, no virtuous craftsmanship, no production of geometric orders, no play with illusions, not even the ostentatious enthusiasm for the wise and wonderful play of strong primary forms beneath the light (to paraphrase the well-known word by Le Corbusier). Snozzi's buildings are sometimes simple shells – often made of fair-faced concrete which, to Snozzi, is a natural material («water and sand!») – the silhouettes are clear and connected; an architecture with precise contours and sparse lines. Large aggregates time and again express something like indifference, an irritation which can be caused by the unmodulated lining up of similar elements (Snozzi has the nerve to repeat where others would have given in to the urge for variation). The architectural detail always remains discrete under Snozzi's hand and is never celebrated: there is never more detail than is necessary – almost always less than is typical among architects of a certain rank. The eye follows the lines and is rarely stopped and is hardly ever engrossed by theatrical effects.

In comparison to all the impressive gestures which one can meet along the streets and in publications, Snozzi's architecture lacks a presence that demands attention. Perhaps the reason for this is a kind of refusal, but it is more probable that it is simply Snozzi's lack of interest in the disguise of the high performance architect. He has his own very good reasons for this, and what is decisive is that the disinterest is convincingly explained by him and transformed into different questions by a purposeful insistence. Therefore, Snozzi is an important architect of our times. Those who deal with his oeuvre can participate in the most various transformations, reevaluate them, and see things in a new light. For example, what at first seems to be an indifference turns out to be an approach to further contexts; the assumed «scarceness» of his buildings can be seen as an expectation ‹taken to the inside›, whereas the sparseness of forms allows for a higher form of enjoyment. The apparent static character of these buildings turns into an unimposing dynamic quality as soon as they are perceived in connection with their im-

zunächst als Indifferenz erscheinen mag, als Blick auf weitere Zusammenhänge, die angebliche Kargheit seiner Bauten läßt sich als ‹nach innen genommener› Anspruch sehen, wobei die Sparsamkeit der Formen eine höhere Form des Genusses ermöglicht. Denn die scheinbare Statik dieser Bauten wendet sich in unaufdringliche Dynamik, sobald sie im Zusammenhang mit ihrer unmittelbaren oder weiteren Umgebung wahrgenommen wird. Was in gewissen Augen, die an den üblichen visuellen Lärm gewöhnt sind, schematisch erscheinen mag, ist in Wirklichkeit eine Äußerung gesteigerter Sensibilität. Snozzis Architektur entfaltet sich in subtilen Zusammenhängen. Kurz: Seine Art von ‹Bescheidenheit› ist notwendige Unbescheidenheit. Auch davon muß ein Buch sprechen, das diese Architekturauffassung vermitteln will.

Selbst in den Jahren der pauschalen Verdammung der Moderne hat Snozzi sich zum Neuen Bauen bekannt, da es zum bisher letzten Mal eine aufklärerische Verbindlichkeit zwischen der Gesellschaft und der Architektur postuliert hatte. Zugleich ist ihm jedoch das fundamentale Versagen der Moderne in der Urbanistik bewußt. Wie kann etwas in einer Hinsicht so wertvoll und in der andern so verfehlt sein? Snozzi sucht nach Strategien des ‹Weiterbauens› mit bestimmten Mitteln der Moderne, die bis zu der Stelle, wo diese in die Irre gegangen ist, zurückgehen und neu ansetzen. Diese Stelle läßt sich benennen: es ist die Ansicht, das Bauen sei a-historisch, nicht in einer geschichtlichen Kontinuität stehend (wobei Kontinuität die Stetigkeit historischer Vorgänge bedeutet, keineswegs deren Widerspruchsfreiheit). Snozzis Entwürfe situieren sich im historischen und örtlichen Kontext und sind – im Unterschied zur Theorie der Moderne – nicht nur aus dem Raumprogramm entwickelt. Der Rayon ihrer Entwurfsmotivationen reicht stets weit über den jeweiligen Grundstücksperimeter hinaus; die Projekte erlangen Plausibilität in unüblich weitgespannten Bezügen. Der Gebäude-Entwurf endet nicht mit der Außenwand, er setzt sich in den Außenraum fort, mit dem er in einer Form wechselseitiger Kontrolle kommuniziert. Snozzi entwirft keine Objekte, sondern definiert mit dem Entwurf stets das Feld einer Intervention.

Seine Entwurfsmethode beruht auf der ‹Lektüre des Territoriums›. Darunter versteht er die gründliche Befragung des spezifischen Ortes nach seiner Bedeutung, nach den geschichtlichen Formungskräften, denen er sich in seiner Unverwechselbarkeit verdankt, nach den von Menschenhand veranlaßten Eingriffen in die ursprüngliche Naturlandschaft. Das Territorium ist die Kulturlandschaft, das Feld früherer und zukünftiger Eingriffe, wo genuine

mediate and wider surroundings. What may seem like a scheme to certain eyes that are accustomed to the normal visual fanfare, is in reality an expression of increased sensibility. Snozzi's architecture unfolds in subtle contexts. In brief: his way of ‹modesty› is a necessary immodesty. And a book that intends to communicate this understanding of architecture will have to speak of this, as well.

Even during the years when modernism was generally condemned, Snozzi confessed to «Neues Bauen» as it had for the last time postulated a clear obligation between society and architecture. At the same time, however, he is aware of the fundamental failure of modernism in urbanism. How could something possibly be so precious in one sense and totally wrong in another? Snozzi searches for strategies of ‹continuing to build› with certain means of modernism that go back to the point where the latter went astray and then he identifies a new approach. The point can be named: it is the idea that building is a-historical and does not stand in a historic continuity (while continuity means the steadiness of historic events and not that they would be free of any contradiction). Snozzi's designs are situated in the historic and local context and are – opposite to the theory of modernism – developed not only from the functional program. The scope of their design motivations always reaches beyond the accorded property perimeter; the projects achieve plausibility in unusually broad contexts. The building design does not end with the outer wall. It continues into the outside space with which it communicates in a form of alternating control. Snozzi does not design objects, but with his design he always defines the field of an intervention.

His design method is based on the ‹lecture of the territory›. This is understood by Snozzi as the engaged questioning of the specific location for its meaning, for the historic forces of formation to which it owes its uniqueness, for the operations on the original natural landscape caused by human hands. The territory is the cultural landscape, the field of former and future operations, where genuine ‹nature› has been successively and unsentimentally made useful and was changed into ‹culture› during the process. Snozzi has always honored the influence of the writings by Vittorio Gregotti and Aldo Rossi – to name only these two. What he has formed from it is a consistent body of work of elaborate individualism, not to mention uniqueness.

He is conscious of the dialectics of the circumstance that the building activities of the past decades would have

‹Natur› sukzessive und unsentimental nutzbar gemacht und dabei in ‹Kultur› umgewandelt worden ist. Den Einfluß der Schriften von Vittorio Gregotti und Aldo Rossi – um nur diese beiden zu nennen – hat Snozzi stets gewürdigt. Was er daraus geformt hat, ist ein konsistentes Werk von ausgeprägter Eigenart, um nicht zu sagen Einzigartigkeit.

Ihm ist die Dialektik des Umstandes bewußt, daß die Bautätigkeit der vergangenen Jahrzehnte viel weniger Verwüstung über die Landstriche gebracht hätte, wenn es ein öffentliches Bewußtsein von der Bedeutung des Bauens gäbe. «Jedes Bauen bedeutet eine Zerstörung. Zerstöre mit Verstand!» lautet seine einprägsame Einsicht und Forderung. Seine Methode, die ‹Lektüre des Territoriums›, verlangt die Fähigkeit, die Landschaften und Städte zu ‹lesen›. Der Entwurf ist zugleich Auslegung. Das Aufspüren der jeweils entwurfsrelevanten Elemente im gegenseitigen Zusammenhang ist in formaler Hinsicht ein Vorgang der Kondensation und inhaltlich einer der Sinnstiftung.

Sein langjähriger Büropartner Bruno Jenni erwähnt in diesem Zusammenhang Snozzis fast unheimliche Fähigkeit, nach wenigen Minuten Aufenthalt, erstmals in irgendeiner Stadt, langjährigen Stadtbewohnern, ja sogar Stadtverantwortlichen entscheidende Merkmale des Ortes zu nennen, die ihnen bis dahin nicht bewußt gewesen sind. Gleichwohl: die ‹Lektüre des Territoriums› ist weder ein metaphysischer noch ein mechanischer Prozess, es gibt keine Linearität des Gelingens, wohl aber eine Insistenz der Fragestellung, die oftmals erst nach verschiedenen Anläufen auf die richtige Spur führt. Wichtig ist dabei in jedem Fall Snozzis Interesse für die Geschichte, da sie – das Wort kommt von ‹Geschehen› – die Dynamik einer Entwicklung meint und nicht bloß eine Abfolge von Zuständen. So gesehen, ist nicht nur das bereits Geschehene Teil der Geschichte, sondern auch das Geschehende. Snozzis Methode benutzt den Blick zurück in die Geschichte, um dank den daraus gewonnenen Aufschlüßen über die Wirkkräfte in der Gegenwart Entwürfe zu formulieren, die für die Zukunft Geltung behalten dürften. Auf die Frage, ob die Architekten für die Gegenwart oder für die Zukunft bauen sollen, gibt Snozzi zur Antwort: «Ich baue immer für die Gegenwart, aber wenn man gut für die Gegenwart baut, ist die Chance, daß es von Dauer sein wird, viel größer, als wenn man zuviel an die Zukunft denkt.»

So sind Snozzis Entwürfe gleichzeitig Vorschläge zur Therapie wie zur Prävention; Maßnahmen, die mittels be-

brought much less devastation to the regions had there been a public awareness of the importance of architecture. «Every architectural intervention represents a destruction. Destroy intelligently!» is his impressive insight and demand. His method, the «lecture of the territory», claims the ability to «read» the landscapes and cities. The design is the interpretation. Finding those specific elements that relate to each other in a mutual context and are relevant for a particular design is, formally speaking, a process of condensation, and contextually speaking, a process of creating a meaning.

His long time office partner, Bruno Jenni, mentions in this context Snozzis almost scary ability to tell to the citizens of a city, or even those responsible for a community, after only a few minutes of having been there for the first time, the decisive characteristics of a place which they had not even been aware of. Nevertheless, the ‹lecture of the territory› is neither a metaphysical nor a mechanical process. There is no linearity of being successful, but rather an insistence in the questions which often leads to the right place only after several attempts. In any case, what's important is Snozzi's interest in the history, meaning not only a sequence of conditions, but the dynamics of development. Seen this way, not only is what has already happened a part of the history, but also what happens. Snozzi's method uses the glance back into history in order to formulate designs in the present due to the insights gained in this way, through the forces of effect which should remain valid in the future. The question of whether architects should build for the present or for the future is answered by Snozzi as follows: «I always build for the present. But if one builds well for the present, the chance that it will endure is much greater than if one thinks too much about the future.»

Thus, at the same time Snozzi's designs are suggestions for therapy and for prevention; measurements which are intended to correct inappropriate developments diagnosed by means of specific operations and manipulations, and to prevent possible future mistakes. The architect as planner; the planner as architect. The technocratic separation of the planning (remaining in the abstract) from the concretely tangible of the architecture of the city, which, to Snozzi, is both a sign of a historic necessity and human life as such, must decisively be overcome. In this respect, the community of Monte Carasso has become the model of international interest.

Those who know Snozzi also know what a distinguished story-teller he is. This has something to do with the above

stimmter Eingriffe und Manipulationen (durchaus materiell, fast chiropraktisch) diagnostizierte Fehlentwicklungen korrigieren und mögliche zukünftige Fehlentwicklungen verhindern sollen. Der Architekt als Planer, der Planer als Architekt: die technokratische Abspaltung der (im Abstrakten verbleibenden) Planung vom konkret Faßbaren der Architektur der Stadt (die für Snozzi zugleich Zeichen historischer Notwendigkeit wie des menschlichen Lebens schlechthin ist) muß entschieden überwunden werden. Die Gemeinde Monte Carasso ist diesbezüglich zum Modellfall von internationalem Interesse geworden.

Wer Snozzi kennt, weiß, was für ein eminenter Geschichtenerzähler er ist. Dies hat mit dem oben Gesagten etwas zu tun. Als Intellektueller hält er kritische Distanz zu den Dingen, als ‹Künstler› begibt er sich in sie hinein. Beim Erzählen wird klar, daß er beides in einem ist. Er macht Dinge greifbar und konkret, die bei anderen unsinnlich und abstrakt blieben; er macht in der Rede über seine Entwürfe den Corpus von plausiblen Überlegungen greifbar. Stets werden dabei Gefühle von Freiheit und Bedauern hervorgerufen: da spricht einer (und schlägt das Publikum in seinen Bann), für den der Entwurf einen Sog zur Wirklichkeit hin entwickelt. Wer einen der zahlreichen Orte besucht, für den Snozzi einen unausgeführt gebliebenen Entwurf gemacht hat, wird das Fehlen spüren. Denn Snozzi will ja nicht die Utopie, den Nicht-Ort (abgesehen davon, daß sie für ihn, auch wenn er sie wollte, nicht das ‹Unrealistische› wäre). Was er will, hat einen Ort – ist ein Ort. Er stellt nur immer wieder fest, daß zur Utopie bequem alles erklärt werden kann, was, in den Gesichtskreis gerückt, andere Perspektiven zeigt als es der gängige ‹Realitätssinn› tut, für den die professionelle Kompetenz sich längst als Loyalität gegenüber den Sachzwängen verinnerlicht hat. Die billigste Methode, sich auf das ‹Utopische› eines Entwurfs (angeblich «auf das, für das hier nicht der Ort ist») hinauszureden, bedeutet die Augen vor den Möglichkeiten des jeweiligen Ortes zu verschließen.

Snozzi nähert sich dem Entwurf von ‹außen›, vom Territorium, nicht vom Raumprogramm her. Dies in doppelter Weise. Erstens von ‹außerhalb› der Architektur her. Der wohl grundlegendste der aphoristischen Merksätze, die Snozzi in seinem Architekturunterricht verwendet und nach dem als Maxime er seine eigene Arbeit ausgerichtet hat, lautet: «Der Entwurf ist – mehr noch als ein Instrument zur Umformung – ein solches der Erkenntnis.» («Il progetto, prima che strumento di trasformazione, è strumento di conoscenza.») Dies ist womöglich der höchste Anspruch, dem sich die Architektur zu stellen hat: er setzt eine stärkere Bemühung um die Wirklichkeit voraus, als

mentioned. As an intellectual he keeps a critical distance to things; as an ‹artist› he gives himself to them. When he tells a story, it becomes clear that he is both in one person. He renders things in a tangible and concrete way – things that, with others, would remain hidden as non-sensible and abstract. When talking about his designs, he communicates the tangibility of a corpus of plausible thoughts. Always, feelings of freedom and regret are evoked: someone is speaking (he puts the audience under his spell) for whom the design develops a suction towards reality. If someone visits one of the many locations for which Snozzi has made an unrealized design, they can feel that something is missing. Snozzi does not want utopia, the non-location (leaving aside that to him, even if he wanted it, it would not be the ‹unrealistic›). What he wants has a location, is a location. He simply notices over and over again that everything showing a perspective different from the more common ‹sense of reality› can easily be declared to be utopian, if brought into the center of attention. Professional competence has long been proven to be a loyalty to the compulsion of circumstances to this sense of reality. The most economical method used to excuse oneself with the ‹utopian› of a design (ostensibly, «whatever the reason – here there is no place») is to close ones eyes to the possibilities of the location which is in front of them.

Snozzi approaches the design from the ‹outside› – from the territory and not from the functional program. And he does so in a double sense. First, from ‹outside of architecture›. Probably the most important aphorism which Snozzi has used in his architectural classes and according to which he has arranged his own work, is as follows: «The design is more than an instrument for transformation. It is an instrument of recognition.» («Il progetto, prima che strumento di trasformazione, è strumento di conoscenza»). This is probably the highest expectation architecture has to face: it presumes a greater effort for reality contrary to understanding architecture simply as an optional possibility of interpretation.

The second is meant as a principle, too; it leads closer to architecture and yet is more closely connected to the first statement: «architecture is a void; it is up to you to define it.» («L'architettura è vuoto, tocca a te definirlo.») It can be seen as a description of the somewhat trivial principle that architecture is ‹space›. However, in Snozzi's description, a subtle allusion takes the place of the unwanted trivial. ‹Void› is stronger and more clear because this word names a real reversal of view. Where ordinarily in architecture, ‹space› changes suddenly into mere pulsing net-

wenn man das Bauen nur als beliebige Interpretationsmöglichkeit verstünde.

Auch die zweite Spur ist grundsätzlich gemeint; sie führt näher zur Architektur hin und steht doch dabei in enger Verbindung mit der ersten Aussage: «Architektur ist Leere; es liegt an dir, sie zu definieren.» («L'architettura è vuoto, tocca a te definirlo.») Sie läßt sich als Umschreibung des – etwas trivialen – Grundsatzes sehen, daß Architektur ‹Raum› sei. Aber in Snozzis Umschreibung tritt an die Stelle der unbeabsichtigten Trivialität feiner Hintersinn. ‹Leere› ist deutlicher, schärfer, weil dieses Wort eine wirkliche Umkehrung des Blicks benennt. Wo sich in der Architektur nur allzuoft der ‹Raum› unter dem Druck von Funktionsdiagrammen und Renditeberechnungen jählings als bloße Nettonutzfläche in der dritten Dimension offenbart, reklamiert Snozzi den Entwurf provokativ als Aufgabe, dessen Lösungsansätze sich vom Negativen her gewinnen lassen, von der Leere her. Also nicht: wieviel umbaute Nutzfläche ist möglich, sondern: wieviel architektonische Intervention ist notwendig, damit der Entwurf den Ansprüchen der Leere genügt? Es verwundert nicht, daß Snozzis Blickrichtung von den Exponenten einer technokratischen Berufsbildung bzw. -ausübung als Provokation aufgefaßt wird.

Der Basler Architekt Roger Diener, der bei Snozzi studierte, drückt dies sehr treffend aus: «Ihre besondere Bedeutung gewinnt die Form erst durch den Zusammenhang, den sie an einem bestimmten Ort zu schaffen vermag. Und obwohl es ihm immer um eine gesellschaftliche, letzlich politische Bedeutung geht, sind die Werte, an denen Snozzi die ‹condition humaine› mißt, elementarer Natur: kosmische, geographische, wie Sonne, Licht, Luft und Wasser und solche der Erinnerung, die Werte menschlicher Arbeit (fatigues humaines), wie er sie eindrucksvoll nennt. Das hat für den Entwurf substantielle Konsequenzen: es steht nicht mehr das Objekt, das Gebäude im Zentrum der gestaltenden Arbeit, sondern es geht darum, im Zusammenhang mit einem bestimmten Gelände (Territorium) durch einen Entwurf jene Werte wiederzugewinnen, welche für Snozzi die Würde der menschlichen Existenz gewährleisten.» (R.Diener: Die Verführung des Architekten, in: P. Disch (Hrsg.), Luigi Snozzi, Lugano 1994, S. 414).

Snozzi gilt als ein radikaler Architekt. «Es ist nicht wahr, daß Kompromisse die Sache leichter machen. Sie machen sie schwieriger», sagt er. Wer so spricht, gilt als Radikaler, und ist es wohl auch in einem Kontext wie dem schweizerischen, der sich auf die Kultur des Kompromisses so verhängnisvoll viel zugute hält: dieser ist oftmals nicht

use surfaces in the third dimension under the pressure of function diagrams and profit calculations, Snozzi provokingly claims the design as a task whose solutions can be gained from the negative approach, from the void. So the question is not how much usable built surface is feasible, but how much architectural intervention is necessary in order for the design to suffice for the expectations of the void. It is no surprise then that Snozzi's outlook is considered a provocation by the exponents of a technocratic professional formation or practice.

The Basel architect, Roger Diener, who studied with Snozzi puts it very pointedly: «Form gains its special meaning only through the context that it may create in a specific location. And although Snozzi's concern is always for a social and, finally, a political meaning, the values at which he measures the human condition are of an elementary nature: cosmic, geographic – like sun, light, air and water and those of memory – the values of human labor (fatigues humaines) as he impressively calls them. This has substantial consequences for the design: no longer is it the object, the building, the center of the design work, but it is about regaining those values in connection with a specific territory through a design that guarantees to Snozzi the dignity of human existence.» (R. Diener: The seduction of the architect, in: P. Disch (Ed.), Luigi Snozzi, Lugano 1994, p. 414).

Snozzi is considered a radical architect. «It is not true that compromises make things easier. They actually make them more difficult», he says. Someone who speaks like this is considered a radical, and probably is one given a context like the Swiss situation, which fatefully accounts for itself on the basis of a culture of compromise. The latter is often not the result of a process of agreement, but rather the false deity disguised as ‹democratic›, whose presence alone demarcates the beginning of every labor. Thus, radicalism always must be misunderstood as extremism and all it does is simply state Snozzi's conviction that, once a problem is recognized, there is not an unlimited number of solutions (which can be customized in different degrees of hardness), but only the plausible concept for each case. Snozzi's phrase speaks of the contradictions in which one gets unavoidably lost if the occupation with compromise confirms that one has almost always lost sight of the true matter. His concern is not that an idea remains intact or the inability to compromise as such. If Snozzi is sometimes described as being ‹partisan›, the sentiment is not entirely inappropriate. Yet, it is misguiding: this attribute may characterize the actual effect he may have, not his own desires. The intentions of his pro-

das Resultat eines Einigungsprozesses, sondern der ‹demokratisch› bemäntelte Götze, dessen Anwesenheit schon den Beginn jeder Arbeit prägt. So muß Radikalität immer als Extremismus mißverstanden werden, dabei gibt sie doch nur Snozzis Überzeugung wieder, daß zu einem Problem, wenn es einmal erkannt ist, nicht beliebig viele (in unterschiedlichen Härtegraden konfektionierbare) Lösungen bereitliegen, sondern nur die jeweils plausible Idee. Snozzis Wort spricht die Widersprüche an, in denen man sich unweigerlich verliert, wenn die Beschäftigung mit den Kompromissen bestätigt, daß man dabei fast immer auch die eigentliche Sache aus den Augen verloren hat. Es geht ihm um die Intaktheit einer Idee, nicht um die Kompromißlosigkeit als solche. Wenn Snozzi gelegentlich als ‹Partisan› bezeichnet wird, ist dies zwar nicht falsch, aber irreführend; das Attribut charakterisiert ihn in seiner tatsächlichen Wirkung, nicht aber in seinen eigenen Wünschen. Seine Vorschläge sind selten wirklich polemisch gemeint, sie werden bloß von den Zahlreichen, die nur das stoßgedämpfte Entwerfen und die wattierte Argumentation kennen, so aufgefaßt. Die ‹Kritik› in Snozzis Entwürfen wiegt für all jene schwerer als das Konstruktive, das sich für Snozzi mit der Kritik verbindet: da tut sich ein Abgrund an Nicht-wissen-wollen auf. Doch an dieser Grundlage hält der Architekt und Entwurfslehrer, der Baumeister und der Intellektuelle Snozzi fest: Ein Architekt mag ein noch so geübter Entwerfer, ein virtuoser Übersetzer in Formen und Materialien sein, wenn er nicht zugleich über die Fähigkeit verfügt, in seiner Arbeit kritisch auf das Vorhandene zu regieren und dieses durch die Wahl der Eingriffe intellektuell und konzeptionell zu etwas anderem zu machen als was es zuvor gewesen war, dann fehlt der Architektur das eigentlichste Fundament, ganz im Sinn von Adornos Wort: Es gibt kein Richtiges im Falschen.

posals are hardly ever polemic. The many who know nothing but the buffered design and the fluffy argumentation do, however, understand it as such. The ‹criticism› in Snozzi's designs has more weight for all those people than the constructivism which, to Snozzi, is linked with whatever he may criticize; here, an abyss of «not-wanting-to-know» opens up. And yet Snozzi, the architect and design teacher, the builder and the intellectual, holds on to this principle: An architect may be a perfectly experienced designer, a virtuous translator of forms and materials. But, if he does not at the same time have the ability to react critically to the existing in his work, and to transform it both intellectually and conceptually through his choice of operations into something other than what it used to be before, then architecture lacks a true foundation. This conforms entirely to the sense of Adorno's saying: There is no right in wrong.

Bauten und Projekte Buildings and Projects

Entwurf für ein Hochhaus
1957

Das Projekt entstand während Snozzis letztem Studienjahres an der Eidgenössischen Technischen Hochschule in Zürich. Das Hochhaus war damals in der Schweiz ein suggestives Thema, ja geradezu ein Symbol für die Überwindung des sogenannten Heimatstils mit seiner kleinräumigen Selbstzufriedenheit (Max Frisch etwa hatte sich zu dieser Frage sehr prononciert geäußert).[1] Sechs kreisrunde Schäfte mit Sanitärzellen bilden die primäre Struktur. Sie erzeugen ein Pattern aus sechs einander überlagernden Kreisen und enthalten Küchen und Badezimmer. Je drei Kreise pro Geschoß bilden die Wohnungen, die drei übrigen Kreise die dazwischenliegenden Loggien. Bestimmendes Merkmal ist die Topologie dieser Struktur. Die beiden funktionellen Einheiten von Wohnung und Loggia werden durch die gesetzmäßige Verwendung eines einzigen Elements generiert: die Loggia ist der Leerraum zwischen der Wohnung darunter und darüber, entstanden durch die geschoßweise alternierende Anordnung der Wohnungen innerhalb der geometrischen Struktur. Snozzi entwarf einen solchen Turm für 3½-Zimmer-Wohnungen und einen zweiten für kleinere Studiowohnungen, wobei letzterer konsequenter durchgebildet ist, da die einzelne Wohnung nur im Bereich der Loggia eine Fensteröffnung benötigt. Überraschend für die Epoche ist das Darstellungsmittel der in Tusche gezeichneten Axonometrie. Das Technische und Objektivierende, das diesem Medium eigen ist, bildet den konzeptionellen Hintergrund für diesen beachtlichen Entwurf.

[1] Vgl. M. Frisch: Cum Grano Salis, in: Werk (Zürich), 40. Jg. (1953), Nr. 11, S. 325ff.

Design for a High-Rise Building
1957

The project came into being during Snozzi's last year of study at the ETH (Swiss Technical University) in Zurich. The high-rise building was a suggestive theme in the Switzerland of those days. It was almost a symbol for overcoming the narrow-minded self-content of the so-called Heimat style (Max Frisch for example took a very pronounced stand with regards to this question).[1] Six circular shafts with sanitary cells form the primary structure. They create a pattern of six overlapping circles and contain kitchens and bathrooms. Three circles per floor form the apartments; the other three form the interstitial loggias. The topology of this structure is a decisive mark. The two functional components – apartment and loggia – are generated by the recurrent application of a single element. The loggia is simply the empty space between the apartment below and the one above and it came into being through the arrangement of apartments within the geometric structure, alternating from floor to floor. Snozzi designed such a tower for 3½ room apartments and a second one for smaller studio apartments. The latter is more consequently designed as the single apartment needs a window opening only in the area of the loggia. Rather surprising for the time is the axonometry drawn in ink. The technique and objectification which is proper to this medium, however, forms a conceptual background for this remarkable design.

[1] See M. Frisch: Cum Grano Salis, in: Werk (Zürich), vol. XXXX (1953), No. 11, p. 325ff.

Axonometrie 1:500 / Modell / Alternierende Grundrisse 1:500

Axonometric view 1:500 / Model / Alternating ground plans 1:500

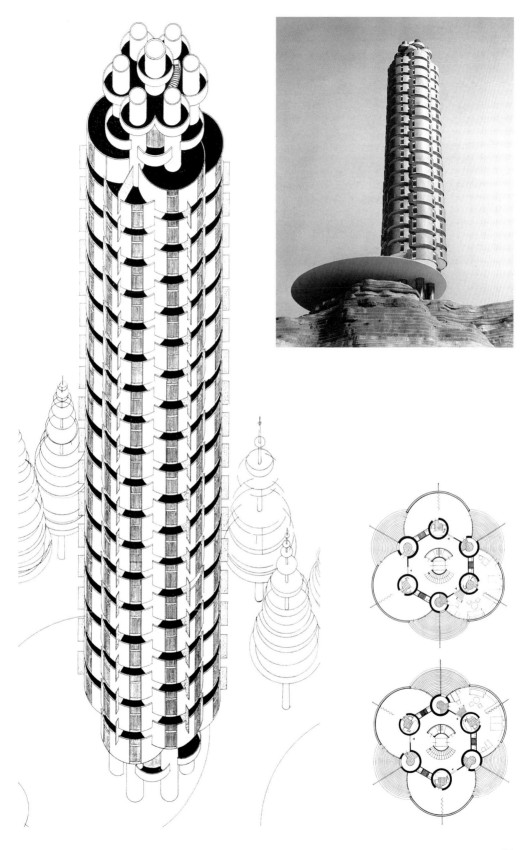

17

Haus Lucchini, Faido
1958–59

Dieses Haus war der erste Auftrag, den Snozzi selbständig ausarbeiten konnte. Das Dorf Faido liegt in der oberen Leventina, unweit des Gotthardmassivs, von hohen Bergen umgeben. Bauherr war ein Arzt mit seiner Familie. Das Haus enthält neben den Wohnräumen (im Grundrißplan rechts) die Arztpraxis (links). Das Raumgefüge besteht aus L- und U-förmigen raumdefinierenden Wänden und großflächigen Fensteröffnungen dazwischen. Im vertikalen Aufbau sind es die Themen des geschichteten Sockels und des prismatischen hölzernen Dachvolumens, die Snozzi beschäftigt haben. Der parallel zur Dachfläche schräg abgeschnittene Kamin und die hölzernen Dreieckrahmen über dem Autoeinstellplatz bringen das Interesse an einer augenfälligen Geometrie zum Ausdruck. Diese Elemente sind, was die Architektur südlich der Alpen betrifft, zeittypisch. Der Einfluß von Frank Lloyd Wright – vermittelt durch Bruno Zevi und im Fall Snozzis durch Tessiner Architekten wie Peppo Brivio – ist unverkennbar. Neben dem ‹Organischen›, das im Lauf von Snozzis Arbeit bald in den Hintergrund treten wird, sind weitere für Snozzi charakteristische Kriterien erkennbar: der hohe Grad an architektonischer Ordnung, der dem Haus innewohnt, und dessen präzise Einbindung ins Terrain.

Lucchini House, Faido
1958–59

This house was the first commission that Snozzi could work on independently. The village of Faido is located in the upper Leventina, not far from the Gotthard massif, and surrounded by high mountains. The client was a doctor with a family. Aside from the living quarters (right side of ground plan), the house also contains the doctor's office (left side). The room structure consists of L- and U- shaped walls defining the space and large surfaces of interstitial window openings. In the vertical design, Snozzi was working with the theme of the layered base and the prismatic wooden roof volume. The chimney, cut off parallel to the roof plane, and the wooden triangular frames above the carport express the interest in an eye-catching geometry. These elements are typical for their time, as far as the architecture south of the Alps is concerned. The influence of Frank Lloyd Wright – mediated by Bruno Zevi and, in Snozzi's case, by architects from Ticino such as Peppo Brivio – can be unmistakably detected. Besides the organic, which in Luigi Snozzi's work was soon to step into the background, further criteria characteristic for him can be seen, e.g., the high degree of architectural order found in the house and its precise integration into the terrain.

Grundriß Erdgeschoß /
Wohnraum / Außenansichten

First floor ground plan /
Living room / Exterior views

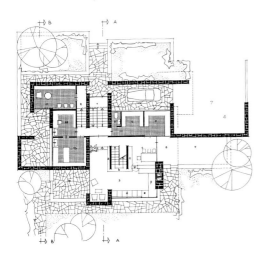
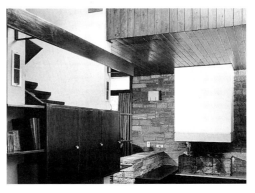

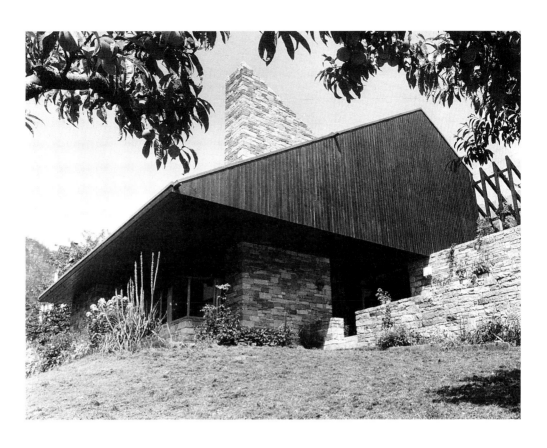

Haus Rotalinti, Bellinzona
Projekt, 1960

Dieses Wohnhaus wurde für ein Hanggrundstück entworfen und kann mit seinem Prinzip von tragendem Schaft und auskragenden Ebenen als ein weiteres Beispiel für den Einfluß Frank Lloyd Wrights auf den jungen Snozzi gelten. Vier hochgeführte, einem Quadrat einbeschriebene bruchsteinverkleidete Schildwände mit je einem flankierenden Treppenlauf generieren die Geometrie des Hauses und bestimmen die Lage der Volumen zueinander. Infolge der Treppenanordnung läßt sich nicht von zusammenhängenden Geschossen sprechen, vielmehr entsteht in der Verknüpfung von Grund- und Aufriß ein ‹Raumplan›. Daß dieses Haus darin der Studentenarbeit von 1957 folgt (vgl. S. 16), dokumentiert, wie wichtig dieses Thema für Snozzi damals schon war. Das Haus entwickelt sich von oben nach unten: Zugang, Autoabstellplatz und Eingang, Küche und Wohn-/Eßraum, drei Schlafzimmer, Bad, Waschküche und Gästezimmer, schließlich ein Atelier, zuunterst der Gartenaustritt. Der Entwurf wurde nicht ausgeführt. Snozzi gab den Auftrag an Aurelio Galfetti weiter, dessen Casa Rotalinti von 1963 als wichtiger Impuls anerkannt ist, der den folgenreichen Einfluß Le Corbusiers auf die Tessiner Architektur mitbegründete.

Rotalinti House, Bellinzona
Project, 1960

This house was designed for a sloping property. With its principle design of a supporting shaft and cantilevered levels it can be regarded as yet another example of Frank Lloyd Wright's influence on the younger Snozzi. Four high, natural-stone clad walls drawn into a square with one flanking staircase each, generate the geometry of the house and determine the relationship of the volumes. Because of the structuring of the staircases, one cannot speak of interconnected levels. The link between the ground-plan and the elevation much rather creates a ‹spatial plan›. The fact that this house thus follows the student's work of 1957 (see p. 16) proves how important this subject was to Snozzi even back then. The house develops from the top to the bottom: access, carport and entrance, kitchen and dining/living room, three bedrooms, bathroom, laundry room and guest room, and finally, a studio at the lowest level with access to the garden. The design was not realized. Snozzi delegated the order to Aurelio Galfetti, whose 1963 Casa Rotalinti is accepted as an important impulse, co-founding the consequential influence of Le Corbusier on the Tessin architecture.

Perspektive / Grundriß Wohngeschoß
(Räume auf verschiedenen Höhen)

Perspective / Living floor ground plan
(rooms on different levels)

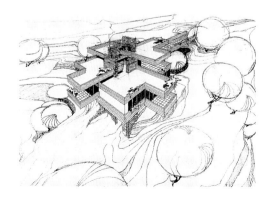
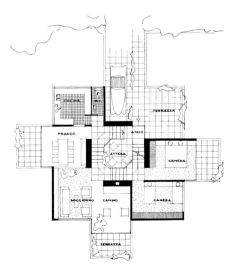

Sozialwohnungen, Locarno
Mit Livio Vacchini, 1962–65

Die Architekten Snozzi und Vacchini erarbeiteten 1962 im Auftrag der Stadt Locarno einen Quartierplan für ein im öffentlichen Besitz liegendes Gelände auf dem Maggia-Delta. Der Plan sah vor, daß im Lauf der Zeit, je nach Bedarf, mehrere derartige Wohnblöcke gebaut werden sollten. Es blieb aber bei diesem einen. Das Gebäude enthält in sechs Stockwerken 54 Wohnungen, wovon 30 Geschoßwohnungen (4½-Zimmer) und 24 Maisonette-Wohnungen sind (18 3½-Zimmer-, sechs 5½-Zimmer-Wohnungen). Drei Treppenhäuser erschliessen je 18 Wohnungen, also drei pro Geschoß. In der Gesamtanordnung der Wohnungen bestehen Bezüge zu Le Corbusiers und Pierre Jeannerets «Immeuble Clarté» in Genf (1931). Die Obergeschoße ruhen auf Zwischenwänden von nur 12 cm Stärke. Einzig die Brandwände zwischen je zwei Hausteilen sind stärker ausgeführt. Den querstehenden Betonscheiben am südlichen Gebäudekopf fällt die Aufgabe der Windversteifung in Längsrichtung zu. Die Außenwände bestanden ursprünglich aus schwarz gestrichenen Holzrahmenelementen von 270 cm Höhe und 60 cm Breite, die die Fensterflügel und Brüstung (letztere ein Sandwichelement mit Eternitoberflächen) enthielten. Diese Fassaden wurden um 1980 (ohne Mitarbeit der Architekten) durch Glas-/Aluminiumpaneele ersetzt, was den formalen Ausdruck des Gebäudes sehr stark veränderte. Die Wohnungen waren für die damalige Zeit außergewöhnlich gut ausgestattet. Sie enthielten neben Bädern und Kochherd einen Kühlschrank, Wandschränke und einen eingebauten Bügeltisch. Die Fußböden bestehen aus roten Ziegelsteinen, im Badezimmer aus weißen Steingutplatten.

Social Housing, Locarno
With Livio Vacchini, 1962–65

In 1962, by the order of the city of Locarno, the architects Snozzi and Vacchini worked out a quarter plan for a publicly owned property on the Maggia delta. The plan projected that in due time and according to needs several such housing blocks would be built. However, only this one was realized. The building contains 54 units on six floors, 30 of which are apartments (4 ½ rooms) and 24 are maisonettes (18 with 3 ½ rooms and 6 with 5 ½ rooms). Three staircases access 18 apartments each, i. e., three per floor. In the overall arrangement of the apartments, a relationship with Le Corbusier's and Pierre Jeanneret's «Immeuble Clarté» in Geneva (1931) exists. The upper floors are resting on partition walls of only 12cm width. Only the fire walls between two parts of the building are thicker. The transverse concrete slabs on the southern building head take on the task of wind bracing in the longitudinal direction. The outside walls were originally made of wooden frame elements of 270 cm height and 60 cm width, painted black, and contained the window wings and parapets (the latter being a sandwich element with Eternit surfaces). These facades were replaced around 1980 by glass/aluminum panels (without the architect's cooperation), which strongly changed the formal expression of the building. The apartments were exceptionally well furnished for the times. Besides bathrooms and stoves they included a refrigerator, wall closets and a built-in ironing table. The floors are covered with red bricks except in the bathrooms which have white earthenware tiles.

Gesamtansicht

Exterior view

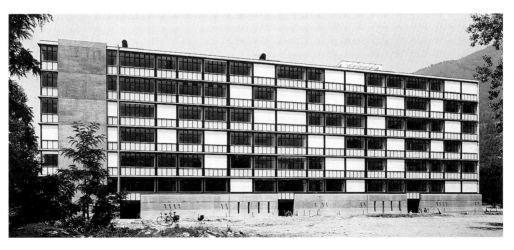

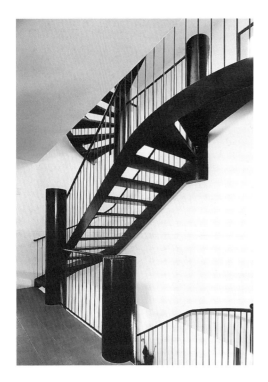
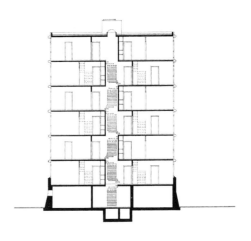

Treppenhaus / Querschnitt / Längsschnitt / Grundriß Obergeschoß 1:500 / Wohnraum der Südwohnung / Ausschnitt der Ostseite

Hallway / Cross section / Longitudinal section / Upper floor ground plan 1:500 / Living room of the southern apartment / Detail of the eastern side

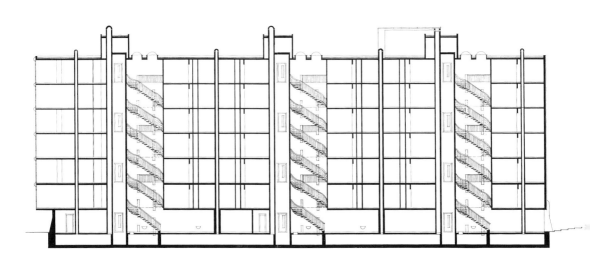
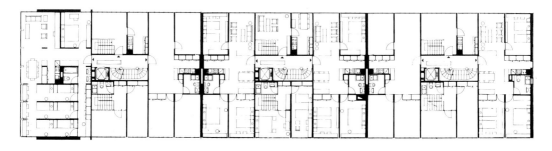

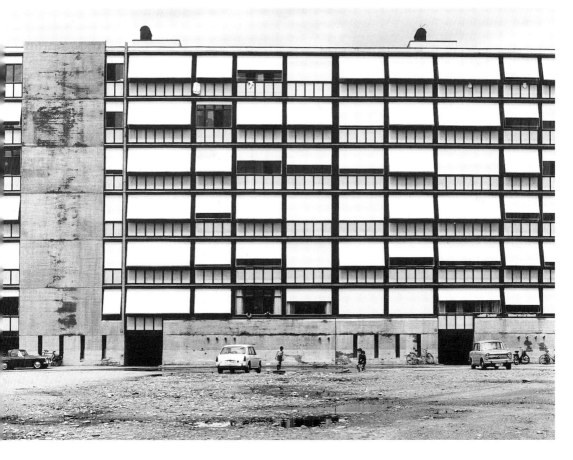

Reihenhäuser Taglio, Orselina
Mit Livio Vacchini, 1963–65

Sieben Häuser sind zu einer Gruppe zusammengefaßt, wobei die vier unten liegenden 3 ½ Zimmer-Einheiten den oberen drei 4 ½-Zimmer-Häusern als vorgelagerte Terrassen dienen. Den Platz des freibleibenden vierten Hauses in der oberen Reihe nimmt der Swimming Pool ein. Seitlich und auch in der Vertikalen sind die Häuser leicht gegeneinander versetzt. Der Erschließungsgang liegt auf der Höhe des Wohngeschosses der unteren Häuser und des Untergeschosses der oberen. Er ist als Kaskade rhythmisiert und erhält jeweils im Bereich der Differenztreppen Tageslicht von oben. Die Bergseite des Korridors enthält auch die Kellerabteile der unteren Einheiten sowie die Waschküche und Heizung für die gesamte Gruppe. Die Fensterfronten bestehen aus hölzernen Rahmen mit aufgesetzten Kasten für die Lamellenjalousien und entsprechen jenen der «Case popolari» in Locarno (vgl. S. 21). Die Gruppenform stellt sich als Alternative zur Zersiedelung der Landschaft durch Einzelhäuser dar. Kenneth Frampton hat bemerkt, daß dieser Entwurf starke Bezüge zur neorationalen Deutschschweizer Architektur aufweise (Siedlung Neubühl, Zürich; Terrassensiedlung in Umiken, Kanton Aargau; Siedlung Halen, Stuckishaus).[1] Snozzi seinerseits erwähnt den namhaften Einfluß der nordeuropäischen und nordamerikanischen Architektur (Wright, Mies, Duiker, Oud, Jacobsen, Kahn) auf die Architekten, die ihre Büros nördlich des Monte Ceneri hatten, während die Kollegen im «Sottoceneri» im wesentlichen eher nach Italien orientiert gewesen seien.[2]

[1] K. Frampton: Die Arbeit Luigi Snozzis von 1957–1984, in: Luigi Snozzi 1957–1984, Mailand 1984, S.11.
[2] Snozzi in einem Gespräch mit Martin Dominguez, in: Voraussetzungen und Hintergründe zur Arbeit Luigi Snozzis, in: Luigi Snozzi – Auf den Spuren des Ortes, Zürich 1996 (Museum für Gestaltung Zürich, Schriftenreihe Nr. 21), S. 60 ff.

Row Houses Taglio, Orselina
With Livio Vacchini, 1963–65

Seven houses are gathered into a group. The lower four 3 ½ room units serve as terraces in front of the upper three 4 ½ room houses. The space of the missing fourth house in the upper row is taken up by the swimming pool. Laterally and vertically, the houses are slightly staggered against each other. The access hallway is located at the height of the upper floor of the lower houses and the lower floor of the upper row. It has the rhythm of a cascade and in the area of the differential staircases it is lighted from above by daylight. The hillside of the hallway also contains the basement sections of the lower units as well as the laundry room and heating system for the entire group. The window fronts consist of wooden frames with attached boxes for the lamella blinds and represent – with their organization, as well – the basis for the «Case popolari» in Locarno (see p. 21). The group shape presents itself as an alternative to the sprawl of single homes in the landscape. Kenneth Frampton has noted that this design makes strong references to the neorational architecture of German Switzerland (Neubühl development, Zurich; terrace dwellings in Umiken, canton of Aargau; Halen development, Stuckishaus).[1] Snozzi, on the other hand, mentions the well-known influence that the North European and North American architecture (Wright, Mies, Duiker, Oud, Jacobsen, Kahn) have had on the architects whose offices were located to the north of Monte Ceneri, while the colleagues in the «Sottoceneri» were, for the largest part, more oriented towards Italy.[2]

[1] K. Frampton: Die Arbeit Luigi Snozzis von 1957–1984, in: Luigi Snozzi 1957–1984, Milano 1984, p. 11.
[2] Snozzi in a conversation with Martin Dominguez, in: Voraussetzungen und Hintergründe zur Arbeit Luigi Snozzis, in: Luigi Snozzi – Auf den Spuren des Ortes, Zurich 1996 (Museum für Gestaltung, Zurich, publication series no. 21), p. 60ff.

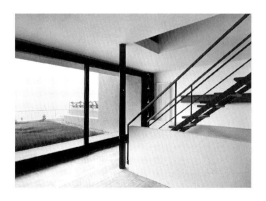
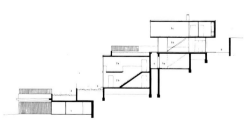

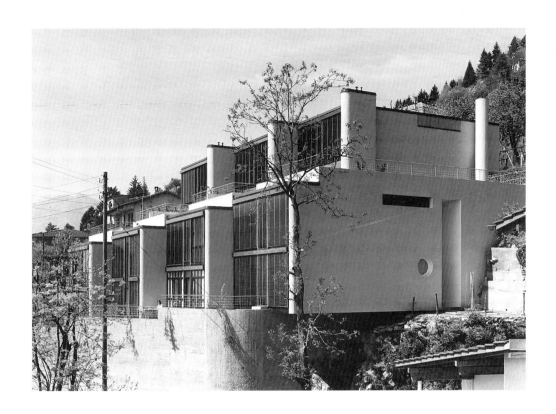

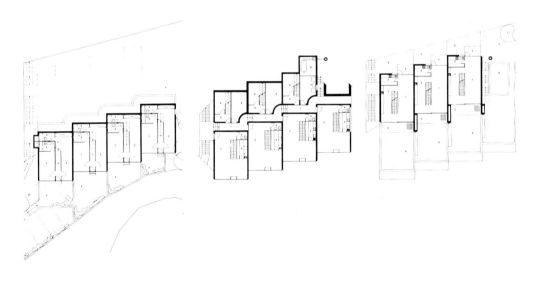

Wohnraum / Schnitt /
Gesamtansicht / Grundrisse

Living room / Section /
Exterior view / Ground plans

Bürogebäude Fabrizia, Bellinzona
Mit Livio Vacchini, 1962–65

Das Gebäude liegt in unmittelbarer Nähe des historischen Zentrums von Bellinzona, in einem Gebiet, das während der sechziger Jahre rasch überbaut wurde. Fabrizia SA ist der Name der Bauherrschaft, die das Gebäude als Miethaus errichtete. Langjährige Mieterin waren die PTT/Telecom-Betriebe, deren Auszug in ein eigenes Gebäude (Architekt Mario Botta) 1997 stattfindet. Das gesamte Grundstück ist mit quadratischen Zementplatten belegt, auf drei Seiten von einer rund zwei Meter hohen Wand aus Zementblocksteinen umgeben und so als räumlich definierter Bereich aufgefaßt, mit dem das Gebäude innen und außen kommuniziert. Der Außenraum dient praktisch der Parkierung, aber auch als Erweiterung der Bar im Erdgeschoß. Vom Eingang aus führt eine in Längsrichtung angeordnete Treppe ins 1. Obergeschoß; von dort aus verlaufen die Treppen quer zur Halle. Dies ist der wichtigste Raum des Gebäudes. Von sieben Quertonnen gedeckt, erstreckt sie sich über die Dachfläche hinaus und erhält von seitlichen Oberlichtern Tageslicht. Die freiliegenden, unverkleideten Stahlstützen sind primäre Elemente und für die Raumbildung wichtig, desgleichen die umlaufenden Galerien. Sekundäre Elemente sind die Leichtbauwände zwischen den Büros und den Galerien sowie die Büro-Trennwände. Die präzise räumliche Definition der Halle läßt an einen von Häusern umgebenen Platz denken: Passerellen und Galerien sind wie Straßen, das Haus ist wie ein auch vertikal sich räumlich entwickelndes Stadtquartier. Die Halle wird von zwei als Binnenformen hineingestellten, zitronengelb gestrichenen Elementen gegliedert: dem Schaft des Aufzugs und dem über dem Erdgeschoß hängenden Sanitärblock. Außergewöhnlich an dem dunkelblaugrau gestrichenen Stahlskelett ist auch, daß es als verschraubte Konstruktion ohne Windverbände ausgebildet ist. Das klare Verhältnis von Konstruktion und Raumbildung macht verständlich, weshalb zwischen den Architekten Snozzi und Vacchini auf der einen Seite und der ‹Solothurner Schule› eines Fritz Haller bestimmte Beziehungen vorhanden sind, zu denen Snozzi sich geäußert hat.

Office Building Fabrizia, Bellinzona
With Livio Vacchini, 1962–65

The building is located in the immediate vicinity of Bellinzona's historic center, in an area quickly developed during the sixties. The client's name was Fabrizia SA, and the building was erected with the intention of it being a rental property. The PTT/Telecom-works has been a long-standing tenant. However, 1997 they move into their own building (architect Mario Botta). The entire property grounds are covered with square cement paving stones, surrounded on three sides by an approximately 2 m high cement block stone wall and thus defined as a spatial area with which the building communicates on the inside and outside. The outside space is used, in a practical sense, for parking; but it is also used as an extension of the bar on the ground floor. From the entrance, a stair case with a longitudinal orientation leads to the second floor. From there, the stairs run diagonally to the lobby, which is the most important room of the entire building. Covered by seven transverse vaults, it stretches out beyond the roof surface and receives daylight through clerestory windows. The bare, uncovered steel supports are primary elements and of great importance for the formation of the space; this also applies to the galleries. The light-weight walls between the offices and galleries as well as the office partitioning walls are secondary elements. The precise spatial definition of the hall reminds one of a town square surrounded by houses: walkways and galleries are like streets; the house resembles a city quarter developing vertically. The hall is structured by two elements placed into it as inner forms and painted in a lemon-yellow. The elevator shaft and the sanitary block are suspended above the ground floor. Another thing that is unusual about the dark-blue painted steel skeleton is that it is designed as a bolt-connected construction without wind bracing. The lucid relationship between construction and spatial formation makes clear why there are certain connections between the architects Snozzi and Vacchini on the one hand and the Solothurn School of Fritz Haller, on the other. This is something which Snozzi has commented on.

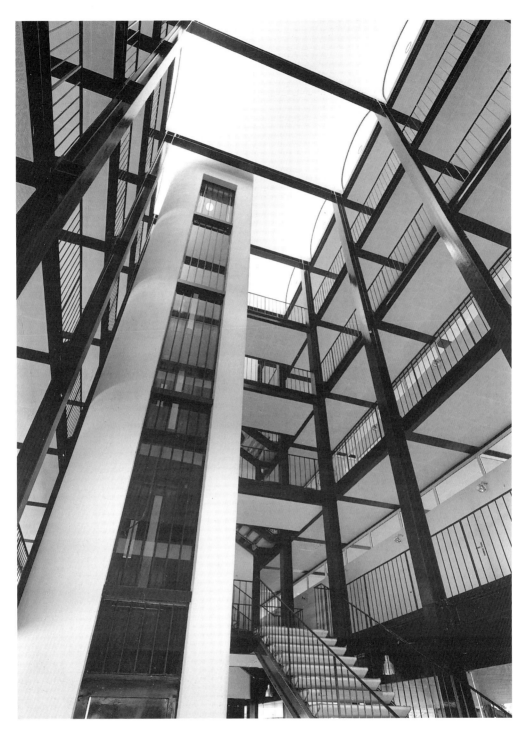

Treppenhalle mit Galerien:
Stahlskelett dunkelblau, Liftkörper
zitronengelb gestrichen

Hall with stairway and gallery:
steel skeleton painted dark blue, elevator
volume painted lemon-yellow

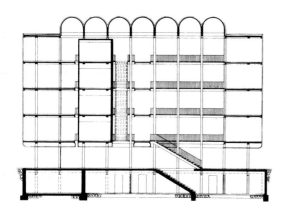

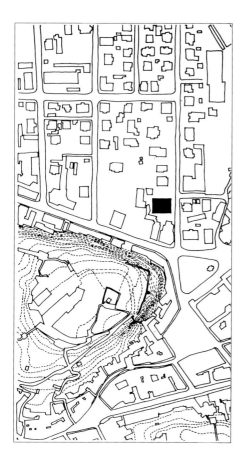
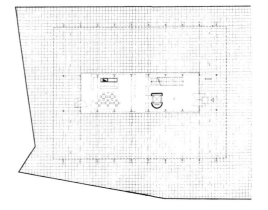

Längsschnitt und Grundriß Normalgeschoß 1:400 / Situation / Erdgeschoß mit Parzellenverlauf

Longitudinal section and ground plan of a normal floor 1:400 / Site plan / First floor with lot development

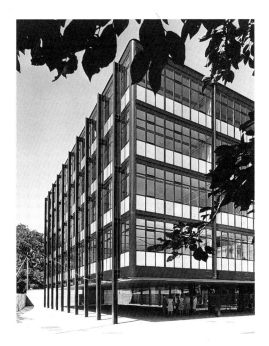
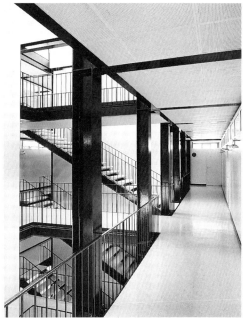
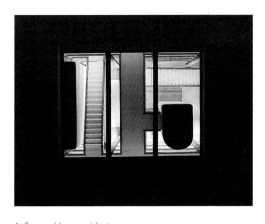
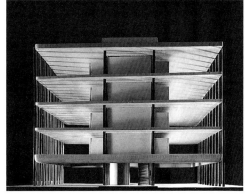

Außen- und Innenansicht /
Modellstudien

Exterior and interior view /
Model studies

Haus Snider, Verscio
Mit Livio Vacchini, 1964–66

Mit dem Haus Snider, das für eine Familie mit sechs Kindern gebaut wurde, nahm das Schaffen Luigi Snozzis die entscheidende Wende zur Realisierung seines Hauptinteresses: Sichtbarmachen und Konkretion der Landschaft gerade durch eine Abstrahierung, die von der Architektur gefordert wird; nicht Anpassung an das Bestehende, nicht Mimikry, sondern die Aufgabe, durch das Herausarbeiten der Charakteristik einer bestimmten Situation eine Qualität sichtbar zu machen. Das Grundstück liegt am westlichen Rand des Dorfkerns von Verscio in einer Hanglage; das Haus thematisiert diese Randstellung mittels der Längswände, die durch wenige, aber präzise gesetzte Öffnungen durchbrochen sind. Mit dem Dorfkern nimmt es die Beziehung über einen Hof auf, den es zusammen mit drei alten Häusern bildet, und mit dem es mittels der einzigen großen Öffnung der Ostseite kommuniziert. Diese Altbauten gehören teilweise derselben Bauherrschaft. Hinter der großflächig verglasten Fassadenöffnung liegt die zweigeschossige Halle mit dem Kaminblock und den Naßräumen. Der Hauseingang liegt an der Westseite, also dorfauswärts. Die Wohn- und Schlafräume entwickeln

Snider House, Verscio
With Livio Vacchini, 1964–66

The Snider house, built for a family with six children, brought about the decisive turning-point in Luigi Snozzi's creative career toward the realisation of his primary interest — making the landscape visible and more concrete through an abstraction which the architecture requires: not an adaptation to the existing, not mimicry, but a recognition of the potential lying in the elucidation of the given site. The property is located on a slope at the Western edge of Verscio's village center. This peripheral position is taken up as a theme in the longitudinal walls of the residence which are pierced by few yet precisely placed openings. It enters into a relationship with the village center, communicating by means of the only large opening on the eastern side, through a courtyard that it shares with three old houses. Some of these old structures are the property of the same clients. Beyond the extensively glazed facade opening lies the two-story hall with the chimney core, which also contains wet rooms. The entrance to the house is located on the western side. The living and sleeping quarters develop within a rigorous and yet playful spatial planning, which is preceded by a clear,

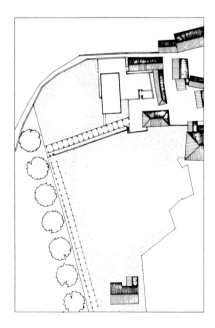

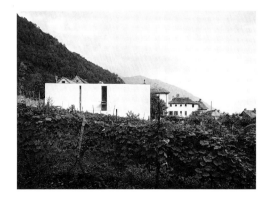

Situation / Ansicht von Westen /
Kaminhalle / Treppenvorplatz

Site plan / View from the west /
Chimney block / Stairway antechamber

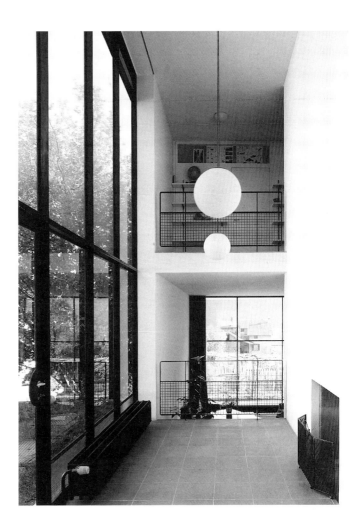

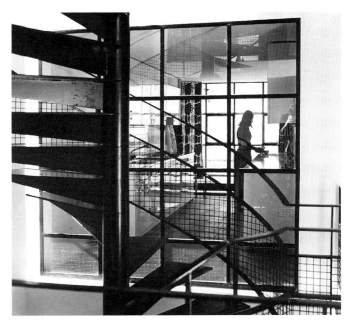

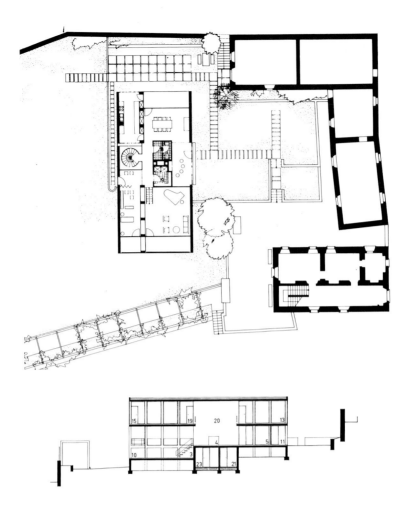

Grundriß Erdgeschoß mit Altbauten /
Längsschnitt 1:450 / Ansicht
von Süden / Ostseite mit Gartenhof

Ground plan of first floor with
old structures / Longitudinal section
1:450 / View from the south /
Eastern side with the garden court

sich innerhalb einer zugleich straffen und komplexen Raumordnung, der ihrerseits eine klare konstruktive Ordnung zugrundeliegt. Eine Pfeilerreihe teilt das Innere in zwei ungleich breite Zonen. Der Raum zwischen den Pfeilern ist variabel genutzt (mit Schränken und Regalen versehen oder offen gelassen). In einem frühen Entwurfsstadium war anstelle der Pfeiler eine Mittelwand vorgesehen. Erst deren Ersatz durch die Pfeilerstruktur ergab den großen räumlichen Reichtum dieses Hauses. Entwurfsvarianten zeigen, daß die Wendeltreppe zeitweise in einem zylindrischen Körper aus Glasbausteinen vorgesehen war. Im ausgeführten Haus entwickelt sie sich frei im Raum.

constructive order. A row of columns divides the interior into two layers of differing depths. The space in between the columns is used variably (provided with closets, shelves or left open). In an earlier design stage a middle wall had been intended instead of columns. Only by replacing it with the column structure was the great spatial wealth of this house achieved. Different versions of the design show that the spiral stair case was also conceived as a cylindrical interior volume behind a shell of glass prisms. In the realized version of the house, the staircase is not enclosed.

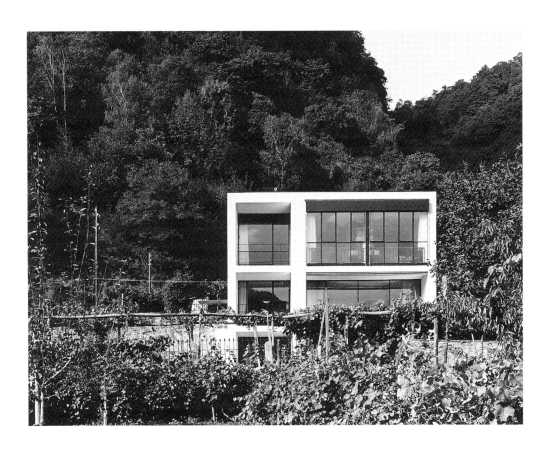
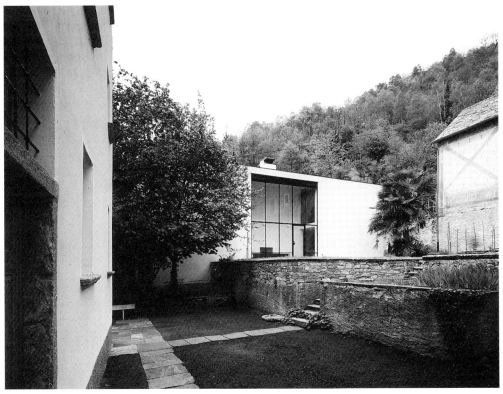

Wohnbau, Carasso
Mit Livio Vacchini, 1967–70

Das Gebäude enthält in den drei Obergeschossen insgesamt 12 Wohnungen, je sechs zu 130 m^2 respektive zu ca. 95 m^2. Die Grundrisse sind offen. Nur die Küchenkombination und WC/Bad sind in innenliegenden Blöcken fest installiert. Darum herum lassen sich über einem Quadratraster mit dem Modul von 95 cm Leichtbauwände (Metall) variabel aufstellen und an den Fassadenprofilen (die demselben Modul unterliegen) verankern. Ende der sechziger Jahre waren Variabilität und Flexibilität eines der zeittypischsten Themen in der Architekturdiskussion. Von der freien Wählbarkeit des Grundrisses machten die Bewohner jedoch kaum je Gebrauch. Snozzi hält heute diese technologische Flexibilität – im Unterschied zur typologischen – nicht mehr für zeitgemäß. Eine weitere Besonderheit des Gebäudes ist der zweigeschossige Versammlungssaal im Erd- und Untergeschoß, der 300 Personen Platz bietet. Das vollständig transparente Erdgeschoß gibt den ungehinderten Blick nach unten in den Saal frei. Diese Konfiguration von Terrainverlauf und der Hohlform des Untergeschosses wirkt gleichsam als ‹gläserner Keller›. Der eingesenkte, abgetiefte Raum wird, architektonisch anders definiert, bei der Turnhalle von Monte Carasso als Thema wiederkehren (vgl. S. 100).

Housing Development, Carasso
With Livio Vacchini, 1967–70

On the upper three levels, the building contains 12 apartments, six of which have a size of 130 m^2, the other six ca. 95 m^2. The layout is open. Only the kitchens and bathrooms are firmly installed in the internal core structure. Around this central core, through the use of a grid with 95 cm square modules, light-weight walls (metal) can be put up and anchored to the facade profiles to create variable floor plans. By the end of the '60s, variability and flexibility were one of the most typical themes in the architectural discussions of that time. However, the inhabitants rarely took advantage of the ability to freely alter and choose the layout of their apartments. Snozzi today believes that this technologically facilitated flexibility – contrary to the typologic one – is no longer up to date. Another special characteristic of the building is the two-story meeting hall reaching from the basement into the first floor and offering space for 300 people. The completely transparent walls of the first floor allow an unobstructed view into the lower hall. This configuration of the terrain development and the hollow form of the lower floor creates the effect of its being a glass basement. The sunken hall will return as a theme, in a different architectural definition, with the gymnasium of Monte Carasso. (see p. 100).

Westseite / Querschnitt / Basement mit Saal /
Grundrisse Obergeschoß, Basement 1:400

West side / Cross section / Basement with hall /
Ground plans upper floor and basement 1:400

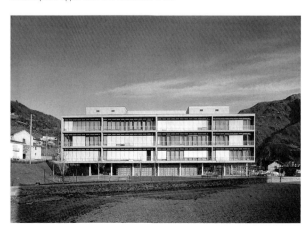
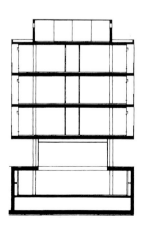

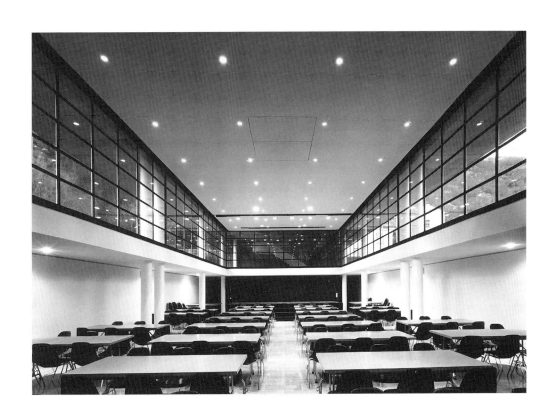
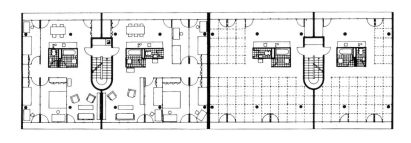
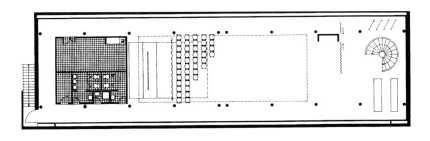

Ecole Polytechnique Fédérale, Lausanne
Mit Mario Botta, Tita Carloni, Aurelio Galfetti,
Flora Ruchat; Wettbewerb, 1970

Der Wettbewerbsentwurf war für die Formierung der ‹Neuen Tessiner Architektur› nach 1970 – und vor allem für deren Bild nach außen – von großer Bedeutung. Verlangt war in diesem öffentlichen Wettbewerb ein Entwurf für die Technische Hochschule der Westschweiz, die in Etappen für bis zu 8000 Studierende ausgebaut werden sollte. Aufbauend auf zwei Haupterschließungsachsen in Nord-Süd und Ost-Westrichtung (analog den römischen Magistralen Cardo und Decumanus) legte die Tessiner Architektengruppe einen Entwurf vor, dessen Form schon in einer Teilausbau-Stufe ausgebildet war und beim sukzessiven Weiterausbau nur mehr verdichtet zu werden brauchte. Entlang der beiden Hauptachsen sind zum einen die Auditorien und Seminarräume angeordnet, zum anderen die öffentlichen Nutzungen wie Mensa, Cafeterias und Studentenwohnhäuser. Le Corbusiers Entwurf für das Spital von Venedig (frühe sechziger Jahre) ist dabei der eine wichtige Bezugspunkt, die Freie Universität in Berlin von Candilis, Josic, Woods der andere. Der Entwurf ist insofern programmatisch, als er die Absicht dokumentiert, das Infrastruktur-Konzept (als ein Denken in funktionalen Patterns) durch eine sinnfällige Ordnung formaler Beziehungen zu kontrollieren. Für Snozzi war bei dieser Arbeit wichtig, in dieser zersiedelten Stadtperipherie ein formal geschlossenes Zentrum zu entwerfen, das einen Gegenpol zum historischen Zentrum der Stadt Lausanne darstellen sollte. Die Vorstellung von Wachstum als einer Verdichtung der gegebenen Form, als Prinzip ‹von außen nach innen› artikuliert sich hier als Widerspruch zur damaligen funktionalistischen bzw. technokratischen Ideologie, gemäß der ein Baukomplex ‹von innen nach außen› zu wachsen habe (vgl. S. 78).

Federal Polytechnical School, Lausanne
With Mario Botta, Tita Carloni, Aurelio Galfetti,
Flora Ruchat; competition, 1970

The competition design was of significant importance for the formation of the New Ticino Architecture after 1970 and, above all, for its image to the outside. This public competition called for a design for the Technical University of Western Switzerland, the construction of which was intended to be phased-in over a period of time and would meet the needs for up to 8000 students. Based on two main development axes going from north to south and from east to west (an analogy to the Roman magistrates Cardo and Decumanus), the Ticino group of architects presented a design whose form was already developed in a partial building stage and, in case of a successive further expansion, would only need to be condensed. Along the two main axes, the two lecture and seminar rooms are arranged on one side and on the other are the public facilities such as the mensa, cafeterias and student housing facilities. In this case, Le Corbusier's design for the Venice hospital (early sixties) is one important reference point; the Free University in Berlin by Candilis, Josic and Woods is another. The design is programmatic in so far as it documents the intention to control the infrastructure-concept (as a thinking in functional patterns) through an obvious order of formal relationships. For Snozzi the important aspect of this work was to design a formally closed center in this sprawling city periphery with the intention of creating a reciprocal pole for the historic city center of Lausanne. The idea of growth as a form evoking condensation, as a principle going from the outside in, is here articulated as a contradiction to the then functionalistic or technocratic ideology according to which a building complex was supposed to grow from the inside out (see p. 78).

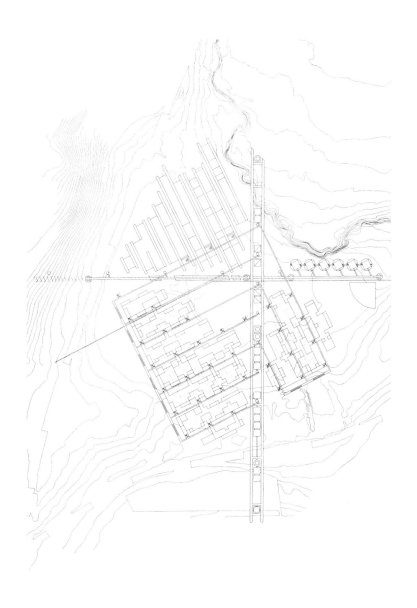

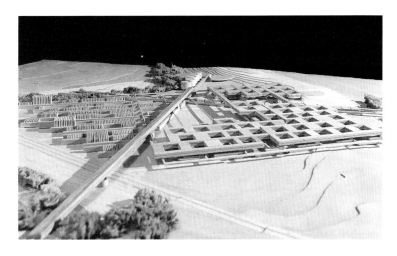

Grundriß der
Gesamtanlage / Modell

Ground plan of
the entire complex / Model

Überbauung Al Rabissale, Minusio
Mit Walter von Euw, 1970–74

Vom Architekturbüro Snozzi stammt der grundsätzliche Entwurf zu dieser Überbauung. Da Snozzi mit der Bauausführung nichts mehr zu tun hatte und diese in Fragen der Materialien und Detaillierung nicht zu seiner Zufriedenheit ausfiel, erwähnte er ihn fast nie. Gleichwohl handelt es sich hier um ein ungewöhnliches Bauwerk. Der Gesichtspunkt der Rendite stand bei diesem Bauvorhaben ungeschminkt im Vordergrund; es galt, ein Hanggrundstück möglichst intensiv für Wohnungsbau zu nutzen. Um die Aufgabe ohne das übliche Auseinanderfallen in bergseitige und seeseitige Wohnungen zu lösen, schlug Snozzi den Bau eines einzigen in der Fallinie des Abhanges stehenden Gebäudes vor, bei dem sich die Wohnungen beiderseits einer mittleren Erschließungszone befinden und somit nach Osten oder nach Westen orientiert sind. Bei der Erschließungszone handelt es sich um übereinanderliegende Passerellen, die mittels kleiner Brücken zu den Wohnungseingängen führen. Dieser Mittelteil ist Teil des Außenraums, aber von einem Glasdach gedeckt. Als historische Entsprechung läßt sich hier die bedeutende «Cité Napoléon» in Paris, ein Familistère für die Arbeiterklasse, nennen (1853). Snozzi wollte, daß die Hofseite der Wohnungen als Wand aus Glasbausteinen bestünde, daß also die präzise architektonische Form sich bewußt den Projektionen des individuellen Lebens auf diesen ‹Screen› aussetzen (und sich dabei behaupten) würde: als architektonisch kontrollierte Fläche in der ‹Zufälligkeit› von hell und dunkel, von verhüllt und transparent, von verschiedenen Lichttemperaturen usw. Das ganze Gebäude ist strukturell von oben her definiert. Das ansteigende Terrain ist freigehalten, die Berührung mit dem Gelände erfolgt punktuell und ad hoc, die Wohnungen der unteren Geschosse erscheinen gleichsam in den Rapport des Tragwerks eingehängt. In dieser Hinsicht – wie auch im formalen Ausdruck – stellt das Gebäude eine Weiterentwicklung des Wohnbaus von Carasso dar (vgl. S. 34).

Development Al Rabissale, Minusio
With Walter von Euw, 1970–74

The basic design for this development stems from the architecture studio Snozzi. Snozzi was no longer involved in its realization and it did not meet with his approval in terms of materials and details, so he has hardly ever mentioned the design. Nevertheless, it is a rather unusual construction. Clearly, the main concern of this building project – a hillside property to be used for a housing construction as intensively as possible – was the aspect of rentability. In order to avoid the usual separation of the apartments into hillside and lakeside units, Snozzi suggested the construction of a single building in the fall line of the slope with apartments on both sides of a centrally developed area oriented towards the east and the west. The central area consists of walkways leading to the apartment entrances via small bridges. This section, although part of the outside space, is covered by a glass roof. A historic reference to this is the important «Cité Napoléon» in Paris, a Familistère for the working class (1853). Snozzi wanted the yard side of the apartments to be built with glass prisms. The precise architectural form would consciously expose itself to the projections of every-day-life on this ‹screen›: an architecturally controlled surface in the ‹fortuity› of light and dark, clothed and transparent, with various light temperatures, etc. The entire building is structurally defined from the top. The rising terrain was kept free and the contacts with the building are punctual and ad hoc. The apartments of the lower floors seem to be suspended in the rapport of the supporting structure. Seen from this perspective, as well as in the formal expression, this building represents a further development of the apartment buildings in Carasso (see p. 34).

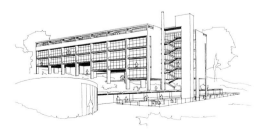
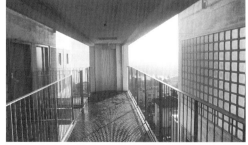

Perspektive / Erschließungs-galerien / Studie zur Innenfassade / Längsschnitt / Grundriß 1:400

Perspective / Access galleries / Study for the inside facade / Longitudinal section / Ground plan 1:400

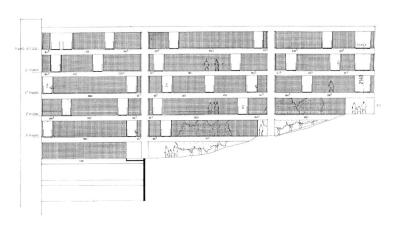

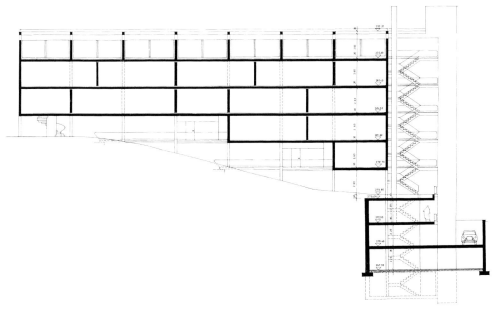

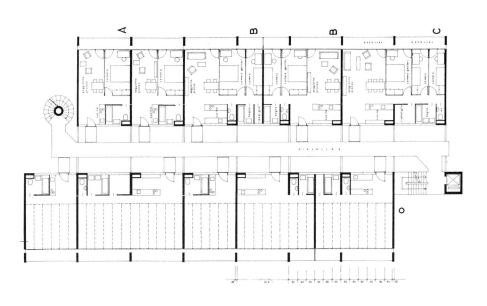

Apartmenthaus Martinelli, Lugano
Projekt, 1971

Der Wohnbau war auf einem Hanggrundstück im Zentrum Luganos vorgesehen. Der unausgeführt gebliebene Entwurf entstand im Auftrag eines Ingenieurs und ist ein von Snozzi unwiederholt gebliebener Versuch, die Kriterien von Flexibilität und Form zu einer Synthese nach Auffassung der späten sechziger Jahre zu bringen. In der Interpretation dessen, worin die Synthese zu suchen sei, ist er ein Zeitdokument. Typologisch betrachtet, stellt er gleichsam die Umkehrung des Wohnhauses in Carasso dar (vgl. S. 34). Liegen dort die Naßzellen als Fixpunkte im Innern, sind sie hier an die Fassade verlegt und in dieser Randzone variabel angeordnet. Ermöglicht wird dies durch das Tragwerk: eine stählerne Superstruktur mit vier Ecktürmen und dazwischengespannten Wabenträgern, die eine freie Führung der Werkleitungen ermöglichen. Der Konstruktionsraster für die Situierung der Naßräume ist über einem Modulmaß von ca. 1,30 m aufgebaut (dem z.B. auch die Breite eines Fensterelements entspricht). Die Anordnung und Ausbildung von Küche und WC/Bad erfolgt im Interesse einer zeitlichen und räumlichen Flexibilität – nicht wegen der ‹lebendigen› Wirkung. Ihre Begründung ist technologisch und funktional (nach damaliger progessiver Auffassung) und keineswegs malerisch. Doch mit diesem Eingehen auf die theoretischen Möglichkeiten einer technologischen Flexibilität schließt das Projekt einen Schaffensabschnitt Snozzis ab.

Apartment House Martinelli, Lugano
Project, 1971

The apartment building was intended for a sloped property in the center of Lugano. The unrealized design was the commission of an engineer and is an attempt by Snozzi, not to be repeated, to bring the criteria of flexibility and form into a synthesis according to the views of the late sixties. In the interpretation of where the synthesis was to be searched for, it is a document of its time. Seen typologically, it also represents a reversal of the apartment building in Carasso (see p. 34). While there the wet rooms are located at fixed inner core positions, here they are moved to positions on the outer perimeter and variably arranged in this boundary zone. This is made possible by the supporting structure – a steel super structure with four corner towers joined by honeycomb girders which allow a free placement of the utility lines. The construction grid for the placement of the wet rooms is built up by a modular measurement of ca. 1.30 m (which, for example, also corresponds to the width of a window element). The arrangement and form of kitchens and bathrooms follows the interest of a temporal and spatial flexibility – not the organic effect. Its reasoning is a technological and functional one (according to the then progressive viewpoint) and not at all painterly. However, by acknowledging the theoretical possibilities of a technological flexibility, the project sets the final point to one of Snozzi's creative periods.

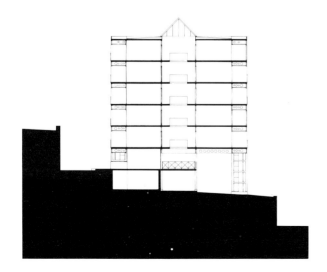

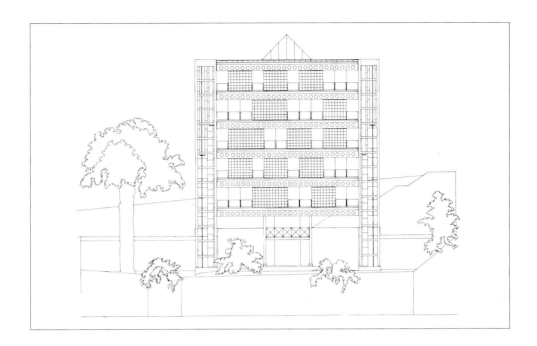

 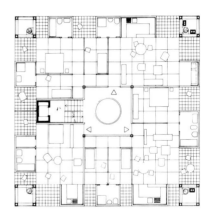

Längsschnitt / Ansicht von der Talseite /
Grundrisse Erdgeschoß und Normalgeschoß 1:400

Longitudinal section / View from the valley /
Ground plans of first floor and a normal floor 1:400

Wohnbau und Bootshafen Foce Sacromonte, Brissago
Alternativprojekt, 1972

Dieser Entwurf, obwohl nicht realisiert, ist für Snozzi von zentraler Bedeutung geworden. Hier war der Wendepunkt, der Snozzi den Ausgang aus der beruflichen Krise wies, in der er sich um 1970 sah; hier wurden erstmals konsequent typologische anstelle technologischer Überlegungen bestimmend. Es handelt sich um ein Gegenprojekt zu einer geplanten Überbauung (die in der Folge denn auch verwirklicht wurde). Snozzi erarbeitete seinen Vorschlag aus eigener Initiative, nachdem er als Mitglied der Heimatschutz-Kommission mit dem Vorhaben konfrontiert und sich einmal mehr der tiefen Unzulänglichkeit der ‹Anpassungs-Ideologie› bewußt geworden war. Auf dem Areal war der Bau von Wohnblöcken geplant, die stark gegliedert und gegenüber dem Seeufer zurückversetzt sein mußten. Für Snozzi bedeutete dies die Zerstörung des Areals jenseits des Baches – einer der höchst seltenen unüberbauten Flecken zwischen Locarno und Intra. Er suchte deshalb nach einer Lösung, die die ‹Leere› dieses Ortes selber zum Thema hat; die Frage war die nach der Definition des Freiraumes. Snozzi suchte der bloßen Vermehrung der Gebäudemasse das Prinzip eines überlegten Wachstums auf der Basis einer qualifizierten Absicht entgegenzusetzen. Sein Vorschlag war ein lang-

Apartment Building and Boat Harbor Foce Sacromonte, Brissago
Alternative project, 1972

This design, although not realized, has taken on a position of central importance for Snozzi. Here was the turning point showing Snozzi the exit to the professional crisis he found himself going through around 1970. Here, for the first time, typological thoughts, instead of technological ones became consequently decisive. We are dealing with a counter-proposal to a planned development (which was executed later on). Snozzi worked out his proposal on his own initiative after he, as a member of the local conservation commission, was confronted with the plans and had realized yet again the insufficiency of the ‹adaptation ideology›. The construction of strictly divided housing blocks set back from the lake – shore had been planned on the grounds. For Snozzi, this represented the destruction of the striking contrast between the densely developed village of Brissago and the mostly undeveloped area beyond the small stream flowing into the lake at this point one of the very rare spots between Locarno and Intra which had so far remained undeveloped. His proposal opposes the principle of mere increase of the building substance with the principle of a thought-through growth on the basis of a qualified intention. Therefore, he searched for a solution which would take up the theme of the

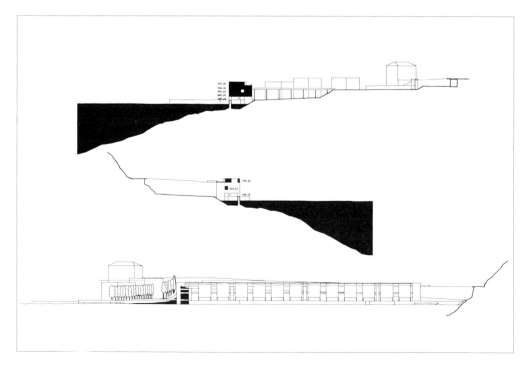

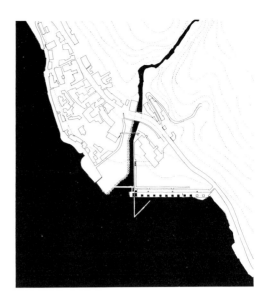

Schnitte, Fassaden / Luftbild von Brissago
um 1950 / Gesamtsituation

Sections / Facades / Aerial view of Brissago,
circa 1950 / Overall site plan

gestrecktes Gebäude direkt am Seeufer, dessen freies Erdgeschoß einen neuen Bootshafen überdeckt. Die Erinnerung an das Bauen am Ufer als ein ursprünglich spezifisch tessinerisches Element ermöglichte die Verbindung und Überlagerung öffentlicher, halböffentlicher und privater Nutzungen, die für die Theorie des Urbanen als entscheidend gilt. Die einzelnen Wohnungen (Maisonette-Typ) sind intensiv auf den See und den rückwärtigen Freiraum – der von der Kantonsstraße und ihrer hohen Stützmauer definiert ist – bezogen. Der Autoparkplatz ist auf dem Dach angeordnet, direkt mit der Straße verbunden. Die Erschließungswege in und um das Gebäude herum sind im Wechsel von Durchblicken und geschlossenen Volumen als «promenades architecturales» im Sinn Le Corbusiers intendiert. Das räumlich-volumetrische Gefüge lebt von der Reihung gleichartiger Elemente und setzt der gängigen Ideologie der vermeintlichen ‹Vielfalt durch Unterschiedlichkeit› das Prinzip der rhythmisierten Wahrnehmung entgegen. Snozzis Erkenntnis aus dem Entwurf ist, daß dieser in allem das exakte Gegenteil dessen darstellt, was als gängige Norm anerkannt ist – nicht nur in der Entwurfspraxis dumpfer Spekulanten, sondern auch in den Köpfen wohlmeinender Heimatschützer.

‹emptiness› of this location; the definition of the free space was the question.
He designed a long stretched-out building directly on the lake shore, as the apartment complex whose free ground floor covers a new boat harbor. The recollection of the building directly on the shore as an originally specific element of the Ticino enabled the connection and superimposition of public, semi-public and private facilities, which is considered decisive for the urban theory. The single apartments (maisonette-type) are intensely oriented towards the lake and towards the free space to their rear, which is defined by the cantonal road and the high supporting wall. Parking is placed on the roof and directly connected to the road. The pathways in and around the building are intended as «architectural promenades» in the sense of Le Corbusier, with interchanging openings and closed volumes. The spatial and volumetric arrangement lives through the lining up of similar elements and opposes the wide-spread and current ideology of ‹versatility through variety› by the principle of a rhythmical perception. Snozzi's insight from the design is that in all its aspects it represents the exact opposite of everything respected as a current norm – not only in the practice of numb-minded speculators but also in the heads of well-meaning local preservationists.

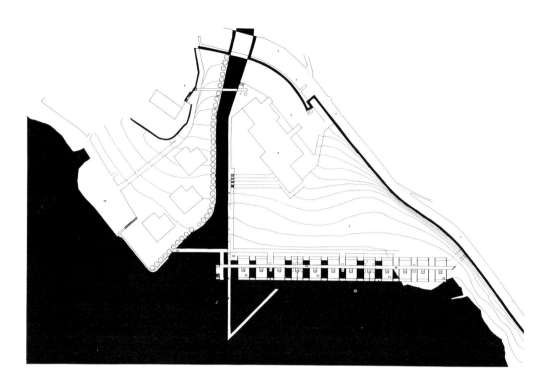

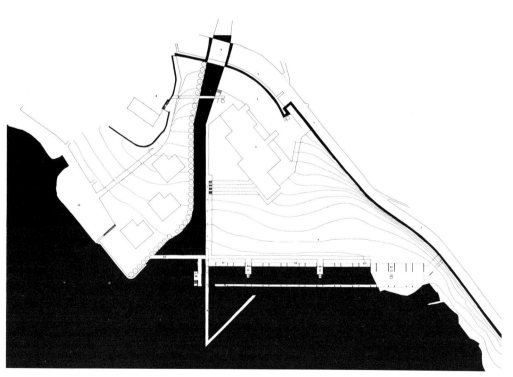

Grundrisse 2. Obergeschoß (Erschließung der Wohnungen)
und Erdgeschoß (Bootshafen), ca. 1:3000

Ground plans of third floor (development of the apartments)
and first floor (boat harbor), approx. 1:3000

Wohnbauten, Celerina
Mit Walter von Euw, Wettbewerb (Ankauf), 1973

Das Wettbewerbsprogramm verlangte etwa 40 Wohnungen unterschiedlicher Größe und eine unterirdische Parkgarage. In der Ausschreibung wurde betont, es werde «eine grundsätzliche Auseinandersetzung mit Form, Funktion und Tradition erwartet». Der Wettbewerb war für Bündner Architekten ausgeschrieben; zusätzlich wurden einige Auswärtige eingeladen, darunter Snozzi. Sein Vorschlag stellte sich in einen pointierten Gegensatz zu den unterschiedlichen Versuchen der anderen Entwerfer, ihre Wertschätzung gegenüber der Oberengadiner Landschaft durch eine formale Anpassung an das Ortsbild ausdrücken zu wollen. «Es geht nicht darum, sich an eine bestehende Situation anzupassen, sondern eine neue Situation zu schaffen». Mit diesem Satz, der so etwas wie die Handlungsmaxime der neueren Tessiner Architektur geworden ist, leitete Snozzi seinen Erläuterungsbericht ein. Der Entwurf setzt den beiden autonomen Einheiten Celerina und Crasta – beide besitzen sie ihre Kirche – eine dritte Einheit entgegen. Sie besteht aus drei Elementen: einem langgestreckten Portikus, an dem 11 Türme angeordnet sind und auf dem eine schmale Zeile aufgeständert ist (Leichtbauweise in Holz). Die Ausrichtung des Gebäudes ist durch einen alten Fußweg bestimmt, der leicht erhöht gegenüber dem Schwemmland des Inn-Flusses zur Talstufe in Richtung St. Moritz verläuft. Die Türme enthalten je das Wohnzimmer mit Küche und die Vertikalerschließung; in der hölzernen Zeile sind die Schlafzimmer angeordnet. Die beiden Teile sind durch eine Brücke miteinander verbunden. Der Parkplatz ist, anders als verlangt, oberirdisch. Das Preisgericht würdigte die «intensive Auseinandersetzung mit dem Problem des Bauens in den Bergen und die dialektische Auseinandersetzung zur umgebenden Besiedlung». Die mit Preisen bedachten Entwürfe lassen aber die Irritation erkennen, die von Snozzis Haltung ausging: «Der Projektverfasser entfernt sich von jeder Suche nach formalen Beziehungen mit der bestehenden Architektur» (aus dem Jurybericht).

Apartment Buildings, Celerina
With Walter von Euw, competition (purchased), 1973

The competition program called for about 40 apartments of varying sizes and an underground parking garage. The competition underlined the expectation of «a basic confrontation with form, function and tradition». The competition invited architects from Bünden. Additionally, some outsiders were also invited with Snozzi being one. His proposal pointedly opposed the various attempts of the other designers who tried to express their appreciation of the Upper Engadin landscape through a formal adaptation to the existing local picture. «It is not about adapting to an existing situation but about creating a new situation». With this sentence, which had become something of a maxim for the newer Ticino architecture, Snozzi introduced his explanatory report. The design contrasts the two autonomous areas of Celerina and Crasta – both having their own church – by adding a third. It consists of three elements: a long stretched portico to which 11 towers are arranged and a small row posted on top (a light weight wooden structure). The orientation of the building is decided by an old walkway, slightly elevated across from the alluvium of the Inn river towards the valley step in the direction of St. Moritz. The towers each contain the living rooms and kitchens and the vertical development; the bedrooms are arranged in the wooden row. The two parts are connected by a bridge. The parking is, other than asked for, above ground. The prize jury honored the «intensive occupation with the problem of building in the mountains and the dialectic consideration of the surrounding settlements». However, the awarded designs reveal the irritation created by Snozzi's attitude: «The author of the project removes himself from any search for formal relations with the existing architecture» (quote from the jury's report).

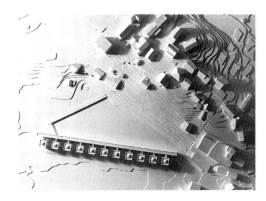

Modell, Norden = rechts

Model, north = right side

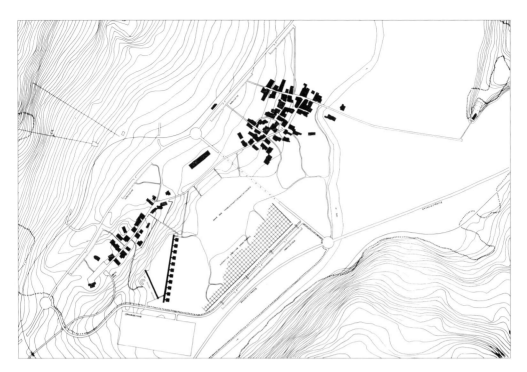

Situation mit den Ortsteilen Crasta (links) und Celerina (rechts) / Regional vorkommende Elemente / Perspektive

Site plan with the communities Crasta (left) and Celerina (right) / Regional elements / Perspective

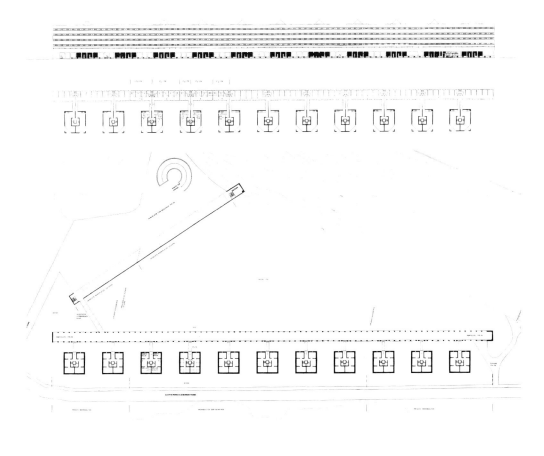
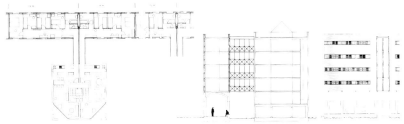

Ostfassade, Westfassade, Grundriß Obergeschoß und Erdgeschoß / Grundriß einer Wohneinheit / Querschnitt, Fassadenausschnitt

East facade, west facade, ground plan of upper floor and first floor / Ground plan of an apartment unit / Cross section, detail of the facade

Wohnbebauung Verdemonte, Monte Carasso
Mit Walter von Euw, Projekt, 1974

Die beiden Situationspläne stellen den Verdemonte-Entwurf bereits in den Zusammenhang des Ortes Monte Carasso; Jahre, bevor die Neuplanung des Dorfes abzusehen war. Der eine Plan verzeichnet die Elemente des Dorfes: den Verlauf der Höhenkurven, die Flüsse Sementina und Ticino, die Autobahn, das ehemalige Kloster. Der andere Plan dokumentiert die Parzellenstruktur, teilweise eine Folge der Erbteilung. Die Analyse des Ortes ergab die Stellung von Verdemonte längs einer Geländestufe und entlang dem Schuttkegel des Wildbaches Sementina. Snozzis Vorstellung einer ‹Stadtmauer› als Schutzwall gegen die Autobahn wurde schon hier entwickelt und galt auch später beim Entwurf des Quartiers Morenal (vgl. S. 154). Die Ausführung von Verdemonte erfolgte durch einen Generalunternehmer und ohne Begleitung durch das Studio Snozzi, wovon vor allem die Ebene der baulichen Details und der Materialien zeugt. Kürzlich wurde der Bau aufgestockt, wobei Snozzis Empfehlung, die Aufstockung als leichte Metallkonstruktion zu realisieren, nicht befolgt wurde. Der Entwurf ist eine Weiterentwicklung der Wohntypologie des Projekts für Celerina. Sind dort die Wohntürme gegenüber der Längszeile abgelöst, so sind sie hier als hervortretende Gebäudeköpfe behandelt. Da sie in den ‹Rücken› eingearbeitet sind, entsteht eine Transparenz in Querrichtung. Die wichtigen Räume sind zum Dorf Monte Carasso hin- und von der Autobahn abgewendet. Die Beziehung dieses Entwurfs zu der Strategie, der heute als ‹Modellfall Monte Carasso› weltweite Aufmerksamkeit zuteil wird, ist evident. Dies, obgleich Snozzi selber damals noch nichts ahnen konnte von der Bedeutung, die das Dorf Monte Carasso für seine Arbeit haben würde. Gerade dadurch bestätigt der Verdemonte-Entwurf die Richtigkeit dessen, was Snozzi vom architektonischen Entwurf fordert: daß er nicht nur ein Mittel zur baulichen Modifikation der Umgebung sei, sondern zuallererst ein Mittel zur Erkenntnis der Wirklichkeit.

Housing Development Verdemonte, Monte Carasso
With Walter von Euw, project, 1974

Both site plans already bring the Verdemonte-design into a relationship with the village of Monte Carasso-years before the new planning of the village was even predictable. One plan shows the elements of the village: the run of the mountain curves, the rivers Sementina and Ticino, the highway and the former monastery. The other plan documents the structure of the lot which, in part, was a result of the inheritance division. The analysis of the village showed the position of Verdemonte along a geological terrace and along the debris cone of the Sementina torrent. Snozzi's concept of a village rampart as a protective shield against the highway was already developed back then and was also valid later on during the design of the Morenal quarter (see p. 154). The construction of Verdemonte was executed by a general contractor and without the guidance of the Snozzi studio. Above all, the level of constructive details and materials is a point of concern here. Recently, the height of the structure was raised; however, Snozzi's recommendation to achieve the heightening through the use of a lightweight metal construction, was not followed. The design is a further development of the Celerina project's residential typology. While the living towers there are detached from the longitudinal row, they are treated as prominent building heads in this case. As they are worked into the ‹back›, a cross-directional transparency emerges. The important rooms are oriented towards the village of Monte Carasso, away from the highway. In general, it can be said that the strong relationship between this design and the strategy which is nowadays providing worldwide attention for Monte Carasso as a model study is evident. Snozzi himself could not have known about the importance that the village of Monte Carasso would have for his work. Especially through this, the Verdemonte project confirms the correctness of Snozzi's demands to the architectural design: that it be not simply a means for the constructive modification of the environment but first and foremost, a means for the recognition of and insight into reality.

Ansicht von Monte Carasso

View of Monte Carasso

Grundrisse Erdgeschoß und Obergeschoß / Gesamtsituation Monte Carasso 1974: Parzellenstruktur, bauliche Elemente, Autobahn, Tessin-Fluß

Ground plans of first floor and upper floor / Overall site plan Monte Carasso 1974: structure of the lots, architectural elements, highway, Ticino river

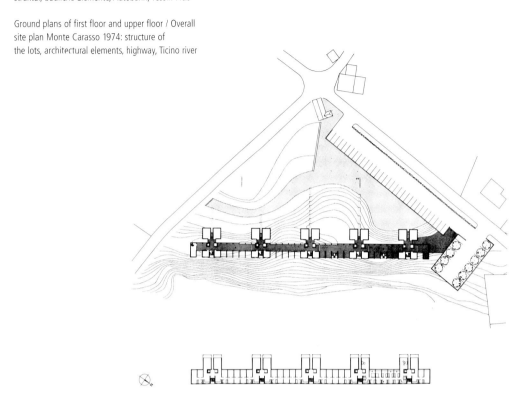

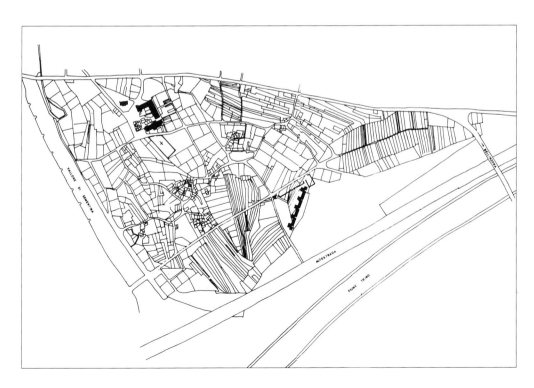

Gemeindehaus und Primarschule, San Nazzaro
Mit Walter von Euw, Wettbewerb 1973, Ausführung 1976–78

Der Bau ist das Resultat eines öffentlichen Wettbewerbes; bis zu Monte Carasso war dies der einzige öffentliche Bau, den Snozzi ausführen konnte. San Nazzaro liegt in Hanglage oberhalb des südlichen Ufers des Lago Maggiore. Die Entwurfsidee besteht darin, einen längs zu den Höhenkurven verlaufenden öffentlichen Gürtel zu schaffen, der – von Westen nach Osten – die Kirche samt Friedhof, das bestehende Gemeindehaus und den Neubau mit Kindergarten, Schulzimmern, Gemeindebüros und dem Gemeindesaal zusammenfaßt. Die Stützmauer bergseits des alten Gemeindehauses ist als Element aufgenommen und verstärkt worden. Das Gebäude ist ein Winkel aus zwei Flügeln, dessen Raumgefüge durch gegenseitige Durchdringungen gekennzeichnet ist. Der Entwurf ging von einem definierten Quadrat aus, dem der Winkel durch die präzise Behandlung des Außenraumes und einen geplanten Eckturm einbeschrieben sein sollte. Leider konnte diese Idee nicht konsequent durchgeführt werden, die Außenraumgestaltung blieb unvollendet. Die Grundrisse geben über die Bedeutung Auskunft, die dem Thema des geschichteten Raumes in diesem Bauwerk zukommt. Ein besonderes Merkmal ist der kommunizierende Luftraum im Nordflügel, wo der Saal im Obergeschoß mit dem Erdgeschoß-Korridor/Foyer verbunden ist; ein Thema, das Snozzi liebt (vgl. auch Vaduz, S. 126 und Lenzburg, S. 109). Um die Anzahl der Klassenzimmer zu vergrößern, schlug Snozzi um 1993 vor, den Gemeindesaal aus dem Obergeschoß des Nordflügels in einen neuen aufgeständerten Brückenbau zu verlegen, der den Pausenplatz gegen den See hin begrenzen würde. Mehr als ein Vorschlag ist dieser bemerkenswerte Gedanke aber vorerst nicht.

Community House and Primary School, San Nazzaro
With Walter von Euw, competition 1973, execution 1976–78

This building is the result of a competition in 1973 and the only public building that Snozzi could realize up to the time of Monte Carasso. San Nazzaro is situated on a slope above the southern shore of the Lago Maggiore. The idea of the design was to create a public belt running lengthwise to the mountain curves and including from West to East: the church with the cemetery, the existing community house and the new building with the kindergarten, the class rooms, the town offices, and the community hall. The supporting hillside wall of the old community house is taken up as an element and was reinforced. The building is a right angle consisting of two wings whose spatial structure is marked by a mutual penetration. The design assumed a defined square whose angle would be inscribed by the precise treatment of the outside space and a planned corner tower. Unfortunately, this idea could not be realized sequentially. The ground plans witness the importance of the theme of the historic space of this building. A unique characteristic is the ‹communicating› air space in the northern wing, where the hall on the upper floor is connected with the first floor lobby; it is a theme Snozzi loves (see Vaduz, p. 126 and Lenzburg, p. 109). In order to increase the number of classrooms, Snozzi suggested around 1993 to move the community hall from the upper floor of the northern wing into a new post and beam bridge building which would create a border between the schoolyard and the lake. So far, this remarkable thought has not gone beyond the stage of being a suggestion.

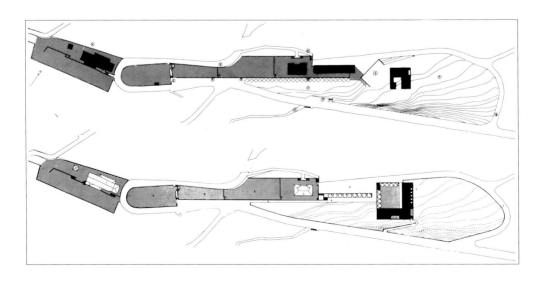

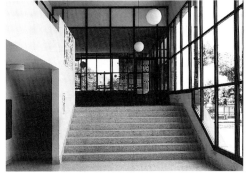
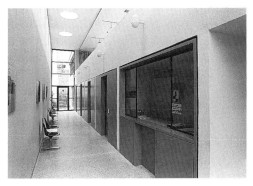
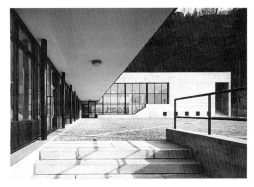

Situation Wettbewerbsprojekt (oben) bzw. Ausführungsprojekt (unten) / Außen- und Innenansichten / Grundrisse Obergeschoß und Erdgeschoß

Site plan competition project (top) and realized project (bottom) / Exterior and interior views / Ground plans of upper floor and first floor

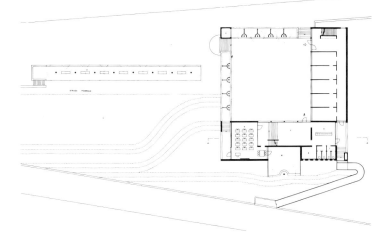

Haus Kalman, Minusio
Mit Walter von Euw, 1972–75

Das Grundstück des Hauses Kalman ist nur 400 m² groß, ein Nordhang mit einem Gefälle von 100 Prozent, von einer heterogenen Ferienhaus-Architektur umgeben und gegenüber der Aussichtsseite abgewandt. Die Voraussetzungen, hier einen vernünftigen Entwurf zu realisieren, schienen anfänglich selbst Snozzi nicht gegeben. Doch seine Beschäftigung mit diesem Ort führte zu einer meisterhaften Lösung. Es gelang ihm, die Eigenschaften des Geländes zur Grundlage des Entwurfs zu machen. Diese sind: die Taleinschnitte der Wildbäche, die die Bergflanke gliedern, die Terrassenmauern entlang der Höhenlinien, ja sogar die rückwärtige Lage, was die Aussicht betrifft. Das Haus ist als schmaler Eisenbeton-Monolith in die Flanke des Bacheinschnitts zurückgeschoben. Der Eingang erfolgt über einen schmalen Steg, der an einen Rebgarten anschließt. (Dieser Steg gehört zur Entwurfsidee, aber er konnte leider nicht ausgeführt werden; der Zugang erfolgt in Wirklichkeit von unterhalb des Hauses.) Vom Eingang im Sockelgeschoß führt eine einläufige Treppe in den Wohnraum. Diesem vorgelagert ist eine zungenartige Terrasse, die schräg vom Haus weggeht und deren Bergseite sich um die Hangschulter dreht. Sie führt zu einer Pergola («Belvedere»), die bis zu dem Punkt vorgeschoben ist, wo das Grundstück zum Aussichtspunkt wird und den herrlichen Blick zum Langensee und zum Maggiadelta

Kalman House, Minusio
With Walter von Euw, 1972–75

The property size of the Kalman house is only 400m² – a steep northern slope – surrounded by heterogeneously designed holiday-apartment architecture, turned away from the vista side. In the beginning, even Snozzi did not seem to have the preconditions of coming up with a reasonable design. However, his occupation with this site led him to an ingenious solution. He succeeded in turning the characteristics of the grounds into the basis for his design. These are: the valleys of the small wild streams structuring the hillside, the terrace walls along the mountain lines and even the backward position with reference to the view. The house is pushed back into the side of the stream incision as a narrow reinforced concrete monolith. The access goes through a narrow bridge adjoining a vineyard. (This bridge is part of the design concept, but could not be realized; now, the house is accessed from below.) From the entrance on the base floor, a single-flight stair case leads to the living space. In front of it, there is a tongue-shaped terrace leading away from the house at an angle and curving around the hillside. It leads to a pergola which is pushed forward to the point where the property becomes a look-out and reveals the glorious view of Lago Maggiore and the Maggia delta. The curved hillside of the house's wall and terrace represents the principle of an architectural adaptation to nature, which Snozzi declares to

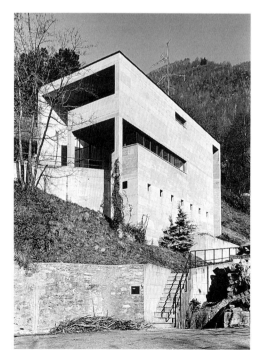

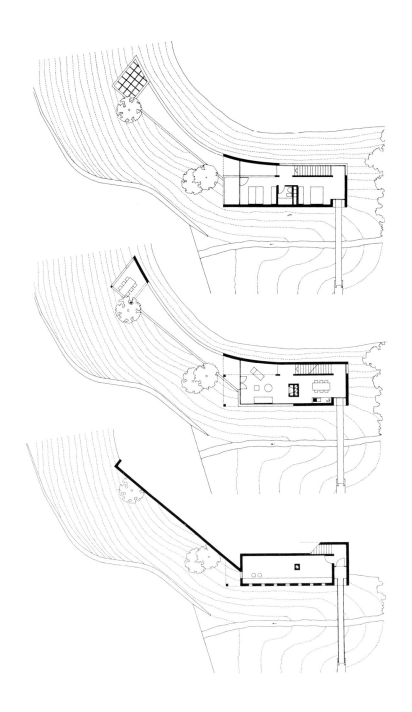

Ansicht von Süden / Gesamtsituation / Grundrisse Obergeschoß, Hauptgeschoß, Eingangsgeschoß, Längsschnitt 1:400

View from the south / Site plan / Ground plans: upper floor, main floor, entrance floor / Longitudinal section 1:400

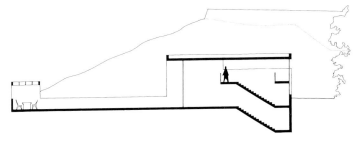

freigibt. Die gekurvte Bergseite von Hauswand und Terrasse steht dabei für das Prinzip der Anpassung der Architektur an die Natur, das von Snozzi an sich als falsch erklärt wird. Deshalb wird es unmittelbar daneben mit dem Gegenprinzip konfrontiert: Opposition von Architektur und Natur. Die gerade geführte Terrassen-Stützmauer schneidet vertikal in den Berg hinein. Die Horizontalkurve der Hangseite und die Vertikalkurve der Talseite sind die beiden extremen Verhaltensweisen, die im Sinn von These – Antithese zur Synthese gebracht sind (vgl. S. 76). Der Innenraum spielt das Thema der räumlichen Transparenz zwischen den Geschossen aus. Dies gilt für die Zone mit dem Treppenlauf ins Obergeschoß, wo die Sicht auf die Terrasse und zur ver- bzw. enthüllenden Hangkurve auch für den Gang nach oben und für das Nordzimmer genutzt wird. Die Stadien des Entwurfs lassen die konzentrierte Arbeit nachvollziehen, die erforderlich war, um zur Stringenz des ausgeführten Hauses zu kommen. Der Entwurfsgedanke schälte sich sukzessive aus der Aufgabenstellung heraus. Bemerkenswert ist besonders das Entwurfsstadium Juni 1974 bis Januar 1975. Das Bauprojekt vom Juni 1974 sah eine ausgeprägte Oppositionsstellung des Hauses gegenüber dem Hang vor: das Wohnzimmer war mit einer Reihe von Fenstern zum Hang hin orientiert, und die Terrasse war vor dem Wohnzimmer seitlich nach hinten geführt. Nur ein Dachstreifen, der mit einem Wandstück verbunden war, definierte das Gebäudevolumen nach Süden. Im Januar 1975 überdeckt das Dach die gesamte Gebäudefläche; aber noch immer gehört der nachmalige zweigeschossige Luftraum zum Außenraum. Das Schlafzimmer ist ausschließlich gegen den Hang orientiert. Dies ist ein starker Gedanke; das Wohnzimmer jedoch ist in dieser Hinsicht unentschieden. Erst die nächste Stufe, das ausgeführte Projekt, brachte die definitive Orientierung der Räume und damit den endgültigen Verlauf der Grenze zwischen innen und außen.

be false. Therefore, it is immediately confronted with the counter-principle: the opposition of architecture and nature. The straight supporting wall of the terrace cuts vertically into the hill. The horizontal curve of the hillside and the vertical curve of the valley side are the two extreme ways of behavior brought to a synthesis in the sense of thesis and anti-thesis (see page 76). The interior space plays with the theme of spatial transparency in between the floors. This applies, above all, for the area with the staircase on the upper floor, where the view of the terrace and the hill curve which can be veiled and unveiled and is also used as the hallway leading to the top and the northern room. The stages of the design allow one to follow the concentrated work which was necessary to achieve the stringency of the realized building. The design concept developed successively from the given task which, at first glance, seemed to be a problem with no solution. What's especially remarkable is the design stage from June 1974 to January 1975. The building project of June 1974 intended a strongly opposed relationship of the house with the hill: the living room was oriented towards the hill with a couple of windows and the terrace led to the back at an angle in front of the living room. Only a strip of roof connected with a section of wall defined the building volume towards the South. In January 1975, the entire building surface was covered by the roof, however, the later, two-story air-space still belongs to the outside. The bedroom is oriented exclusively towards the hill. This is a strong thought; the living room is, however, undecided in this respect. Only the next step – the realized project – brought about the definitive orientation of the rooms and thus the final progression of the border between the inside and outside.

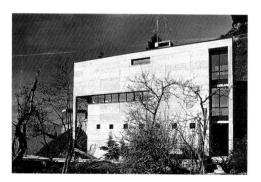
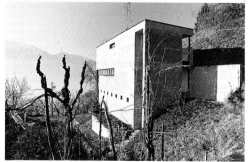

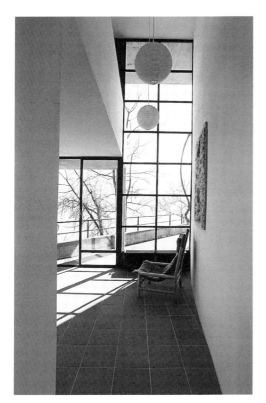
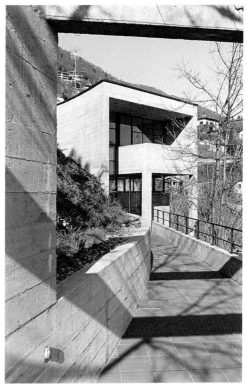

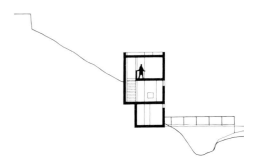

Ansichten aus Osten und Nordosten /
Wohnraum, Blick gegen Terrasse /
Blick vom «Belvedere» aus / Querschnitt 1:400

Views from the east and northeast /
Living room, view facing the terrace /
View from the «Belvedere» / Cross section 1:400

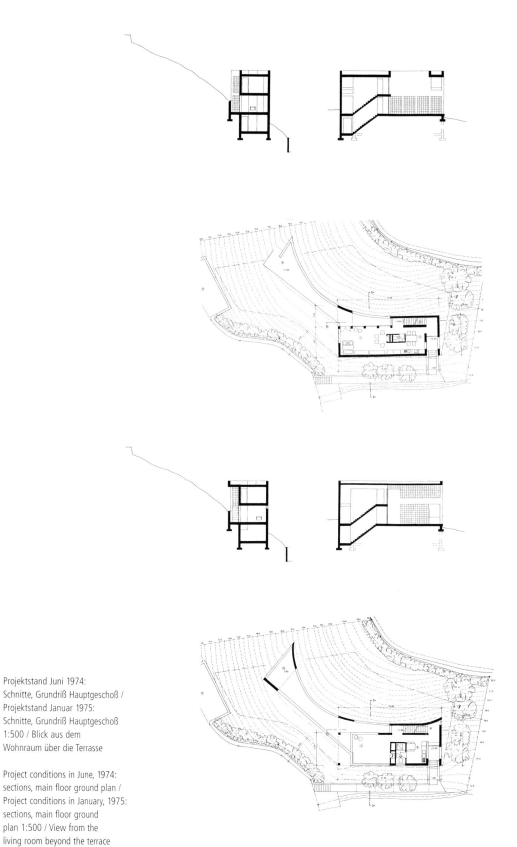

Projektstand Juni 1974:
Schnitte, Grundriß Hauptgeschoß /
Projektstand Januar 1975:
Schnitte, Grundriß Hauptgeschoß
1:500 / Blick aus dem
Wohnraum über die Terrasse

Project conditions in June, 1974:
sections, main floor ground plan /
Project conditions in January, 1975:
sections, main floor ground
plan 1:500 / View from the
living room beyond the terrace

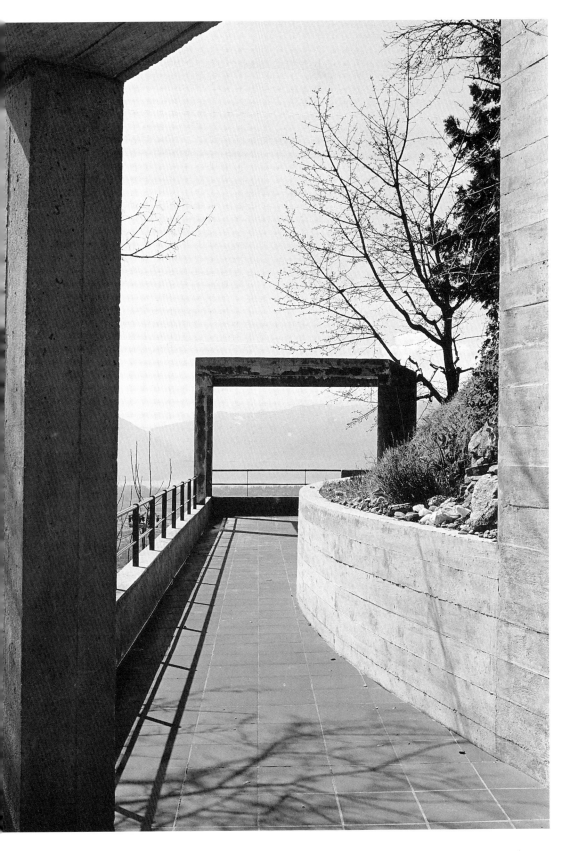

Haus Bianchetti, Locarno-Monti
Mit Walter von Euw, 1972, 1975–77

Der erste Entwurf sah ein viergeschossiges Wohnhaus vor, das an die östliche Grenze des großen Hanggrundstücks gerückt war. Dort definierte es die Stelle, wo der Rebhang in den steil abfallenden Kastanienwald oberhalb des Klosters Madonna del Sasso übergeht. Eine Änderung des Baureglementes verhinderte jedoch wegen der zu großen Bauhöhe diese Lösung. Das Haus war als Stahlskelettbau gedacht. Der Entwurf – annähernd einem Würfel einbeschrieben, zusammengesetzt aus einem Winkel- und einem Turmelement, die durch einen Leerraum voneinander getrennt (und an bestimmten Stellen mittels Passerellen wieder verbunden) sind – ist Ausdruck einer bewußten Inszenierung von inneren Wegen, von Durch- und Ausblicken sowie von Spiegelungseffekten. Der Turmbau war für die Kinder, der Winkel für die Eltern und die Familie als Ganzes gedacht. Der ausgeführte Bau wurde bemerkenswerterweise nicht an derselben Stelle – bloß niedriger – errichtet, sondern als vollständig anderer Entwurf an der westlichen Grundstückgrenze. Vom ursprünglichen Projekt wurde der Punkt übernommen, von dem aus sich die architektonische Komposition entwickelt: der Autoparkplatz am Standort des ersten Projekts, der als definiertes Volumen aus Betonstützen und -kämpfern das Haus an der Hangkante anbindet. Von ihm aus führt der Zugang zum Haus über einen 20 m langen, talseits von einer hohen Brüstung begrenzten Weg. Er setzt sich im Hausinnern, hinter der vollverglasten Front, fort. Das Thema der Durchdringung von innen und außen ist folglich vom ersten Entwurf übernommen worden. Das Haus besteht im wesentlichen aus einem einseitig geschlossenen Schirm, gebildet aus der Westwand und dem Dach, beide in Sichtbeton ausgeführt. Der Zugangsweg, der sich im Haus als Erschließungsgalerie fortsetzt, ist gleichsam eingehängt (in freier Analogie zu Mario Bottas Haus in Riva San Vitale von 1971). Die Räume sind gegen die einige Kilometer entfernte Mündung des Tessin-Flusses und das Ostende des Langensees orientiert. Dieser Blick nach Südosten ist von großer Wichtigkeit, was durch die Ausschwingung des Daches und den sichtlenkenden Effekt der gekrümmten Dachstütze dokumentiert wird. Die Wendeltreppe zwischen den beiden Geschossen wurde in der Projektierung spät eingeführt. Sie bildet gegenüber der *promenade* architecturale der Erschließungsgalerie die direkte Verbindung zwischen den Hauptgeschossen. Von einem vertikalen Fensterschlitz erhellt, drückt diese Treppennische aus, «daß die Welt hinter jener Wand nicht zu Ende ist» (Snozzi). In den Publikationsplänen ist auch der erste Entwurf dokumentiert, da die beiden sich in den Augen Snozzis nicht ausschließen, ja mehr: sich sogar gegenseitig stützen.

Bianchetti House, Locarno-Monti
With Walter von Euw, 1972, 1975–77

The intent of the first design was for a four-story apartment building to be placed at the eastern border of the large sloping property. There it would define the place where the vineyard meets the steep slope of the chestnut tree forest above the Madonna del Sasso monastery. However, a change of the building regulations made this solution impossible due to the height of the proposed structure. The house was conceived as a steel skeletal construction. The design – a vaguely described cube consisting of an angular element and a tower element separated by an empty space (and connected, in certain places, by walkways) – is an expression of a conscious staging of inner paths, of insights and outlooks as well as a reflection. The tower structure was designed and intended for the children, and the angular element was to be for the parents and for the family as a whole. Remarkably, the actualized building was not erected at the originally planned location with merely a lowered design height. Instead, it was a completely different design and was placed at the western property border. Only that point from which the architectural composition develops was adopted from the original project – the carport – which, as a defined volume of concrete columns and abutments, joins the house to the edge of the slope. From there, the access to the house follows along a 20 m long pathway, limited on the valley side by a high parapet. This walkway continues inside the house behind the glass enclosed front. The theme of the interweaving of inside and outside has thus been adapted from the first design. The house essentially consists of a one-sided closed umbrella form, and is formed by the western wall and the roof, both executed in raw, exposed concrete. The access pathway, which continues into the house as a promenade, is at the same time suspended (in a free analogy to Mario Bottas house in Riva San Vitale, realized 1971). The rooms are oriented towards the estuary of the Ticino river a couple of kilometers away and the eastern end of Lago Maggiore. This view to the southeast is of great importance, as is documented by the curved swinging out of the roof line and the view-guiding effect of the bent roof support. The spiral stair case between the two levels was introduced at a very late point in the project. It forms the direct connection between the main floors, as opposed to the architectural promenade of the interior walkway. Lighted by a vertical window slit, this stair niche expresses that «the world behind that wall is not at an end» (Snozzi). In the publication plans, the first design is also documented as in Snozzi's eyes, the two designs would not be mutually exclusive. On the contrary, they would support one another.

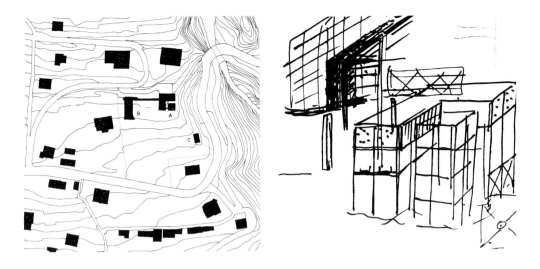
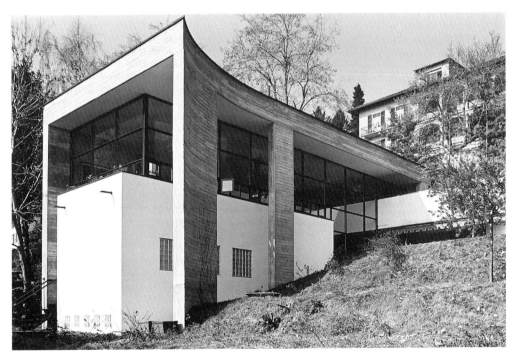

Situation / Skizze zum ersten
Entwurf 1972 / Ansicht aus Südosten

Site plan / Sketch for the first
design in 1972 / View from the southeast

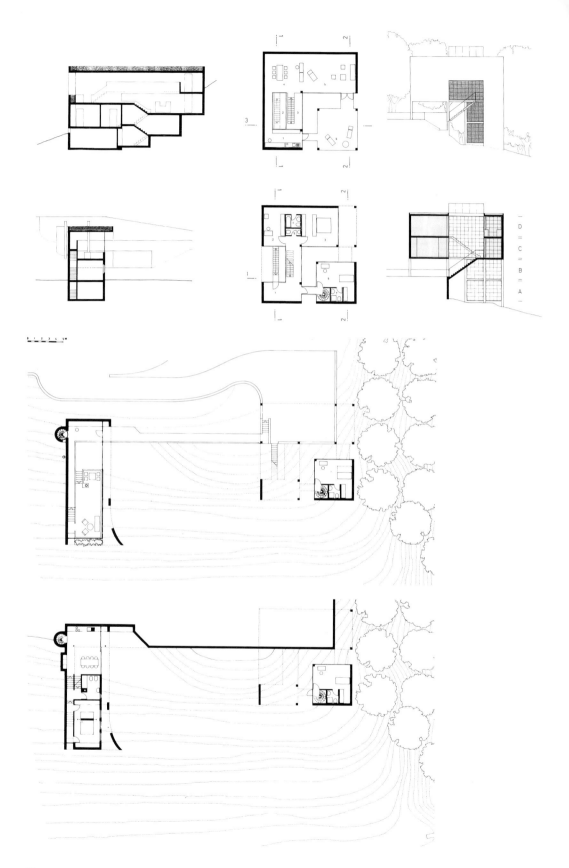

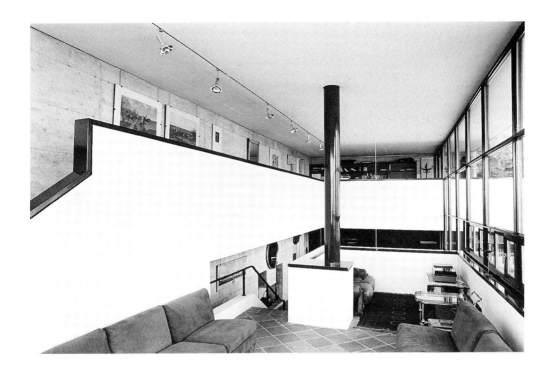

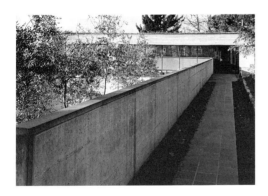
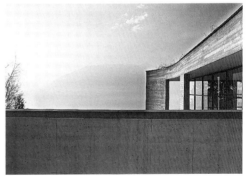

Synthetische Darstellung beider Entwürfe:
Grundrisse, Längs- und Querschnitte,
Fassade 1:500 / Wohnraum, Blick gegen
Erschließungsgalerie / Zugang /
Blick vom Zugangsweg nach Süden

Both designs shown synthetically:
ground plans, longitudinal and cross sections, facade 1:500 / Living room, view
towards the access gallery / Access / View
from the access way towards the south

Restrukturierung des Klosters Madonna del Sasso, Orselina
1974–79

1974 erhielt Snozzi vom Kapuzinerorden des Kantons Tessin den Auftrag, eine Studie zur Restaurierung des Klosterkomplexes Madonna del Sasso vorzulegen. 1977 wurde der Auftrag seitens des Kantons Tessin ausgeweitet auf die Wiederherstellung der Kirchendächer und der Annexbauten. Als erste nahm Snozzi die Grundriß- und Aufrißpläne des gesamten Komplexes auf. Sie waren die Grundlage für die notwendige ‹Lektüre des Monuments› und die hypothetische Rekonstruktion des jahrhundertelangen Baugeschehens, aus der sich wiederum die nötigen Eingriffe ableiten ließen. Von dieser höchst anspruchsvollen Aufgabe kann hier nur die Quintessenz wiedergegeben werden. Die erste Bauphase des Klosters legte um 1500 mit den ersten beiden Elementen die Grundlage zu den beiden Polen der Anlage: die Kirche auf dem Felsplateau und der etwas unterhalb gelegene Klosterhof. Beide Teile wurden in mehreren Stufen über die Jahrhunderte vergrößert und ausgebaut. Als Blütezeit nennt Snozzi – unter Bezug auf den von ihm hoch geschätzten Historiker Virgilio Gilardoni – das 17. Jahrhundert, als eine große Treppenanlage zwischen dem Kloster und der Kirche angelegt wurde. Nach einer zweihundert-

Restructuring of the Madonna del Sasso Monastery, Orselina
1974–79

In 1974, Snozzi was asked by the Capuchin order of Ticino to submit a study for the restoration of the monastery complex, Madonna del Sasso. In 1977, the task was expanded by the Canton to include the restoration of the roofs above the church and its annex buildings. Snozzi had to first take on the ground and elevation plans of the entire complex. They were the basis for the necessary ‹lecture of the monument› and the hypothetical reconstruction of the building activities which went on over the centuries. From this, the necessary operations could be concluded. Altogether, this was a highly demanding task and we can only go into its quintessential steps in this description. The first building phase of the monastery took place around 1500 and put forth the basis for the two poles of the complex with its two elements: the church on the rocky plateau, and the monastery courtyard beneath it. Both parts were expanded throughout the centuries in several phases. To Snozzi, the 17th century was the golden age – with reference to the historian Virgilio Gilardoni, whom he holds in high regard – when a large staircase between the monastery and the church was built. After a stagnant period of 200 years, the next build-

17. Jh., Obergeschoß: einzelne Elemente (Kirche nicht dargestellt) / um 1880, 1. Obergeschoß: Schließung des Hofes / um 1880, 2. Obergeschoß und Substruktion des verlängerten Kirchenchors 1:1000

17th century, upper floor: various elements (church is not shown) / Circa 1880: second floor: enclosure of the yard / Circa 1880, third floor and substructure of the extended church choir 1:1000

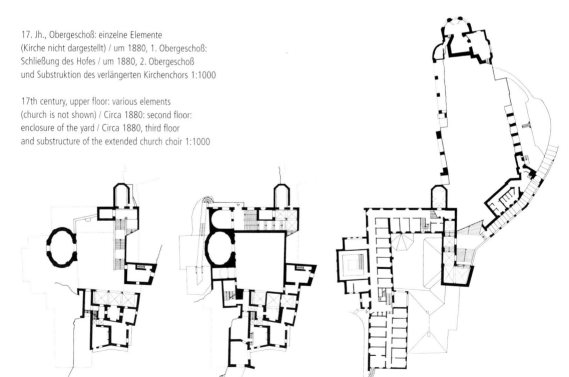

jährigen Stagnation wurde erst ab 1880 wieder gebaut. Damals wurde die Klosteranlage von einer um den Hof versammelten Baugruppe zu einem geschlossenen Geviert umdefiniert. Damit einher ging die Inversion zu einer nach innen gewendeten Anlage – Mönchszellen gegen den Hof, Korridore an der Außenseite. Sie bildete die Trennung von Kirche und Staat ab. Als architektonischen Eingriff bewertete Snozzi diesen Umbau recht hoch. Als Phase des wirklichen Niedergangs sieht er jedoch das 20. Jahrhundert an, als der Klosterhof mit Einbauten typologisch zu einem bloßen Restraum degradiert wurde, zu dem das Publikum keinerlei Zugang mehr hatte. Auch der Bau der Drahtseilbahn tat das seine zur Verunklärung der Anlage. Anstatt daß die Besucher den Felsen bestiegen, wurden sie von der Bergstation auf luftigen Passerellen an ihn herangeführt; man gelangte unter Umgehung des Klosterhofes auf den Kirchenvorplatz, der Hof war von der Wahrnehmung abgeschnitten. Die zentrale Folgerung Snozzis war, diesen Klosterhof als vermittelnden Raum zwischen der Außenwelt und der Kirche wiederherzustellen und den Zugang zur Kirche wieder über den Hof zu führen. Diese spezifisch architekturimmanente Analyse traf sich mit der Absicht des Ordens, die Abschließung zu überwinden und im Kloster ein Studienzentrum einzurichten. Snozzi sieht in diesen Entsprechungen von gesonderten – architektonischen, gesellschaftlichen, ökono-

ing phase started in 1880. The monastery was then redefined from a group of buildings surrounding the courtyard into a confined quarter. At the same time, the complex was inverted towards the inside – monk cells facing the courtyard, corridors on the outside. It represented the separation of church and state. In Snozzi's opinion, this conversion was of great importance as an architectural operation. The 20th century, however, has to be viewed as a phase of true downfall, when the monastery courtyard was typologically degraded into a mere remnant space to which the public no longer had any access. The construction of a cable car contributed to the confusion of the complex. Instead of the visitors climbing up the rock, they were lead to it from above (mountain station) on airy walkways. By avoiding the monastery courtyard, they arrived at the square in front of the church. The courtyard was cut off from perception. One of Snozzi's primary insights gained by his analysis was the necessity to reestablish this monastery courtyard as a mediating space between the outside world and the church, and to have the access to the church again go through it. As a direct consequence, the architecturally inherent analysis of Snozzi brought about exactly what the order had intended: overcoming the isolation and setting up a study center inside the monastery. To Snozzi, these relationships between separate intentions (architectural, societal, economic) al-

Um 1912, Niedergang: Hofeinbauten,
Abschließung: 1. Obergeschoß / 2. Obergeschoß mit erweiterten Substruktionen des Felsens 1:1000

Circa 1912: descent: yard installations,
enclosure second floor / Third floor with continued cladding of the church rock 1:1000

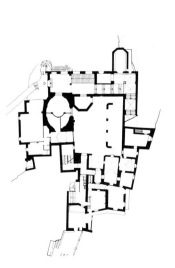
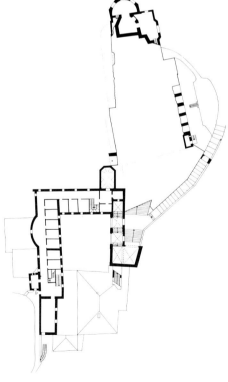

mischen – Intentionen stets einen gewichtigen Indikator für die ‹jetztzeitliche› Stringenz eines Vorhabens. Entscheidend bleibt, daß ein Entwurfsproblem auch mit architektonischen Mitteln gelöst wird: architektonisch autonom, nicht aber autark (Autonomie bedeutet Eigengesetzlichkeit, Autarkie wäre die Unabhängigkeit der Architektur, ein für Snozzi wichtiger Unterschied). Der Abbruch der Passerellen und der späten Hofeinbauten, die Öffnung zugemauerter Arkaden und die Wiederherstellung des ursprünglichen Zugangs von oben sowie die Systematisierung der Dachflächen waren die vorgeschlagenen und auch durchgeführten Maßnahmen. Ein weiteres Konzept Snozzis wurde hingegen von den Verantwortlichen abgelehnt. Er hatte festgestellt, daß bei der Vergrößerung der Kirche (besonders seit 1912) ihre Grundfläche größer wurde als das Felsplateau. Die entsprechenden Unterfangungen verkleiden die Felsflanken und denaturieren die Situation empfindlich. Snozzi schlug vor, die Kirche wieder zu verkleinern und den Fels wieder sichtbar zu machen. Der Vorschlag ging den Verantwortlichen (selbstverständlich) «zu weit». Snozzi resümierte seine Erfahrungen mit folgenden Worten:

«Auf der fraglichen Operationsbasis, d.h. der Wiederherstellung des Denkmals in seiner Totalität, mit all seinen Überschichtungen aus den unterschiedlichen Epochen, bleibt als wesentlichstes Problem, konkret zu entscheiden, was geschützt oder wiederhergestellt und was preisgegeben werden soll. Diese Linie läßt sich meines Erachtens nur in einer aufmerksamen Lektüre des Baudenkmals in all seinen Bestandteilen erreichen, mit dem Ziel, es mit neuen Antworten auf heutige Bedürfnisse neu-vorzuschlagen (reproposer), und genau hierin kann der kompetente Zugang des Architekten liegen. Leider kam ich – bei unserer Berührung mit den Autoritäten der Denkmalpflege – zur Einschätzung, daß die Befolgung des Prinzips ‹Wiederherstellung› nicht in der Absicht geschieht, das Baudenkmal für die Gegenwart neu vorzuschlagen, sondern als Ausflucht vor bewußten und engagierten Entscheidungen: sie scheint eine Praxis radikaler Erhaltung eines jeden Elementes und ohne jedes Setzen von Prioritäten zu erlauben. Hierin zeigt sich die Attitüde einer gewißen Fertigkeit, die es erlauben soll, ohne große Anstrengungen Fehler zu vermeiden. Die Folge daraus ist aber eine Haltung unfruchtbarer Selbstbescheidung, die sich in Tat und Wahrheit auf die in der Vergangenheit begangenen Irrtümer stützt, und die im Übereifer alle oberflächlichen Eingriffe und Reinigungen erstarren läßt.»[1]

[1] Luigi Snozzi: La lecture d'un monument, in: Archithese 1/1981, S. 16f. (Übersetzung aus dem Französischen: C. L.)

ways represent an important indication of the ‹time-appropriate› stringency of a project. What counts is that a design problem can be solved with architectural means: architecturally autonomous, however not autarchy (autonomy means defined by its own laws, autarchy would be the independence of architecture which, to Snozzi, has always been an important difference). Tearing down the walkways and recent yard installations, opening up closed-up arcades, reestablishing the original access from the top, and systematizing the roof surfaces were the proposed and executed measures. Another concept by Snozzi, however, was denied by the people in charge. He had found out during his recapitulation of the building's history that the church had been enlarged – especially during the last expansion phase of 1912 – in a way that its basic surface had become larger than that of the original rock plateau. The necessary underpinnings clothe the sides of the rock and painfully denaturalize the situation. Snozzi therefore proposed to reduce the church to its former size and make the rock once again visible. This proposal went «too far» (of course) for those in charge. Snozzi summarized his experiences as follows:

«On the operational basis in question, that is, the recreation of the monument in its totality with all its overlapping layers from the different eras, the essential problem remains to find a line which allows concrete decisions on what will be protected or recreated or given up. This line, in my opinion, can be found only through the lecture of the monument with all its components, the goal being to re-propose it with new answers to current needs. This is exactly where one can find a competent approach as an architect. Unfortunately, I came to the conclusion – after having been in touch with the conservation authorities – that the intention of following the principle of ‹recreation› was not to re-propose the monument for the present, but as a way out of a conscious and engaged decision. It seems to allow for a practice of radical conservation of each element without setting any priorities. Therein the attitude of a certain capability can be seen which is supposed to allow the avoidance of mistakes without great effort. The consequence being, however, an attitude of unfruitful self-contempt which in deed and truth builds onto the errors made in the past and freezes all superficially remaining operations and cleansing processes with an overdone eagerness.»[1]

[1] Luigi Snozzi: La lecture d'un monument, in: Archithese 1/1981, p. 16f.

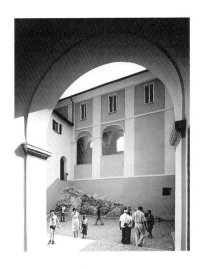
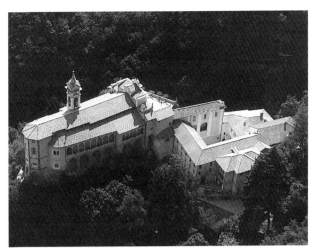
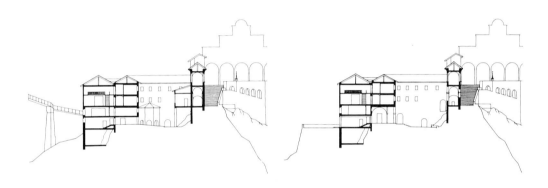
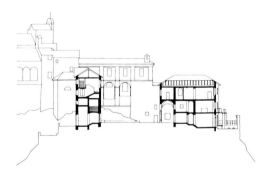
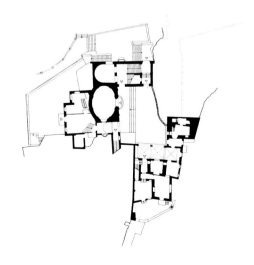

Von Einbauten befreiter Hof mit wiedergeöffneter Treppenarkade / Luftbild nach der Restauration / Querschnitte durch den Hof vor (links) und nach der Restauration (rechts) / Längsschnitt durch Klosterhof und Erdgeschoß-Grundriß seit 1979, 1:1000

Yard freed of installations with reopened stair arcade / Aerial view after the restoration / Cross sections of the yard before (left) and after (right) the restoration / Longitudinal section of the monastery yard and ground plan of the first floor since 1979, 1:1000

Brücke, Golino
Projektskizze, 1976

Nach dem Teileinsturz der Brücke über die Melezza in Golino (Centovalli) beabsichtigten die Tiefbauingenieure den Neubau einer Brücke von 9,50 m Breite – dreieinhalbmal so breit wie die alte Brücke (2,60 m). Snozzi gewann als ehemaliges Mitglied der Heimatschutz-Kommission Einblick in das Vorhaben, das er als vollständig verfehlt beurteilte, und er erarbeitete in kurzer Zeit diesen Gegenvorschlag. Seine Kritik betrifft das Denken ausschließlich nach dem Kriterium der Verkehrsgerechtigkeit. Er wies nach, daß im Centovalli nicht nur die Kantonsstraße zeitgemäß sei, sondern auch die historische alte, gewundene und langsamere Straße, an der Golino liegt. Die Begründung sah Snozzi durch die landschaftliche Ordnung gegeben, die ihrerseits eine architektonische Ordnung stiftet. Sein Entwurf richtet sich gegen das Ignorieren dieser Werte. Im Detail erkannte Snozzi die Differenziertheit des Ensembles aus einigen Häusern und einer Umfriedungsmauer auf der Seite des Dorfes Golino, die auf der anderen Seite des Tals mit einer kleinen Kapelle einen Brückenkopf aufwies. Snozzis Vorschlag war nun der Neubau einer einspurigen, aber zweigeschossigen Brücke (oben für Autos, unten für Fußgänger) anstelle der zerstörten Brücke. Er argumentierte, daß die neue Brücke wegen ihrer Identität mit dem Ort zum neuen Wahrzeichen Golinos würde. Damit sprach er ganz andere Sachverhalte an als die Allianz aus technokratischer Verkehrsplanung und eindimensional ‹konservierender› Denkmalpflege, die sich darauf einigten, die Brücke wie vorgesehen zu bauen und daneben zugleich die Ruine zu konservieren. Der Unterschied des Denkens ist fundamental. Für Snozzi ist die Permanenz des Bedeutungszusammenhangs, das heißt die Definition des ‹Gebrauchs› stets im architektonischen Kontext grundlegend wichtiger als eine bloß zeichenhafte Konservierung.

Bridge, Golino
Project sketch, 1976

After the partial collapse of the bridge across the Melezza, in Golino (Centovalli), the civil engineers planned the new construction of a 9.50 m wide bridge, which would make it three times the width of the old bridge (2.60 m). Snozzi, as a former member of the local conservation commission, gained insight into the plan which he considered to be completely wrong and, within a short period of time, he worked out this counter-proposal. His criticism was aimed at the thinking that was directed exclusively towards the criteria of traffic suitability. He showed that in Centovalli not only the cantonal street is contemporary, but also the old, historic, winding and slower street, which Golino is located along. Snozzi saw the justification in the order of the landscape which again creates an architectural order. His design is directed against the ignorance of these values. In detail, Snozzi recognized the differentiation of the ensemble consisting of a few houses and an enclosure wall on one side of Golino village which, on the other side of the valley, had a bridge head in the form of a small chapel. Snozzi's proposal was the new construction of a one-lane, but two-level bridge (above for cars and below for pedestrians) in place of the destroyed bridge. His argument was that the new bridge would become a new landmark of Golino due to its identity with the village. He thus addressed completely different circumstances than those of the alliance of technocratic traffic planners and the one-dimensional preservationists, who had come to an agreement to rebuild the bridge as it was and therefore conserve the ruin. The difference in thinking is a fundamental one. For Snozzi, the permanence of the meaningful relation, i.e., in an architectural context, the definition of use, has always been fundamentally more important than a simply symbolic conservation.

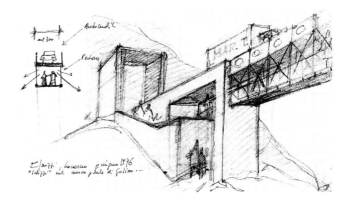

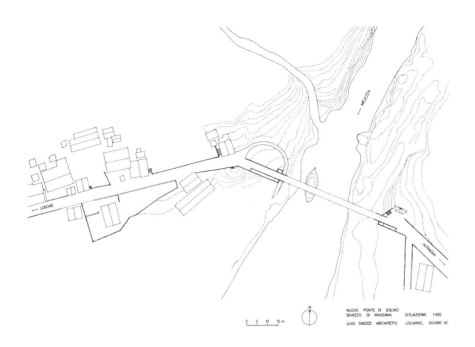

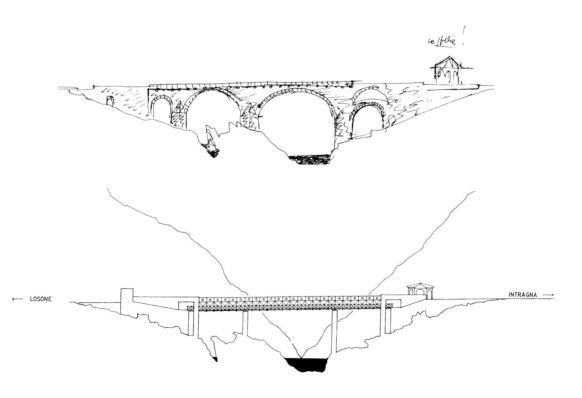

Skizze der Doppeldeck-Brücke / Situation /
Skizze der alten Brücke / Seitenriß des Neuvorschlags

Sketch of the double-deck bridge / Site plan /
Sketch of the old bridge / Lateral section of the proposal

Psychiatrische Klinik, Münsterlingen
Mit Bruno Jenni, Wettbewerb, 1976

In früherer Zeit bestand in Münsterlingen am Bodensee (Kanton Thurgau) auf einer kleinen Insel in unmittelbarer Ufernähe ein Dominikanerkloster. Seine Gebäude zerfielen, und der Orden errichtete einen Neubau auf dem Festland. Der Wasserarm zwischen dem Ufer und der Insel verlandete, die Insel wurde zur Halbinsel, und auf ihr entstanden die ersten Gebäude einer psychiatrischen Klinik. Der Wettbewerb betraf deren Erweiterung, einerseits mit zentralen Einrichtungen, andererseits mit einem zusätzlichen Betten-Pavillon für 60 Personen. Snozzis Vorschlag schlug eine andere Richtung ein als die von der ausschreibenden Behörde erwartete. Verlangt war ein Entwurf für das Wettbewerbsgebiet zwischen der ehemaligen Insel und dem Festland: gemeinschaftliche Bauten und der neue Bettenpavillon. Snozzi empfand diese Problemstellung als willkürlich. Statt einer unreflektierten Nutzungsdurchmischung suchte er eine klare funktionelle Gliederung. In seinem Entwurf sind dem Areal der Halbinsel die gemeinschaftlichen Einrichtungen der Institution zugewiesen (Arbeit, Freizeit). Dieser Bereich ist durch einen Hartbodenbelag definiert. Die Betten-Pavillons sieht der Entwurf entlang einer inneren Promenade vor. Sie ist die Verlängerung der ursprünglichen Erschließungsstraße zur Direktorenvilla, ein Sträßchen, an dem bereits einige Gebäude der Klinik standen. Den Pavillons vorgelagert sind Gärten für die jeweiligen Bewohnerinnen und Bewohner, sie gehen in einen Parkgürtel über, der sich dort erstreckt, wo früher das Wasser zwischen der Insel und dem Ufer war. Der Zugang zum gesamten Gelände erfolgt in Snozzis Entwurf – entgegen dem Programm – vom Ostende her. Von dort gelangt man zum Zentrum der Institution, von der aus wiederum eine Verbindung zur Promenade führt. Diese ist also im wesentlichen von innen her erschlossen. Die Lage der Teile zueinander ist klar systematisiert, d.h. hierarchisiert, was für Snozzi im doppelten Sinn ein Anliegen war: institutionell wie auch architektonisch-urbanistisch.

Psychiatric Clinic, Münsterlingen
With Bruno Jenni, competition, 1976

In an earlier time, a Dominican monastery existed on a small island directly off the shore of Lake Constance in Münsterlingen (canton of Thurgau). Its buildings had deteriorated and the order erected a new building on the mainland. The channel between the shore and the island silted up and the island became a peninsula. There, the first structures of a psychiatric clinic were built. The competition was concerned on one hand with an extension of the clinic with central facilities, and an additional pavilion with beds for 60 people on the other. Snozzi's proposal went in another direction than the one expected by the inviting institution. They asked for a design for the competition grounds between the former island and the mainland: communal buildings and the new pavilion. To Snozzi, this task seemed to be posed arbitrarily. Instead of a mixture of facilities which wasn't thought through, he strove for a clear functional structure. In his design, the new central facilities are situated in a compact building complex on the former island, defined as a coherent area by a hard floor covering. The design plans for pavilions along an inside promenade. It is the extension of the original access road to the director's villa, a small street along which some of the clinic's buildings were already located. In front of the pavilions there are gardens for the inhabitants, and they turn into a park belt along the area where the water used to flow in between the island and the mainland. In Snozzi's design, the access to the entire grounds is from the eastern end, as opposed to the invitation guidelines. From there, one reaches the center of the institution where a connection leads to the promenade. The latter is developed from the inside, as well. The relationship of the parts to one another is clearly systematized, i. e., there is a hierarchy which was a motive for Snozzi in a double sense: institutionally as well as urban-architecturally.

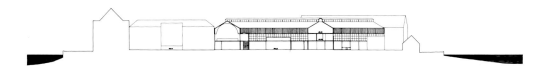

Schnitt durch die Gemeinschaftsbauten / Modell / Grundrisse: Erd- und Obergeschoß des Zentrums / Situation mit Zentrum und den aufgereihten Bettenpavillons (unten)

Section of the common buildings / Model / Ground plans: first floor and upper floor of the center / Site plan with center and the lined-up bed pavilions (bottom)

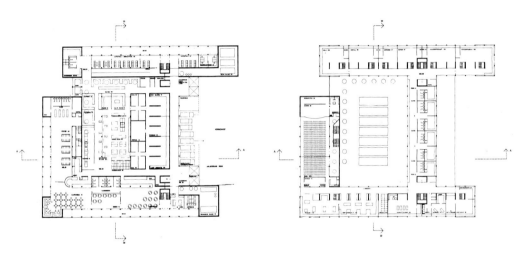

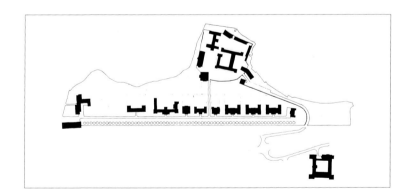

Sportzentrum, Tenero
Mit Walter von Euw, Wettbewerb, 1976

Das Wettbewerbsareal liegt am westlichen Ende der Magadinoebene unweit der Einmündung des Tessin-Flusses in den Langensee. Hier ist die Berührungsstelle von unterschiedlichen Landschaftstypen: es kommen ein Naturschutzgebiet, eine Landwirtschaftszone, ein Campingplatz und das Randgebiet des Ortes Tenero zusammen. Je nach Pegelstand des Langensees bildet sich eine neue Uferlinie. Um das Areal für Bauten nutzen zu können, verlangte das Wettbewerbsprogramm, daß der Baugrund um etwa drei Meter auf die Kote 197 Meter über Meer angehoben werde. Bereits in der Aufgabenstellung war also die Notwendigkeit eines künstlichen Eingriffes formuliert; die Frage war nur, ob man diese Künstlichkeit verleugnen, durch Indifferenz tarnen oder sie als Quantité negligeable betrachten wolle. Für Snozzi stand außer Frage, daß die erforderliche Aufschüttung zum Ansatzpunkt des Entwurfs zu machen sei; das Problem lag einmal mehr in der plausiblen Form des Eingriffs. Snozzi stellte beim Studium alter Karten fest, daß schon früher einige Bauernhäuser auf erhöhtem Baugrund (+197) gestanden hatten und daß bestehende Baumreihen frühere, heute verschwundene, Flußarme gesäumt hatten. Mit diesen Erkenntnissen über die historische Bedeutung der Baumreihen und Standorte von Häusern ließ sich nun das Gebiet für den architektonischen Eingriff definieren. Die Anlage entwickelt sich als Hofgeviert um die neugeschaffene Bucht herum. Das Freibad ist als Schräge gegenüber dem orthogonalen Hof eingeführt. Sie bestimmt die Bucht parallel zur südlichen Baumreihe. Der gesamte Komplex von Hochbauten und Terrain ist als ‹Pol› aufgefaßt, auf den von den verschiedenen Seiten her die unterschiedlichsten Landschaftstypen bezogen sind. Im Norden sind dies die von Snozzi vorgeschlagene planmäßige Erweiterung von Tenero und die naturgeschützte Uferzone, im Süden das Sportgelände und im Osten das Landwirtschaftsgebiet. Den Hoftypus wählte Snozzi wegen seiner organisierenden Klarheit als primäre architektonische Form und mit direktem Bezug auf den Typus des lombardischen Gehöfts in der Poebene.

Sports Complex, Tenero
With Walter von Euw, competition, 1976

The competition grounds are located at the western end of the Magadino plain, close to the mouth of the Ticino river where it discharges into Lago Maggiore. It is the meeting point of varying landscapes. A nature preserve, an agricultural zone, a campground, and the peripheral area of Tenero village all come together in this location. Depending on the water level of Lago Maggiore, a new shore line develops. In order to be able to use the grounds for building, the competition program demanded that the building grounds be raised by approximately three meters to 197 meters above sea level. The necessity of an artificial operation was defined already in the task. The question however was, whether to deny this artificiality, disguise it by indifference or consider it a negligible quantity. For Snozzi there was no question that the necessary landfill was to be regarded as the basis for the design. The problem once again lay in the plausible form of the operation. When studying old maps, Snozzi found that in earlier times a few farm houses had already stood on raised grounds (+197) and that existing rows of trees had lined earlier tributaries which today no longer exist. With these insights into the historic meaning of the tree lines and locations of houses, the new area could be defined for the architectural operation. The complex develops as a yard around the newly created bay. The pool is introduced as a diagonal line to the orthogonal yard. It defines the bay parallel to the southern tree line. The entire complex of high buildings and terrain is understood as being a ‹pole›, to which, from the various sides, the differing types of landscapes refer. To the North, these landscapes are: the planned expansion of Tenero and the naturally preserved shore zone suggested by Snozzi, to the South the sports complex, and to the East the agricultural area. Snozzi chose the yard type because of its organizing clarity as a primary architectural form and with a direct reference to the Lombard farm in the Po plain.

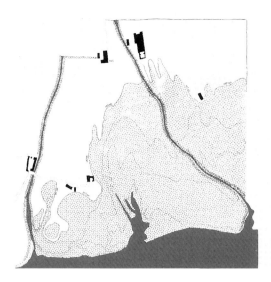

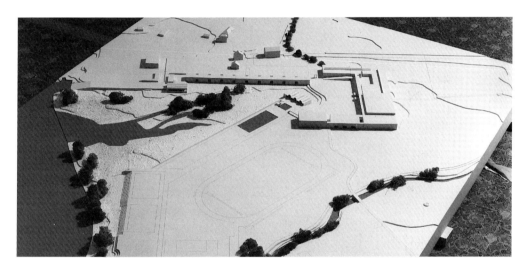

Mündung des Tessin-Flusses / Lektüre des Ortes:
Baumreihen an Wasserarmen, alte Gebäude /
Definition der Uferlinie / Modellaufnahme / Elemente
des Entwurfs und anstoßende Landschaftstypen.
Seite 72: Grundriß Hauptgeschoß, Schnitt und Fassade

Mouth of the Ticino river / Lecture of the location:
rows of trees along tributaries, old buildings /
Definition of the river bank / Model / Elements
of the design and adjoining landscape types.
Page 72: ground plan of main floor, section and facade

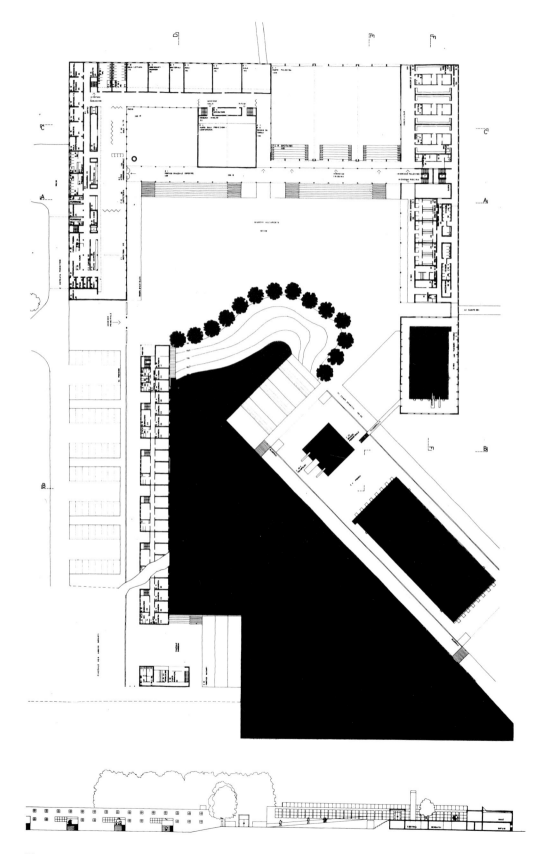

Haus Cavalli, Verscio
Mit Walter von Euw, 1976–77

Dieses Haus steht in unmittelbarer Nachbarschaft des Hauses Snider, parallel dazu und seitlich versetzt (vgl. S. 30). Im Unterschied zu diesem, das durch den Hof, den es mit den alten Häusern teilt, der ‹Porosität› des Dorfes auf das Schönste entspricht – immer wieder erweitern sich die Gäßchen vor den Häusern zu kleinen Plätzen – liegt das Haus Cavalli etwas außerhalb. Um den Zusammenhang mit dem Dorf herzustellen, machte Snozzi den Weg zum Haus hin zum Angelpunkt des Entwurfs. Er setzte den Hauseingang in die Achse des bestehenden Gäßchens, wobei diese über den Scheitelpunkt einer Linkskurve hinaus verlängert wird. Der Weg setzt sich im Hausinnern als Treppe fort, die nach rechts zunächst zum Wohngeschoß hinauf und von dort weiter ins Schlafgeschoß führt. Der Raum oberhalb der Treppe ist über die gesamte Gebäudehöhe offen und von hochliegenden Fensteröffnungen erhellt (reflektierende Dachschräge).

Cavalli House, Verscio
With Walter von Euw, 1976–77

This house is located in the same neighborhood as the Snider house. It lies parallel to it and is laterally set back (see p. 30). Contrary to the Snider house which shares its yard with the old houses and beautifully corresponds to the ‹porosity› of the village – the small alleys in front of the houses time and again widening into small squares – the Cavalli house is located a little bit outside of the village. To create a relationship with the village, Snozzi made the path leading to the house the cardinal point of the design. He placed the entrance to the house into the axis of the existing alley, whereby the latter gets elongated beyond the apex of a left turn. The path continues inside the house as a staircase which, turning to the right, first leads up to the living room and then to the bedroom level. The space above the staircase is opened up through the entire building height and lightened by high window openings (reflecting the pitch of the roof).

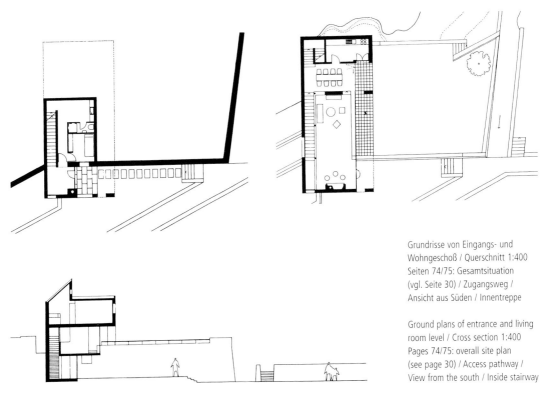

Grundrisse von Eingangs- und Wohngeschoß / Querschnitt 1:400
Seiten 74/75: Gesamtsituation (vgl. Seite 30) / Zugangsweg / Ansicht aus Süden / Innentreppe

Ground plans of entrance and living room level / Cross section 1:400
Pages 74/75: overall site plan (see page 30) / Access pathway / View from the south / Inside stairway

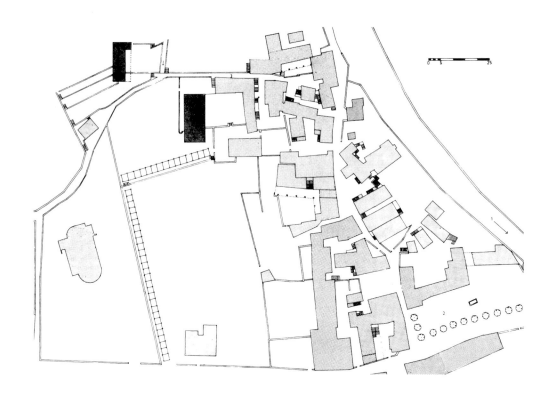

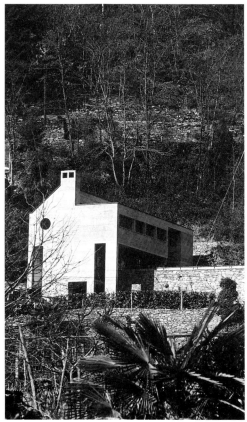

74

Geschäft Costantini, Minusio
Mit Walter von Euw, 1977–79

Die Straße von Minusio nach Orselina wurde in den 1970er Jahren verbreitert. Durch den dafür notwendigen Abbruch einer Reihe von Häusern wurde die morphologische Struktur dieses Ortsteils stark verändert. Das Gebäude nimmt dazu Stellung. Sein Grundstück ist ein Dreieck, dessen rechtwinklig aufeinanderstehende Schenkel auf die alte Dorfstruktur verweisen, und dessen Hypotenuse durch die Straße gegeben wird. Die historische Bebauung waren Häuser parallel und quer zu den Höhenlinien, wie die Umgebung des Grundstücks sie noch aufweist. Bergseits ist der Laden an ein altes Haus angebaut. Auch die talseitige Begrenzung des Grundstücks bildet diese Ordnung ab: eine alte Mauer, die ein Rest der ehemaligen Dorfumfriedung ist. Das Ladengeschäft macht den Konflikt zwischen der alten Ordnung und der neuen Diagonale produktiv. Es erstreckt sich als etwa 6 m tiefer Baukörper längs der Straße. Das obere Geschoß öffnet sich ausschließlich gegen die Straße, das untere (Parkplätze) gegen den Hof. Der östliche Teil enthält im Untergeschoß das Lager; er nimmt die Beziehung zur bestehenden Bebauung auf, verläuft parallel zur Dorfmauer und endet in einer scharfen Kante. Diese Stelle bringt durch die Art ihrer Ausbildung die beiden Richtungen zur dialektischen Reaktion; sie ist die buchstäblich auf die Spitze getriebene Synthese zwischen der ‹These› der alten Bebauungsstruktur (Rückwand) und der ‹Antithese› der schräg ansteigenden Straße. Der Innenraum des Ladens endet vor der Kante, wodurch eine Art Tor entsteht, das die Elemente der Rückwand, der Dachplatte und des ‹eingeschobenen› Ladens in ihrem Zusammenwirken artikuliert. Der Durchbruch in der Rückwand ist nicht bis zum Dach hochgeführt, sondern weist einen Sturz auf, wodurch er für Betrachter auf der Straße auf die Schildwand verweist, deren Teil er ist.

Costantini Store, Minusio
With Walter von Euw, 1977–79

The street leading from Minusio up to Orselina was widened in the '70s. The morphologic structure of this part of town was considerably changed due to the necessary demolition of a couple of houses. This building comments on that. The shape of the grounds is a right triangle whose legs refer to the old village structure and whose hypotenuses is taken by the street. Historically, the houses were built in lines, both parallel and perpendicular to the mountains, as the surroundings of the lot still show. Towards the hillside, the store is connected to an old house. The border of the lot towards the valley, an old stone wall which is a remnant of the former village rampart, reflects this order. The store makes the conflict between the old order and the new diagonal line productive. It stretches along the street as a building volume with an approximate depth of 6 m. The upper floor opens exclusively towards the street, the lower floor (parking lots) towards the courtyard. In the basement, the eastern part contains a storage area. It takes up a relationship with the existing development and runs parallel to the village wall, ending in a sharp edge. This spot brings the two directions into a dialectic reaction through its form; it is literally the overly exaggerated synthesis of the ‹thesis› of the old development structure (back wall) and the ‹anti-thesis› of the slanted climbing street. The interior space of the store ends before the edge, thus creating a kind of gate which articulates through their interaction the elements of the back wall, the roof slab, and the ‹inserted› store,. The opening in the back wall is not brought up all the way to the roof but ends with a lintel, thus pointing, when viewed from the street, to the sentry wall of which it is a part.

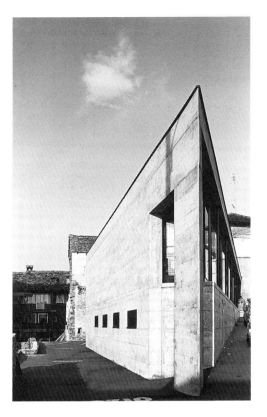
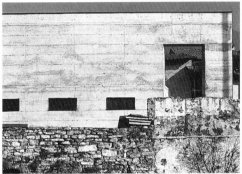

Eckansicht / Blick aus Süden /
Grundrisse von Laden- und Sockelgeschoß

Corner view / View from the south /
Storeroom and basement ground plans

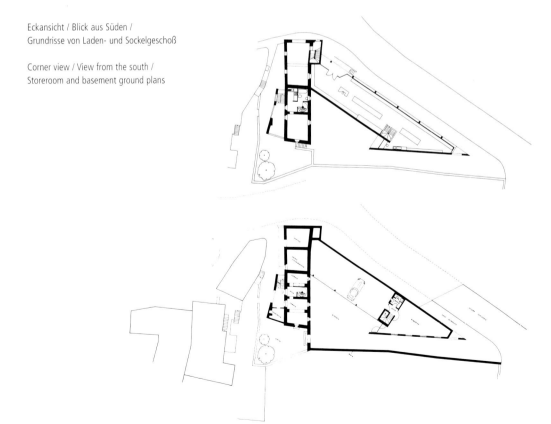

Primarschule, Montagnola
Mit Walter von Euw, Wettbewerb (2. Preis), 1978

Montagnola, ein wohlhabendes Dorf unweit Lugano, liegt in einem stark hügeligen Teil des Tessins. Das Wettbewerbsgebiet war ein ausgedehntes, von einem kleinen Bach durchflossenes Grundstück, zur Hauptsache flach, aber umgeben von steilen Abhängen. Snozzi nahm die Entwurfsaufgabe zum Anlaß, die vorhandenen Elemente in ihrer Spezifik stärker zu artikulieren. Der Ausgangspunkt der Komposition ist der bestehende Dorfplatz, an den Snozzi den – etwas höhergelegten – Schulhausplatz mit dem Aulagebäude anfügt. Dieses wird, als dem Typus des Palazzo zugehörig, als öffentlicher Ort interpretiert. Außergewöhnlich ist dieses Gebäude durch die Anordnung der wichtigsten Räume im Attikageschoß, d.h. à niveau mit dem Plateau der Schule. Ein Treppenportikus verbindet den Pausenplatz mit dem um drei Meter höherliegenden Plateau der Klassenzimmer, das als eingeschossig überbaute Flächenstruktur an eine kleine Stadt erinnert, bestehend aus Klassenzimmer-Pavillons, Erschließungsgassen und Höfen. Dieser Teil, flächenmäßig am ausgedehntesten, ist etappierbar, die Pavillons entsprechen in ihrer Anlage dem Thema der ‹Group form›, wobei Snozzi aber erneut nicht strukturalistisch verfährt, sondern mit der östlichen Stützmauer des Plateaus und ihrer Baumreihe eine formale Kontrolle schon für die erste Ausbaustufe etabliert (vgl. S. 36). Die Turnhalle liegt am südlichen Ende des gesamten Areals, mit der geometrisierten Schul-Stadt durch einen geschwungenen Weg (entlang einer alten Mauer) verbunden. Sie bildet den Endpunkt der Sukzession aus Gebäuden, Frei- und Aussenräumen; das Sportgelände (Wiese) liegt dazwischen, ist folglich nicht der passive Rest und rückwärtige Bereich wie allzuoft, sondern ist in die Komposition des Ganzen einbezogen. Mit dem ersten Preis ausgezeichnet und daraufhin ausgeführt wurde der Entwurf Livio Vacchinis.

Elementary School, Montagnola
With Walter von Euw, competition (second prize), 1978

Montagnola, a wealthy village close to Lugano, is located in a very hilly part of Ticino. The competition area was a large property with a small stream, basically flat but surrounded by steep slopes. Snozzi took the design requirements as an occasion to even more strongly illustrate the specific characteristics of the existing elements. The starting point of the composition is the existing village square to which Snozzi links the somewhat more elevated school yard with the assembly hall. The latter is interpreted as a public space, matching the archetype of the Palazzo. This building is unusual because of the structure of the most important rooms on the top floor, i. e., on the same level with the school's plateau. A staircase portico connects the school yard with the three meter higher plateau of the classrooms which, given the one-story construction of the surface structure, reminds one of a small city consisting of classroom pavilions, passageways, and yards. This part has the most widely spread surface and can be phased in. The pavilions correspond to the theme of ‹Group form› in their characteristics, but again, Snozzi does not go about it in a structural way. Rather, he already establishes a formal control for the first building phase with the supporting wall at the east end of the plateau and the row of trees (see p. 36). The gymnasium is located on the southern end of the grounds and is connected with the geometric school-city by a curved pathway along an old wall. It forms the end point of the succession of buildings, free areas, and outdoor spaces. The sports field is situated in between. Thus it is not relegated to a passive, backwoods region as is often the case, but is instead integrated into the entire composition. The design by Livio Vacchini was awarded the first prize and realized thereafter.

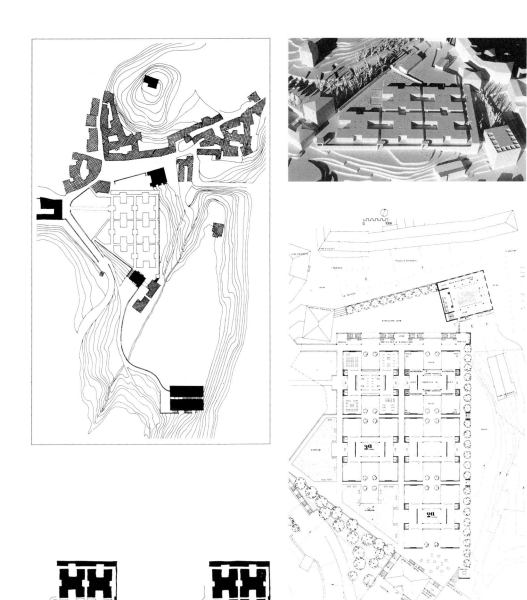

Ostfassade und Schnitt durch Aulagebäude /
Gesamtsituation mit Dorfkern (oben) und Turnhalle
(unten) / Teilausbau und Vollausbau / Modell-
aufnahme aus Osten / Grundriß Hauptgeschoß

East facade and section of the aula building /
Site plan with village center (top) and gymnasium
(bottom) / Partial and full development /
Model from the east / Main floor ground plan

Erweiterung des Hauptbahnhofs, Zürich
Mit Mario Botta, Wettbewerb, 1978

Da die 1866 für fünf Perrons gebaute Bahnhofshalle längst zu klein geworden war, wurden die Perrons 1938 nach außerhalb des Aufnahmegebäudes verlegt. Der Wettbewerb sollte diese Verschiebung nach Westen städtebaulich und funktionell präzisieren. Das Raumprogramm betraf ein zusätzliches Aufnahmegebäude ca. 400 m westlich des alten, das als Bahnhofreiter die beiden Stadtviertel Kasernenareal und Industrieviertel miteinander verbinden sollte, ferner Parkflächen für Busse und Personenwagen sowie eine Wohnsiedlung für die Speisewagen-Gesellschaft, die über den Gleisen zu entwerfen war. Die beiden Tessiner Architekten kamen zum Schluß, daß das vorgeschriebene Wettbewerbsareal falsch definiert sei. Sie situierten den Bahnhofreiter weniger weit westlich als verlangt, nämlich in der Verlängerung der Sihlpost, wodurch beidseits der Gleisanlagen höchst plausible Brückenköpfe entstanden. Vorteilhaft war seine Lage auch wegen der Gleise, die dort noch parallel verlaufen und so – im Unterschied zum Wettbewerbsperimeter – bei den Parkdecks einen regelmäßigen Stützenraster ermöglichen. «Die neue Struktur übernimmt die Höhe der Sihlpost als gegebenen Horizont der umliegenden Stadtquartiere, mit der Absicht, neben dem funktionellen einen ebenso wesentlichen räumlichen Bezug zwischen den beiden Stadtteilen herzustellen» (aus dem Projektbericht der Architekten). Die Brückenfunktion des Gebäudes wird durch eine in luftiger Höhe eingepflanzte Baumreihe betont, die die Lücke zwischen beiden Teilen des Sihlquai zeichenhaft überbrückt. Die Planung der Wohnsiedlung über den Gleisen wurde von den Verfassern mit dem Argument abgelehnt, das Gleisfeld in einer Stadt müsse als etwas Wertvolleres betrachtet werden denn nur als eine lästige Leerstelle im Stadtgewebe: «Für mich gibt es in Zürich drei Flüsse: die Limmat, die Sihl und die Geleise. Alle drei haben für mich den gleichen Wert.»[1] Im Bestreben, diese Fläche nicht einfach dem dumpfen Verwertungsinteresse zuzuführen und zu überdecken, schlugen sie die Wohnungen in einer Reihe gleichartiger Wohnhäuser entlang der Zollstraße vor. Obgleich die verschiedenen Verstöße gegen die Ausschreibung gut begründet waren, wurde der Entwurf nicht einmal juriert, und die beiden Architekten wurden vom weiteren Verlauf der Ereignisse ausgeschlossen. Skandalöserweise wurde jedoch, was den Ausschluß hervorgerufen hatte, später zur Grundlage der weiteren Projektierung erklärt: die Verschiebung des Projektierungsareals.

[1] L. Snozzi, in: H.-J. Rieger (Hrsg.) Das Unding über den Geleisen, Zürich 1987, S. 32.

Central Railroad Station Extension, Zurich
With Mario Botta, competition, 1978

The terminal, built in 1866 with only five platforms, had long become too small. As a result, the platforms were moved out of the station's hall in 1938. The goal of the competition was to more precisely express this shift to the west in a practical and urbanistic way. The program addressed the need for an additional reception building approximately 400 m west of the old one, which was supposed to connect the two city quarters of the barracks area and the industrial quarter as a station concourse. Moreover, parking spaces for buses and passenger cars as well as a housing development for the dining car company above the tracks were to be designed. Both Tessin architects came to the conclusion that the projected competition area was falsely defined. They situated the concourse not as far to the West as was asked for, i. e., in the extension of the main post office, thus creating highly plausible bridge heads on both sides of the railroad tracks. Its location was advantageous with respect to the tracks which still run parallel in this location, thus, contrary to the competition parameters, enabling a regular support grid at the parking decks. «The new structure takes on the height of the main post as a given horizon of the adjoining city quarters, with the intention being to create an equally important spatial relation between the two city parts aside from the functional relation» (excerpt from the project report). The bridge function of the building is underlined by a row of trees planted in an airy height, symbolically bridging over the gap between the two parts of the Sihl quay. The planning of the housing development above the tracks was rejected by the authors with the argument being that the tracks in a city must be regarded as something more precious than just a bothersome void in the city structure: «In my view, Zurich has three rivers: the Limmat, the Sihl – and the railroad tracks. I consider all three of them to have the same value.»[1] In their endeavor to not simply turn this area over to the dumb interest of utilization and to cover it up, they suggested the apartments in a row of equal houses along the Zollstraße. Although the various violations that went against the invitation of the competition were well founded, the design did not even reach the jury and the two architects were excluded from the further participation in the process. It turned out to be a scandal, however, since what had caused their exclusion (among other things) was later on declared to be the basis for the further planning, i. e., the shifting of the project's grounds.

[1] L. Snozzi in: H.-J. Rieger (publisher) Das Unding über den Geleisen, Zurich 1987, p. 32.

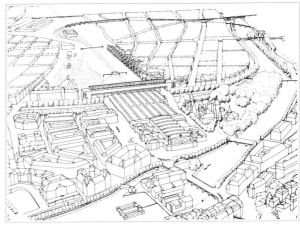

Querschnitt / Schaubild / Situation /
Ostfassade / Grundriß Brückengeschoß

Cross section / Display / Site plan /
East facade / Bridge level ground plan

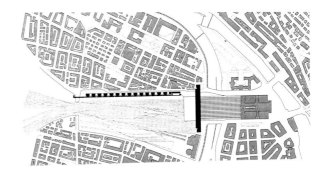

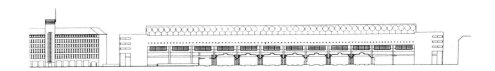

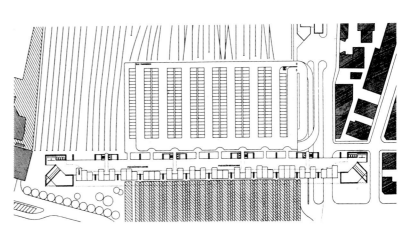

Guide Plan for Monte Carasso
1977–79, 1990

Luigi Snozzi calls the Monte Carasso project his most fascinating professional experience up to this day. Its past development confirms Snozzi's long-held conviction that the two most important problems of the Ticino – the rural exodus, and the loss of cultural identity as a consequence of uncontrolled urbanization – could not be overcome by defensive attitudes and generalized planning approaches. Monte Carasso stands to the contrary. It owes its existence to the question of the specifics of this location and to the conviction that urbanization as such is not the problem unless and only if it takes place without a qualitative urban framework. This conclusion can claim an almost global validity beyond the situation of the Ticino.

According to a zoning plan decided upon in 1977 – the result of a 15-year-long political process – the village center of Monte Carasso was to be the core zone and the surrounding village parts peripheral zones.[1] Snozzi's plan fundamentally opposed this evaluation. Monte Carasso developed around the women's monastery of St. Augustus, which is the only renaissance monastery of the Ticino; a complex from the 16th century, run down to quite some extent since the secularization of the 19th century (insertions, heightenings, conversions, demolitions). In 1965, important parts of the monastery were torn down and a provisional school was erected on the newly freed grounds. The 1977 zoning plan released the remaining parts of the monastery for demolition. A replacement for the temporary school house and for other public facilities was to be erected on the south-east edge of the community grounds, close to the highway. However, this plan was met with controversy by the population. A citizen's initiative submitted a counter-proposal. According to it, the public facilities were planned to be in the village center which again would have necessitated the relocation of the cemetery. In view of this heated controversy – which also was due to party-politics – Snozzi was asked in 1977 to draft a development concept for the community. His guide plan for Monte Carasso's center was accepted in 1979. The design for the Verdemonte housing shows that Snozzi, according to his professional understanding, had already endeavored a structuring of the entire community grounds in 1974 (lot plan and building plan with topographic elements – see p. 49). Then already, the importance of the former monastery as a historic center of the village was beyond any questions for Snozzi. This is also the precondition for the guide plan of 1978/79. Snozzi suggested a restruc-

 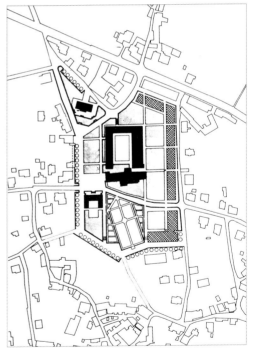

Luftbild aus Osten, 1979 / Situation des Dorfzentrums, 1979 / Projekt Snozzi für das Zentrum, 1979

Aerial view from the east, 1979 / Site plan of the village center, 1979 / Project Snozzi for the center, 1979

Snozzi die Wichtigkeit des ehemaligen Klosters als historisches Zentrum des Dorfes außer Frage. Dies ist auch die Prämisse des Richtplans von 1978/79. Snozzi schlug vor, die Reste des Klosters zu restrukturieren und das Gebäude erneut zum Zentrum des Dorfes, zum öffentlichen Ort, zu machen. Es sollte die Primarschule und andere Nutzungen aufnehmen (Ausstellungsräume, Bar usw.). Einige weitere Elemente des Zentrumsplanes waren:

– Eine Ringstraße um das Zentrum herum, die den Rahmen für eine längerfristige urbanistische Entwicklung bildet; an ihr sollen öffentliche und private Nutzungen angelagert werden. Sie soll mittels Baumreihen hervorgehoben sein.
– Ein ringartiger Park um die Zentrumsgebäude herum, durch Fußwege mit der Ringstraße verbunden.
– Ein Plateau südlich der Kirche, das aus der Vergrößerung des Friedhofes entstehen und den öffentlichen Bereich gegenüber den Wohnquartieren hervorheben soll. Snozzi sah vor, dieses Plateau durch die Turnhalle und deren vorgelagerten Spielplatz zu schaffen.
– Die verbesserte Erschließung der Kirche, die bereits in früheren Jahrhunderten zwei Eingänge besessen hatte.
– Die Aufhebung der allseitigen Grenzabstände: Neubauten sollen auf die Grenze gestellt werden, um die Straße als öffentlichen Raum wieder in ihr Recht zu setzen.
– Die Absicht, eine höhere Ausnutzung zu erreichen und damit die biedere Verdörfelung zu überwinden: statt zweigeschossig darf nun dreigeschossig gebaut werden, in gerechtfertigten Fällen auch noch höher.
– Die Verifizierung (bzw. Falsifizierung) der Baureglemente durch das Kriterium architektonischer und städtebaulicher Qualität: «Ist ein Projekt besser, als es die Reglemente zulassen, wird die Regel geändert – und nicht das Projekt.» (Snozzi).
– Dabei gelten ausschließlich typologische und morphologische Kriterien, aber keinerlei stilistischen oder materialmäßigen Vorgaben.

Snozzi legte seinen neuen Richtplan für das Dorfzentrum 1977 vor, 1979 wurde er angenommen. Er ermöglichte die Realisierung eines städtebaulich prägnanten Zentrums, dessen Elemente auf einen Zustand hin angelegt sind, wo die Gemeinde Monte Carasso ein Vielfaches der heutigen Einwohner zählen wird. Snozzi kann sich eine Stadt Monte Carasso mit dreißig- oder vierzigtausend Einwohnern vorstellen. Ziel war die Realisierung eines entwicklungsfähigen Kontexts. Die nächste Aufgabe war die Erweiterung dieser Planungsrichtlinien vom Zentrum auf das ganze Gemeindegebiet. Dies war eine langwierige und gegen die Widerstände des Kantons durchzusetzen-

turing of the remnants of the monastery and to make the building once again the center of the village – a public space. It would be comprised of the primary school and other facilities (exhibition spaces, a bar etc.). Some further elements of the plan for the center were:

– A ring road around the center, forming the framework for a long-term urban development; public and private facilities were to be located along the street. It was to be enhanced by rows of trees.
– A circular park around the central buildings, connected with the ring road by pathways.
– A plateau south of the church, which would develop from the enlargement of the cemetery and would enhance the public area as opposed to the living quarters. Snozzi planned to create this plateau through the gymnasium and the playground in front of it.
– An improvement of the church which had already had two entrances in former centuries.
– The abolition of the border distances: new buildings were to be placed right on the border in order to put the street back to its proper position as a public space.
– The intention of achieving a higher use and thus overcoming the typical ‹anti-urban› tendency which strives to maintain the status quo of the village; instead of two-story buildings, there can be three-story structures, and, if appropriate, even higher ones.
– The verification (or repealing) of the building regulations through the criterion of architectural and urban quality: «If a project is better than the regulations allow, the rule is changed – and not the project.» (Snozzi)
– For this, however, only typological and morphological criteria are valid; no stylistic or material-related changes were allowed.

Snozzi submitted his new guide plan for the village center in 1977, and in 1979 it was approved. He enabled the realization of a center – meaningful in an urban sense – whose elements are designed for a situation when the community of Monte Carasso will have a multiple number of today's inhabitants. Snozzi can imagine a city of Monte Carasso with thirty or forty thousand residents. The goal was the realization of a context with the potential to develop. The next task was the extension of these planning guidelines from the center to the entire community. This was a lengthy task which had to be brought about despite a resistance from the canton. The entire traffic plan (Piano viario comunale) had to be redesigned and approved. Snozzi's first draft was rejected in 1980; a second draft presented by Snozzi and a traffic specialist was approved in 1983; however, the new guide plan

de Aufgabe. Der gesamte Verkehrsplan (Piano viario comunale) mußte neu erarbeitet und verabschiedet werden. Snozzis erster Entwurf wurde 1980 abgelehnt; ein zweiter Entwurf, der von Snozzi und einem Verkehrsfachmann vorgelegt wurde, erhielt 1983 die Zustimmung. Der neue Richtplan konnte jedoch erst 1990 in Kraft gesetzt werden. Die von Snozzi geforderte Ausweitung der Planungsrichtlinien auf das ganze Gemeindegebiet erfolgte nach langwieriger Arbeit erst 1990. Bis dahin galt die Forderung nach dem Zonenplan von 1977, auf eine Verbreiterung der Straßen hinzuwirken. Seit 1990 besteht die Strategie darin, die bestehenden Straßen und die typologischen Elemente des Dorfes wieder zu restrukturieren, wobei dies nicht rückwärtsgewandt und orthodox denkmalpflegerisch zu geschehen hat, sondern mit Blick auf eine mögliche zukünftige Stadt Monte Carasso, deren Herkunft als bäuerliches Dorf in urbane Qualitäten gewendet ist. «Der Stadtbegriff ist heute etwas vom Schwierigsten, weil es die herkömmlichen Grenzen zwischen der Stadt und dem Land nicht mehr gibt. Wo endet Bellinzona und wo beginnt Locarno? Im Tessin spricht man deshalb schon von der Stadt Ticino, die von Bellinzona bis Locarno reicht. Wenn man nur wenig in die Zukunft blickt, gehört das Tessin ja eigentlich zur Stadt Milano-Como-Varese. Das ist die große Aufgabe heute: in einer Agglomeration urbane Situationen zu schaffen an Orten, die heute irgendwo zwischen peripher und ländlich sind. Ich bin sicher, daß Experimente wie das von Monte Carasso die einzige Möglichkeit sind, um zu verhindern, daß ein solcher Ort vom Wachstum der Stadt – und ich bin froh, daß sie wächst! – aufgefressen wird. Wenn wir es schaffen, bestehende Elemente, wie es etwa das Kloster von Monte Carasso ist, in einem solchen Gefüge aufzuwerten, können solche Orte morgen ein urbaner Kern in einer großen Stadtagglomeration sein: in der Stadt drin und nicht mehr außerhalb. Das ist das Konzept, und ich bin ziemlich sicher, daß dies die Möglichkeit ist, um in diesem Prozeß die Bedeutung der Dörfer zu retten und darüber hinaus aufzuwerten.»[2]

[1] Zum politischen Prozess in Monte Carasso vgl. C. Bertinelli: Der kommunale Planungsprozeß, in L. Snozzi: Monte Carasso – die Wiedererfindung des Ortes, Basel, Boston, Berlin 1995, S. 103ff.
[2] In: L. Snozzi – Auf den Spuren des Ortes. Ein Gespräch in und um Monte Carasso, Zürich 1996 (Museum für Gestaltung Zürich, Schriftenreihe Nr. 21), S.16ff.

could be implemented only in 1990. The expansion of the planning guidelines to include the entire community, as was demanded by Snozzi, followed only in 1990 after much tedious work. Up to that point, the demand, according to the zoning plan of 1977 for working towards a widening of the streets, was valid. Since 1990, the strategy has been to restructure the existing streets and the typological elements of the village, whereas this is not supposed to happen retrospectively and in an orthodox, conservationist way, but by keeping in mind a possible future city of Monte Carasso, whose origins – a farming village – will be transformed into urban qualities. «The perception of a city is today one of the most difficult things, as the traditional borders between the city and countryside no longer exist. Where does Bellinzona end and Locarno begin? Therefore, in the Ticino there is already talk of the city of Ticino, reaching from Bellinzona to Locarno. When looking only a bit into the future, the Ticino is really part of the city of Milano-Como-Varese. This is the great task of today – to create urban situations in an agglomerate at places which today are somewhere between peripheral and provincial. I am sure that experiments such as Monte Carasso are the only possible way to avoid having such a place devoured by the growth of the city – and I am glad that it is growing! If we succeed in appreciating existing elements, like the Monte Carasso monastery, in such an arrangement these places can tomorrow become an urban core in a large city agglomerate. They can be incorporated into the city and no longer relegated to the outside. That's the concept and I am pretty certain that this is the possibility for preserving the meaning of the villages and can even increase their value in the process.»[2]

[1] With reference to the political process in Monte Carasso, see C. Bertinelli: Der kommunale Planungsprozess, in L. Snozzi: Monte Carasso – die Wiedererfindung des Ortes, Basel, Boston, Berlin (1995), p. 103ff.
[2] In: L. Snozzi – Auf den Spuren des Ortes. Ein Gespräch in und um Monte Carasso, Zurich 1996 (Museum für Gestaltung, Zurich, publication series no. 21), p. 16ff.

Braunschweig: Eine Utopie für die Stadt
1979

Anläßlich eines Kurses an der TU Braunschweig beabsichtigte Luigi Snozzi, folgende Kurzübung zu stellen: Erarbeitung von Vorstellungen, wie die Stadt Braunschweig sich nach den schweren Kriegszerstörungen vom März 1944 urbanistisch hätte verhalten können. Die Aufgabe wurde von der Architekturfakultät zurückgewiesen, da man sich davon überfordert fühlte. Snozzis eigener, daraufhin skizzierter Vorschlag ist hier dargestellt. Aus den Trümmern wird ein Wall aufgeschüttet, der dem Verlauf der historischen barocken Stadtumwallung folgt. Er wird durch neue Stadttore unterbrochen und mit der ‹neuen Stadt› außerhalb des Walles verbunden. Als Vergleich für die vorgestellten neuen Stadttore zieht Snozzi El Lissitzkys Vision von 1924 bei, die radial verlaufenden Ausfallstraßen Moskaus mit einem Kranz aus ‹Wolkenbügeln› zu markieren. Das Areal innerhalb des Trümmerringes soll als Denkmal belassen werden: die offenliegenden Hauskeller und die Straßen werden dabei, analog Pompeji, zu Zeichen der Geschichte.

Braunschweig: a Utopia for the City
1979

At the occasion of a course at Braunschweig's technical university, Luigi Snozzi intended to pose the following short exercise: Work out ideas on how the city of Braunschweig could have behaved, in an urban sense, after the wide-spread destruction from the war in March 1944. The exercise was rejected by the architectural department as they felt overextended by it. We are showing Snozzi's sketch of his proposal. A rampart is filled up with the rubble, following the run of the historic baroque city rampart. It is interrupted by new city gates and connected with the new city on the outside of the rampart. Snozzi refers to El Lissitzky's vision of 1924 as a comparison for the introduction of new city gates, which was to mark the radial arterial roads of Moscow by a wreath of ‹sky scraping gateways›. The area inside the ring of debris was intended to be left as a monument. The open basements and streets thus would become, as in Pompeji, symbols of history.

Braunschweig, Zerstörungskataster 1945 / El Lissitzky: Vorschlag für Moskau, Wolkenbügel-Stadttore (Umzeichnung Snozzi) / Plastillinmodell / Schematischer Stadtgrundriß und -schnitt

Braunschweig, destruction button 1945 / El Lissitzky: proposal for Moscow, sky-scraper city gates (redrawing by Snozzi) / Plasticine model / Schematic city ground plan and section

Piazza del Sole, Bellinzona
With Michele Arnaboldi, competition (purchase), 1980

The Piazza del Sole is situated at the foot of a striking hill on top of which the castle, Castelgrande, rises. It was restored by Aurelio Galfetti at the end of the '80s. The competition invitation asked for suggestions for improving the situation of the square – for a long time unclear – without linking this with specific ideas of utilization. When studying old plans, Snozzi noticed that the former existing quarter was marked by apartment buildings and small shops. The public buildings of Bellinzona were all located outside the wide ring around the castle rock. Snozzi judged the existing square fronts (whose improvement wasn't part of the competition) to be rather inferior and decided not to react to this situation with a proposal for a systematized and reevaluated square with public buildings, but rather to articulate a space which would be a broadened street fork rather than a square. The chosen irregular triangular form favors the tangential and intentionally hinders the axial view. In between the curved row of houses and the castle rock, a large empty space comes into being where the remaining part of the former city ramparts are worked out as a trace of history. At the time of the competition, the castle rock was heavily overgrown with trees and bushes which Snozzi considered to be an important falsification of its urban meaning. Since then, hand in hand with the restoration of the Castelgrande by the architect Galfetti, it was stripped of these woods that had developed over the course of time and is now completely bare – to which Snozzi happily commented. Only in this way could it become a strong element in the city. Snozzi: «Aurelio Galfetti had installed an elevator inside the rock a couple of years ago and for this he included the entire rock in his projection. He had cut down more than one thousand trees, had the rock cleaned until it stood there naked. Thus the rock, to an incredible extent, has become an integral part of the city. Galfetti left three trees on a sloping field on top which have become true monuments. This is the quality of an architect who understands how to appreciate nature. But in order to appreciate it, he had to remove a lot from it.»[1] The first prize for the competition was awarded to Livio Vacchini; however, neither his nor another project has been realized up to this day.

[1] See L. Snozzi – Auf den Spuren des Ortes. Ein Gespräch in und um Monte Carasso, Zurich 1996 (Museum für Gestaltung Zurich, publication series no. 21), p. 48.

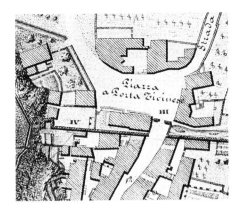 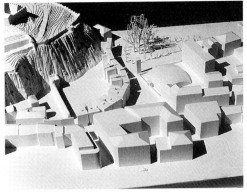

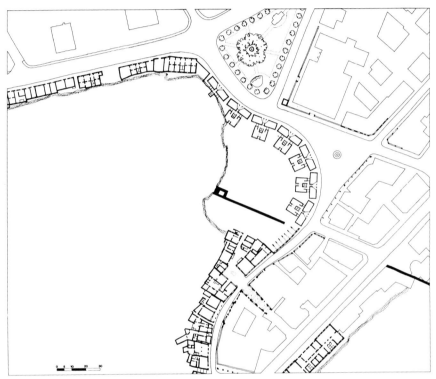

Zustand 1845 / Modell / Situation /
Schematischer Aufriß mit Burgfelsen

Conditions in 1845 / Model /
Schematic elevation with castle hill

Klösterli-Areal, Bern
Mit Michele Arnaboldi, Bruno Jenni, Wettbewerb, 1981

Das Klösterli-Areal liegt stadtauswärts auf dem Talboden des Aare-Flusses, beim ältesten Flußübergang der Stadt Bern (Untertorbrücke, seit 1260). Im 19. Jahrhundert wurde unmittelbar daneben die Nydeggbrücke gebaut, die als Viadukt über das Flußtal führt. Der Wettbewerb verlangte Vorschläge für eine Neuüberbauung des Klösterli-Areals, dessen Bauten – Wohnhäuser, Wehrturm usw. – sich in sehr schlechtem Zustand befanden. Auch hier ist Snozzis Vorschlag eine Antwort auf die geschichtliche Entwicklung dieses Gebiets. Er geht über eine bloße Weiterführung des Bestehenden hinaus und versteht sich als eine Infragestellung: Was von dem im Lauf der Zeit Hinzugekommenen soll entfernt werden, um hinderliche Widersprüche aufzulösen? Der Entwurf gibt darauf eine Antwort, eliminiert bestimmte Elemente und klärt andere in ihrem Zusammenhang. Heute wird die Höhendifferenz zwischen der Untertor- und der Nydeggbrücke durch zwei Straßen überwunden. Snozzis Entwurf hebt diese Verbindungen auf, da sie funktionell nicht begründet sind und eine trügerische Gleichwertigkeit der Brücken postulieren. Sein Entwurf akzentuiert die Elemente neu. Einerseits: Die Nydeggbrücke wird als Hauptverbindung zur Altstadt hervorgehoben, als Magistrale, die mit einem halbkreisförmigen Platz beginnt, das Tal überbrückt und sich auf dem Altstadtgebiet in drei primäre Straßenzüge auffächert. Auf dem halbkreisförmigen Platz können Busse parken, unterirdisch befinden sich weitere Parkplätze (ein Belvedere, vergleichbar der Piazzale Michelangiolo, Florenz). Andererseits: Auf dem Klösterli-Areal mündet die Untertorbrücke in einen offenen Hofkomplex, von dem aus die Stadt sich linear entwickelt: flußaufwärts unter dem Widerlager der Nydeggbrücke hindurch in die Erholungslandschaft südlich des Aareknies, flußabwärts in eine mögliche lineare Stadterweiterung am Südhang des Flußtals. Dabei sind über den gesamten Verlauf des Flusses jeweils bebaute (urbane) und grüne Zonen einander komplementär zugeordnet; so hat etwa das skizzierte neue Stadtviertel als Gegenüber den begrünten Hang nördlich der Altstadt. Die analoge Komplementarität findet sich auf der Südseite des Flußknies.

Klösterli Area, Bern
With Michele Arnaboldi, Bruno Jenni, competition, 1981

The Klösterli area is located outside of the inner city on level with the Aare river at the oldest bridge of Bern across the river (Untertorbrücke, since 1260). In the 19th century, the Nydegg bridge was built immediately next to it, crossing the river valley as a viaduct. The competition asked for suggestions for a new development of the Klösterli area whose buildings – houses, guard tower, etc. – were in very poor condition. Here also, Snozzi's suggested solution is an answer to the historic development of this area. He goes beyond a mere continuation of the existing and perceives it as a question: what should be removed from what was added during the course of time in order to solve the present contradictions? The design answers this question by eliminating certain elements and clarifying others within their context. Today, the different levels of the Untertor and the Nydegg bridges are accessed by two streets. Snozzi's design removes these connections as they are not logical in a functional way and misleadingly postulate the equivalence of the two bridges. His design accentuates the elements anew. On one hand, the Nydegg bridge is enhanced as the main connection to the old part of town, functioning as a magisterial beginning with a semi-circular square, bridging the valley and fanning out into the three primary streets in the old city. The semi-circular square receives underground parking and buses can park on top (a belvedere, comparable to the Piazzale Michelangelo, Florence). On the other hand, the Untertor bridge leads to an open yard complex in the Klösterli area from where the city develops linearly: up the river, running beneath the abutment of the Nydegg bridge to the recreational landscape south of the bend of the Aare, and down the river into a possible linear expansion of the city on the south slope of the river valley. Developed (urban) zones and green areas are complementarily situated along the entire run of the river. For example, the outlined new city quarter is opposed by the planted hill north of the old city. The analogous counterpart lies on the southern side of the river bend.

Gesamtsituation: Klösterli-Areal rechts / Modell / Aufriß und Querschnitt / Wegführung ursprünglich – heute – Vorschlag Snozzi / Übersichtsplan des Entwurfs

Site plan: to the right Klösterli area / Model / Elevation and cross section / Lead of the pathway, original – current – proposal by Snozzi / General plan of the design

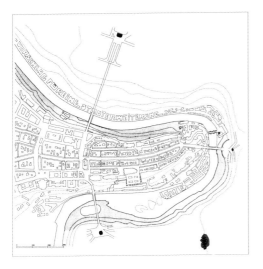
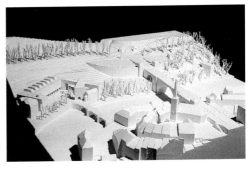
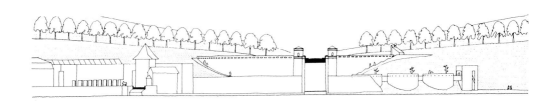
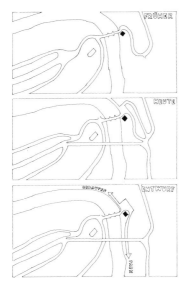
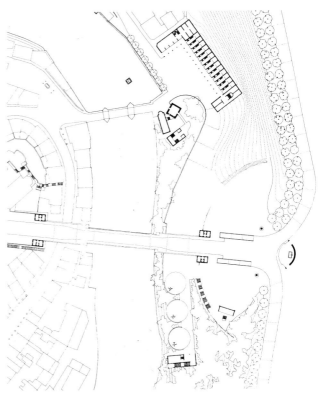

Kunstmuseum und Bibliothek, Chur
Wettbewerb (1. und 2. Preis)
Mit Jo Coenen, Bruno Jenni; Mitarbeiter
Michele Arnaboldi, 1981

Das Wettbewerbsareal lag unweit des Bahnhofs von Chur und war räumlich sehr eingeschränkt. Auf dem verfügbaren Grundstück stand die Villa Planta, ein historizistischer Bau aus dem 19. Jahrhundert. Das Wettbewerbsprogramm verlangte Vorschläge zu zwei verschiedenen Szenarien:
– Entwurf nur des Museums, wenn die Villa stehenbleibt
– Entwurf von Museum und Bibliothek, wenn die Villa abgebrochen wird.

Snozzi wies (wie auch einige andere Teilnehmer) mit seinen Entwurfsvarianten nach, daß die Villa Planta auch dann stehenbleiben könne, wenn die Bibliothek gebaut werde. Er hielt sie – ein Element der Stadterweiterung des 19. Jahrhunderts – für ein zu wichtiges Element, um abgebrochen zu werden. In Variante 1 ist die Villa Planta integral erhalten, der Neubau umgibt sie auf der einen Seite als Mantel, wobei ein segmentförmiger Hof als Leerraum zwischen die beiden Teile gelegt ist. Die Villa ist Eingang, Auftakt und Austauscher, bleibt also das Herz der Anlage, obwohl sie nicht die eigentliche Ausstellung beherbergt. Dadurch, daß sie in ein flaches Wasserbassin gesetzt wird (‹Spiegel›), wird ihr Solitär- bzw. Objektcharakter gesteigert. Durch die Identität der Teile entsteht eine Wechselrede von Alt und Neu. Radiale Erschließungen (Passerellen, Brücken) führen aus der Villa zum Anbau. Dessen Erdgeschoß ist Ausstellungsfläche des Museums, sein Obergeschoß ist die Bibliothek, die separat erschlossen ist. Diese prägnante Lösung stellte zur Bedingung, daß der Anbau die Baulinie an der Grabenstraße um etwa 3 m überschreite, eine Konsequenz, die Snozzi als problemlos möglich einschätzte. Variante 2 hält die Baulinie ein, da der sichelförmige Leerraum, Raison d'être der Variante 1, hier fehlt: der Anbau ist direkt mit der Villa verbunden. Diese aber ist hier im wesentlichen als ‹Leere› interpretiert (Entfernung ihres Daches, Umkehrung von Innen und Außen). Auf der sekundären Ebene wird jedoch ihre Leere wieder gefüllt. Die Bibliothek ist in dieser Variante ein selbständiger halbkreisförmiger Annex gegen Süden. Von den beiden Varianten erhielt die erste zu Recht viel Aufmerksamkeit. Sie wurde als eine Haltung verstanden, die substantiell weit mehr anzubieten hatte als die kenntnisreiche Plazierung von Motiven aus der Architekturgeschichte. 1983 wurde von Snozzi eine Weiterbearbeitung verlangt, jedoch unter der Prämisse, daß die Baulinie an der Grabenstraße eingehalten werde. Deshalb mußte der

Museum and Library, Chur
Competition (first and 2nd prize)
With Jo Coenen, Bruno Jenni;
collaborator: Michele Arnaboldi, 1981

The competition area was situated near the Chur train station and was quite limited. The Villa Planta, a historic building from the 19th century, stood on the available property. The competition asked for proposals for two different scenarios:
– design of the museum alone, if the villa were to remain
– design of museum and library, if the villa were to be demolished.

Snozzi (and a few other participants) proved with his design versions that the Villa Planta could remain even if the library were to be built. He considered it far too important an element of the city's 19th century expansion to be demolished. Version 1 shows the integral preservation of Villa Planta – the new building surrounds it like a ‹coat› on one side, with a semi-circular yard placed as a void between the two parts. The villa is the entrance, the prelude and interchange, and it remains the heart of the complex although it does not host the exhibitions. Snozzi surrounds it with a surface of water thus accentuating its solitary and object character. A dialogue between old and new comes about because the parts can be clearly identified. Radial developments (walkways, bridges) lead out of the villa to the addition. The library constitutes its ground floor, the curved reading table is at level with the flat water basin in the inside yard. The library is developed separately. The exhibition space of the museum is located on the second floor and is accessible from Villa Planta. The precondition for this epigrammatic solution was that the addition would exceed the building line at Grabenstraße by about 3 m – a consequence which, in Snozzi's opinion, was feasible without any problems. In version 2, the building line has been maintained because the crescent-shaped void – the Raison d'être for version 1 – is not present here and the addition is directly connected with the villa. However, the villa is interpreted essentially as a ‹void› (removal of its roof, reversal of inside and outside). On a secondary level, however, this empty space is yet again filled. In this version, the library is an independent, semi-circular annex facing south. Of both versions, the first one (and rightly so) received a lot of attention. It was understood as an attitude which substantially had much more to offer than the knowledgeable placing of motifs from architectural history. In 1983, Snozzi was asked for a further revision, but on the premise that the building line at Grabenstraße would have to be maintained. As a

Neubauteil schlanker ausgebildet werden, was nicht zu seinem Vorteil war. Im Wettbewerbsbericht suchte Snozzi das Preisgericht zu überzeugen, im Interesse einer möglichst guten Lösung die Baulinie gleichwohl zu verschieben da darin «der Schlüssel zu einer qualitativen Lösung aller gestellten Probleme (Museum und Bibliothek unter Erhaltung der Villa)» liege.

result, the new building would have had to have been designed in a more narrow way, which was clearly not an advantage. In his competition report, Snozzi tried to convince the judges that, in the interest of obtaining a good solution, the building line would have to be moved inasmuch as «the key to a qualitative solution to all posed problems» would lie in this action (museum and library while preserving the villa).

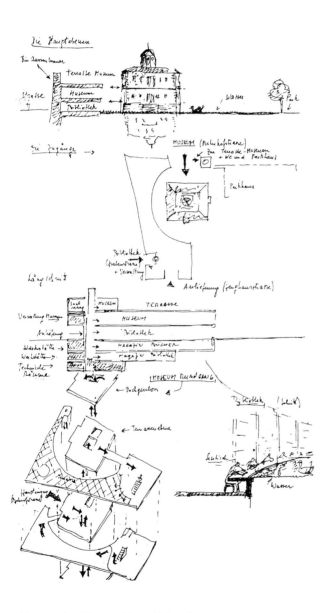

Skizzen aus dem Erläuterungsblatt zur Variante 1

Sketches from the explanatory sheet for version 1

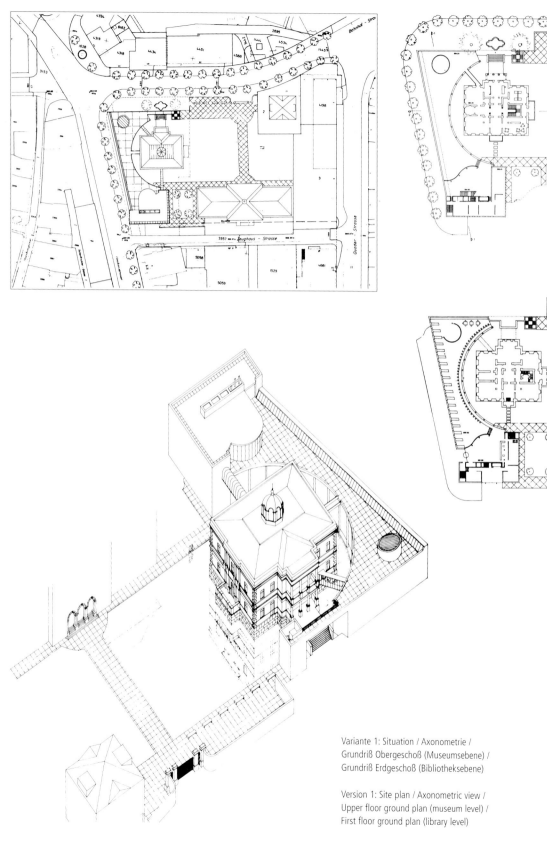

Variante 1: Situation / Axonometrie / Grundriß Obergeschoß (Museumsebene) / Grundriß Erdgeschoß (Bibliotheksebene)

Version 1: Site plan / Axonometric view / Upper floor ground plan (museum level) / First floor ground plan (library level)

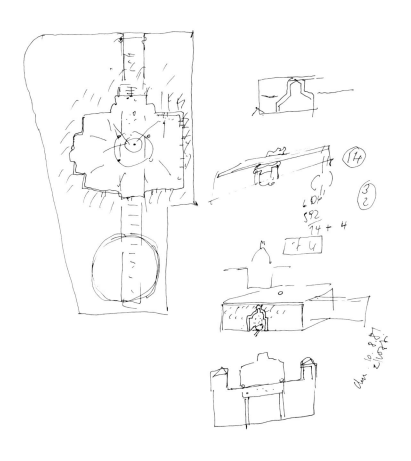

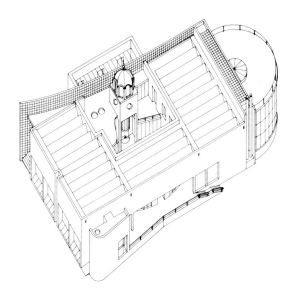
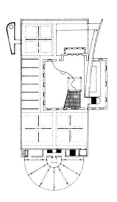

Variante 2: Skizzen / Axonometrie / Grundriß
2. Obergeschoß; in der Rotunde die Bibliothek

Version 2: Sketches / Axonometric view /
Ground plan of third floor, in the rotunda: library

Raiffeisenkasse, Monte Carasso
Mit Claudio Buetti, 1984

Die Bank ist das erste ausgeführte Beispiel einer Reihe von Gebäuden, die an dieser Stelle von Monte Carasso entstehen sollen. Snozzis Richtplan sieht hier eine Platzwand gegenüber dem erweiterten ‹Convento› vor, als deren erstes Element die Bank entworfen und ausgeführt wurde (vgl. S. 83). Nach dem alten Reglement wäre eine Ausnützung von 0,4 erlaubt gewesen, das Bauvolumen wäre folglich von der Parzellengröße diktiert worden. Nun wurde es von den städtebaulichen Vorstellungen her bestimmt, und die sich daraus ergebende Ausnützungsziffer beträgt 1,3. Hier wurde erstmals der Programmpunkt der raumabschließenden Grundstückumfriedungen erprobt: Mauern von bis zu 2,50 m Höhe, die den Garten definieren, und an die bei Bedarf einstöckige Anbauten angefügt werden können. Das Haus enthält die Räume der Bankfiliale (Untergeschoß und Erdgeschoß) und eine Wohnung (1. und 2. Obergeschoß). Das Raumgefüge ist durchaus ungewöhnlich und sinnreich. Die gewählte Schnittlösung ergibt einen geräumigen (hohen) Kundenraum der Bank und eine räumlich spannungsvolle Anlage der Wohnung. Die Zweigeschossigkeit gegen die Ringstraße bzw. den Platz und die Dreigeschossigkeit gegen den Hof sind ein Beispiel zu Adolf Loos' wichtigem Thema des ‹Raumplans›. Selbst die Klassizität des Gebäudes und die leicht ironische Preziosität des Bankeingangs (Messingbeschlag der Türe, dunkle Kanten) beziehen sich auf Loos' Forderung, ein Bankhaus solle dem Kunden die Gewißheit geben, daß sein gespartes Geld hier bei ehrlichen Leuten wohlverwahrt sei.[1] Die Gesimsoberkante dieses von Glasflächen umgebenen, weiß verputzten und starkwandigen Fassadenschildes entspricht der Traufhöhe der heute noch existierenden Häuser, an die später, nach erfolgter Transformation dieser Straßenfront, so noch erinnert wird.

[1] Vgl. Adolf Loos: Architektur (1910), in: F. Glück (Hrsg.): Adolf Loos, Sämtliche Schriften Bd. 1, Wien 1962, S. 317.

Raiffeisen Bank, Monte Carasso
With Claudio Buetti, 1984

The bank is the first realized example of a series of buildings which are to be constructed at this location in Monte Carasso. Snozzi's guide plan calls for a plaza wall on the opposite side of the extended ‹Convento› (see p. 83). The bank was its first element to be designed and executed. According to the old regulations, a utilization rate of 0.4 would have been permissible, thus the building volume would have been dictated by the size of the lot. Now however, it was determined by the urban imagination and the utilization rate resulting from this was 1.3. For the first time, the program topic of the space-enclosing walls for properties was tried here: walls of up to 2.50 m height define the garden and, if so needed, one-story expansions can be joined to them. The house contains the rooms of the bank (lower floor and first floor) and an apartment (second and third floors). The spatial structure is, by all means, unusual and purposeful. The chosen profile solution creates a spacious (high) teller room in the bank and a spatially exciting layout of the apartment. The two-story effect on the side of the ring road or the square and the three-story effect towards the yard are an example of Adolf Loos' most important theme of the ‹spatial plan›. Even the classicism of the building and the slightly ironic preciousness of the bank's entrance (brass fittings on the door, dark edges) refer to Loos' claim that a bank should give the customers a security in knowing that their savings are well-guarded by honest people in this place.[1] The upper cornice edge of this white plastered, thick-walled facade shield surrounded by glass surfaces, complies with the eaves height of the houses still existing today. Later on, after the realized transformation of this street front, they will thus be remembered.

[1] See Adolf Loos: Architektur (1910), in: F. Glück (Ed.): Adolf Loos, Sämtliche Schriften, Vol. 1, Vienna 1962, p. 317.

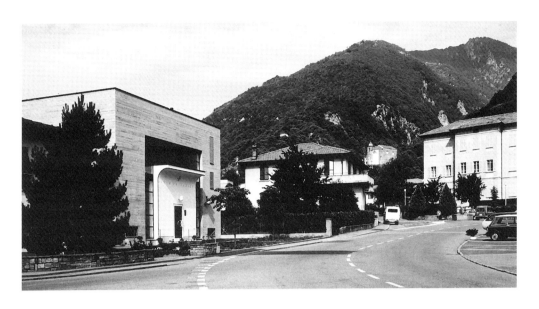

Straßenfront / Querschnitt / Grundriß oberes
Wohngeschoß / Grundriß Erdgeschoß (Bank)

Street facade / Cross section / Upper living
floor ground plan / First floor ground plan

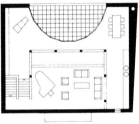

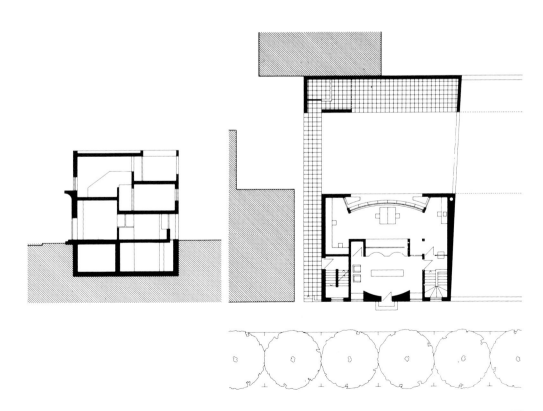

Bibliothek und Museum, Thun
Mit Michele Arnaboldi, Raffaele Cavadini, Bruno Jenni, Wettbewerb, 1982

Das Entwurfsgebiet liegt in der Altstadt: ein aufgeschüttetes Areal in der Aare, worauf einige große Mühlenbauten standen. Es galt, sie durch eine Bibliothek, ein Museum, Läden und ein Restaurant zu ersetzen. Snozzi wurde zur Teilnahme eingeladen. Hauptelement seines Entwurfs ist der Vorschlag, das Mühlenareal von der Altstadt abzutrennen, indem der Mühlenkanal wieder freigelegt und der geplante Neubau als Insel mitten in den Fluß gestellt wird. Damit wird die Insel ein wichtiges öffentliches Gebäude im Dialog mit den Uferzeilen, dem Schloß und der Stadtkirche. Der Bau fungiert auch als Durchgangsweg für Fußgänger, indem zwei versetzte Stege die Verbindung zur Stadt herstellen. Wichtig ist der Vorschlag, den Torso einer Quaianlage aus dem letzten Jahrhundert zu reprivatisieren. Dem liegt die Erkenntnis zugrunde, daß es sich bei diesem ‹Quai› um ein Mißverständnis handle: Die Häuser der Thuner Altstadt waren immer vom Fluß abgewandt und den Straßen zugewandt, die Flußseite war stets in typologischer Hinsicht die Rückseite gewesen. Der Entwurf besteht aus zwei quadratischen Turmbauten an den beiden Enden der Insel und einem dazwischengespannten, von einer Halbtonne überwölbten Längsbau. Der Entwurf war etappierbar. 1. Etappe: Insel mit Bibliotheksturm (Bibliothek mit Magazinen und Leseplätzen vertikal organisiert). Zweite Etappe: Zweiter Turm mit Ausstellungsfläche und Saal am flußaufwärts gelegenen Ende der Insel. Dritte Etappe: Horizontale Bibliothekserweiterung mit einem großen Lesesaal nach dem Vorbild von Boullées Projekt für eine Bibliothek (1790); der nördliche Turm wird im Endausbau Büchermagazin.

Library and Museum, Thun
With Michele Arnaboldi, Raffaele Cavadini, Bruno Jenni, competition, 1982

The design area is located in the old part of the city: a filled-in area of the Aare river where several large mill buildings stood. The task was to replace them with a library, a museum, shops, and a restaurant. Snozzi was invited to participate in the competition. The main element of his design is the proposed separation of the mill area from the old city by reopening the mill canal and placing the planned new building as an island in the river. The island thus becomes an important public structure, conversing with the shoreline, the castle, and the city church. The construction also functions as a connecting passageway for pedestrians with two offset footbridges leading to the city. The suggestion to re-privatize the core of a quay facility from the last century is important. It is based on the knowledge that this ‹quay› was a misconception: the houses in Thun's old city with their fronts facing the streets, were always turned away from the river. Typologically, the river side was always the back side. The design consists of two cuboid tower-like buildings at either end of the island and a long building stretching out in between and vaulted by a semi-barrel roof. The design could be phased-in. Phase one: the island with library tower (library with storerooms and reading areas organized vertically); phase two: the second tower with exhibition space and hall at the up-river end of the island; phase three: horizontal library extension with a large reading hall following the example of Boullée's project for a library (1790) – the northern tower in the final development becomes a book storeroom.

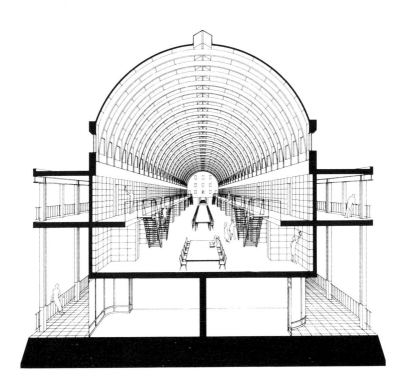

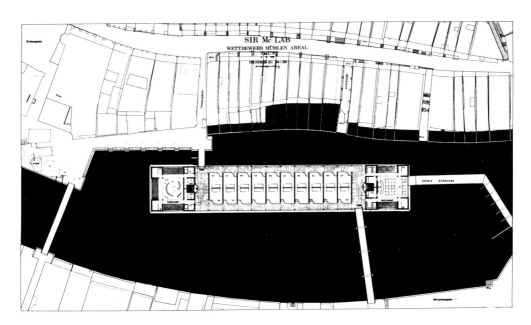

Luftbild der Innenstadt / Modell / Querschnitt mit Ladengeschäften
und Bibliothek / Situation und Erdgeschoß-Grundriß

Aerial view of the inner city / Model / Cross section with stores
and library / Site plan and first floor ground plan

Turnhalle, Monte Carasso
Mit Michele Arnaboldi und Giuliano Mazzi, 1982–84

Der Ort für die Turnhalle war in Snozzis Entwurf des Richtplans von 1977 bereits festgelegt: ein neuzuschaffendes Plateau südlich der Kirche und neben dem Friedhof, das, von der Ringstraße begrenzt, die Nordostecke des Zentrums definieren würde (vgl. S. 83). Um diesen Platz zu definieren, sah Snozzi anfänglich einen winkelförmigen Bau, bestehend aus Garderobengebäude und Turnhalle, vor. Die Turnhalle sollte gegenüber dem Plateau teilweise versenkt sein, denn eine freistehende Turnhalle hätte den Maßstab der übrigen Zentrumsbauten zerstört. Dieses Konzept wurde auf faszinierende Weise weiterentwickelt. Das Garderobengebäude mit den Gemeinde-Depots begrenzt als schlanker Baukörper den Südrand des Plateaus: ein eingeschossiger Portikus gegenüber dem Platz, zweigeschossig gegenüber der Straße. Die Turnhalle ist von der Randzeile abgelöst und gegenüber der Baulinie leicht abgedreht. Dadurch wird sie zum ‹Objekt› und ist dank dieser Autonomisierung allseitig ins Plateau eingesenkt, bleibt dabei als Raum in sich zentriert und zerfällt nicht in eine Platz- und eine Straßenseite (wie dies bei der Ausführung nach der Vorstudie 1977 der Fall gewesen wäre). Der Zugang zur Halle erfolgt unterirdisch durch einen schwarz gestrichenen kurzen Tunnel. Das Betreten der Halle ist ein Gang ins Licht und in die Farbigkeit: der Hallenboden ist ein zartes Blau (Sonderanfertigung). Der Raum ist wie eine von Licht erfüllte Wanne. Snozzi wollte zeigen, daß das Erdniveau, bzw. die Berührungslinie von Gebäude und Terrain, ein wichtiges Element der Architektur ist. Etwa in halber Höhe umläuft ein schräggestelltes Lichtband aus Glasbausteinen den Raum, beantwortet durch eine Wandschräge. Diese Ausweitung ist rhythmisiert von Rundstützen und den Erddruck aufnehmenden integrierten Flügelmauern, unterbrochen nur von den beiden Stirnwänden, auf die von hochliegenden verdeckten Dachfenstern Tageslicht fällt. Auch das große Oberlicht tritt visuell zurück. Der obere Teil der Längswände und die Decke sind schwarz gestrichen, was die Raumwirkung überzeugend verstärkt. Der unterirdische Teil des Raumes ist hell und farbig, der oberirdische Teil dunkel wie ein Nachthimmel, also scheinbar paradox und genau reziprok zur gewöhnlichen Sichtweise, wonach das Unterirdische dunkel und das Oberirdische hell sei. Städtebaulich, baukörperlich und vor allem räumlich ist dieser Bau ein Meisterstück Snozzis. Die gewählte Lösung erforderte ein Abgehen von den üblichen Turnhallen-Normmaßen und Norm-Farben und bedeutete deshalb den Verzicht auf finanzielle Unterstützung durch die Sport-Toto-Gesellschaft. Die keineswegs wohlhabende Gemeinde war bereit, Snozzi darin zu folgen; sie hat es nicht bereut.

Gymnasium, Monte Carasso
With Michele Arnaboldi and Giuliano Mazzi, 1982–84

In Snozzi's 1977 recommendation plan, the location for the gymnasium was already determined. A plateau was to be newly created south of the church and next to the cemetery which, limited by the ring road, would define the northeastern corner of the center (see p. 83). In order to define this space, Snozzi at first planned on an angular structure consisting of the locker room building and the gymnasium. The gym would be partly lowered into the ground with relation to the plateau since a free-standing gym would have destroyed the scale of the other central buildings. This concept was further developed in a fascinating way. The locker room building, along with the community storehouse, limits the southern edge of the plateau as a long, narrow building: a portico with one story towards the playing field, and two stories towards the street. The gymnasium is detached from the perimeter row and is set at a slight angle to the building line. It is thus made into an ‹object› and thanks to this autonomy it is lowered into the plateau on all sides. However, it remains centered within itself as a space and does not fragment into a street side and a field side (as would have been the case if the 1977 pre-study had been realized). The access to the gymnasium is through a short, underground tunnel which is painted black. Entering the gym is like stepping into light and color; the floor of the gym has been specially produced in a light blue. The space has the effect of a basin filled with light. Snozzi wanted to show that the earth level or the contact line of the building and the terrain is an important architectural element. A slanted light-band of glass blocks runs around the space at half-height and responds to a contra-slanted band of wall. This expansion obtains its rhythm through the round columns and integrated flank walls taking on the earth's pressure and it is interrupted only by the two front walls which receive daylight through high, hidden skylights. Visually, the large skylight recedes as well. The upper part of the longitudinal walls and the ceiling are painted black, the spatial effect is thus convincingly enhanced. The subterranean part of the space is light and colorful and the part above the ground is as dark as the sky at night. It is something of a paradox and antithetical to the usual perception that the subterranean is dark and the above-ground light. This building is a masterpiece of Snozzi's in an urban, volumetric and, above all, spatial sense. The chosen solution demanded that the customary gymnasium masses and colors were left behind and thus represented the abandonment of financial support from the Sport-Toto-society. The community, which is not wealthy at all, was willing to follow Snozzi's idea – and it has never regretted this decision.

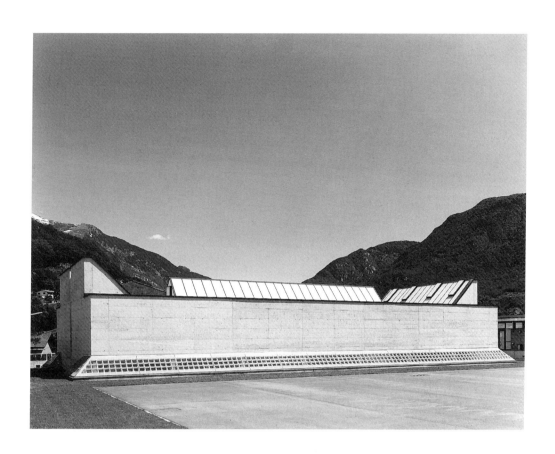

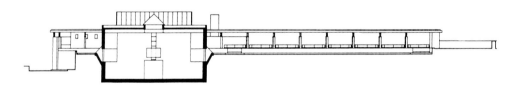

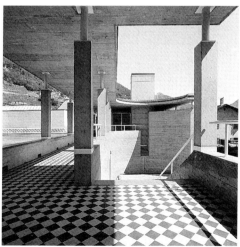

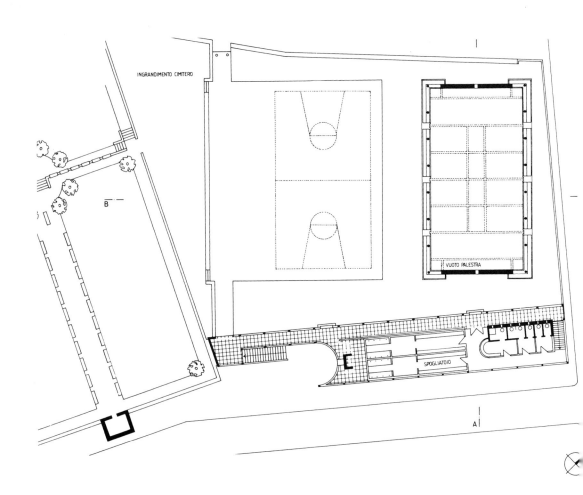

Seite 101: Ansicht vom Turnplatz / Querschnitt Turnhalle, Ansicht Garderobengebäude 1:500 / Lage in der Umgebung / Portikus mit Treppenabgang. Grundriß Erdgeschoß 1:500 / Grundriß Untergeschoß 1:1000 / Längsschnitt durch Turnhalle 1:500 / Turnhalle, Nordwestecke / Detaillierter Querschnitt 1:135

Page 101: View from the sportsfield / Gymnasium cross section, view of the locker room 1:500 / Location in the surrounding area / Portico with staircase. Ground plan first floor 1:500 / Lower level ground plan 1:1000 / Longitudinal section of gymnasium 1:500 / Gymnasium, northwest corner / Detailed cross section 1:135

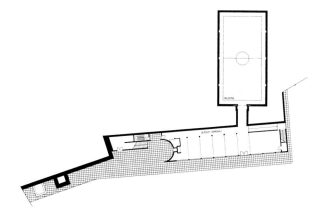

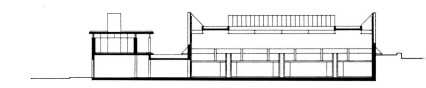

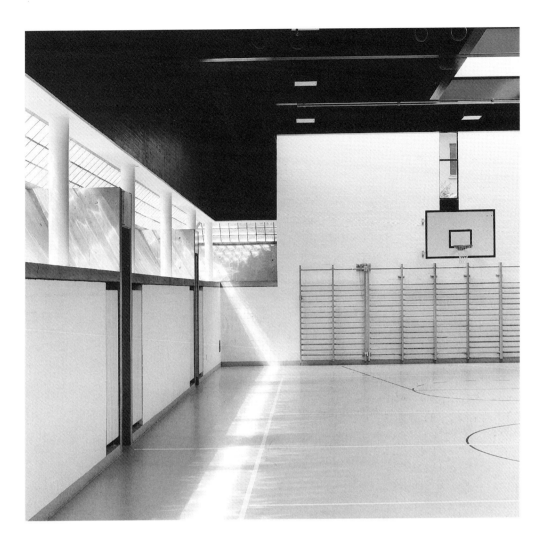

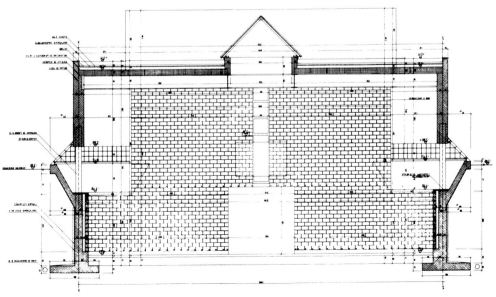

Telecom-Gebäude, Bellinzona
Mit Michele Arnaboldi, Raffaele Cavadini,
Wettbewerb (Ankauf), 1983

Der Wettbewerb verlangte Vorschläge für ein Verwaltungsgebäude der Telecom PTT, wobei die Fassaden eines Gebäudes aus dem letzten Jahrhundert stehenbleiben mußten. Der Entwurf führt auf der städtebaulichen Ebene die Grundlage des siegreichen Projekts zur Piazza del Sole weiter (Architekt Livio Vacchini, vgl. auch S. 88). Er verstärkt noch Vacchinis Entscheidung, die Bedeutung der quer zur Viale Stazione (Bahnhofstraße) verlaufenden und tangential in die Piazza del Sole einmündenden Largo Elvezia abzuschwächen und dafür die beiden ins Ortszentrum führenden Längsverbindungen (Viale Stazione und Via Molo) aufzuwerten. Dabei ist der Entwurf in typologischer Hinsicht als Entsprechung zum benachbarten Block am unteren Ende der Bahnhofstraße gestaltet. Dessen Besonderheit ist eine Galerie – eine Querverbindung für Fußgänger, gewonnen durch eine aufgelassene ehemalige Kirche, deren beide Fassaden entfernt worden waren. In Analogie zu dieser Galerie ist auch in diesem Entwurf eine sechsgeschossige Galerie das städtebauliche und architektonische Kernstück. Sie ist als öffentlicher Ort aufgefaßt, als Durchgang auch für Passanten. Im Erdgeschoß enthält sie Läden, im Mezzaningeschoß ein Restaurant. Die Obergeschosse sind den Angestellten der Telecom vorbehalten. Diese sind an den ausgekernten ‹Altbau› angefügt. Der Innenbereich dieses Neu-Einbaus, ein quadratischer Innenhof, ist durch das Bauvolumen der Aula bestimmt.

Telecom Building, Bellinzona
With Michele Arnaboldi, Raffaele Cavadini,
competition (purchase), 1983

The competition asked for suggestions for an administrative building for Telecom PTT. The facades of a building, dating back to the last century, were to be preserved. The design, on an urban level, continues the basis of the winning project for the Piazza del Sole (architect Livio Vacchini, see p. 88). It underlines Vacchini's decision to devalue the Largo Elvezia running crosswise to the Viale Stazione (Station street) and tangentially joining the two longitudinal connections leading into the center of town. Typologically, the design corresponds to the neighboring block at the lower end of the Station street. Its special feature is a gallery – a cross link for pedestrians, which was created by leaving open a former church whose two facades had been removed. Analogous to this gallery, a six-floor gallery is the urban and architectural core in the design, as well. It is understood as a public space, a passageway for pedestrians. The lower level contains shops and there is a restaurant on the mezzanine level. The upper floors are reserved for the employees of Telecom. They are connected to the gutted ‹old building›. The inner area of this new installation – a square courtyard – is determined by the building volume of the assembly hall.

Perspektivischer Schnitt durch die Galerie / Situationsplan mit Bahnhofstraße, Piazza del Sole, Passage bei ehemaliger Kirche (links), Entwurf / Modellaufnahme von Norden / Längsschnitt durch Galerieraum / Grundriß Mezzaningeschoß

Perspective section of the gallery / Site plan with Bahnhofstrasse, Piazza del Sole, passageway at the former church (left), design / Model from the north / Longitudinal section of the gallery space / Mezzanine floor ground plan

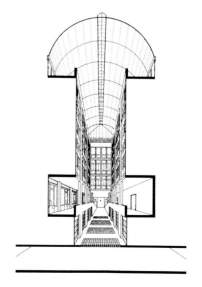

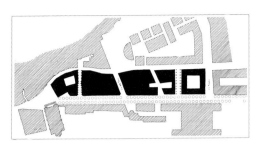
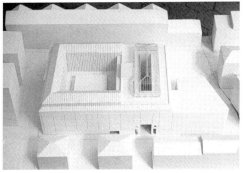
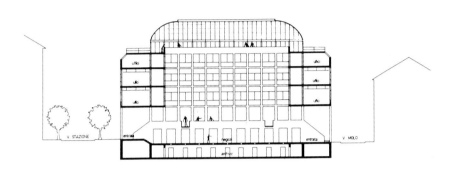
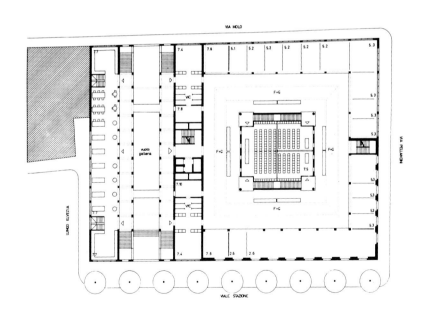

Central Railroad Station, Bologna
With Michele Arnaboldi, Jo Coenen, Bruno Jenni, competition, 1983

The competition was a public invitation and the task was loosely phrased: design of a new station – after the bomb attack on the Bologna station (1980) – and suggestions for a new structuring of that part of the city north of the railroad. The entire railroad yard was available as a planning area. The demand was for plans with a scale of 1:200, mentioning the names of the project designers. The urban conditions were unsatisfactory since the urban context between the center and the outer quarter was created only by two streets widely separated from each other (Viale Matteotti and the underpass of Via Zanardi); however, only in a functional way and hardly developed in a spatial sense. For Snozzi it was therefore clear that the station should be the third connection, conceived as a bridge going over the «valley of the railroad tracks» (Snozzi). When it came to the question of the proper location, Snozzi discovered a fragment of a square outside the old part of town which apparently was planned in the 19th century with a circular shape but never completed (Viale Pietramellara/Via Boldrini). Here, right in the middle of the two existing connections, the most cogent site for the station was given. North of the railroad tracks, a clearly structured area with block perimeter buildings and an unstructured zone are mixed together. The introduction of the station bridge at this site was intended to have a clarifying effect. The station ends in a rectangular square with a wrap-around portico to which, further north, an extended park adjoins. The entire complex takes notice of one of the characteristics of the city – the fact that its urban context shows itself as a layer of constant thickness into which the squares and street axes seem to be immersed. The station concourse is developed on several floors. The lower floor contains all functions of the railroad traffic, the upper level is developed as a multi-story shopping mall with public facilities such as movie-theaters, theaters, restaurants, cafeterias etc. The three upper floors on both sides of the gallery's air space are office spaces. The base area and the gallery would be covered with light marble, a material especially well-priced in Italy and easy to care for. The outside facades would consist of red bricks, yet another material characteristic of Bologna's architecture. Instead of the required 15 plans in the scale 1:200, Snozzi and his collaborators submitted only three large-format boards at a ratio of 1:500, showing the essentials of the design. For Snozzi, this proposal is still a valid contribution to the city of Bologna. With respect to these unrealized projects, the most consistent of which

immer ein gültiger Beitrag zur Stadt Bologna. Er sagt zu solchen unausgeführt gebliebenen Projekten, von denen die konsistentesten auch nach Jahren nichts an Schlüssigkeit eingebüßt haben: «Wenn ich die betreffenden Städte besuche, dann sehe ich den Entwurf vor meinem inneren Auge, als ob er verwirklicht wäre. Das genieße ich jedesmal sehr. Aber am Ende ist es doch schade, daß bestimmte Arbeiten nicht verwirklicht worden sind. Es ist von der Gesellschaft aus gesehen ein Fehler.»

have not lost any of their logic even after many years, Snozzi remarks: «If I visit the cities in question, I see the design before my inner eye, as though it had been executed. I enjoy that a lot every time. In the end, however, it is a pity that certain works were not realized. It is a mistake from society's standpoint.»

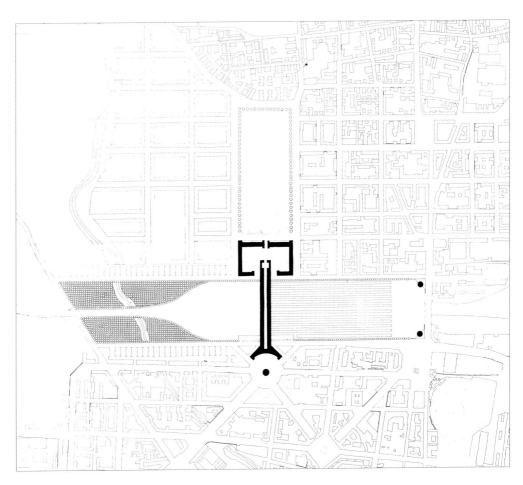

Gesamtsituation mit angrenzenden Stadtvierteln
Seite 108: Situation / Grundriß des Galeriegeschosses
mit Läden / Fassade / Perspektivischer Schnitt

General site plan with adjoining city quarters
Page 108: Site plan / Ground plan of the gallery level
with shops / Facade / Perspective section

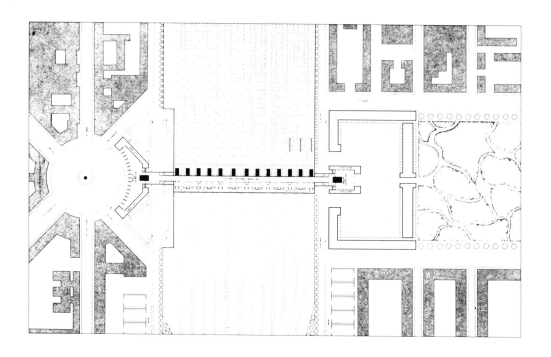

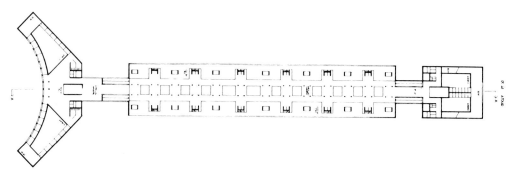

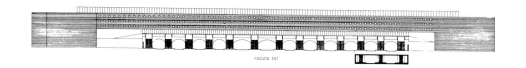

FACCIATA EST

Pfarreizentrum, Lenzburg

Mit Michele Arnaboldi, Raffaele Cavadini, Bruno Jenni, Wettbewerb (1. Preis) 1983; Ausführung 1993–94

Auf dem Grundstück standen bereits eine Kirche (Baujahr 1933) und eine alte Kapelle. Das Wettbewerbsprogramm verlangte einen Gemeindesaal, Sitzungszimmer, Wohnungen und eine Kinderkrippe. Die Entwurfsidee basierte auf der Schaffung einerseits eines gepflasterten Plateaus längs der Bahnhofstraße, andererseits einer Grünfläche hinter der Kirche. Das Plateau ist um die alte Kapelle herumgeführt (was die Entfernung des angebauten alten Pfarrhauses verlangt), ist von einer Umfassungsmauer begrenzt und faßt das Ensemble aus Wohnhaus, Gemeindehaus und Kirche zusammen. Die Kinderkrippe liegt dem gegenüber im Park hinter der Kirche. Freistehend wie die Villen und Einfamilienhäuser in diesem Gebiet und halbkreisförmig-symmetrisch, erinnert sie typologisch und morphologisch an klassizistische öffentliche Bauten im Aargau (19. Jahrhundert). Der ganze Bezirk ist von der Bahnhofstraße her durch eine Freitreppe erschlossen, vom südlich angrenzenden Wohnquartier her durch eine Allee (dort befindet sich zugleich ein Parkplatz). Ausgeführt wurde nach einer fast zehnjährigen Unterbrechung ein verkleinertes Raumprogramm ohne Kinderkrippe und Wohnungen. Die Idee des Platzes wurde den veränderten Gegebenheiten angepaßt. Er ist auf etwa die halbe Länge verkleinert worden; die Kapelle (mit dem nunmehr stehengebliebenen Pfarrhaus) bleibt außerhalb des Areals. Der Zugang zur Anlage erfolgt von Osten her (Freitreppe). Das L-förmige Gemeindehaus definiert zusammen mit der Kirche den Platz. Ein Portikus umgibt den Außenraum und vermittelt zur Architektur. Der Haupteingang liegt im Westflügel in der Längsachse des Platzes. Treppen führen zum Foyer hinauf, dessen Lage mit dem Erdgeschoß-Portikus übereinstimmt. Seine beiden Hofseiten sind voll verglast. Die Dachflächen des Winkels sind in der Höhe gestuft: der Gemeindesaal und die Sitzungszimmer sind um ca. 1,50 m höher als das Foyer und daher zweiseitig belichtet.

Parish Center, Lenzburg

With Michele Arnaboldi, Raffaele Cavadini, Bruno Jenni, competition (first prize) 1983; execution 1993–94

A church (built in 1933) and an old chapel already stood on the property. The competition program demanded a congregation hall, meeting rooms, apartments, and a day-care center for children. The design idea was based on the creation of a paved plateau along Bahnhofstrasse on one hand, and on the other, a green area behind the church. The plateau leads around the old chapel (as is required by the distance of the added-on old rectory) and is limited by a wall. It brings together the ensemble of apartment house, parochial house, and church. The day-care center, on the contrary, is located in the park behind the church. Being free-standing – like the villas and single-family-homes in this area – and with its symmetrical semi-circular shape, it reminds one typologically and morphologically of the classical public buildings in the Aargau (19th century). The entire district is accessed from Bahnhofstrasse by outdoor steps, and from the adjoining southern residential quarter by an avenue which, at the same time, offers parking. After almost ten years, a smaller spatial program without the day-care center and apartments was realized. The idea of the square was adapted to the modified conditions. It has been brought down to half the length and the chapel (with the preserved rectory) remains outside of the area. Access to the complex is from the east (outdoor stairs). The L-shaped parochial house together with the church defines the square. A portico surrounds the outside space and mediates towards the architecture. The main entrance is in the west wing in the longitudinal axis of the square. Stairs lead up to the foyer whose location corresponds to the ground-floor portico. Both sides facing the yard are completely glassed-in. The roof planes of the angle are stepped in their height: the parochial hall and the meeting rooms are about 1.50 m higher than the foyer and therefore receive light from two sides.

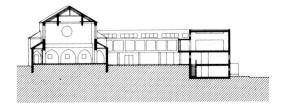

Ausgeführter Entwurf: Schnitt durch Kirche, Hof und Kirchgemeindehaus

Realized design: section of the church, yard and parish center

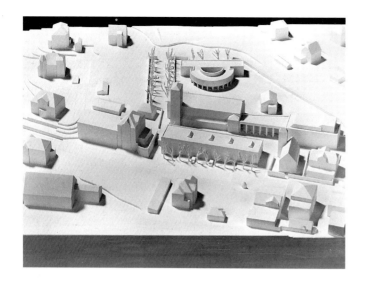

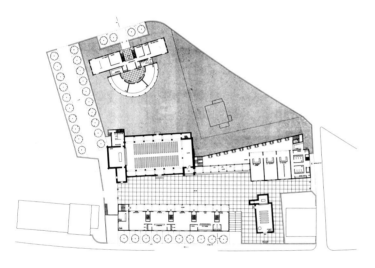

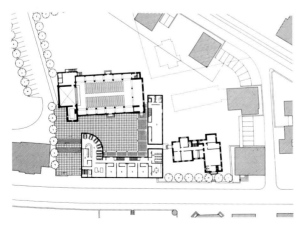

Wettbewerbsmodell / Erdgeschoß Wettbewerbsentwurf / Erdgeschoß ausgeführter Entwurf / Ansicht von der Bahnhofstraße / Hof mit Cafeteria-Rotunde / Grundriß Obergeschoß mit Saal 1:725

Competition model / First floor competition design / First floor of the realized design / View from Bahnhofstrasse / Yard with cafeteria rotunda / Upper floor ground plan with hall 1:725

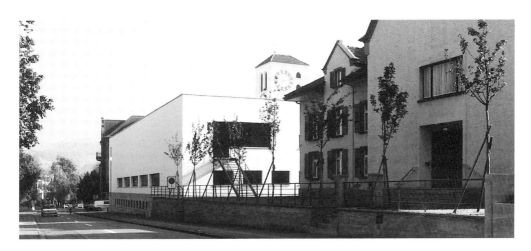

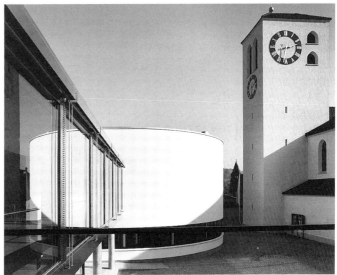

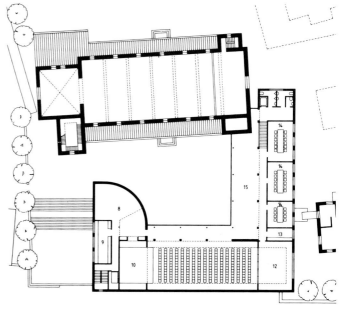

Friedhofserweiterung und -verdichtung, Monte Carasso
1983, 1990

Wenige Eingriffe – bereits durchgeführt oder geplant – machen deutlich, daß Snozzi auch den Friedhof als ein urbanes Element versteht. Er wurde, etwas schräg zur Kirche liegend, im 19. Jahrhundert angelegt. Snozzis Konzept für Monte Carasso beinhaltete, von der (ursprünglich geplanten) Verlegung an den Dorfrand abzusehen. Mit den vorgesehenen Erweiterungen – zwei seitlich anschließenden Dreieckflächen – wird er vielmehr stärker in die Geometrie des Zentrums eingebunden. Die eine dieser Erweiterungen, jene gegen die Turnhalle, ist schon vorbereitet, gehört aber vorerst noch zum Turnplatz. Es fehlt nur noch der Bau der neuen Umschließungsmauer. Die ‹Nekropole› und der Spielplatz liegen unmittelbar nebeneinander, mehr: sie sind in Snozzis Begriff von der ‹Stadt› eigentlich ineinander gedacht. Die beiden Eingriffe innerhalb des Friedhofs lassen ebenfalls die Absicht erkennen, diesen Ort architektonisch zu artikulieren. 1983 wurden auf die Quermauer Urnengräber aufgesetzt, die auf den Geländesprung von ca. 50 cm Höhendifferenz reagieren. 1990 wurden die Grünhecken längs der Hauptachse entfernt und an deren Stelle eine Doppelreihe aus Urnengräbern angelegt. Beides sind Systematisierungen von eminenter Form- und Materialdisziplin. Es handelt sich um vorfabrizierte Betonelemente, jene auf der Quermauer sind beidseitig orientiert. Die Abdeckplatten sind polierter schwarzer Granit, die Schriftfelder der Urnengräber längs des Weges Carrara-Marmor.

Expansion and Condensation of the Cemetery, Monte Carasso
1983, 1990

Only a few realized or planned operations make clear Snozzi's understanding that a cemetery also functions as an urban element. This cemetery was designed in the 19th century and sits at a slight angle towards the church. Snozzi's concept for Monte Carasso included ignoring its originally planned relocation to the edge of the village. With the planned expansions – two laterally adjoining triangular spaces – it is to a greater degree strongly integrated into the geometry of the center. One of these expansions – towards the gymnasium – is in preparation; however, for the time being it still is a part of the sports center. Eventually, it will only require the enclosing wall to be built. The ‹necropolis› and the playground are located right next to each other; moreover, they are thought into one another in Snozzi's concept of the ‹city›. Both operations within the cemetery also reveal the intention to articulate this location architecturally. In 1983, urn graves were set on top of the cross wall, reacting to the landscape's height difference of about 50 cm. In 1990, the bushes along the main axis were removed and in their place a double row of urn graves was laid out. Both represent a systematization of eminent discipline in form and material. They are pre-fabricated concrete elements; the ones on the cross wall are oriented towards both sides. The covering plates are made of polished black granite and the inscription plates of the urn graves along the path are made of Carrara-marble.

Situation mit Kirche und Turnhalle / Graburnen auf der Quermauer 1983 / Graburnen längs des Hauptweges 1990 / Ansicht und Querschnitt der Urnen von 1983

Site plan with church and gymnasium / Grave urns on the cross wall, 1983 / Grave urns along the main walkway, 1990 / View and cross sections of the urns, 1983

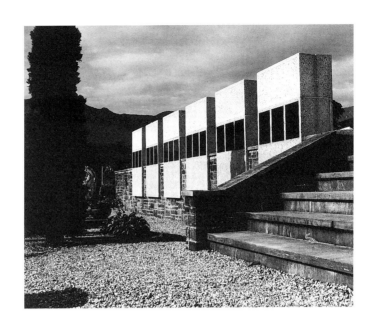

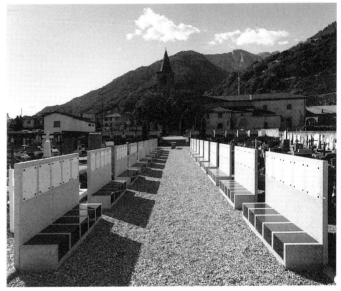

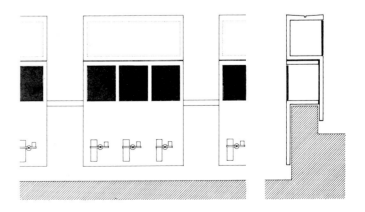

Haus Guidotti, Monte Carasso
1983–84

Einer der ersten Bauten Snozzis im Zusammenhang mit dem Projekt ‹Monte Carasso› war das Haus für den Bürgermeister Guidotti. Sein Standort war die Stelle, wo nach Snozzis Entwurf die Richtungsänderung der Ringstraße vorgesehen war (deren Bau erfolgte nach dem des Hauses). Das Grundstück war ein leicht abfallender Rebgarten in einem Dorfteil mit schmalen und langen Parzellen. An dieser besonderen, von verschiedenen Seiten einsehbaren Stelle entschied sich Snozzi, ein turmähnliches Haus zu bauen, das infolge seiner Prominenz als Angelpunkt fungieren sollte. Mit den sonst erlaubten drei Geschossen wäre dieses Ziel nicht erreicht worden. Das Haus ist viergeschossig und nach Snozzis Worten die notwendige Ausnahme von der Regel, um mit dem Entwurf hier richtig reagieren zu können. Es ist ein Baukörper von sehr geringer Bautiefe (6,0 m) und mit einer Dachterrasse. Die Gartenumfriedung führt zu einer gut 25 Meter vom Haus entfernten Pergola. Die Grundrisse sind eher kleinmaßstäblich, auch dies mit Grund: Snozzi bezweckte damit, in der Grundrißordnung ein abstrahiertes Abbild der Rebzeilen zu schaffen, das auch nach dem allmählichen Verschwinden der Rebstöcke künftige Generationen an die ursprüngliche Bedeutung dieses Ortes erinnern soll (Transformation von Elementen). Ausführung: Sichtbeton mit Schaltafeln.

Guidotti House, Monte Carasso
1983–84

One of Snozzi's first buildings in connection with the ‹Monte Carasso› project was the house for the mayor, Guidotti. Located in the spot where, according to Snozzi's design, the change in direction of the ring road was planned, the property was a slightly sloping vineyard in a part of the village with long, narrow plots (the house was built before the ring road). At this distinct site which could be seen from different sides, Snozzi decided to build a tower-like house which would be given the task of being a central focal point. This goal could not have been achieved with the usual three floors permitted by regulations. The house has four stories and in Snozzi's opinion represents the necessary exception to the rule in order to allow a proper reaction with the overall design. It is a building volume having very little building depth (6.0 m) and it has a rooftop terrace. The garden wall leads to a pergola which is a good 25 m from the house. The ground plans were designed on a rather small scale – and this was done for a reason: Snozzi intended to create an abstract image of the vineyard rows in the structure of the ground plan which, even after the gradual disappearance of the vines, would remind future generations of the original meaning of this location (transformation of elements). Execution: fair-faced concrete with form-work panels.

Schalungsplan Fassade / Ansicht von Nordosten (vor dem Bau der Ringstraße) / Gartenseite / Grundrisse 2. und 1. Obergeschoß / Grundriß Erdgeschoß / Längsschnitt

Facade: plan of the formwork / View from the northeast (before the construction of the ring road) / Garden side / Ground plans: third floor, second floor and first floor / Longitudinal section

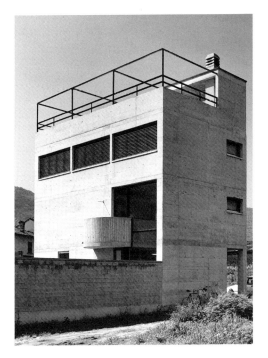
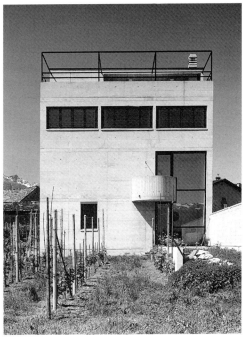
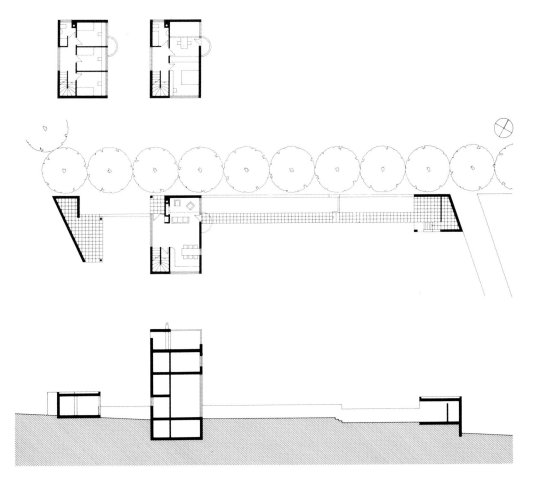

Reihenhäuser Büchel, Brione
Mit Gustavo Groisman, Projekt, 1984

Es galt, für ein großes Grundstück unterhalb der Höhenstraße zwischen Brione und Orselina (unweit des Hauses Kalman) ein Bauprojekt zu entwickeln. Der vorliegende Vorschlag konnte leider nicht realisiert werden, weil das Grundstück nicht an Snozzis Auftraggeber, sondern an einen Dritten verkauft wurde. Als Antwort auf die architektonische Vereinzelung, wie sie krass die Anhöhen über Locarno kennzeichnet, kam für Snozzi nur ein konzentrierter Eingriff in Frage. Gegenüber der Flächenstruktur der Überbauung Taglio, 20 Jahre früher entworfen (vgl. S. 24), ist dieser Entwurf jedoch linear strukturiert: als Reihung von sechs winkelförmig um einen Patio herum organisierten Elementen. Der bergwärts ungegliederte langgestreckte Baukörper nimmt auf die Höhenstraße zwischen Brione und Orselina Bezug. Am Nordende, wo die Straße wegen eines kleinen Bacheinschnitts bergwärts einbiegt, ist eine platzartige Erweiterung geschaffen, an der die ganze Anlage angebunden ist. Von hier geht die Fußgängererschließung ab (Passerelle und Treppenabgang ins mittlere Geschoß und weiter bis zum Schwimmbassin), und die gekurvte Autorampe führt ins Eingangsgeschoß. Die starke Hangneigung führte zu einer durchaus ungewöhnlichen Schnittlösung. Das erwähnte Eingangsgeschoß ist als Zwischenebene ausgebildet, von der aus man nach unten in das Wohn- und Gartengeschoß absteigt oder nach oben in das Schlafgeschoß gelangt. Ungewöhnlich ist die ‹Leere› dieses Zwischengeschosses: Es umfaßt den Längsportikus in der Fortsetzung des Treppenabganges, die gedeckte Halle als Vorplatz und Autoabstellplatz und den Hauseingang. Wichtig sind die beiden Lufträume über dem Patio und dem Wohnraum.

Büchel Row Houses, Brione
With Gustavo Groisman, project, 1984

The task was to develop a building project for a large plot of land below the mountain road from Brione to Orselina (near the Kalman House). Unfortunately, the present proposal could not be realized because the land was sold to another party instead of Snozzi's clients. As an answer to the architectural isolation which strikingly characterizes the hills above Locarno, Snozzi considered nothing less than a concentrated operation. Opposed to the surface structure of the Taglio development from 20 years earlier (see p. 24), this design is structured linearly: a row of six elements organized at an angle around a patio. The long building volume, unstructured towards the hillside, refers to the mountain road between Brione and Orselina. At the northern end where the street turns towards the mountains to avoid a small ravine in its path, a plaza-like extension was created to which the entire complex refers. From here, the pedestrian development (passageway and stairs descending to the middle level and continuing to the swimming pool), and the curved car ramp to the entrance level debark. The strong slope led to a rather unusual cross sectional solution. The mentioned entrance level is designed as an interstitial level from which one descends into the living and garden level or ascends to the bedroom level. The ‹emptiness› of this interstitial level is unusual. It includes the longitudinal portico in the extension of the stair descent, the covered hall as a small square, and the car lot and entrance to the house. The two air spaces above the patio and the living space are important.

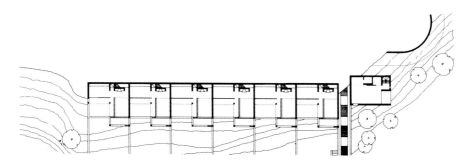

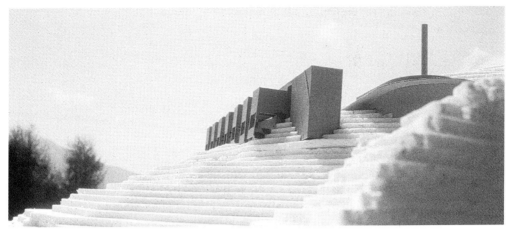

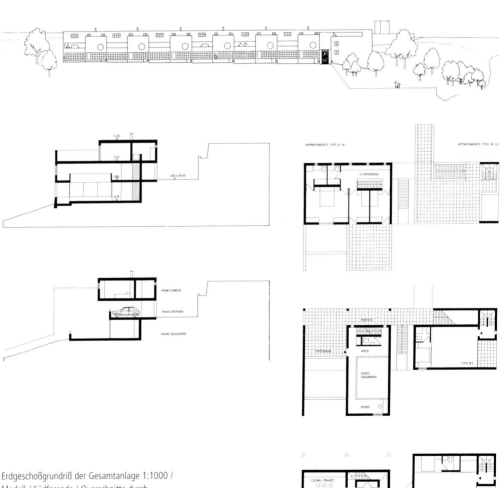

Erdgeschoßgrundriß der Gesamtanlage 1:1000 / Modell / Südfassade / Querschnitte durch Gartenhof bzw. Wohnzimmer / Grundrisse Obergeschoß, Eingangsgeschoß, Erdgeschoß

First floor ground plan of the entire complex 1:1000 / Model / South facade / Cross sections of the garden yard and living room / Ground plans: upper floor, entrance floor and first floor

Haus Barbarossa, Minusio
Mit Claudio Buetti, 1985

Im Unterschied zu Monte Carasso gilt in fast allen anderen Tessiner Gemeinden die Regel des allseitigen Grenzabstandes. Die Folge daraus ist das Problem des zerstörten baulichen Gewebes und die Paradoxie, daß gerade die Vereinzelung einen Mangel an Privatheit schafft – und mithin häufig soziale Spannungen zwischen Nachbarn. Im vorliegenden Fall mußte Snozzi sich dieser Bauvorschrift anpassen. Sein Ziel war deshalb ein freistehendes Haus, das eine Antwort auf das Problem sein sollte. Das Haus nutzt die leichte Hanglage aus, indem es einen Geländesprung zwischen der Vorder- und der Rückseite schafft. Die Eingangsfront gegen Norden ist zweigeschossig, die Gartenseite gegen Süden dreigeschossig. Eine schmale, doppelt geführte Treppe erschließt vom Hauseingang aus das Sockelgeschoß und setzt sich als offener Durchgang zum Hauptteil des Gartens fort. Dieses verbindende Element verleiht durch seine Funktion und durch seine zentrale Stellung der gesamten Anlage eine klar hierarchisierte Ausrichtung. Die Eingangsseite ist teilweise als gepflasterter Hof ausgeführt. Das Haus besitzt eine fast reine Würfelform und ist von lapidar einfachem Aufbau. Der Sockel ist betoniert, die aufgehenden Geschosse bestehen aus Isolier-Blocksteinen und sind weiß verputzt. Die Seitenfassaden sind nahezu fensterlos. Der Balkon über dem Eingang gehört zur Diele und bezieht sich insofern auf die Bautradition des Tessins. Das Grundstück hätte den Bau von vier solchen Häusern erlaubt, aber es wurde nur dieses eine realisiert.

Barbarossa House, Minusio
With Claudio Buetti, 1985

Contrary to Monte Carasso, almost all other Ticino communities forbid building closer to a property line than the minimum distance required by local zoning codes. The result and problem is the destruction of the constructive web and the paradox that it is this isolation which creates a lack of privacy – and oftentimes causes social tensions between neighbors. In the present case, Snozzi had to accept this building regulation. His goal, therefore, was to build a free-standing house which would resolve this problem. The house uses the slightly sloped property by introducing a difference in the levels of ground between the front and the back. The north facing entrance facade has two stories, whereas the garden side facing south has three stories. A narrow, double staircase leads from the entrance into the basement and continues as an open passageway into the main section of the garden. This connecting element lends a clearly hierarchical orientation to the entire structure as a result of its central location. A section of the entrance side is realized as a tile-covered yard. The house is an almost pure, cube-shaped structure, and its construction is simple and succinct. The base is concrete and the floors on top of it are constructed with insulation bricks covered with white plaster. The side facades are almost bare of windows. The terrace above the entrance is part of the hallway and thus relates to the building tradition of Ticino. The construction of four such houses would have been possible on the grounds, but only this one was realized.

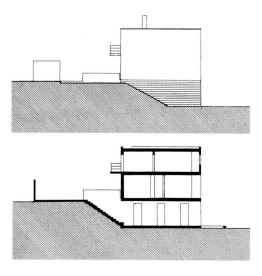

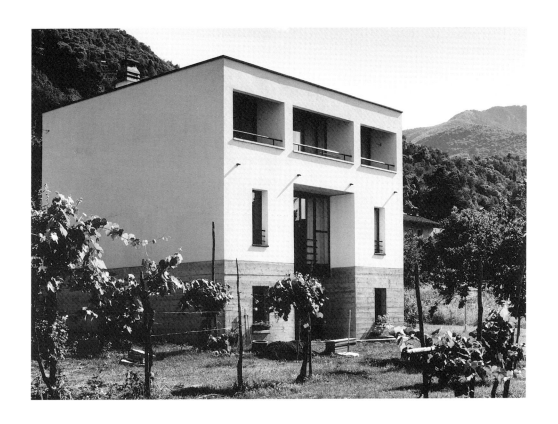

Ostfassade und Längsschnitt 1:500 /
Gartenseite / Eingangsseite / Grundrisse
Sockelgeschoß, Wohngeschoß, Schlafgeschoß

East facade and longitudinal section 1:500 /
Garden side / Entrance side / Ground
plans: base floor, living floor and bedroom floor

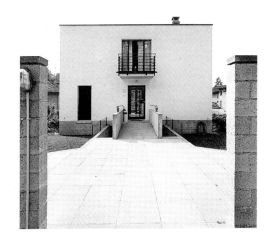

Apartmenthaus Bianchini, Brissago
Mit Bruno Barosso, Gian Franco Chiappini, Michele Arnaboldi, Maurizio Vicedomini, 1982, 1985–87

Bereits vor 1970 beschäftigte sich Snozzi mit einem Anbau an das bestehende turmartige Wohnhaus aus dem 18. Jahrhundert, das zur wertvollen Renaissance-Kirche des Dorfes gehört. Deren Renovation war einer der frühesten selbständigen Aufträge für ihn gewesen (1961–63). Das ausgeführte Projekt legt einen winkelförmigen Baukörper um das barocke Turmhaus und den ihm nach Süden vorgelagerten kleinen Platz. Der Kontrast zwischen dem vom Boden emporstrebenden Turm und dem Neubau wird akzentuiert durch das weitgespannte transparente Erdgeschoß, das als Durchgang zum Platz und der Kirche ausgebildet ist, und an dem ein voll verglastes Ladengeschäft liegt (Glasfront und Sockel: vgl. S. 59). Der Kopf des Neubaus wird von nur zwei Eckstützen getragen (Spannweite quer ca. 13 m, längs 17 m, vorgespannter Beton). Der Turm enthält drei Kleinwohnungen und eine Penthouse-Wohnung, seitlich von den Treppen des neuen Flügels her erschlossen. Das oberste Turmgeschoss, achteckig, stammt von Snozzi, und dementsprechend auch der obere Abschluß der Südfassade. Im Neubauteil liegen auf drei Obergeschossen je eine 1-, eine 2- und eine 4-Zimmer-Wohnung. Die Erschließung ist formal als Zäsur zwischen Alt und Neu ausgearbeitet: offenliegende Laubengänge, an deren südlichem Ende der Lift liegt.

Apartment Building Bianchini, Brissago
With Bruno Barosso, Gian Franco Chiappini, Michele Arnaboldi, Maurizio Vicedomini, 1982, 1985–87

Before 1970, Snozzi was already concerned with an extension to the existing tower-like 18th century apartment building belonging to the precious Renaissance church in the village. Its renovation had, by the way, been one of his earliest independent orders (1961–63). The realized project places an L-form building volume around the baroque tower house and the small square at its front facing towards the South. The contrast between the tower rising up to the sky and the new building is accentuated by the wide stretched-out transparent ground floor and developed as a passageway to the square and the church. A completely glassed-in store is located there (glass front and base: see p. 59). The head of the new building is supported only by two corner columns (span ca. 13 m, length 17 m, prestressed concrete). The tower contains three small apartments and a penthouse apartment, accessible from the side via the stairs of the new wing. The upper tower floor with an octagonal shape was designed by Snozzi and accordingly also the upper termination of the South facade. The three upper floors in the new part each have a 1, 2, and 4-room apartment. The access – open external corridors with the elevator on their southern end – is worked out formally as a caesura between the old and the new.

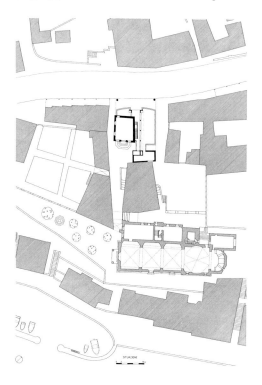

Situation und Erdgeschoßplan /
Ansicht von der Straße / Entwurfsskizze

Site plan and first floor ground plan /
View from the street / Design sketch

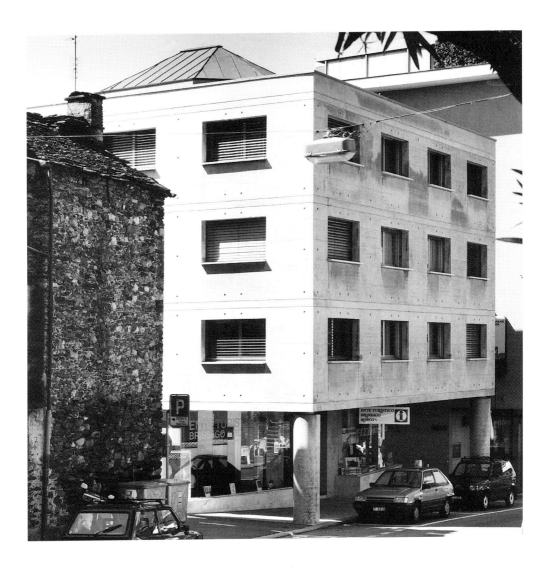

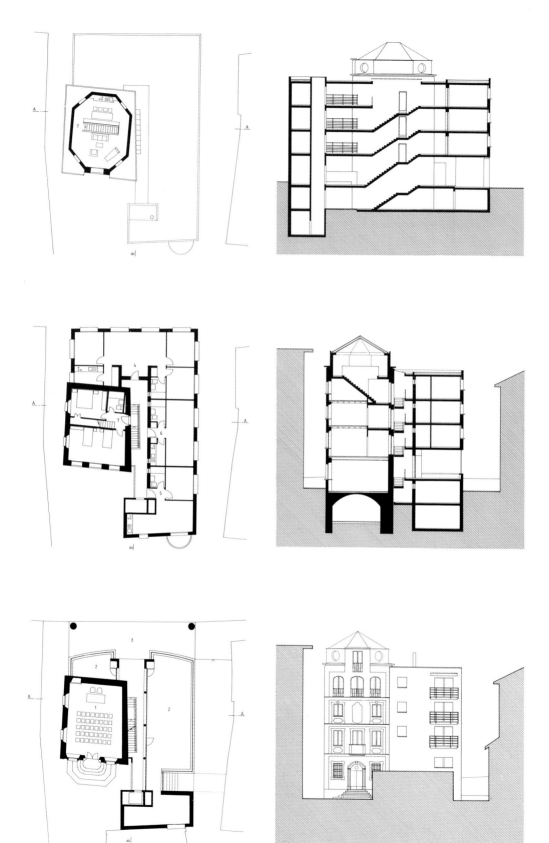

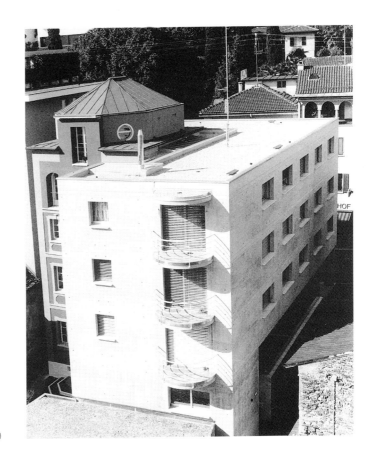

Grundrisse, Schnitte, Südfassade
1:400 / Ansicht vom Campanile aus /
Schalungsplan der Ostfassade 1:200

Ground plans, sections, south facade
1:400 / View from the Campanile /
Formwork plan of the east facade 1:200

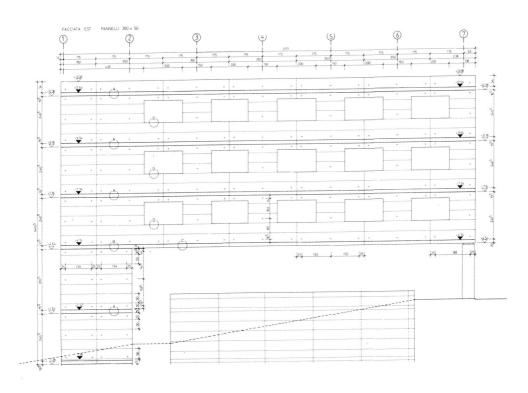

Regierungszentrum des Département du Bas-Rhin, Straßburg

Mit Michele Arnaboldi, Bruno Jenni, Jean Paul Rayon und Atelier B.E.A.U., Wettbewerb, 1986

Das Entwurfsareal schließt nördlich an die Straßburger Altstadt an und liegt auf dem rechten Ufer des Rhein-Marne-Kanals, unmittelbar neben dem Schleusenriegel aus dem 17. Jahrhundert, einem Werk des großen Festungsbaumeisters Vauban. Der politische Hintergrund für den Wettbewerb war die Reform des Conseil Général und die Aufwertung der einzelnen Departements. Das Raumprogramm war sehr umfangreich und verlangte große Büroflächen für das Parlament und die Administration sowie zahlreiche Parkplätze. Der Hauptgedanke des Entwurfs ist die Akzentuierung des Areals mittels einer gestuften Plattform, die als Verlängerung des Altstadtsockels aufgefaßt wird. Das umgebende, tieferliegende Terrain wird demgegenüber als Grünanlage behandelt. Die Leere des neuen Sockels antwortet auf die große Freifläche des ‹Quartier Blanc› auf dem anderen Kanalufer; beide Außenräume sind für Fußgänger durch Vaubans Brücke miteinander verbunden. Diese wird dadurch, daß sie freigelegt wird, in ihrer urbanistischen Bedeutung gesteigert. Der Sockel enthält hauptsächlich die Autoparkierung. Die kanalseitige Plateaukante wird von einer noch vorhandenen ehemaligen Befestigungsmauer gebildet. Die Baumassen sind auf der vom Kanal abgewandten Seite konzentriert, wo der Sockel durch die beiden langgestreckten, seitlich versetzten Trakte der Administration definiert ist. Deren einbündig organisierte Geschosse zeigen eine klare Ausrichtung auf das Plateau hin. Das Parlament schließt in der Längsachse die Anlage ab. Hinter der mehrgeschossigen, von oben belichteten Halle ragt das Volumen des Ratssaals hoch auf, das als Dominante diese stadträumliche Sukzession abschließt. Mit einer leichten Abdrehung reagiert dieses Gebäude auf den Seitenschub infolge der Versetzung der Sekretariatstrakte. Vom Parlamentsgebäude aus gesehen, liegt über dem weiten Platz die Altstadt im Blickfeld, gefaßt linkerhand von Vaubans Bau, rechts von der Platzwand, die die unstrukturierte Neustadt verdeckt. In den Sockelrand eingetiefte Treppenabgänge verbinden den Platz unter dem Sekretariatsgebäude mit dem umgebenden Grünraum.

Government Center of the Département du Bas-Rhin, Strasbourg

With Michele Arnaboldi, Bruno Jenni, Jean Paul Rayon and the studio B.E.A.U., competition, 1986

The design area adjoins the old part of Strasbourg to the north and is located on the right bank of the Rhine-Marne-canal and immediately next to the 17th century lock, a work of the great fortification architect Vauban. The political background for the competition was the reforming of the General Council and the revaluation of the separate departments. The spatial program was very large and asked for large office areas for the parliament and the administration as well as numerous parking spaces. The main idea of the design was the accentuation of the area through a layered platform which can be perceived as an elongation of the old city base. Contrary to this, the surrounding lower terrain is treated as a green area. The emptiness of the new base answers to the large free area of the ‹Quartier Blanc› on the other side of the canal; both outdoor spaces are connected by Vauban's pedestrian bridge. The bridge, by being exposed, is enhanced in its urban importance. The base mainly contains parking. The edge of the plateau towards the canal is formed by an existing former fortification wall. The building masses are concentrated on the side turned away from the canal where the base is defined by the two long, stretched out and laterally offset administration tracts. The single-depth organization of their levels shows a clear orientation towards the plateau. The parliament building places the end-point of the complex in the longitudinal axis. Behind the multi-level hall lit from above, the volume of the council hall rises up, closing off the urban spatial succession as the dominating factor. This building reacts to the sideways push with a slight turn due to the offset placement of the administrative tracts. Seen from the parliament building, the central view beyond the wide square is the old part of town. It is bordered on its left side by the Vauban building, and on the right of the square wall covering the unstructured new city. A descending stairway set into the edge of the base leads to a passageway beneath the administrative building, connecting the square with the surrounding green space.

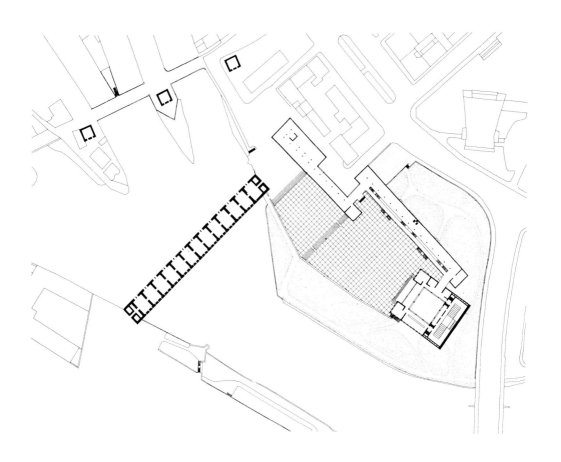

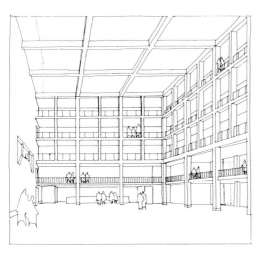

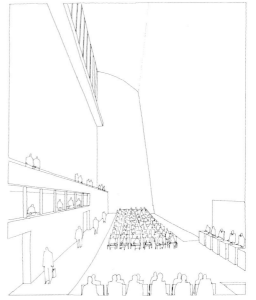

Längsschnitt durch Platzsockel / Hauptgrundriß
mit der Vauban-Brücke 1:2600 / Perspektive
der zentralen Halle / Perspektive Parlamentssaal

Longitudinal section of the base / Main ground plan
with the Vauban bridge 1:2600 / Perspective
of the central hall / Perspective of the parliament hall

Regierungsviertel, Vaduz
Mit Gustavo Groisman, Renato Magginetti,
Zweistufiger Wettbewerb (1. Rang), 1987

Snozzi wurde als einer von zehn ausländischen Architekten zur Teilnahme an diesem zweistufigen Wettbewerb eingeladen, der für Architekten des Fürstentums Liechtenstein ausgeschrieben war. In der ersten Stufe ging es vor allem um die städtebauliche Neugestaltung des Regierungsviertels im Hauptort Vaduz, wobei das Verhältnis der Neubauten zu den bestehenden Gebäuden (u.a. Regierungsgebäude, Musikschule und Pfarrkirche) ein wichtiges Kriterium war. In der zweiten Stufe (ausgetragen unter den ersten vier Preisträgern) handelte es sich um die Überarbeitung der Projekte und die Konkretisierung insbesondere des Parlamentsgebäudes. Snozzis Entwurf (Kennwort: ‹Polis›) obsiegte in beiden Wettbewerbsstufen. Die vorgefundene Situation ist geprägt vom steil aufragenden Schloßberg, dessen starke Bewaldung bis in die unmittelbare Nähe der öffentlichen Gebäude am Hangfuß herabreicht. Für Snozzi manifestierte sich darin das Problem: fehlende Urbanität und Schwäche der Stadt gegenüber der sie bedrängenden Natur. Die Lösungsidee lag im Gedanken, das Planungsgebiet bergseits durch einen Platz auszuweiten und durch ein Sockelgebäude zu befestigen. Die Geländeformation führte so zu einem langgestreckten viergeschossigen Gebäude, das, dem Verlauf des Schloßbergs folgend, den so geschaffenen Platz mit einer doppelt geschwungenen Struktur ‹ausfüttert›. Diese raumhaltige Wand wird im 1. OG von einer seitlich offenen Galerie durchzogen, an deren Enden das Landesmuseum bzw. die Musikschule liegen. Zugleich ist sie ein Teilstück des Fußwegs zum Fürstenschloß. Dieses von Snozzi «Galeriegebäude» genannte Element ist der Bezugsrahmen für sämtliche übrigen Teile des Entwurfs. Durch die architektonische Definition des Hangfußes wird ein einheitlicher städtischer Platz geschaffen, auf dem die wichtigen Bauten als freigespielte Protagonisten agieren: das bestehende Regierungsgebäude, die Musikschule und andere Häuser sowie der Entwurf zum Landtagsgebäude (Parlament). Letzteres ist ein solitäres Element auf der Platzfläche, das durch seine Halbkreisform sowohl der geradlinigen Geometrie von Städtlestraße und Regierungsgebäude entspricht, als auch mit dem zurückweichenden Galeriegebäude harmoniert. Funktionell, räumlich und volumetrisch ist der Landtag konzipiert als Durchdringung zweier Halbzylinderkörper. Der untere Halbzylinder übernimmt die Traufhöhe des Regierungsgebäudes und enthält die Eingangshalle mit der Vertikalerschließung und im Untergeschoß ein Auditorium. Diese Halle ist eine außerordentliche und virtuose Raumschöpfung: ein geo-

Government Quarter, Vaduz
With Gustavo Groisman, Renato Magginetti,
two-stage competition (first place), 1987

Snozzi was one of ten foreign architects invited to participate in this two-phase competition for architects of the Liechtenstein principality. In the first phase, the task was the urban redesign of the government quarter in Vaduz, the capital, whereby the relationship of the new buildings with the existing one (such as the government building, the music school and the parochial church) was an important criterion. The second phase (with the four winners of the first one competing) dealt with the revision of the projects, and above all, the specification of the parliament building. Snozzi's design (code word ‹Polis›) won both stages. The given location is marked by the steeply rising castle hill whose dense forest reaches the immediate vicinity of the public buildings at the foot of the slope. For Snozzi, the following problem manifested itself in this: the lack of urbanity and weakness of the city towards the imposing nature. The idea for the solution was to expand the development area towards the hill and to reinforce it by a base building. The landscape formation thus led to a long, stretched-out four-story building which, following the shape of the castle hill, would ‹fill› the created space with an S-curve structure. A gallery on the second floor, open on the side facing the valley, runs the length of this space containing wall. At its end are the regional museum and music school. At the same time, it is part of the walkway leading to the castle. This element, called the «gallery building» by Snozzi, is the reference point for all the other parts of the design. Through the architectural definition of the foot of the hill, a unified urban square is created in which the important buildings act as freed protagonists: the existing government building, the music school, and other houses, as well as the design for the parliament building. The latter is a solitary element on the square surface corresponding with its semi-circular shape to the straight geometry of Städtlestraße and the government building. It also forms a harmony with the receding gallery building. The parliament building has been conceived as a penetration of two semi-cylindrical volumes in a functional, spatial, and volumetric way. The lower semi-cylinder adopts the eaves height of the government building and contains the entrance hall with a vertical development and an auditorium on the lower floor. This hall is an exceptional and virtuous spatial creation: a geometric, precisely limited space which opens up in a terrace-like movement towards the top with two different centerpoints. Above two semi-circles standing one on top of the other, the foyer, lit by a zenith skylight, surrounds the vol-

metrisch präzis gefaßter und nach oben terrassenartig sich weitender Raum mit zwei verschiedenen Kreismittelpunkten. Über zwei übereinanderstehenden Halbkreisringen umgibt das – von Zenitallicht erhellte – Foyer als Raumschale den an der äußeren Zylinderwand aufgehängten Körper des Parlamentssaales. Die Pläne und Schnittzeichnungen vermitteln einen deutlichen Eindruck von der räumlichen Stärke, den Durchblicken und Lichtverhältnissen, die dieser Entwurf verspricht. Durch die gewählte klassizistische Grammatik hindurch scheint hier die Idee der räumlichen Transparenz als zentraler Gedanke des 20. Jahrhunderts.

ume of the parliament hall which is suspended from the outer cylinder wall as a spatial shell. The plans and cross section drawings convey a clear impression of the spatial strength, the openings, and lighting conditions which are promised by this design. The idea of spatial transparency as a central thought of the 20th century shines through the chosen classicist grammar.

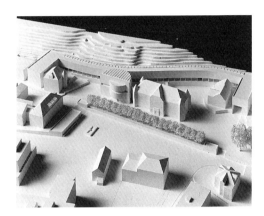
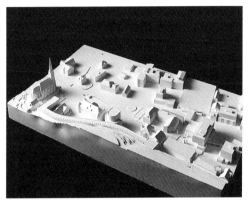
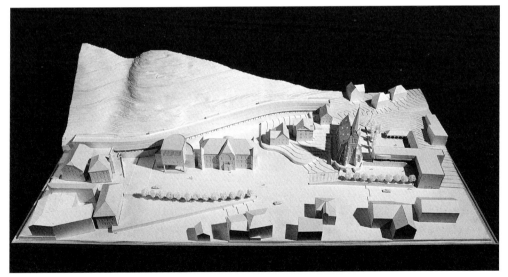

Modell der 1. Wettbewerbsstufe, Februar 1987 /
Modell der 2. Wettbewerbsstufe, September 1987 /
Modell der Weiterbearbeitung, 1991 (vgl. Seite 158)

Model of the first competition phase, February 1987 /
Model of the second competition phase, September 1987 /
Model of the continued design, 1991 (see page 158)

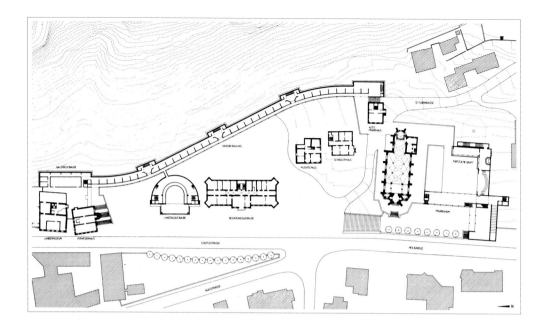

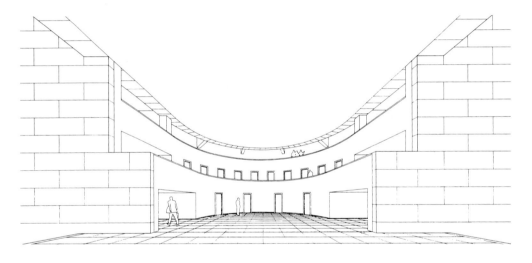

Gesamtsituation, Projektstand 1991, u.a. mit Parlament, Regierungsgebäude, Pfarrheim (vgl. Seite 158) / Eingangshalle des Landtagsgebäudes (Parlament) / Landtagsgebäude: Grundrisse Saalgeschoß, 3. Obergeschoß, Erdgeschoß, Untergeschoß / Südfassade / Längsschnitt / Querschnitt 1:570

Site plan, state of project in 1991, among others with parliament, government building, parish center (see page 158) / Entrance lobby of the legislature building (parliament) / Parliament building: ground plans of the hall level, fourth floor, first floor, lower level / South facade / Longitudinal section / Cross section 1:570

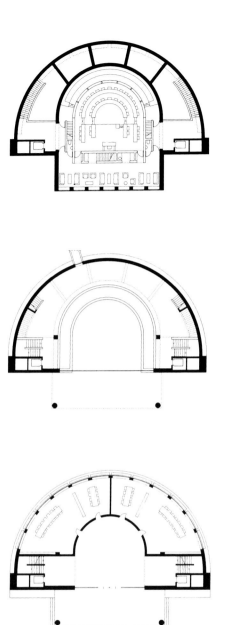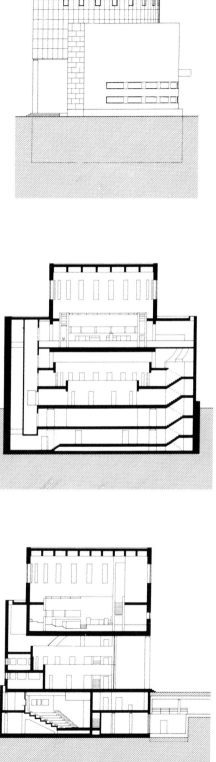

Restrukturierung und Umbau des Convento, Monte Carasso
(Primarschule und andere Nutzungen)
Mit Giuliano Mazzi, 1979, 1987–93

Das ehemalige Augustinerinnenkloster ist das wichtigste Element in Snozzis Konzept zu Monte Carasso. Die Vorgeschichte dieser Arbeit ist hier an anderer Stelle resümiert (vgl. S. 82). Das Resultat – unspektakulär und raffiniert, bescheiden und selbstbewußt – ist beispielhaft für Snozzis Methode und die Qualität der daraus resultierenden Architektur. 1965 war (was Snozzi bedauert) der mittelalterliche Klosterhof abgerissen worden – es war dies die dynamische und «geschichtslose» Zeit der Hochkonjunktur. Die verbleibenden Teile des Klosters waren die Kirche und der unvollendete Hof aus dem 16. Jahrhundert, der aber durch Ein- und Umbauten sehr stark verändert war. Mitte der siebziger Jahre wurde erwogen, auch diese Reste abzureißen; diese Absicht war kontrovers. Snozzi plädierte für Erhaltung und Restrukturierung, überzeugt, das ehemalige Kloster müsse auch das Zentrum eines künftigen Monte Carasso sein. Er erhielt 1979 den Auftrag, eine Studie für die Primarschule an diesem Standort vorzulegen. In der daraufhin durchgeführten Bauaufnahme bestätigte sich seine Vermutung, daß die seit 1864 (Profanisierung) aufgeführten Mauern gegen den Hof die intakten Arkaden des 16. Jahrhundert verbargen. Kernstück von Snozzis Konzept war die Restrukturierung des Komplexes um einen rechteckigen Platz herum. Das Modell zum Ortszentrum, 1979 vorgestellt, zeigt einen systematisierten und vervollständigten Hof von einheitlicher Höhe und mit einfachen Satteldächern. Snozzi wollte aber nicht eine denkmalpflegerische Rekonstruktion, sondern einen Neuvorschlag (riproposta). Das heißt: Nachvollzug der Baugeschichte, Erkenntnis von Eigenart und Bedeutung der Anlage und deren Aktualisierung vor dem Hintergrund einer gegenwartsbezogenen Entwurfsidee (vgl. S. 64). Es galt, die Charakteristik der Anlage des 16. Jahrhunderts wieder herauszuarbeiten (wozu auch die Freilegung originaler Bausubstanz gehört), und zugleich den Eingriff als Beitrag des 20. Jahrhunderts erkennbar zu machen. Dies umsomehr, als die Klassenzimmer gute Lichtverhältnisse verlangen, was bei einer Rekonstruktion kaum möglich gewesen wäre. Summa summarum verlangte dies ein neuzeitliches Architekturverständnis bzw. Entwurfsverhalten. Dem widersetzte sich aber die Tessiner Denkmalpflege, das Vorhaben war jahrelang blockiert, und erst die Unterstützung Snozzis durch die Eidgenössische Denkmalpflege machte die Realisierung möglich. Ein Hauptpunkt seines Vorschlags war, das 1. Obergeschoß und die verschiedenen Aufstockun-

Restructuring and Conversion of the Convento, Monte Carasso
(Primary school and other functions)
With Giuliano Mazzi, 1979, 1987–93

The former convent of the Augustan nuns is the most important element in Snozzi's concept for Monte Carasso. The prehistory of this work has been summarized in another article (see p. 82). The result – unspectacular and smart, modest and self-confident – is a perfect example of Snozzi's method and the quality of the resulting architecture. In 1965, the medieval monastery yard was torn down (regrettable, in Snozzi's opinion). It occurred during the dynamic and «unhistorical» boom time of economy. The remaining parts of the monastery were the church and the unfinished yard from the 16th century. However, they had been modified very strongly by installations and conversions. In the middle of the '70s, tearing down these remnants had also been considered; however, this scheme was controversial. Snozzi, convinced that the former monastery would have to be the center of a future Monte Carasso, pleaded for preservation and restructuring. In 1979 he received the order to submit a study for the primary school in this location. The following commencement of the construction work confirmed his suspicion that the walls facing the yard – mentioned since 1864, the year of secularization – did indeed cover the intact arcades of the 16th century. The core of Snozzi's concept was the restructuring of the complex around a rectangular square. The model for the town center, shown in 1979, shows a systematized and completed yard with a unified height and simple saddle roofs. However, Snozzi did not want a conservationist reconstruction. Instead, he envisioned a re-proposal, i. e., a following of the building history and a recognition of the uniqueness and importance of the complex and its actualization with the background of a relevant contemporary design idea (see p. 64). The point was to once again work out the 16th century characteristics, which would include the uncovering of the original building substance while at the same time making the operation visible as a 20th century contribution. This is especially true since the classrooms required good lighting conditions. In the case of a reconstruction, this would not have been at all feasible. Altogether, this required a contemporary perception of architecture or design behavior. However, the Ticino preservationists were opposed to this endeavor. As a result, it was blocked for several years. Only Snozzi's support from the Swiss federal preservationists made the realization of this design possible. A main issue of his proposal was the removal of the second floor, and the various height increases of the east

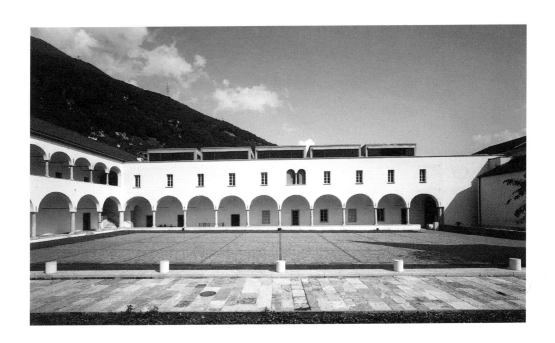

Ansicht von Westen / Entwurfsskizzen (undatiert, um 1980)
Seite 132: 1. Obergeschoß, Vergleich des Zustandes 1979 mit dem Umbau
Seite 133: Bildvergleich: Zustand heute und 1979 / Ostfassade mit Aufbauten

View from the west / Design sketches (undated, around 1980)
Page 132: second floor, comparison of the conditions in 1979 with the conversion
Page 133: comparison, conditions today and in 1979 / East facade with superstructure

gen des Ostflügels abzutragen und das Obergeschoß mit den Klassenzimmern neu aufzubauen. Denn die Grundrißeinteilung des ehemaligen Obergeschosses mit den Zellen der Nonnen war ungeeignet für eine Schulnutzung, und zudem war die originale Bausubstanz weitgehend verloren. War der Grundriß des Obergeschosses ursprünglich zweibündig mit einem innenliegenden Korridor, übernahm Snozzi nun die Geometrie des Erdgeschosses. Hinter der Fassade führt ein breiter Korridor (mit den zwei erhaltenen Seitenwänden) über die ganze Länge des Flügels. Die Raumflucht der Klassenzimmer entspricht so der entsprechenden Zone im Erdgeschoß – und den Kellergewölben. Eine undatierte Skizze (ca. 1980) veranschaulicht die Idee der restrukturierten Renaissance-Hoffassade als raumhaltiges Element, an das von der Rückseite her die einzelnen Klassenzimmer (dargestellt als Zylinder) angeschlossen sind. Snozzi dachte auch ursprünglich daran, einige Stahlcontainer als Klassenzimmer mit einem Pneukran auf das intakte Erdgeschoß zu stellen. Heute bezeichnet er diese Idee als technischen Romantizismus. (Sie ist nicht nur das: in ihr manifestiert sich die für Snozzi zentrale Frage nach der Hierarchie von Mitteln und Zwecken in der Architektur.) Die fünf Klassenzimmer sind zweigeschossig, mit einem Vierteltonnen-Dach gedeckt und gegeneinander abgesetzt. Es sind fünf gereihte Elemente, zusammengehalten von der Fassade. Das obere Geschoß der Klassenzimmer besteht aus einer Spielgalerie (mit gläsernen Verbindungstüren), die die ad-

wing, and a rebuilding of the upper floor with the classrooms. The floor plan structure of the former upper floor with its nuns' cells was unfit for use as a school. In any event, the original building substance had been for the most part lost. While the floor plan for the upper floor originally had two depths with an interior hallway, Snozzi now appropriated the geometry of the ground floor. Behind the facade, a wide hallway (with the two preserved side walls) leads along the entire length of the wing. The spatial alignment of the classrooms thus conforms to the corresponding zone on the ground floor and the basement vaults. An undated sketch (ca. 1980) clarifies the idea of the restructured renaissance courtyard facade as a space-containing element to which the various classrooms (shown as cylinders) are connected from the back side. Snozzi originally considered having a couple of steel containers (serving as classrooms) put onto the intact ground floor with a crane. Today, he calls this idea a technical romanticism. (It is not only that, however: it manifests the central question for Snozzi about the hierarchy of means and purposes in architecture.) The five classrooms have two floors, are covered with a quarter barrel roof, and are set off against each other. They are comprised of five lined-up elements held together by the facade. The upper floor of the classrooms consists of a game gallery (with glass connection doors) which joins the added volumes together lengthwise. It now marks the dimension and position of the former upper floor central

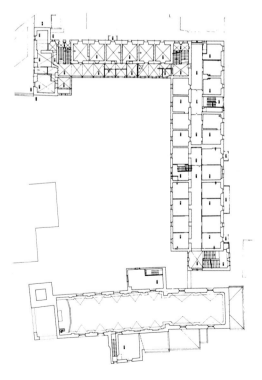 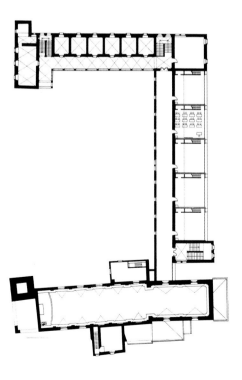

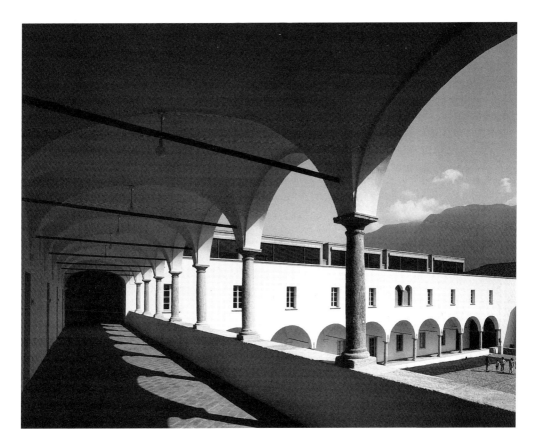

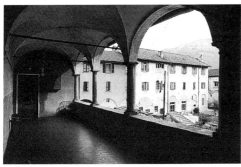
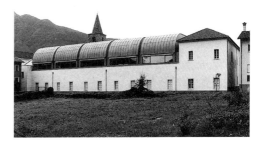

dierten Volumen längs zusammenbindet. Sie markiert, nun im 2. Obergeschoß, Dimension und Lage des früheren Obergeschoß-Mittelkorridors. Die Klassenzimmer sind beidseits belichtet. Während eines Tages ändern sich die Lichtverhältnisse stark. Die Fenster der unteren Ebene liegen an der Ostfassade, geben Morgensonne und erlauben den Blick ins Dorf; jene der Galerie liegen auf der Westseite und zeigen den Himmel, die Berge und die Spitze des Kirchturms. Das Doppelfenster mit der Säule gehörte zum kreuzförmigen Korridor und ist von Snozzi als Erinnerung daran behandelt worden. Dies jedoch nur in der Fassade. Die Säule ist zwar auch innen sichtbar, aber zum Korridor hin weist das betreffende Fenster die

hallway on the third floor. The classrooms receive light from both sides. During the day, the light conditions change considerably. The windows on the lower level face the eastern facade, letting in the morning sun, and offering a view towards the village; those of the gallery face the western facade and reveal the sky, the mountains, and the spire of the church tower. The double window with the column was once a part of the cross-shaped hallway. It was treated by Snozzi as a recollection thereof, but only on the outside. The column is visible from the inside, but towards the hallway the window has the same measurements as all the others. The rhythm would have otherwise been disturbed. «These are the possibilities the architect

gleichen Maße auf wie die anderen; der voll ausgespielte Sonderfall hätte sonst den Rhythmus zerstört. «Das sind die Möglichkeiten, die der Architekt hat, um gleichzeitig zwei Möglichkeiten spürbar zu machen.» (Snozzi)[1] Ein analoges Verhalten dokumentiert das Dachgesimse. Der Nordflügel (Satteldach) und der Ostflügel (Flachdach) sind mit einem feinen Gesimsgurt aus Granit gegeneinander ausgeglichen. Vorgesehen ist auch der Bau des Westflügels, der den Hof gegenüber der Ringstraße abgrenzen wird. In den schönen Kellergewölben und auf dem gepflasterten Platz finden heute periodisch Ausstellungen statt. Wichtig für das soziale Leben des Dorfes ist auch die Bar, die in der Westecke eingerichtet wurde. Diese Nutzungen machen den Unterschied zu einer gewöhnlichen Schule aus, oder, anders ausgedrückt: sind Ausdruck des Willens, an diesem Ort nicht nur eine Schule zu machen, sondern einen Bau für die Gesellschaft. Snozzi beurteilt diese exemplarische Arbeit fast kokett: «Wir haben eigentlich nichts gemacht – nur ‹gereinigt›.»[2]

[1] In: L. Snozzi – Auf den Spuren des Ortes. Ein Gespräch in und um Monte Carasso, Zürich 1996 (Museum für Gestaltung Zürich, Schriftenreihe Nr. 21), S.22.
[2] ebd., S. 26.

has in order to communicate two possibilities at the same time» (Snozzi).[1] The roof ledge documents an analogue behavior. The northern wing (saddle roof) and the eastern wing (flat roof) are balanced against one another with a granite ledge. The construction of the west wing, which will limit the yard towards the ring road, is also planned. Today, exhibitions periodically take place in the beautiful basement vaults and on the cobble-stone square. The bar, which was installed in the western corner, is important for the social life of the village. These services create a contrast to the ‹normal› school environment, or said differently: they are the expression of the will to install in this location not only a school, but a building for society as a whole. Snozzi judges this exemplary work almost in a coquettish way: «We haven't really done anything – we simply ‹cleaned up›.»[2]

[1] In: L. Snozzi – Auf den Spuren des Ortes. Ein Gespräch in und um Monte Carasso, Zurich 1996 (Museum für Gestaltung, Zurich, publication series No. 21), page 22.
[2] ibid., page 26.

Schnitt durch den Hof und Gebäudeflügel, heute und 1979 / Zustand seit 1993 / Klassenzimmer / Korridor vor Klassenzimmern / Westfassade mit Dachaufbauten

Section of the yard and wing, as of today, and in 1979 / Condition since 1993 / Classroom / Hallway outside of the classrooms / West facade with roof superstructure

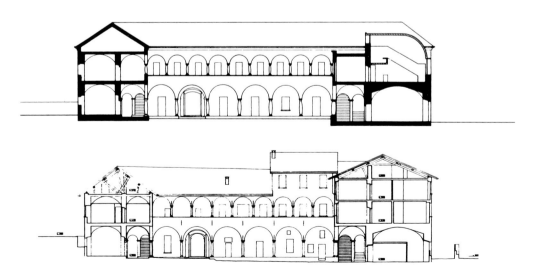

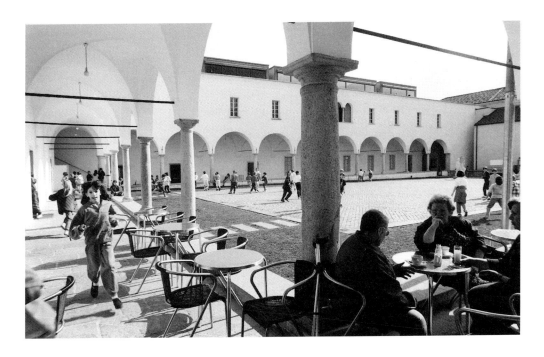

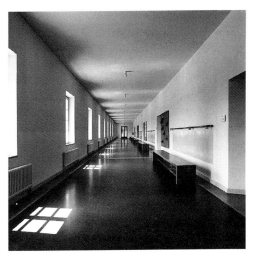

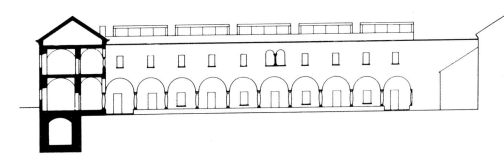

Haus Bernasconi, Carona
Mit Gustavo Groisman, 1989

Das Grundstück liegt an einem steilen Osthang mit flachem Mittelteil. Das Wohnhaus ist bei der Übergangsstelle situiert und nimmt spezifisch auf beide Seiten Bezug: auf den Hang und die Wiesenterrasse. Dies gilt analog auch von der Pergola an der vorderen Hangkante. Eine schräg in den Hang gelegte Treppenflucht führt zum Hauseingang in einer tiefliegenden Nische. Wie beim Projekt für die Reihenhäuser in Brione, liegt der Eingang im mittleren Geschoß, dessen Luftraum großzügig mit dem Erdgeschoß kommuniziert. Es ist eine Art Galeriegeschoß für Kunstwerke, bei dem jeder Sichtbezug zur Talseite unterdrückt ist. Von ihm aus gelangt man über den hochgezogenen, von einem unsichtbaren Oberlicht erhellten Treppenraum ins Wohngeschoß. Der Parcours zum Wohnraum als ein Absteigen von oben nach unten ist ein wiederkehrendes Thema bei Snozzi. Der Wohnraum ist – wie auch das Obergeschoß – nun gegen die Talseite hin orientiert, läßt aber dank der Deckenöffnung den zurückgelegten Weg erinnern. Der Querschnitt zeigt deutlich die wechselseitige Exposition der drei Etagen. Von der Einmündung der Treppe in den Wohnraum aus geht der Blick talwärts, längs des Schwimmbeckens bis zur Pergola, die die zweite Übergangsstelle, jene zwischen der Terrasse und der Fortsetzung des Hanges, markiert. Das Gartenstück war von Natur aus flach und brauchte nur unwesentlich geglättet zu werden.

Bernasconi House, Carona
With Gustavo Groisman, 1989

The property is located on a steeply sloped hill facing the east with a naturally flat middle section. The house is situated at the point of transition. This also applies to the pergola at the front edge of the slope. A stairway alignment placed slanted into the hill leads to the house entrance which is in a lower level niche. Similar to the project for the row houses in Brione, the entrance is located on the middle floor whose air space generously communicates with the ground floor. It is a kind of gallery level for works of art, which suppresses any reference to the valley side. From here, one accesses the living floor via a staircase lit by a hidden skylight. The passage towards the living space as a descent from the top to the bottom is a reoccurring theme for Snozzi. The living room – and the upper floor as well – is oriented towards the valley; however, due to the ceiling opening, one is reminded of the path taken. The cross section clearly shows the reciprocal display of the three levels. From the point where the staircase enters the living room, the view is directed towards the valley and proceeds along the swimming pool to the pergola. The flat garden section has a natural origin in the landscape and was leveled off only to a negligible degree.

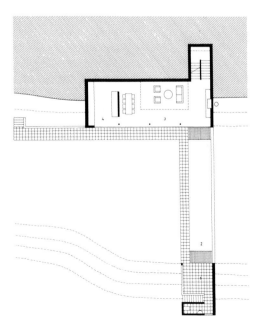
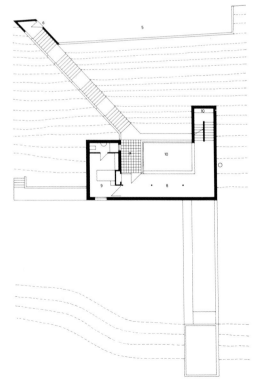

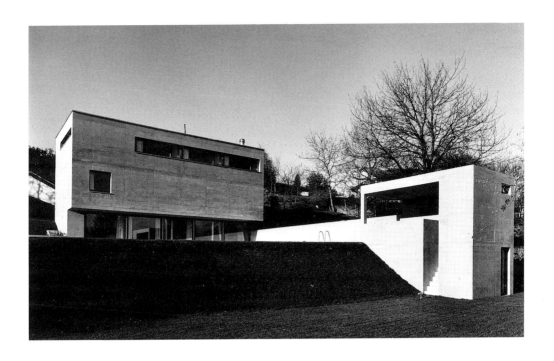

Grundrisse Wohngeschoß, Eingangsgeschoß
1:400 / Ansicht von Osten /
Zugang von Süden / Querschnitt 1:400

Ground plans: living floor, entrance floor
1:400 / View from the east /
Access from the south / Cross section 1:400

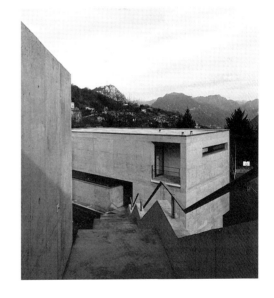

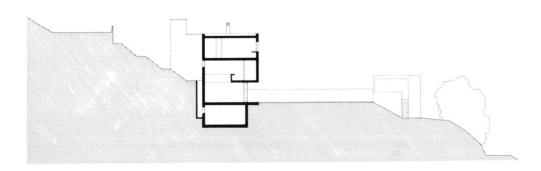

Restrukturierung der Ecole Polytechnique, Lausanne
1988

Es handelt sich um Snozzis Vorschlag auf eine Initiative, die aus dem Kreis der Professorenschaft an der Eidgenössischen Technischen Hochschule Lausanne (Ecole Polytechnique Fédérale Lausanne, EPFL) selber kam. Der Vorschlag beabsichtigt, die Isolation der an der Peripherie Lausannes gelegenen Hochschulen (EPFL und Universität), zu durchbrechen. Er verknüpft den Hochschulcampus in Ecublens mit dem innerstädtischen Flon-Quartier in Lausanne, dessen Charakter durch teilweise leerstehende Lagerhäuser mit vorgelagerten Asphaltflächen bestimmt ist. Snozzi schlug vor, im Flon wichtige Hochschulnutzungen zu implantieren (Hörsäle, Ausstellungsräume usw.), um dadurch den ‹Kopf› der Institutionen wieder in die Stadt und die Stadt in die Hochschulen (zurück) zu bringen. Dies soll aber nicht nur im funktionalen Sinn geschehen (Bereitstellung von Nutzflächen), sondern architektonisch. Als Verbindungselement sah Snozzi die bestehende Straßenbahnlinie zwischen dem Stadtzentrum und Ecublens vor – mitsamt ihren Stationen, die architektonisch vereinheitlicht werden sollten, um als Elemente dieser speziellen Verbindung sinnfällig zu sein. Im Außengelände selber wird der jetzige Gebäudekomplex der EPFL neu interpretiert, indem das Erdgeschoß – betrieblich die Anlieferungs- und Service-Ebene – als zusammenhängende Fläche systematisiert und aufgewertet wird. Mit ihrem Asphaltboden entspricht diese architektonisch vereinheitlichte Plattform dem Flon-Quartier, wodurch der Zusammenhang zwischen dem Zentrum und der Peripherie veranschaulicht wird. Andere Elemente sollen mithelfen, dem Gelände in Ecublens den Charakter eines städtischen Ortes zu geben, dessen es ihm heute völlig ermangelt. Diese Elemente sind für die EPFL: eine Stützmauer mit Bäumen nach Süden, Studentenwohnungen als Bauzeile entlang der Westgrenze, ein Turm mit der Verwaltung als auch von der Lausanner Innenstadt aus sichtbares Zeichen, eine Brücke zum Universitätsgelände. Dieses ist in seiner Gegensätzlichkeit zur Technischen Hochschule als ein von Bauten durchsetzter Grünraum artikuliert.

Restructuring of the Polytechnical School, Lausanne
1988

We are dealing here with Snozzi's proposal to an initiative which originated with a circle of professors at the Federal Technical University Lausanne (Ecole Polytechnique Fédérale Lausanne, EPFL) itself. The proposal intended to break through the isolation of the EPFL and of the University located at Lausanne's periphery. It connects the university campus in Ecublens with the inner city's Flon quarter in Lausanne, whose character is determined by partly unused storage buildings with paved asphalt surfaces at their fronts. Snozzi's suggestion was to implant important university facilities in the Flon (auditoriums, exhibition rooms, etc.), in order to return the ‹head› of the institution back to the city and the city to the university. However, this would have to happen not only in a functional sense (disposition of utility space) but in an architectural one as well. As a connecting element, Snozzi determined that the existing tram line, with all its stations between the city center and Ecublens unified architecturally in order to stand out as elements of this special connection, would serve very well. The current building complex of the EPFL is now reinterpreted on the outside grounds by systematizing and reassessing the ground level – utilized for deliveries and services – into a coherent area. With its asphalt floor, this architecturally unified platform corresponds to the Flon quarter, whereby the relationship between the center and the periphery is illustrated. Other elements are to help lend an urban character to the grounds in Ecublens: a supporting wall with trees facing south, student housing as a row of buildings along the western border, an administration tower as a beacon which would be clearly visible from Lausanne's center, a bridge to the University grounds. The latter are, contrary to the Technical University, articulated as green areas interspersed with buildings.

Hochschulcampus Ecublens (links)
und Lausanne (eingekreist: Quartier «Flon») /
Situation / Elemente des Vorschlags

University campus Ecublens (left)
and Lausanne (encircled: «Flon» quarter) /
Site plan / Elements of the proposal

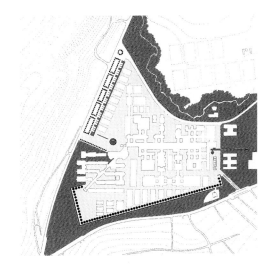

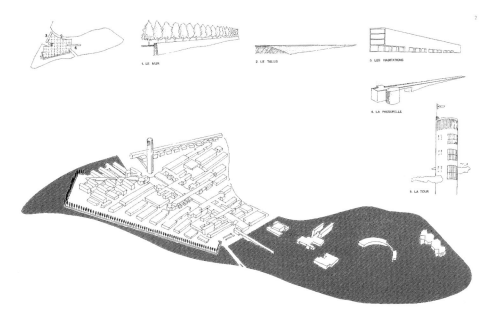

Architekturmuseum, Rotterdam
Mit Marie-Christine Aubry, Bruno Jenni,
Wettbewerb, 1988

Die Ausschreibung zum Wettbewerb des Architekturmuseums Rotterdam ging von der Annahme aus, daß das Gebäude auf die Quartierstraße bezogen werde, an der auch das Boymans-van Beuningen-Museum liegt. Snozzi kam während der Entwurfsarbeit jedoch zur Überzeugung, daß das Architekturmuseum sich in weitergehenden Bezügen zu definieren habe. So kam es zur Erweiterung des Projektierungsperimeters bis zur Hauptstraße südlich des Parks neben dem Boymans-van Beuningen-Museum (Westzeedijk). Von dort her ist der Entwurf entwickelt. Eine Terrasse systematisiert die Straße; von ihr aus führt eine Rampe zum tiefergelegenen Park. Es galt somit, den rund 500 m langen Weg zum Architekturmuseum zu definieren. Die Lösung des Problems liegt im Vorschlag eines Kanals entlang der Westgrenze des Parkareals. Er entwickelt sich aus einem Bassin, das eine Villa aus dem 19. Jahrhundert umgibt. Mit dem Element des Wassers greift Snozzi ein Charakteristikum der Stadt Rotterdam auf, die an manchen Stellen mit Wasserflächen durchsetzt ist. Folgerichtig ist auch das Architekturmuseum in eine teichartige Erweiterung des Kanals hineingesetzt, mit der Snozzi das eigentliche Wettbewerbsgelände definiert. Das Gebäude ist eine nach Süden geöffnete halbkreisförmige Schale, vorgesehen als Sichtbacksteinbau wie das Boymans-van Beuningen-Museum. Es enthält im Erd- und 1. Obergeschoß die Ausstellungsräume; die Halle ist gegen den Park hin verglast. Dabei ist die Strenge der Geometrie gemildert durch eine Verglasung der Ausstellungsgeschosse gegen Nordosten, wodurch einige bedeutende rationalistische Villen (ca. 1930) der Architekten Brinkman und van der Vlugt, die außerhalb des Grundstücks stehen, einbezogen und gleichsam Teil der permanenten Ausstellung werden. Im 2. bis 6. Obergeschoß liegen die Archive, in den beiden obersten Geschossen wieder öffentliche Nutzungen wie die Bibliothek. Von dort aus erschließt sich im Blick über den gesamten Park hinweg der größere urbanistische Zusammenhang, dem sich dieser Entwurf verdankt

Museum of Architecture, Rotterdam
With Marie-Christine Aubry, Bruno Jenni,
competition, 1988

The invitation for the competition of the Museum of Architecture, Rotterdam, presumed that the building would be oriented toward the quarter street where the Boymans van Beuningen Museum is also located. However, during the design work, Snozzi gained the conviction that the Museum of Architecture would have to be defined in a broader context. Thus, the projecting perimeter was extended to the main street south of the park, next to the Boymans van Beuningen Museum. The design is built up from there. A terrace systemizes the street from which a ramp leads to the lower level of the park. The 500 m long path to the Museum of Architecture had to be defined. The solution to the problem was a proposal for a canal along the western border of the park area. It develops from a basin surrounding a 19th century villa. With the water element, Snozzi integrates into the design the characteristics of Rotterdam, a city interspersed in some places with water surfaces. As a logical consequence, the Museum of Architecture is set into a pond-like extension of the canal, with which Snozzi covers the original competition grounds. The building is a semi-circular shell opening towards the south and it is planned with fair-faced brick walls, comparable to the Boymans van Beuningen Museum. The ground and first floors contain the galleries; the hall is glassed-in on the side facing the park. The strict geometry is softened by the glazing of the galleries towards northeast, through which some important rationalistic villas by the architects Brinkman and van der Vlugt, situated outside the property, are integrated and, at the same time, become a part of the permanent exhibit. The archives are located on the second to sixth floors of the semi-circular shell and on the two upper floors one again finds various public facilities such as the library. From there, the view across the entire park reveals the larger urban context which was the basis for this design.

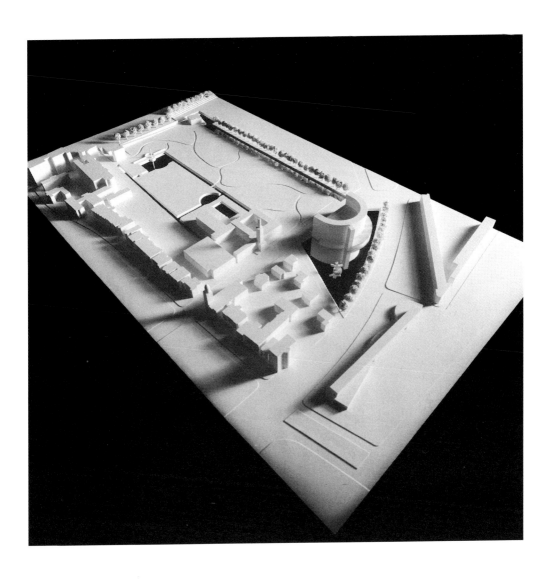

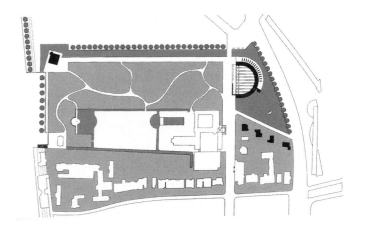

Skizzen zum Architekturmuseum /
Modell / Situation (links oben
die alte Villa, Mitte: Boymans-van
Beuningen-Museum,
rechts: Villen des Neuen Bauens)

Sketches of the Architectural Museum /
Model / Site plan (upper left:
the old villa, center: Boymans van
Beuningen Museum, right:
villas of the «Neues Bauen»)

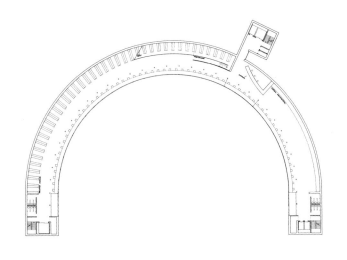
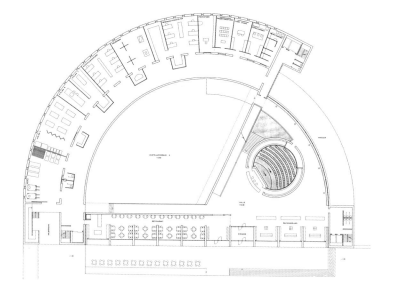
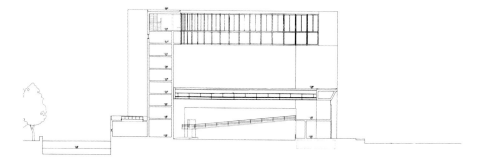

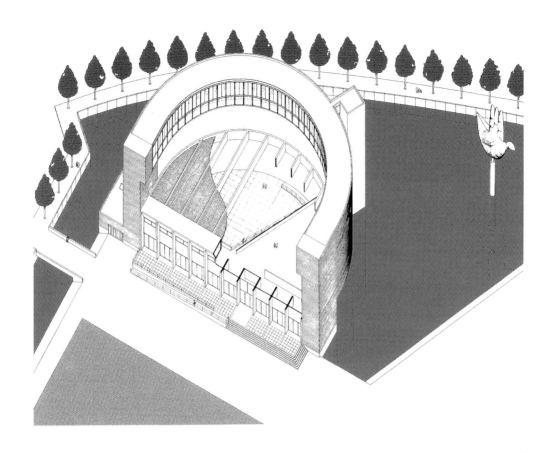

Grundrisse 8. Obergeschoß (Bibliothek) und Erdgeschoß / Längsschnitt 1:1000 / Axonometrie / Frontfassade und Querschnitt

Ground plans: 9th floor (library), first floor / Longitudinal section 1:1000 / Axonometric view / Front facade and cross section

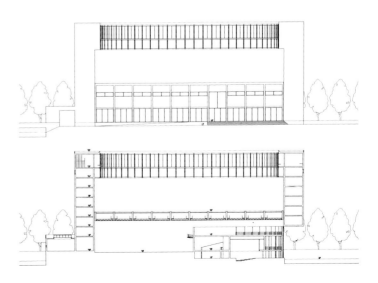

Haus Rapetti, Monte Carasso
Mit Gustavo Groisman, Umbau, Projekt 1988

Es gibt immer weniger Bauern in Monte Carasso – Abbild eines geschichtlichen und gesellschaftlichen Prozesses von mindestens gesamteuropäischer Größenordnung. Das neue Reglement von Monte Carasso erlaubt es, dieser Dynamik Rechnung zu tragen und aus Ställen Wohnhäuser zu machen. Es gibt nur eine Bedingung, die dabei einzuhalten ist: nein, nicht die Bewahrung des ‹bäuerlichen Charakters› eines solchen Hauses, sondern die Beibehaltung der tradierten Parzellenstruktur. Die Tierhaltung hatte in diesem Dorf zu schmalen Riemenparzellen geführt. Deren Erhaltung ist für Snozzi die zentrale Bedingung. Die Innenbreite des Hauses beträgt an der schmalsten Stelle nur 2,15 m, an der breitesten ca. 3,50 m. Doch es erwies sich als möglich, innerhalb dieser Streifenparzellen-Ordnung einen Stall umzubauen und durch Aufstockung zu einem brauchbaren kleinen Wohnhaus zu machen. Snozzi zeichnete für den Bauherrn ein Planblatt im Maßstab 1:50: Grundrisse, Schnitte und Fassaden. Die Ausführung besorgte der Bauherr selber.

Rapetti House, Monte Carasso
With Gustavo Groisman, conversion, project 1988

There are ever fewer farmers in Monte Carasso. This reflects, at least on a European scale, the historical and societal processes that have and are taking place. The new building codes for Monte Carasso accommodate these dynamic changes and allow the conversion of barns into apartment housing. There is only one condition which has to be fulfilled: no, it's not, as one might think, the ‹farming character› of such a building that has to be maintained. Rather, it is the integrity of the traditional parcel structure that must be preserved. Keeping animals in this village had led to narrow strip parcels. Their preservation is the central condition to Snozzi. The inner width of the house at its most narrow place is only 2.15 m, and at its widest place 3.50 m. However, it proved to be possible to convert a barn within this strip-parcel order and, by increasing its height, turn it into a small but serviceable apartment house. Snozzi drew up a plan in 1:50 scale – ground plans, cross sections and facades – for the owner. The execution was carried out by the owner himself.

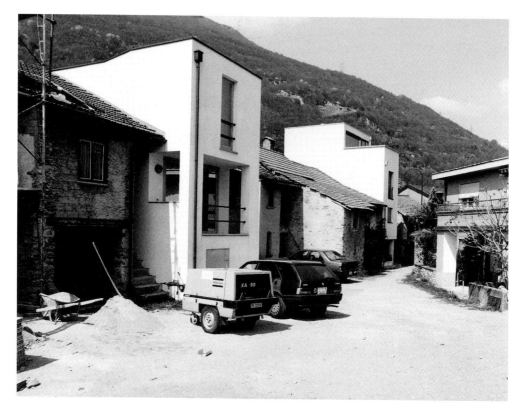

Stall-Umbauten: vorne Casa Rapetti,
hinten ein weiterer Umbau (nicht
von Snozzi) / Haus Rapetti, Frontfassade /
Grundriß Erdgeschoß / Längsschnitt

Stable conversions: front: Casa Rapetti,
back: an additional conversion (not by
Snozzi) / Rapetti House, front facade /
Ground plan first floor / Longitudinal section

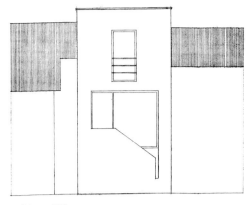

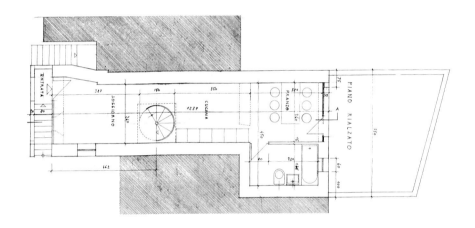

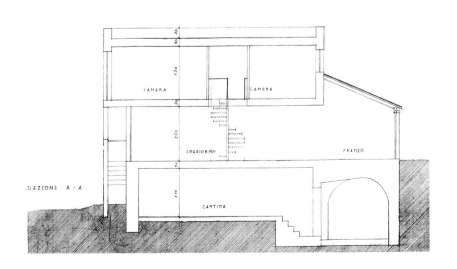

Haus Diener, Ronco
1989–90

Das Haus liegt 100 Meter über dem Langensee an einem nach Süden abfallenden Steilhang, von dem aus man eine großartige Sicht quer und längs über den See genießt. Es liegt oberhalb der Straße, ist also – im Unterschied etwa zum Haus Bernasconi – ein ‹aufsteigendes› Haus. Östlich des Terrains ist das Bett eines Wildbaches eingeschnitten, an der westlichen Grundstücksgrenze verläuft steil ein schmaler öffentlicher Weg; dort liegt das Tor, von dem aus man auf einer plattenbelegten Terrasse horizontal zum Hauseingang gelangt. Der Entwurf bezieht sich auf die hier seit alters vorhanden gewesenen Terrassenmauern aus rötlichem (eisenhaltigem) Granit. Bereits in frühen Studien Snozzis werden die sich zum Einschnitt hinbiegenden Terrassenmauern als Thema erkennbar. (In deren Vorhandensein liegt ein wesentlicher Unterschied zur Situation des Hauses Kalman). Sie sind in ihrer Gegensätzlichkeit zum Betonvolumen eines der bestimmenden Elemente des Entwurfs. Der Hauskörper aus hellem feinporigem Beton (Kalkbeimengung) ist quer zu den Terrassen in den Hang hineingeschoben und als schmaler Monolith mit ausgeschnittenen Teilen definiert: die schlanken zweigeschossigen Pfeiler zwischen Haussockel und Obergeschoß sind gleichsam materialisierte Kanten des idealen Prismas. Ein schmales Treppenhaus verbindet den Autounterstand mit der ersten Gartenterrasse. Am Schwimmbecken vorbei steigt man die der Hausfront vorgelagerte Treppe hoch und gelangt zur zweiten Terrasse auf der Höhe des Sockelgeschosses (Gästezimmer). Zum Wohngeschoß mit dem sekundären Hauseingang (bzw. Gartenaustritt) führt eine weitere, dem Gebäudevolumen einbeschriebene Außentreppe empor. Die beiden Haustüren liegen einander exakt gegenüber. Der Wohnraum ist großflächig verglast mit weit herunterreichenden Fenstern und weist eine auf drei Seiten umlaufende niedrige Sitzbank auf Konsolen auf, wodurch der Fußboden als flaches Gefäß definiert ist (vgl. auch S. 150). Das Wohngeschoß

Diener House, Ronco
1989–90

The house is situated 100 meters above Lago Maggiore on a steep slope facing south that provides a delightful view of the entire lake. It is located above the street and is therefore (contrary to the Bernasconi House, for example) an ‹ascending› building. East of the terrain, the bed of a stream cuts in and along the western property border lies a steep narrow public path. The gate from which one reaches the house entrance horizontally via a tile-covered terrace is located here. The design relates to the reddish granite terrace walls which have been in this location for ages. The terrace walls curving towards the cut-in can already be recognized as a theme in the early studies by Snozzi. (Their existence represents an essential difference to the situation of the Kalman House.) In their polarizing contrast to the concrete volume they are one of the determinant elements of the design. The house volume made of light, finely porous concrete (lime mixture) is pushed into the slope at a right angle to the terraces and is defined as a narrow monolith with excised parts. The slender two-story columns in between the base of the house and the upper floor are at the same time materialized edges of the ideal prism. A narrow staircase connects the carport with the first garden terrace. Going past the swimming pool, one ascends the stairs in front of the house and reaches the second terrace at the height of the base level (guest room). Another outdoor staircase integrated into the whole of the building volume leads to the living level with the second house entrance (or garden exit). Both house doors are exactly across from each other. The living space is generously glazed with windows reaching far down the walls, and on three sides it has a low sitting bench on consoles which defines the floor as a flat vessel (also see p. 150). The living floor is articulated as a ‹gap› between the base and the upper floor to the east and south sides of the house by the lateral and frontal undercutting of the ceiling above the living floor

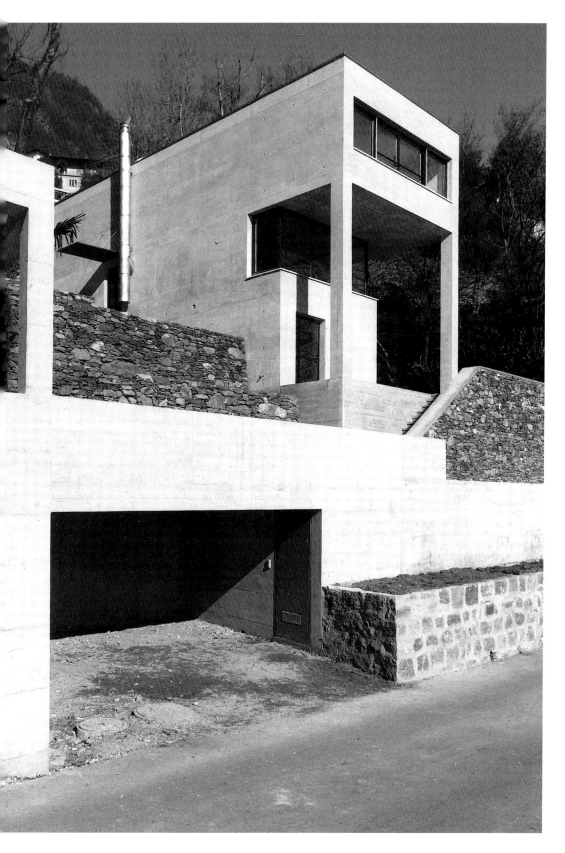

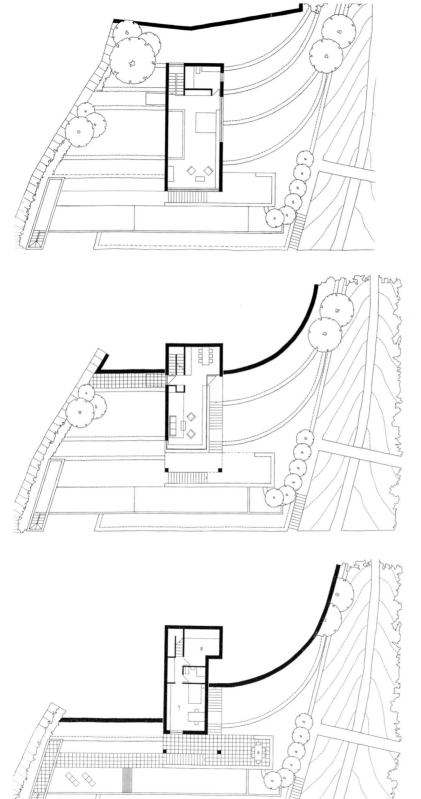

Seiten 146/147: Entwurfsskizzen / Ansicht aus Südwesten Grundrisse Obergeschoß, Wohngeschoß, Sockelgeschoß (Gästezimmer) 1:400 / Westseite mit Hauseingang / Ostseite mit Gartenaustritt / Geländeschnitt und Westfassade / Längsschnitt

Pages 146/147: design sketches / View from the south west Ground plans: upper floor, living floor, basement floor (guest rooms) 1:400 / West side with house entrance / East side with garden access / Section of the ground and west facade / Longitudinal section

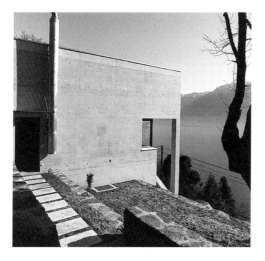 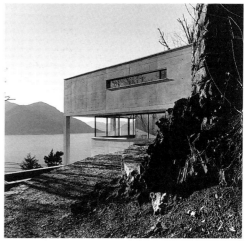

ist nach der Ost- und Südseite hin als ‹Lücke› zwischen dem Sockel und dem Obergeschoß artikuliert; dies mit dem seitlichen und stirnseitigen Unterschneiden der Decke über dem Wohngeschoß (vergleichbar dem Haus Bianchetti, siehe S. 59). Die zurückversetzte Lage des Wohnraumes gegenüber der Decke über diesem Geschoß (zweigeschossige Loggia!) erzeugt eine Orientierungstendenz des Raumes schräg nach unten zu den Brissagoinseln hin. Zudem entwarf Snozzi das Haus so, daß die Inseln vom Eingang aus betrachtet genau innerhalb des Sichtfensters der Loggia zu liegen scheinen. Die Raumtendenz ‹nach unten› und der Rückhalt dank der raumfassenden Sitzbank sind perfekt ausgewogen. Die Absicht des Sichtbezugs zum Wasser und den Inseln wird noch dramatisiert mit dem Element der Deckenöffnung über dem Wohnraum, wodurch eine räumliche Transparenz im hinteren Teil des Hauses hergestellt wird: als Blick in die Tiefe vom Treppenansatz im Obergeschoß aus zu den von grünlichem? gleißendem? bleigrauem? Wasser umgebenen Inseln.

(comparable with the Bianchetti House, see p. 59). The set back location of the living space opposed to the ceiling above this floor (two-story loggia!) creates a tendency of the space to orient itself at a downward angle towards the Brissago islands. Moreover, Snozzi designed the house in a way that the islands seem to be situated exactly within the picture window of the loggia when seen from the entrance. This spatial ‹downward› tendency and the support thankfully given by the space-embracing bench are perfectly balanced. The intention of the visual relation with the water and the islands is made even more dramatic with the element of the ceiling opening above the living space. A spatial transparency in the back part of the house is created: a view from the bottom of the staircase of the upper floor into the depths towards the islands that are surrounded by greenish? glowing? lead-gray? water.

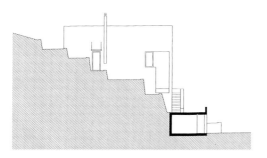 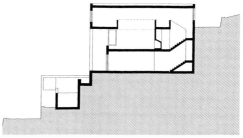

Häuser Cerri/Joppini, Roveredo

Mit Claudio Buetti, Sabina Snozzi Groisman,
Projekt, 1989

Das Grundstück des Entwurfs, ca. 2000 m² groß, war ins Auge gefaßt aus der Zusammenlegung von zwei leicht nach Nordwesten abfallenden Parzellen. Die beiden Bauherren hatten sich zusammengetan und Snozzi mit dem Entwurf beauftragt. Der Bau kam jedoch nicht zustande. Die Grundrisse der Häuser sind schmale, rechtwinklig aufeinander bezogene Rechtecke. Vom höchstgelegenen Punkt des Grundstücks aus – einem kleinen Platz neben der Erschließungsstraße – betritt man das Haus A im Obergeschoß, in dem sich die Schlafzimmer befinden. Von dort steigt man zum Wohngeschoß hinab. Die Treppe ist in einem eigenständigen Baukörper auf der Gartenseite untergebracht und endet vor dem Eßbereich. Wie dieser liegt auch der Portikus vor der Glasfront des Wohnzimmers genau zu ebener Erde, doch gegenüber diesem so definierten «Normalniveau» ist der Boden des Wohnbereichs um drei Stufen vertieft. Die Raumzonen und -qualitäten sind dadurch mit höchster Präzision artikuliert. Der Eingang zum Haus B liegt im Erdgeschoß. Eine ca. 1,50 m hohe Mauer führt als Leitwand vom Vorplatz aus ins Innere und wird nach einer Abwinkelung zum raumtrennenden Element hinter dem Wohnbereich. Auch hier ist dessen Boden gegenüber der ihn umgebenden Erschließungsfläche um drei Stufen tiefergelegt. Die einläufige Treppe führt an der Schmalseite zum Schlafgeschoß, womit ein Seitenwechsel verbunden ist: der Erschließungskorridor liegt auf der Gartenseite, und das Elternschlafzimmer mit seiner Loggia ist nach außen orientiert. Daß dieser Entwurf unverwirklicht blieb, ist ausgesprochen schade, denn die beiden Häuser zeigen exemplarisch Snozzis Fähigkeit als Architekt: eine hochentwickelte Subtilität innerhalb des scheinbar verzichtsvoll Elementaren. Sie erweisen einen hohen Grad an räumlicher Spannung, was die im Zusammenhang mit ihm oft genannte «Kargheit» als höchstens die halbe Wahrheit offenbart: Wer es sehen will und kann, entdeckt in Entwürfen wie diesem eine Transzendierung des Einfachen, die ihresgleichen sucht.

Cerri/Joppini Houses, Roveredo

With Claudio Buetti, Sabina Snozzi Groisman,
project, 1989

The property for this design, with a dimension of approximately 2000 m², consisted of two plots slightly slanted towards the northwest. The two contractors joined together and had given the design order to Snozzi. However, the building was never realized. The layout is two small rectangles positioned at a right angle to each other. From the property's highest point – a small square next to the access road – one enters house A on the upper floor where the bedrooms are located. The staircase is situated in a separate building volume on the garden side and ends just before reaching the dining area. Like the latter, the portico lies in front of the glass front of the living room on leveled ground. However, opposed to this «normal level» thus defined, the floor of the living area is lowered by three steps. Hence, the spatial zones and qualities are articulated with the greatest precision. The entrance to house B lies on the ground floor. A wall with a height of approximately 1.50 m leads from the square in front to the interior. After making a turn, it becomes the room-dividing element behind the living area. Here as well, the floor is lowered by three steps as opposed to the surrounding access space. The single-flight staircase leads to the bedroom level in the narrow section, creating a change of sides. The access hallway lies on the garden side and the master bedroom with its loggia is oriented towards the outside. It is a pity that this design was never realized because both houses stand as examples of Snozzi's abilities as an architect: a highly developed subtlety within the seemingly scarce elementary. It illustrates a high degree of spatial tension that reveals the «scarcity» often mentioned in this context to be, at most, only half the truth. For those who wish to and are able to, a transcending of simplicity that is still searching for the likes of itself can, in a design such as this, be discovered.

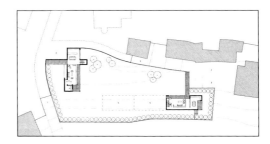

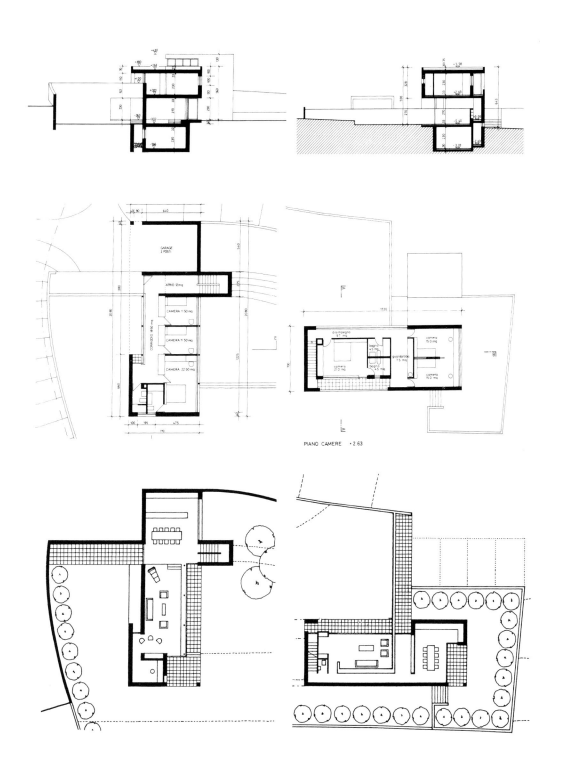

Gesamtsituation / Links Haus A, rechts Haus B:
Schnitte, Obergeschosse, Erdgeschosse 1: 400

Site plan / Left: house A, right: house B: sections,
ground plans upper floors and first floors 1:400

Doppelhaus Guidotti, Monte Carasso
Mit Claudio Buetti, 1989–91

Dieses Doppelhaus visualisiert sehr treffend das Prinzip der Verdichtung, ein Hauptelement von Snozzis Strategie für Monte Carasso (vgl. S. 82). Nach dem alten Baureglement (allseitiger Grenzabstand) wäre auf diesem Grundstück nur ein sehr enges zweigeschossiges Haus möglich gewesen, nach dem neuen Reglement ist es ein bis an die Straßenlinie gerücktes Doppelhaus mit drei Stockwerken (ursprünglich waren sogar drei Hauseinheiten geplant). Das Erdgeschoß ist gegenüber der Straße leicht erhöht. Es enthält neben dem Hauseingang ein Arbeits- oder Gästezimmer mit WC. Im 1. Obergeschoß liegen Wohnraum und Küche/Eßplatz, im 2. Obergeschoß je drei Schlafzimmer. Man gelangt zu den Hauseingängen von einem Portikus auf der Gartenseite her, aber nicht außenherum, sondern nachdem man unter dem Haus hindurchgegangen ist. Die gedeckte Halle (Autoabstellplatz und Zugang) gehört so zugleich dem Straßenraum und dem Haus an, was den Gedanken an die Stadt verrät: Überlagerung von Privatem und Öffentlichem. Folgerichtig sind die beiden Hausteile nicht gespiegelt, sondern gereiht: aus dem Doppelhaus könnte dereinst eine Zeile werden.

Guidotti Double House, Monte Carasso
With Claudio Buetti, 1989–91

This double house visualizes the principle of condensation very well, a fundamental element of Snozzi's strategy for Monte Carasso (see p. 82). According to the old building regulations (border distance on all sides), only a very narrow two-story house would have been possible on this tract. With the new regulations, it was developed into a three story double house and shifted to the street line (originally, three units were even planned). The ground floor is slightly raised up from the street level. In addition to the house entrance, it also accommodates a room with a half-bath, which can serve as an office or guest room. The living room and kitchen/dining room are on the second floor and the third floor has three bedrooms. One reaches the house entrances from a portico on the garden side; however, not from the outside, but only after having passed under the house. The covered hall (carport and access) thus belongs simultaneously to both the street space and the house, revealing an awareness of the city: the overlapping of private and public parts. Logically, the twin parts of the house do not mirror each other, but are instead lined-up. As a result, the double house could easily become a row.

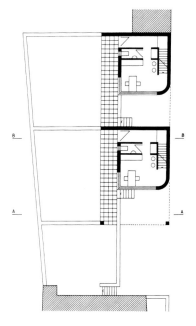
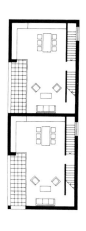
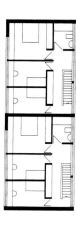

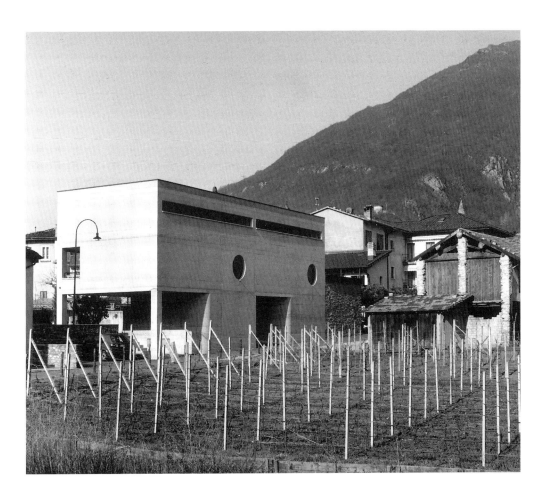

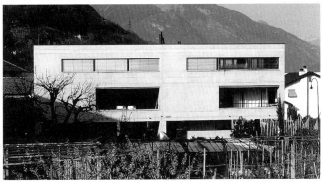

Grundrisse Sockelgeschoß, Wohngeschoß, Schlafgeschoß 1:400 / Straßenseite / Gartenseite / Querschnitt / Südfassade 1:400

Ground plans: base floor, living floor, bedroom floor 1:400 / Street side / Garden side / Cross section / South facade 1:400

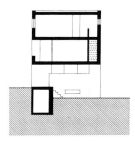

Wohnquartier Morenal, Sementina/Monte Carasso

Mit Francesco Bianda, Anne-Catherine Javet, 1990–96

Anderthalb Jahrzehnte nach dem Entwurf der Überbauung Verdemonte konnte Snozzi das begonnene Konzept zum «Quartier an der Autobahn»[1] fortführen. «In dieser Zone ging es mir darum, durch bauliche Eingriffe den Rand des Schuttkegels (des Baches Sementina, C.L.) in neuer Weise hervortreten zu lassen, um so dem gesamten Flußbett bis hinüber zum Dorf Sementina auf der anderen Seite ein neues Aussehen zu verleihen.»[2] Das Projekt Morenal ist der westliche Eckpunkt dieses Konzeptes: zwei rechtwinklig zueinanderstehende Baukörper mit 75 Wohnungen, Läden, Ateliers und einem Restaurant. Das erste Element verläuft als abgewinkelte Randzeile neben der Autobahn und paraphrasiert die Idee der Stadtmauer. Die Wohnungsgrundrisse (3½-Zimmer-Wohnungen) reagieren auf die besondere Lage dadurch, daß an jener Seite die Nebenräume Küche und Bad liegen und die Schlafzimmer nach hinten orientiert sind (Nordwesten, Blickrichtung Berg). Der Wohnraum ist durchgehend und wird von zwei gegenüberliegenden Loggien belichtet. Der abgewinkelte Gebäudeteil enthält Ateliers und 1½-Zimmer-Wohnungen und im 1. OG das Restaurant. Das zweite Element ist ein achtgeschossiger Baukörper mit Duplex-Wohnungen und Laubengängen an der Nordostseite (unten jeweils Küche/Wohnen, oben die Schlafzimmer und Bad). Die Wohnungen liegen im Lärmschatten der Randzeile; die Südwestfassade ist durch die zweigeschossigen Loggien charakterisiert, die – Le Corbusiers früher Forderung nach der verdoppelten Höhe der Wohneinheiten im Stadtbild folgend – einen anderen Maßstab in diese Architektur bringen. Laut Snozzi ist diese Anlage die hier notwendige Ausnahme von der eigenen Regel der Gemeinde Monte Carasso, notwendig wegen der Definition des südlichen Ortsrandes durch Baukomplexe von

Housing Quarter Morenal, Sementina/Monte Carasso

With Francesco Bianda, Anne-Catherine Javet, 1990–96

A decade and a half after the design for the Verdemonte development, Snozzi was able to continue with the already started concept for the «quarter along the highway».[1] «In this zone, I wanted to let the edge of the debris cone (of the Sementina stream, C.L.) reappear in a new way through constructive operations in order to lend a new look to the entire river bed up to the village of Sementina on the other side.»[2] The Morenal project is the western corner point of this concept: two building volumes positioned to each other at a right angle with 75 apartments, shops, studios, and a restaurant. The first element runs along the highway as a perimeter row and paraphrases the idea of the city rampart. The apartment ground plans (3½ room apartments) react to this special situation by having the kitchens and bathrooms located on this side and the bedrooms oriented towards the back (north west, with a view of the mountain). The living room passes through the width of the building and is lit by two loggias on the opposite side. The smaller ell part of the building contains studios, 1½ room apartments, and a restaurant on the second floor. The second element is an eight-story building volume with duplex apartments and arcades on the north east side (with kitchen/living room on the bottom, bedrooms and bath on the top floor). The perimeter row serves as a noise barrier for the apartments; the south west facade is characterized by the two-story loggias which, following Le Corbusier's demand for the doubled height of the apartment units in the townscape, bring a different scale into this architecture. According to Snozzi, this complex is the necessary exception from the rule of the Monte Carasso community. Necessary because of the need to delineate the southern town border through the use of a different scale for the

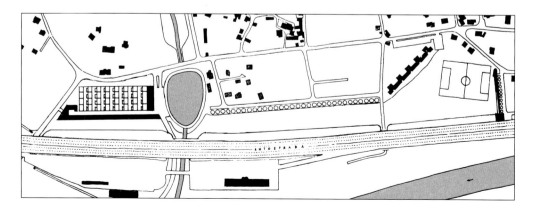

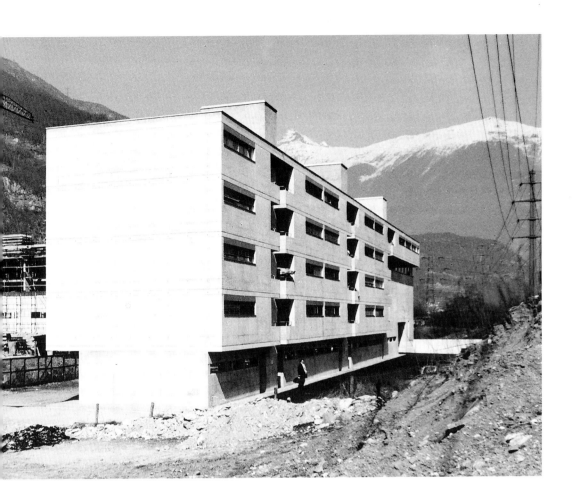

anderer Maßstäblichkeit. Mit der Wohnzeile Verdemonte soll Morenal durch eine markant aufgewertete Straße verbunden werden, die Snozzi als von Bäumen gesäumten Boulevard vorsieht. Damit hängt der Vorschlag zusammen, das neben Morenal gelegene Rückhaltebecken des Wildbaches als Schwimmbad für die Bevölkerung einzurichten. Der Boulevard soll an zwei Stellen unter der Autobahn hindurch mit dem Fluß Ticino verbunden werden. «Diese Betonung des Bezugs zum Fluß bedeutete auch, den Ort an die Parklandschaft anzuschließen, die sich vom Lago Maggiore dem Fluß Tessin entlang bis nach Bellinzona zieht, und ihn damit zugleich in einen viel größeren urbanen Raum einzubinden, der weit über Bellinzona hinaus letztlich einen Großteil des gesamten Tessins umfasst.»[3]

[1] L. Snozzi: Monte Carasso. Die Wiedererfindung des Ortes. Basel, Boston, Berlin 1995, S. 87.
[2] ebd.
[3] ebd., S. 89.

building complexes. Morenal and the Verdemonte housing row are to be connected by a strikingly revaluated street, planned by Snozzi as a boulevard lined with trees. The suggestion to turn the retaining pool of the stream into a swimming pool for the population is directly connected with this idea. The boulevard is to be connected with the Ticino river at two places beneath the highway. «This stress of the relationship to the river also meant that the town needed to be connected to the landscape which stretches from Lago Maggiore, along the Ticino river, to Bellinzona, while at the same time integrating it into a larger urban space that reaches far beyond Bellinzona and in the end embraces a large part of the entire Ticino.»[3]

[1] L. Snozzi: Monte Carasso. Die Wiedererfindung des Ortes. Basel, Boston, Berlin 1995, page 87.
[2] ibid.
[3] ibid., page 89.

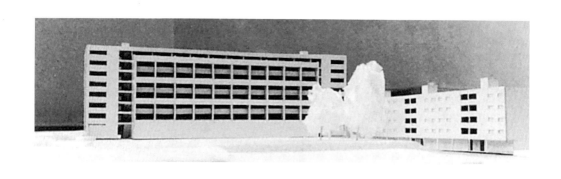

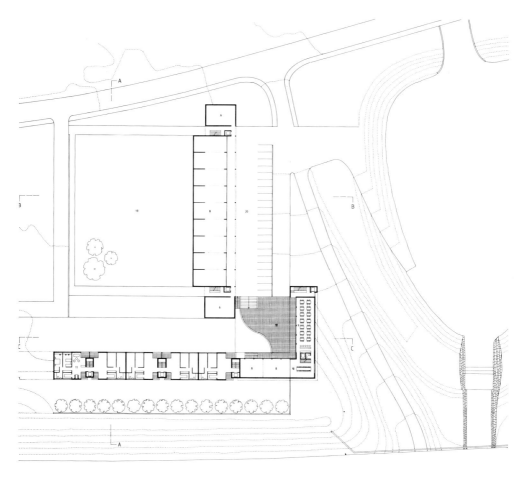

Seiten 154/155: Gesamtsituation, 1. Entwurf (links Morenal, rechts Verdemonte) / Ansicht der 1. Bauetappe von Süden Modell / Westfassade und Schnitt / Grundriß Erdgeschoß / Querschnitt durch Maisonette-Gebäude 1:600 / Ostfassaden / Grundriß Obergeschosse, 1:1200

Pages 154/155: Site plan, first design (left Morenal, right Verdemonte) / View of the first construction stage from the south Model / West facade and section / First floor ground plan / Cross section of the maisonette building 1:600 / East facades / Ground plans upper floor 1:1200

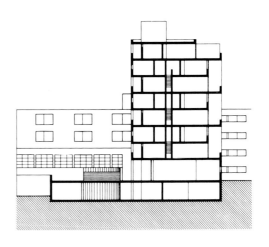

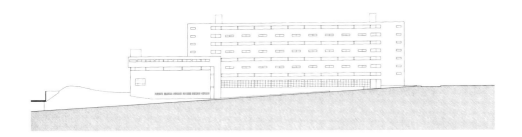

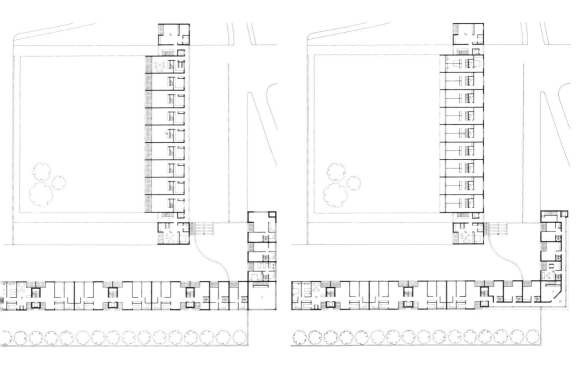

Pfarreiheim St. Florin, Vaduz
Mit Gustavo Groisman, Wettbewerb (1. Preis), 1990

Der Wettbewerb wurde unabhängig von der Planung zum Regierungsviertel Vaduz durchgeführt, doch Snozzi wurde aus guten Gründen erneut zur Teilnahme eingeladen (vgl. S. 126). Sein Vorschlag setzt die Projektierung zum Regierungsviertel ungemein plausibel fort. Es galt, neben der neugotischen Kirche und der fürstlichen Gruft ein Gemeindehaus zu entwerfen (Gemeindesaal mit Foyer, Jugendräume, Übungsraum des Kirchenchors, Parkierungsmöglichkeiten). Das vorgeschlagene Gebäude wird in dieser Situation zum Element, das den Entwurf zum Regierungsviertel im doppelten Wortsinn ‹zum Abschluß bringt›. Es begrenzt L-förmig einen der Kirche seitlich vorgelagerten und gegenüber dem großen Freiraum um rund 3 m erhöhten Platz. Die Absicht in der ersten Wettbewerbsstufe 1987, das geschwungene Galeriegebäude mittels quer zur Straße vorstoßender Flügelbauten an den Straßenraum anzubinden, wurde hier überzeugend aktualisiert und präzisiert. Der höher gelegene Kirchenvorplatz wird über eine großzügige Freitreppe längs zur Hauptachse Städtlestraße/Heiligkreuz erreicht. Deren Schräge trägt dazu bei, diesen städtischen Raum visuell abzuschließen. Hatte in den beiden Wettbewerbsstufen von 1987 die Kirche außerhalb des Entwurfsareals gelegen, ist sie mit diesem Vorschlag ein wichtiges Element der Gesamtkomposition geworden.

Parish Center St. Florin, Vaduz
With Gustavo Groisman, competition (first prize), 1990

The competition was held independently from the planning of the government quarter in Vaduz, and Snozzi (for good reason) was again invited to participate (see p. 126). His proposal continues the projection of the government quarter in a very plausible way. The task was to design a parish center (parish hall with foyer, youth rooms, rehearsal space for the church choir, parking) right next to the princely tomb and the neo-gothic church. The proposed building becomes an element in this setting which, in a double literal sense, brings the design for the government quarter ‹to an end›. With its L-shape, it sets a limit to a square elevated by approximately 3 m in relation to the large free space and set off sideways in front of the church. The intention of the first competition stage of 1987 – to connect the curved gallery building to the street space with wing sections reaching out at an angle towards the street – was updated and made more convincingly precise with this design. The elevated square in front of the church is accessible via a generous outdoor stairway along the main axis of Städtlestraße/Heiligkreuz. Its angle adds to the visual end-effect of this urban space. The church was situated outside the design area in the original competition stages of 1987. With this proposal it has become an important element in the entire composition.

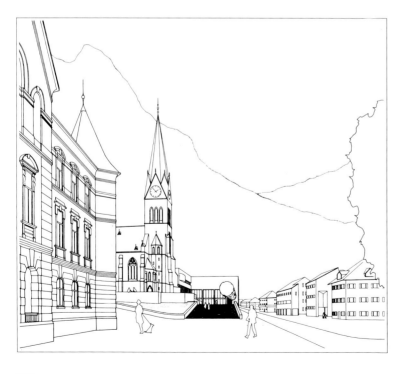

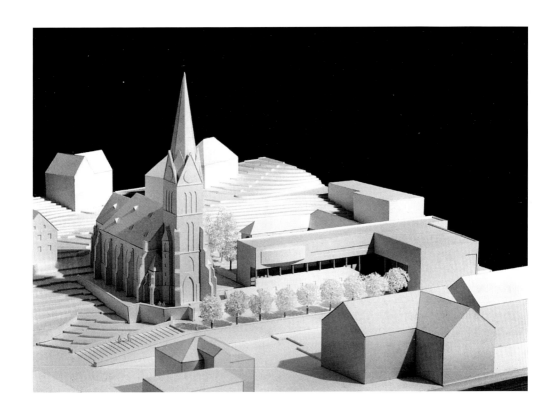

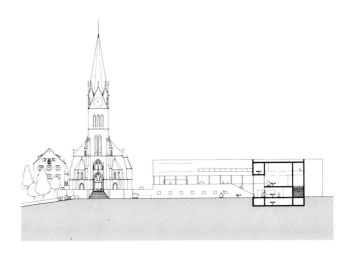

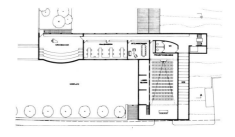

Perspektive / Modell (vgl. Seite 126) /
Schnitt / Grundriß Obergeschoß

Perspective / Model (see page 126) /
Section / Upper floor ground plan

Geschäfts- und Wohnhaus, Sursee

Mit Anne-Catherine Javet, Daniel Ruggiero,
Wettbewerb (1. Preis), 1990

Die Kleinstadt Sursee besitzt eine kohärent strukturierte Altstadt mittelalterlichen Ursprungs und die üblichen amorphen Außenquartiere. Das Entwurfsareal liegt an der Grenze zwischen den beiden Gebieten. Der Entwurf sucht in diesem Fall nicht die Integration der Teile, sondern setzt als starke Solitärform ein Grundrißquadrat von ca. 57 m Seitenlänge, auf das sich die umliegenden Stadtteile in unterschiedlicher Weise beziehen können. Viergeschossig, besitzt es einen umlaufenden dreigeschossigen Portikus und darüber eine Attika vor den Wohnungen im obersten Stockwerk. Das Erdgeschoß ist durchgehend genutzt, darüber befindet sich ein großzügiger Lichthof, für den der Entwurf eine Baumbepflanzung vorsieht. Hinter dem Portikus liegen Ladengeschäfte und Büros. Hauptmieterin im Erdgeschoß sind die PTT Telecom, die auch den unter dem Lichthof gelegenen Raum beanspruchen. Die auf der primären Ebene allseitig-reguläre und ungerichtete Form erweist sich auf der sekundären Ebene als spezifiziert und gerichtet. Die Seite gegen die Altstadt ist durch eine zum Lichthof emporführende Treppenanlage hervorgehoben; die vier innenliegenden Treppenhäuser sind demgegenüber von privaterem Charakter. Auf der von der Altstadt abgewandten Seite liegen die Laderampe der Post und die Abfahrtsrampe zu den Parkierungsgeschossen. Der Entwurf ist ein schönes Beispiel für die abgestufte Überlagerung von privaten, halbprivaten und öffentlichen Bereichen und für die kontrollierte Porosität einer präzisen Außenform. Dies sind wichtige Instrumente zur Erzeugung dessen, was für Snozzi die Stadt ausmacht.

Business and Apartment House, Sursee

With Anne Catherine Javet, Daniel Ruggiero,
competition (first prize), 1990

The small town of Sursee has a coherently structured old center with its origins in the Middle Ages and the usual amorphous outer quarters. The design area is located at the transitional point of the two. The design in this case is not aimed towards the integration of the parts, but takes a ground plan square with a lateral length of approximately 57 m to which the surrounding quarters can relate in different ways. With four floors, it has a three-story portico. Above is a roof parapet in front of the apartments on the upper floor. The ground floor is used in its entirety; above it is a spacious atrium. The design calls for trees to be planted in this area. Behind the portico there are shops and offices. On the ground floor, the main tenant is PTT Telecom which also uses the space under the atrium. The shape, unaligned and regular on all sides on the primary level, proves to be specified and aligned on the secondary level. The side facing the old town section stands out due to a staircase ascending to the atrium. Opposed to this, the four staircases on the inside have a more private character. On the side turned away from the old town section, the loading ramp of the post office and the ramp down into the parking floors are located. The design is a very good example for the layered overlapping of private, semi-private and public areas, and for the controlled porosity of a precise outer shape. These are important instruments to create what to Snozzi characterizes a city.

Situation / Südfassade /
Schnitt / Grundriß Erdgeschoß

Site plan / South facade /
Section / First floor ground plan

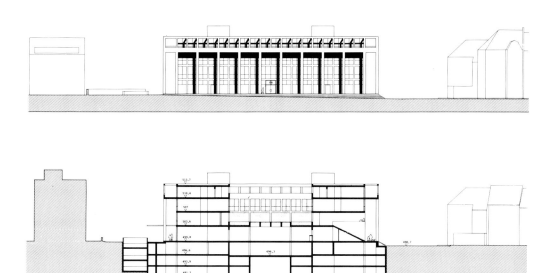
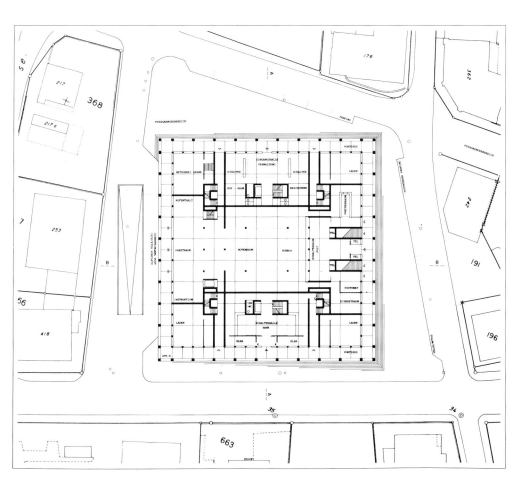

Bahnhofplatz und Volkshochschule, Pforzheim
Mit Bruno Jenni, 1990

Bei dem Studienauftrag, eine Volkshochschule und Musikschule für den Standort am *Bahnhofplatz* in Pforzheim zu entwerfen, erwies es sich für Snozzi erneut als notwendig, ein erweitertes Entwurfsgebiet in Betracht zu ziehen. Das Projekt nimmt sich zunächst die Einbindung des in unbestimmter Relation zu den umliegenden Stadtteilen stehenden Bahnhofgebäudes vor. Die Neustadtgebiete nördlich der Bahn werden an den Bahnhof durch vier je paarweise miteinander durch Unterführungen verbundene 5-geschossige Gebäude angeschlossen, deren Bezug zueinander architektonisch durch Torelemente kenntlich gemacht ist. Für diese Neubauten sind Büro- und Ladennutzungen vorgesehen. Nördlich der Bahn wird dadurch ein längsrechteckiger Platz mit einer Baumreihe zwischen den Neubauzeilen geschaffen. Südlich der Geleise – also stadtseitig – flankieren die Neubauten das Bahnhofgebäude und ermöglichen den Neuvorschlag von zwei Dreieckplätzen, wie sie vor dem Zweiten Weltkrieg bestanden haben. Damit verbunden ist der Vorschlag, das unentschiedene Verhältnis des Schloßbergs zum Bahnhofplatz zu klären. Im Schloßberg, dem leicht gegen die Stadtmitte hin abfallenden Gebiet, liegt die gotische Schloßkirche. Snozzi schlägt vor, mit der geplanten Universität und Musikschule den Schloßberg gegenüber dem Bahnhofsvorplatz abzugrenzen und die beiden Areale in der jeweiligen Identität zu festigen. Universität bzw. Musikschule folgen als offener Winkel dem Verlauf der mittelalterlichen Stadtmauer und zeichnen sie mit heutigen Mitteln nach. Dementsprechend ist die Volkshochschule in den unteren drei Geschossen bis auf kleine Quadratöffnungen gegenüber dem Bahnhofsvorplatz abgeschlossen und eindeutig nach Süden gegen den Schloßberg hin orientiert. Von dort her ist auch die Musikschule (mit Konzertsaal) erschlossen. Nur die beiden obersten Geschosse des Komplexes (Musikschule) sind beidseitig ausgerichtet.

Station Square and Adult Evening School, Pforzheim
With Bruno Jenni, 1990

When Snozzi received the order to make a study for an adult evening school and music school at the site of the station square in Pforzheim, it was again necessary for him to consider an expanded design area. First, the project aims at the integration of the station building's undefined relation to the adjoining city quarters. The new parts north of the station are joined to the station by four five-story-buildings. Each pair is connected through underpasses, their relationship with one another made clear architecturally with gate elements. Offices and stores are planned for these new buildings. A long rectangular square lined with trees is thus created north of the station between the rows of new buildings. South of the railway tracks facing the city the new buildings flank the station building and enable the new proposal for two triangular squares as they existed before World War II. Linked to this is the suggestion to structure the undecided relationship of the Schloßberg (castle hill area) with the station square. In the Schloßberg, the area slightly descending towards the city center, lies the gothic castle church. Snozzi suggests differentiating the Schloßberg from the station square by means of the planned adult evening school and music school, and to clarify the identity of both areas. The adult evening school and music school follow the course of the medieval city rampart as an obtuse angle and redraw it with current means. Appropriately, the adult school is closed off towards the station square in the lower three floors except for small square openings and it is clearly oriented towards the south and towards the Schloßberg. From there, the music school with its concert hall is accessed. Only the two upper floors of the complex (music school) are oriented towards both sides.

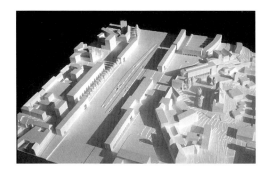

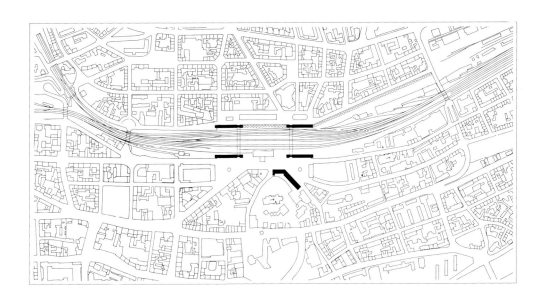

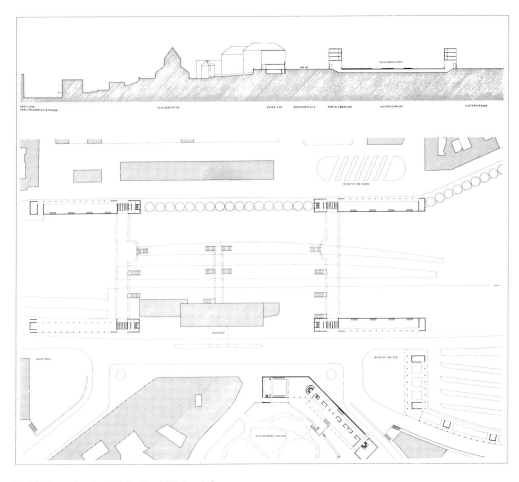

Modell / Gesamtsituation / Schnitt, Grundriß Erdgeschoß

Model / Site plan / Section, first floor ground plan

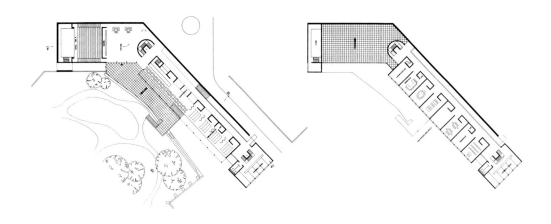

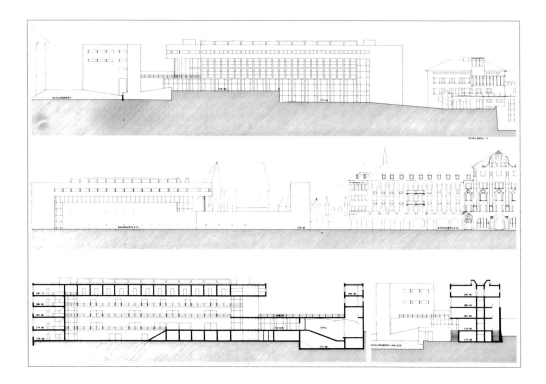

Schulbauten: Grundriß Erdgeschoß,
1. Obergeschoß / Fassaden und Schnitte

School buildings: ground plans:
first and second floor / Facades and sections

Masterplan für Le Bouveret
Mit Anne-Catherine Javet, 1991

Master Plan for Le Bouveret
With Anne-Catherine Javet, 1991

Das Dorf Le Bouveret liegt bei der Einmündung der Rhone in den Genfersee und ist wegen seiner Lage ein beliebter Ort für Segel- und Campingferien. Der Auftrag an Snozzi lautete, die Quaianlagen zu verbessern und einen Parkplatz für 1000 Fahrzeuge zu entwerfen. Was er stattdessen unterbreitete, war ein Stadtentwicklungskonzept. Die vorgefundenen Elemente der Situation waren u.a.: die Ebene mit dem Rhonedelta, der Stockalperkanal, der historische Dorfkern am Fuß des Berges, ein Bootshafen und eine ungeplante Ansammlung von Wohnhäusern in Streubauweise, sowie eine neue Siedlung im ‹spanischen Stil› um einen Teich herum. Beim Studium alter Pläne stieß Snozzi auf ein unausgeführtes Projekt aus dem mittleren 19. Jahrhundert, das zugleich verblasen und klar war: ein französischer Graf beabsichtigte, Le Bouveret zur international bedeutenden Relaisstation zwischen Genf und Peking zu machen; die Passagiere würden mit dem Schiff von Genf hier landen und die vom Grafen betriebene Bahn nach China besteigen. Der Bahnhof wurde später tatsächlich gebaut, nur nicht als Terminus, sondern als Durchgangsbahnhof in Richtung Evian, weshalb der See aufgeschüttet werden mußte und das Dorf vom Wasser abgeschnitten wurde. An diese problematische Interven-

The village of Le Bouveret is situated at the estuary of the Rhone river as it flows into Lake Geneva. Because of this location, it is a favorite destination for sailing and camping holiday makers. The commission required Snozzi to improve the quay system and propose a parking system for 1000 cars. Instead, what he submitted was a city development project. The existing elements of the site were, among others things, the plain with the Rhone delta, the Stockalper canal, the historic village center at the foot of the mountain, a boat harbor, and a casual accumulation of houses in a scattered architectural style as well as a new development in the ‹Spanish style› around a pond. While studying old plans, Snozzi discovered an unrealized project from the middle of the 19th century that was rather obscure and yet, at the same time, quite clear. A French count intended to make Le Bouveret into an internationally important relay station between Geneva and Beijing. The passengers would arrive by ship from Geneva and then board the Count's train to China. The station was actually built later on to serve not only as a terminal, but also as a transit station to Evian. Therefore, part of the lake had to be filled and the village was cut off from the water. Snozzi's project takes this problematic intervention

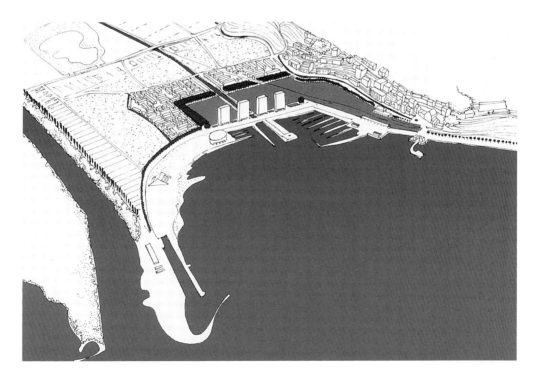

tion knüpft Snozzis Projekt an. Es arbeitet die ehemalige Uferlinie als die Südgrenze eines großen rechteckigen Freiraums heraus, in dessen Mittelachse der aufgewertete Stockalperkanal sich in den See ergießt und dem die Quaianlagen, der Bootshafen und Badeanlagen vorgelagert sind. Vier turmartige Hochbauten mit öffentlichen Nutzungen sind die weithin wirksamen Dominanten dieses Bereiches und das Zeichen für Le Bouveret. Hinter der grünen, von Bäumen gesäumten Freifläche – die zugleich der verlangte Parkplatz ist – schließt sich winkelförmig das Cityerweiterungs-Gebiet an, auf das ein Wohngebiet folgt, umgeben seinerseits von einem Gürtel mit Einkaufsgelegenheiten, Sportanlagen usw. Zudem schlägt Snozzi die Anlage einer Straße im Westen vor, die den alten Dorfkern über die Ebene hinweg mit der Hauptstraße jenseits der Rhone verbindet. Zum Vergleich zwischen dem offiziellen Zonenplan und dem vorliegenden Entwurf sagt Snozzi in berechtigter Polemik, die üblichen Zonenpläne würden nicht mehr leisten, als daß sie den bestehenden Zustand willenlos in erlesenen Tönen einfärbten, während nur mit einer stadträumlichen und architektonischen Vorstellung zur Entwicklungsperspektive eines Ortes – mit den gleichen Farben – zu veranschaulichen sei, daß und wie sich die Wirklichkeit modellieren ließe, wenn ein substantielles Resultat erreicht werden soll.

as a starting point. It works out the former shore line as the southern border of a large rectangular free space. In its middle axis, the revalued Stockalper canal discharges into the lake. The quays, the boat harbor, and the beaches lie along the shoreline. Four tall, tower-like buildings accommodating public facilities and services effectively dominate this area and are the symbols of Le Bouveret. Behind the green, tree-lined free area, which also serves as the required parking area, the city expansion zone adjoins and wraps around with a right angle. It's followed by a residential area, which again is surrounded by a belt with shopping areas, sports complexes, etc. Furthermore, Snozzi suggests the construction of a road on the west side, which would connect the old village center, across the plain, to the main road beyond the Rhone river. For the purpose of making a comparison between the official zoning plan and the existing design, Snozzi states (with justifiable polemics) that the usual zoning plans would not be of any use other than to color the existing situation without resoluteness in selected tones, whereas an urban and architectural concept for the development perspective of a location executed in exactly the same tones would make clear that reality has to be modeled. How it can be accomplished must also be elucidated in order for a substantial result to be obtained.

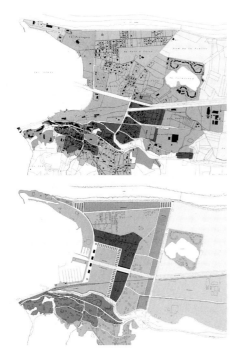

Seite 165: Schaubild mit Rhonemündung
Bestehender Zonenplan (oben),
Vorschlag Snozzi (unten) / Modell / Masterplan

Page 165: display with the estuary of the Rhone
Existing zoning plan (top),
proposal Snozzi (bottom) / Model / Master plan

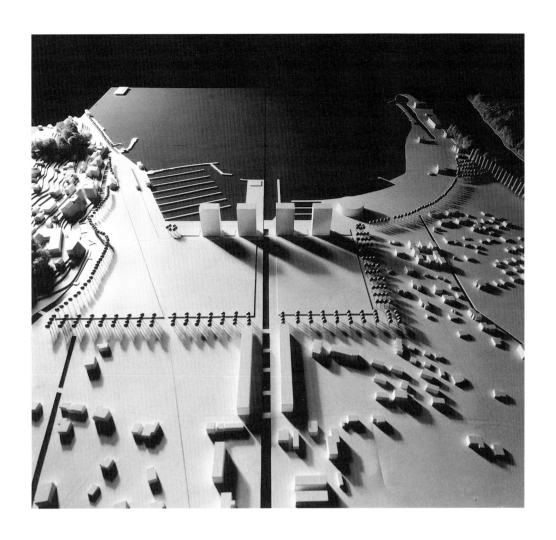
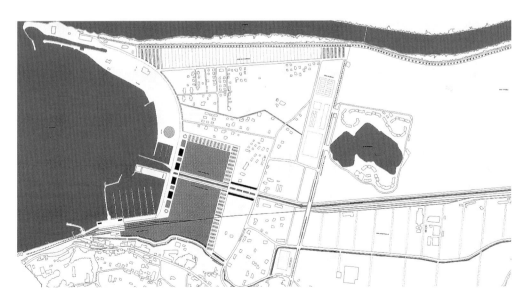

167

Lido, Brissago
Mit Gustavo Groisman, Wettbewerb (1. Preis), 1991

Lido, Brissago
With Gustavo Groisman, competition (first prize), 1991

Der Ort des Entwurfs liegt am Westende des Dorfes Brissago am Langensee. Zwischen dem Strand und der Kantonsstraße liegt die Renaissancekirche Madonna di Ponte als markanter Kopf des Dorfes. Der Vorschlag konzentriert die Funktionen des Bades in einem Gebäude, das, in der Verlängerung der Friedhofmauer stehend, den Lido dorfauswärts abschließt. Im definierten Volumen des Hauses wechseln sich abgeschlossene und offene Bereiche von Geschoß zu Geschoß unterschiedlich ab, und darin entwickelt sich im sukzessiven Absteigen ein architektonischer Spaziergang über vier Geschosse nach unten. Erdgeschoß: Kasse und Brücke am Luftraum der Cafeteria vorbei zur Treppe. 1. Untergeschoß: Cafeteria und gedeckte Terrasse. 2. Untergeschoß: Umkleidekabinen. 3. Untergeschoß: Familienkabinen. Jedes Geschoß korrespondiert mit einer der vier aufeinanderfolgenden Geländeterrassen von der Kirche zum See; die Beziehung zwischen Haus und Terrain ist der des Hauses Diener vergleichbar, aber hier noch dialektischer. Die Abtreppung des Geländes ist als hochkontrollierte, straffe Auffächerung durchgeführt – die Borromäischen Inseln sind als regionale Referenz mit großer Ausstrahlung darin erkennbar. Der Entwurf ist etappiert: In der 1. Etappe soll der Neubau realisiert und der alte Pavillon abgebrochen werden. In der 2. Etappe soll der Fußweg vom Dorf gebaut werden (neuer Steg über den Wildbach) und der Weg an der Kirche vorbei zum Bad-Eingang geführt werden. In der 3. Etappe soll die am Friedhof vorbeiführende Treppe ausgebaut und die Situation bergseits der Kirche bereinigt werden. Oder besser: ‹hätte sollen›, denn anstelle dieses Entwurfes wurde der eines anderen Architekten realisiert.

The location for the design is at the western end of the village of Brissago at Lago Maggiore. The renaissance church, Madonna di Ponte, lies between the beach and the cantonal road marking the head of the village. The proposal concentrates the functions of the bath into one building which, with the extension of the cemetery wall, closes off the Lido towards the outside of the village. In the defined volume of the building, closed and open areas alternate differently from floor to floor and therein lies the development of an architectural walk, successively descending through four levels to the bottom. Ground floor: cashiers and bridge going past the air space of the cafeteria to the staircase; 1st sub-level: cafeteria and covered terrace; 2nd sub-level: changing rooms; 3rd sub-level: family changing rooms. Each floor corresponds to one of the four terrain terraces leading from the church to the lake; the relationship between building and terrain can be compared to the Diener House; however, in this case it is more dialectic. The steps in the terrain are executed as tight, highly controlled segments – the Borromaic Islands can be recognized as a very alluring regional reference point. The design was to be phased-in. In the first phase, the new building would have been realized and the old pavilion torn down. In the second phase, the walkway from the village would have been built (with a new bridge across the stream) along with the path leading past the church to the entrance of the bath. In the third phase, the staircase leading past the cemetery would have been built out and the situation along the hillside of the church clarified. It would be better to say ‹should have been› because, unfortunately, the design of another architect was realized instead of this one.

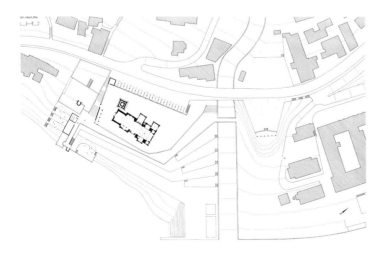

Situation und Eingangsgeschoß /
Modell / Schnitt / Grundrisse der
Terrassengeschosse 1–3

Site plan and entrance floor /
Model / Section /
Ground plans terrace floors 1–3

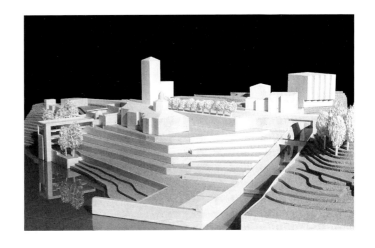

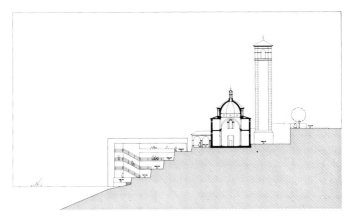

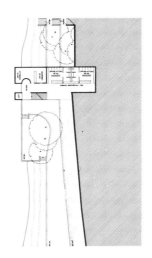
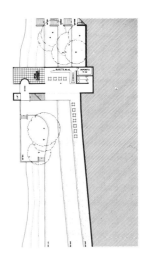

Neustrukturierung Sulzer-Quartier, Winterthur
Mit Mario Ferrari, Anne-Christine Javet, Bruno Jenni, Wettbewerb (2. Preis), 1992

Der Beschluß des Sulzer-Konzerns, die industrielle Produktion aus dem Zentrum Winterthurs auszulagern, macht eine Fläche von 7 Hektaren – was nahezu der gesamten Altstadt entspricht – öffentlich zugänglich. Im Wettbewerb ging es unter anderem um die Frage, ob und welche von den bestehenden Industriebauten erhalten werden sollen. Der Wettbewerb wurde unter acht Architekturbüros ausgetragen und war international besetzt. Das Programm verlangte eine sehr hohe Baudichte und umfaßte Geschäfte, Büros, kulturelle Einrichtungen, Wohnungen und Autoparkplätze. Snozzi sah hier die äußerst seltene Gelegenheit gegeben, einen ganzen einheitlichen neuen Stadtteil mitten in der Stadt zu entwerfen. Ihm käme die Aufgabe zu, durch seine Größe und Lage – jenseits der Bahngeleise – ein Gegengewicht zur Altstadt zu schaffen. Die Erinnerung an den industriellen Produktionsstandort von Weltrang suchte Snozzi auf der Ebene einer inneren Entsprechung zu evozieren anstatt auf jener der materiellen Kontinuität. Elemente dieser Neuvorschlags sind dabei:
– die Erhaltung der Einheitlichkeit des Quartiers;
– die Erhaltung der Großmaßstäblichkeit;

Restructuring of the Sulzer-Quarter, Winterthur
With Mario Ferrari, Anne-Christine Javet, Bruno Jenni, competition (second prize), 1992

The decision of the Sulzer-trust to move the industrial production out of the center of Winterthur releases an expanse of 7 hectares for public use which is roughly equal to the entire old city center. The competition dealt above all with the question of whether and which of the existing industrial buildings ought to be preserved. The competition was held between eight architectural studios and was internationally staffed. The program called for a very high density use of the buildings which would include shops, offices, cultural institutions, apartments and car parking. Snozzi saw an extremely rare opportunity in this case to design a completely unified and new city quarter within the center of a city. Its task would be to create a counterweight to the existing old city elements with its size and location beyond the railroad tracks. Snozzi tried to evoke the memory of the globally important industrial production location on the level of an inner analogy instead of that of a materialistic continuity. Some elements of this new proposal are as follows:
– the preservation of the unity of the quarter
– the preservation of the large scale
– the consideration of the main directions and geometry

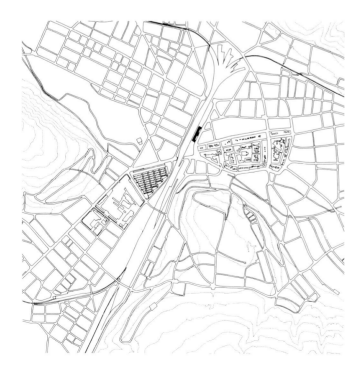

Gesamtsituation mit Wettbewerbsareal und Altstadt / Modellaufnahme aus Süden

Site plan with competition grounds and old city center / Model from the south

– die Aufnahme der hauptsächlichen Richtungen bzw. Geometrien;
– das Bauen in einer horizontalen Schicht, die die Höhe von 28 m nicht überschreitet;
– die Umwandlung einiger bestehender Bauten wegen ihrer besonderen städtebaulichen und architektonischen Qualität;
– die Wiederaufnahme des Themas «Sheddach», um die «fünfte Fassade» als Lichteinläße für die verschiedenen Nutzungen und als Sonnenfänger für die Wohnungen zu verwenden;
– die Wiederverwendung des Materials Sichtbackstein als typisches Material für die Außenfassaden.

Das Projekt schlägt als Groß-Struktur eine zusammenhängende Baumasse von 28 m Höhe und eine überbaute Fläche von 68'000 m² (im Endausbau) vor. Kerngedanke ist die horizontale Überschichtung von einem Stadtbereich (Platz, Straße, Öffentlichkeit), mit darübergelegten Bürogeschossen und zuoberst einem Wohnquartier mit Duplex-Wohnungen, Kindergarten, Café, Pflanzgärtchen, das infolge seiner hohen Dichte die Analogie zur mittelalterlichen Stadt erlaubt und in seinem hohen Grad typologischer Ordnung zugleich an die Gartenstadtsiedlungen Winterthurs erinnert.

– the construction in a horizontal layer not exceeding a height of 28 m
– the conversion of some existing buildings due to their special urban and architectural quality
– the reconsideration of the «saw-tooth roof» theme in order to use the «fifth facade» for lighting effects for the different utilities, and as sun collectors for the apartments
– the recycling of the fair-faced brick work as a typical material for the outside facades.

The project suggests an interconnected building volume with a height of 28 m and a built surface of 68.000 m² (in the final development) as the large-scale structure. The central thought is the horizontal layering of one city district (square, street, public utilities) with the office floors above, and a residential quarter with duplex-apartments, a kindergarten, a café, and a planted garden on the very top which, due to its high density, allows an analogy with the medieval city to come about and at the same time commemorates, with its high degree of typological order, the garden communities of Winterthur.

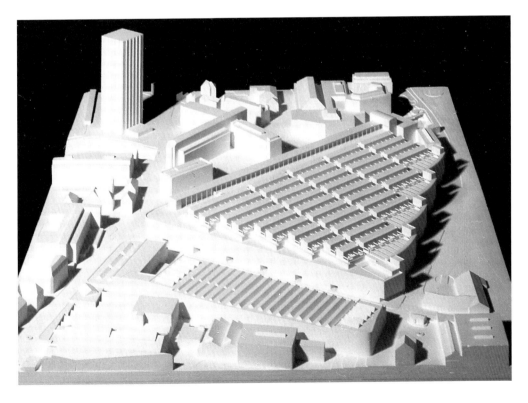

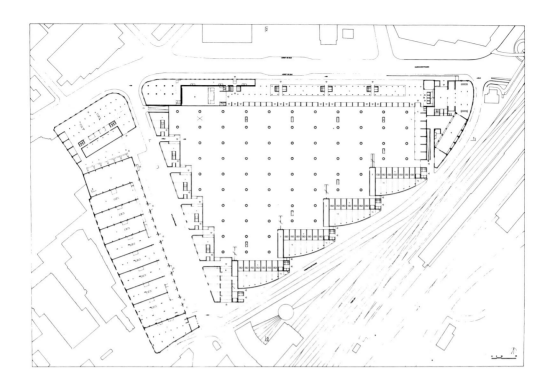

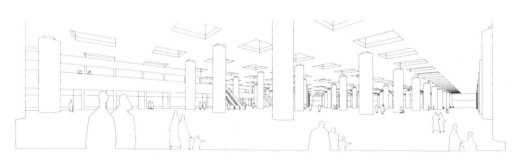

Oben: Grundrisse Erdgeschoß und 4. Obergeschoß (Büros)
Mitte: Erdgeschoß-Halle mit Lichtatrien /
Querschnitt Nord-Süd / Südfassade
Unten: Grundriß-Ausschnitt aus Bürogeschoß und Grundriß-
Ausschnitte 5. und 6. Obergeschoß (Maisonette-Wohnungen)

Top: first floor ground plan / Fifth floor ground plan (offices)
Center: first floor lobby with light atriums/
Cross section north-south / South facade
Bottom: detail of the office floor and details of sixth and
seventh floor ground plans (maisonette apartments)

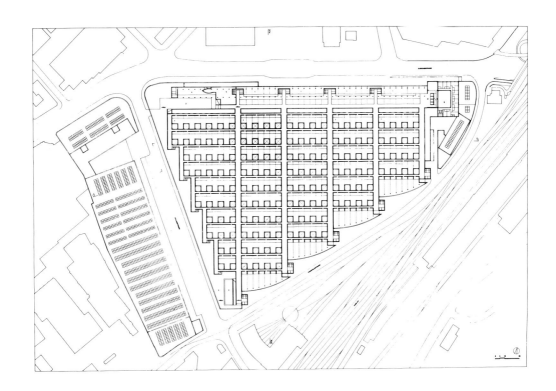
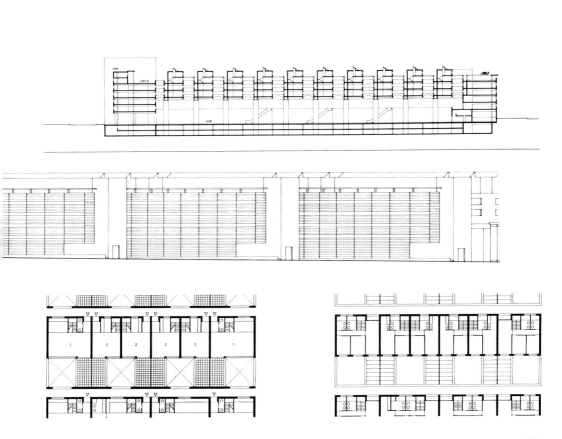

Häuser Giannini/Salzborn, Cureglia
1992–95

Die Ähnlichkeit dieses Doppelhauses mit dem Reihenhausprojekt Büchel ist offensichtlich (vgl. S. 116). Auch im vorliegenden Fall wandte Snozzi das Prinzip der Reihung von winkelförmig um private Höfe herum gebauten Einheiten an, um zu verhindern, daß einmal mehr ein neuerschlossenes Gebiet durch trügerischen Individualismus und Schein-Vielfalt zerstört wird («Die Vielfalt ist das Präludium zur Monotonie. Willst du sie vermeiden, dann wiederhole dein Element», lautet einer der prägnantesten Merksätze aus seinem Entwurfsunterricht.) Der Entwurf bezog die Möglichkeit ein, daß die nachfolgenden Bauvorhaben sich mindestens typologisch an dieses Doppelhaus anschließen würden (was sich nicht bewahrheiten sollte). Da die Hangneigung kleiner ist als beim erwähnten Entwurf für Brione, ist auch der Gebäudeschnitt ein anderer. Die Häuser sind nur zweigeschossig, wobei das Erdgeschoß sich auf zwei Niveaux erstreckt: der hangseitige, an die gedeckte Halle anschließende Teil (mit Garderobe, Küche, Eßplatz) ist die Bezugsebene, die sich gegenüber dem etwas tiefergelegten Wohnraum als ‹Galerie› lesen läßt. Vor den sehr großformatigen Scheiben der Stirnfront liegt eine gegenüber dem Wohnraum ihrerseits tiefergelegte Loggia.

Giannini/Salzborn Houses, Cureglia
1992–95

The similarity of this double house with the Büchel row house project is obvious (see p. 116). In this case as well, Snozzi applied the principle of lining up units built at an angle around private courtyards in order to prevent a newly developed area from once again being destroyed by a misleading individualism and a false diversity. («Diversity is the prelude to monotony. If you want to avoid it, repeat your element» – this is one of the most poignant guiding principles from his design teachings.) The design included the possibility that the subsequent building projects would connect to this double house at least typologically (what would later prove not to be the case). Since the slope of the property is smaller than that of the aforementioned design for Brione, the cross section of the building is different as well. The houses only have two floors; the ground floor has two levels. The section on the side of the hill adjoining the covered hall (with wardrobe, kitchen, dining area) is the reference level which can be read as a ‹gallery›. It's juxtaposed to the somewhat lower living room, and beyond the large-format windows in the front there is a loggia on a still lower level with reference to the living room.

Blick von der Loggia auf jene des anderen Hauses / Ansicht aus Süden / Schnitt durch Gartenhof / Grundrisse Erd- und Obergeschoß 1:400

View from the loggia to that of the other house / View from the south / Section of the garden yard / Ground plans: first and upper floor 1:400

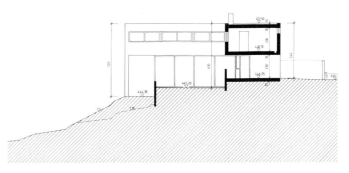

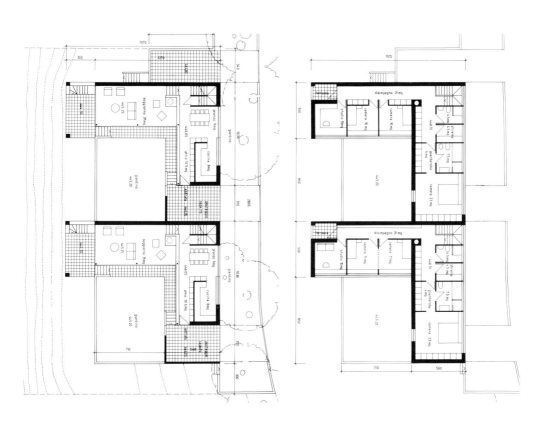

Stadtviertel Ticosa, Como
Mit Mario Ferrari, Anne-Catherine Javet,
Wettbewerb (1. Preis), 1993

Town Quarter Ticosa, Como
With Mario Ferrari, Anne-Catherine Javet,
competition (first prize), 1993

Der Viale Innocenzo XI, westlich der Altstadt von Como verlaufend, entstand zu Beginn des 20. Jahrhunderts durch Überdeckung des Baches Cosia, entlang dem die Textilfabriken und Färbereien den Platz der früheren extra muros liegenden Klöster eingenommen hatten. Hier entstand zwischen der Bahnlinie und der Altstadt ein Industriegebiet, das jedoch im Lauf der vergangenen Jahrzehnte weitgehend verlassen wurde und heute am Zerfallen ist. Um einen Vorschlag zu seiner Restrukturierung zu erhalten, schrieb die Stadt Como, zusammen mit einigen Grundeigentümern, einen Wettbewerb unter fünf Architekturbüros aus. Snozzis Konzept beruhte zunächst auf der Entscheidung, die Hauptelemente auf Arealen zu situieren, die in öffentlichem Besitz sind (Italienische Staatsbahnen FS und Gemeinde Como). Der Vorschlag wertet den heute nicht sonderlich attraktiven Straßenzug Via Ambrosoli/Via Innocenzo XI zum Boulevard auf, der zwei wichtige Grünräume der Stadt miteinander verbindet: die Parks am Seeufer im Norden und das Universitätsgelände im Süden. In der Gewißheit, daß der Güterbahnhof ohnehin dereinst nach außerhalb der Stadt verlegt werden wird, schlägt Snozzi diese Maßnahme konkret vor, um für die drängenden Probleme der Stadt eine unmittelbare Lösung zu finden. Das entsprechende Areal – ein gegenüber der Stadt erhöhter Damm – soll von allen alten Bauten befreit und zum Knotenpunkt von Verkehrsmitteln (Bahn, Bus, Taxi, Park-and-ride-Parkplätze) werden. Der Personenbahnhof, urbanistisch gut plaziert und von einer gewissen architektonischen Qualität,

Running west of Como's old town center, the Viale Innocenzo XI was created in the beginning of the 20th century when the Cosia stream was covered up. Textile factories and dyeworks had taken over the sites along this stream that had earlier been occupied by monasteries located extra muros. An industrial quarter between the railroad tracks and the old town center was developed in this location. However, during the past few decades this area has been abandoned and is now in a state of decay. In order to receive suggestions for its restructuring, the city of Como along with some proprietors invited five architectural studios to participate in a competition. Snozzi's concept was based first on the decision to situate his main elements on areas on public property (Italian State Railroads FS and the community of Como). The proposal reevaluates the not-very-attractive street sections of Via Ambrosoli – Via Innocenzo XI into a boulevard connecting two important green areas of the city: the parks along the lake border in the north, and the University compound in the south. Knowing that at some point in the future the freight depot would be moved to the outside of the city anyway, Snozzi concretely suggests this measure in order to attain an immediate solution to the impending problems of the city. The area in question – an area along the river on a higher level than the city – would be opened up and freed of all old buildings thus becoming an interchange for transportation services (railroad, buses, cabs, park-and-ride lots). However, the main station (in contrast to the freight station) is well-placed in an urban sense

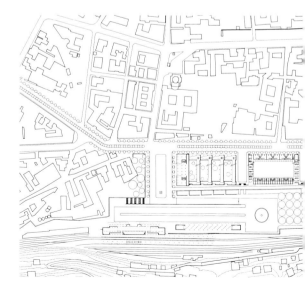

Übersichtsplan mit dem Rand der Altstadt (oben, angeschnitten) und der Bahn (unten)

Overall site plan showing the edge of the old town center (top) and the railroad (bottom)

bleibt hingegen an seinem Ort. Die neugeschaffene Fläche auf dem Damm soll durch Baumreihen strukturiert und mittels Treppen und Rampen mit dem tieferliegenden Boulevard verbunden sein. Snozzi sieht diesen neuen Bahnhofsplatz jedoch nur als mittelfristige Lösung vor, langfristig hingegen als Arbeitsplattform für verschiedene – noch zu entwickelnde – urbanistische Ideen. Für das Gebiet Ticosa-Süd postuliert der Vorschlag ein städtisches Verwaltungsgebäude (Palazzo pubblico) und einen großen öffentlichen Park. Da hier die Geometrie der Stadt nicht eindeutig ist, greift er auf ein Vorbild aus der Architekturgeschichte zurück: auf den Prato della Valle in Padua. Wie dort löst hier die Großform der Ellipse die Aufgabe, die unterschiedlichen Richtungen und Baudenkmäler (zu denen u.a. der ausgedehnte städtische Friedhof gehört) in eine gegenseitige Beziehung zu bringen. Hier sollen der Wochenmarkt und eine versenkte Parkgarage ihren Platz finden. Für den westlich des Boulevards liegenden Streifen von Privatgrundstücken (vor dem Bahnhofsplatz und Ticosa-Süd) skizziert das Projekt eine Reihe unterschiedliche, als Typen spezifizierter Baukomplexe. Sie wollen nicht als endgültige Entwürfe verstanden sein, sondern als Ausdruck von bestimmten Regeln zur weiteren Entwicklung und Konkretisierung. Zu diesen gehören die Prinzipien der Großmaßstäblichkeit und im wesentlichen der Monofunktionalität dieser Blocks. Das in diesem Rahmen Unterschiedliche der Baukomplexe wird seinerseits zusammengebunden durch die dazwischenliegenden Straßen. Drei von ihnen sind Stichstraßen; sie enden in Treppenanlagen am Fuß des Bahnhofsplatzes und repräsentieren damit ein urbanistisches Muster, dessen Vorzüge Snozzi von Bellinzona her vertraut sind.

and, having a certain architectural quality, should remain in its present location. The newly created space on the levee would be structured by rows of trees and connected with the lower boulevard by stairs and ramps. However, Snozzi envisions this new station square only as a medium-term solution. In the long run, he sees it as a working platform for various urban ideas which still need to be developed. The proposal suggests a communal administrative building (Palazzo pubblico) for the Ticosa-south area, and a large public park. As the geometry of the city is not clear, he goes back to an example from architectural history: the Prato della Valle in Padua. In this case as well, the large form of the ellipse solves the task of creating a mutual relationship between the various directions and the historic monuments (the expansive city cemetery, for example). This ellipse accommodates the weekly market and in its center there is a lower level parking garage. For the strip of private property lots west of the boulevard (in front of the station square and Ticosa-south), the project suggests a row of various building complexes. However, they should not be taken as final designs but as an expression of certain guidelines for further development and concrete implementation. Among these rules are: the principle of large scale; and, essentially, the mono-functionality of these blocks. The distinct and different characteristics of these building complexes are again held together by the streets running between them. Three of the streets are dead-ends that lead to stairways at the foot of the station square thus representing an urban pattern whose advantages are well-known to Snozzi from Bellinzona.

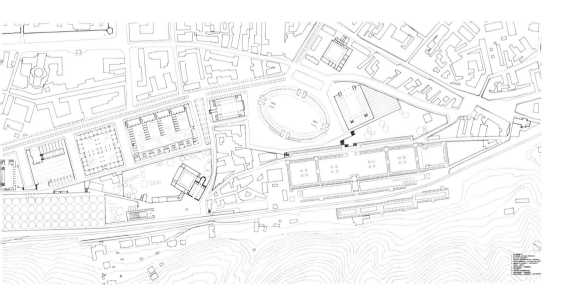

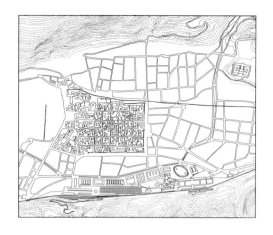

Gesamtsituation / Drei Beispiele zu Hof- und Blockgebäuden: Warenhaus und Wohnbauten / Längsschnitt durch Ellipse: Markt und Parking / Ansicht und Grundriß eines Hofkomplexes

Site plan / Three examples for yard and block buildings: warehouse and apartment houses / Longitudinal section of ellipse: market and parking / View and ground plan of a yard complex

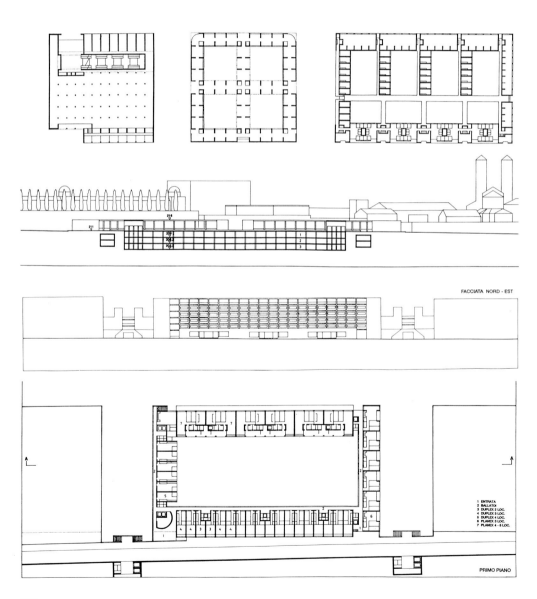

Haus d'Andrea, Monte Carasso
Mit Giuliano Mazzi, Umbau, 1993

Ein typisches Wohnhaus aus der Nachkriegszeit hat durch Umbau und Aufstockung einen ganz neuen Charakter bekommen. Das Haus, auf einem Eckgrundstück gebaut, wandelte sich durch den Umbau von einem beengten ‹Landhaus ohne Land› zu einer stolzen Stadtvilla von Loos'scher Prägnanz. Das Walmdach wurde entfernt und das Haus über einem Teil des ersten Obergeschosses aufgestockt. Die Aufstockung, eine eigenständige Kleinwohnung, ist flach gedeckt und besitzt eine gegen Süden orientierte Terrasse. Im Erdgeschoß wurde ein großer Wohnraum geschaffen (mit Küchenblock und Eßplatz), der von der Straße zum Garten hin umorientiert wurde. Der Garten selber, ein schmaler Streifen, wurde gegen die Straße durch eine 2,50 m hohe Mauer abgeschirmt, hinter der sich nun ein Schwimmbecken erstreckt. Er gehört nun zu beiden anstoßenden Häusern. Im Erdgeschoß wurden aus den liegenden Fenstern bis zum Boden reichende Öffnungen. Die Klappläden wurden am ganzen Haus entfernt und Rolljalousien montiert. Für Snozzi war die Modifikation dieses – wie er sagt: eigentlich banalen – Hauses eine Bestätigung seiner Erkenntnis, daß im Bestehenden immer Qualitäten aufzuspüren und herauszukristallisieren sind.

D'Andrea House, Monte Carasso
With Giuliano Mazzi, conversion, 1993

A typical post-war apartment building has received a completely new character through conversion and an increase in height. The house, which was build on a corner property, underwent a transformation from a cramped ‹country-home without land› to a proud town villa of Loosian distinction. The hipped roof was removed and the height of the house was increased above part of the second floor. The heightened section, a small, independent apartment, is covered with a flat roof and has a terrace oriented towards the south. On the ground floor a large new living room was created (with kitchen block and dining area) which was reoriented from the street towards the garden. The garden itself, a narrow strip, was protected on the street side by a 2.50 meter high wall. Behind it, a swimming pool now stretches out. It belongs to the two adjoining houses. On the ground floor, the horizontal windows were turned into openings that reach down to the floor. The folding shutters were removed from the entire building and slatted roller blinds were mounted instead. For Snozzi, the successful modification of this (in his words) «banal» house was a confirmation of his insight that within the existing there are always qualities which can be discovered and crystallized out.

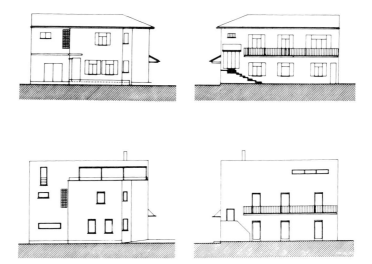

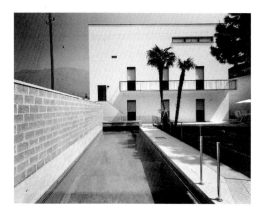

Gegenüberstellung von Straßen- und Gartenfassade «vorher – nachher» / Straßen- und Gartenansicht / Grundrisse 2. Obergeschoß, 1. Obergeschoß, Erdgeschoß 1:400

Comparison of street and garden facade «before and after» / Street and garden view / Ground plans: third, second and first floor 1:400

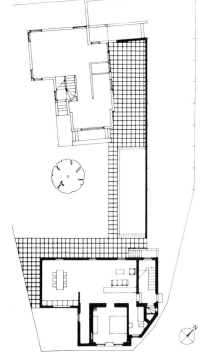

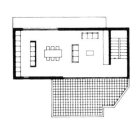 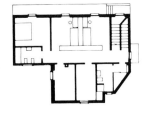

«Céramique», Maastricht
Mit Aurelio Galfetti, Mario Ferrari,
Wettbewerb, 1994–96

Wo früher in Maastricht eine Keramikwarenfabrik stand, entsteht gegenwärtig ein ganzes Stadtviertel, ein von Jo Coenen geleitetes Vorhaben mit namhaften Architekten. Neben Alvaro Siza, Aldo Rossi, Mario Botta, Oriol Bohigas u.a. gehören dazu auch Luigi Snozzi und Aurelio Galfetti mit dem vorliegenden gemeinsamen Entwurf einer ausgedehnten Wohnzeile mit ca. 170 Wohnungen. Das für die beiden Architekten vorgesehene Grundstück liegt zwischen einer großzügigen Erschließungsstraße und einer geplanten Grünanlage längs des leicht erhöhten Uferdammes der Maas. Die Längenausdehnung von 300 m ermöglicht ihnen, das beständige Interesse am Thema der ausgedehnten und rhythmisierten Wohnzeile in einem städtebaulich neuen Maßstab zu konkretisieren. So ist der Entwurf als eine weiterführende Variation zum Problem der ‹erwählten Gleichförmigkeit› eine programmatische Antithese zum ‹Variationszwang›, dem die Architekten allzuoft unterliegen. Im Unterschied zu diesem postuliert er gerade die Wiederholung eines Elementes, um den Eindruck von Monotonie nicht aufkommen zu lassen, und liegt damit im Interesse eines städtischen Atems. Der Entwurf führt damit die Gedanken zu Brissago (1970), Celerina (1973), Monte Carasso/Verdemonte (1974) in direkter Linie weiter (vgl. S. 42, 45, 48), zeigt dabei aber neue Möglichkeiten, wie sich die aus einem Element aufgebaute Großform zur Erzeugung sowohl hoher urbanistischer Qualitäten als auch neuartiger Wohnungstypen verwenden läßt. Der Entwurf sieht zwölf identische und ohne Betonung der Enden aufeinanderfolgende Abschnitte vor. Über den sechs Normalgeschossen erheben sich 12 Paare von Maisonette-Wohnungen mit dazwischenliegenden

«Céramique», Maastricht
With Aurelio Galfetti, Mario Ferrari,
competition, 1994–96

At the site of a former ceramic factory an entire city quarter is currently under construction. It's an enterprise led by Jo Coenen and includes several renowned architects. Besides Alvaro Siza, Aldo Rossi, Mario Botta, Oriol Bohigas and others, Luigi Snozzi and Aurelio Galfetti are participating with their collaborate design of an expansive row of houses containing approximately 170 apartments. The property assigned to the two architects is located between a generously large access road and a park planned for along the slightly elevated embankment of the Maas river. The longitudinal expanse of 300 m enables them to make more concrete the continuing interest in the theme of the expanded and rhythmic row of houses in a new urban architectural scale. Thus, the design as an ongoing variation of the problem of the ‹chosen uniformity› is a programmatic antithesis to the ‹constraint of variation› which the architects all too often must give in to. Contrary to the latter, it postulates the repetition of an element in order to avoid the impression of monotony and thus accomodates the interest in an urban «breath». The design continues the ideas of Brissago (1970), Celerina (1973), Monte Carasso/Verdemonte (1974) in a direct line (see p. 42, 45, 48) and yet it shows new possibilities for using the large form built from one element for the creation of both high urban qualities and new types of housing. The design suggests twelve identical sequential sections without any emphasis given to their ends. Above the six normal floors, twelve pairs of maisonette apartments rise up with interstitial rooftop terraces between them by which the river-side obtains a rhythmic silhouette. The street front is structured by openings between the elements; in

Gesamtsituation

Site plan

Dachterrassen, durch welche die Fluß-Seite eine rhythmisierte Silhouette erhält. Die Straßenfront ihrerseits ist durch Einschnitte zwischen den Elementen gegliedert; an einigen Stellen markieren diese die öffentlichen Passagen zwischen Straße und Flußpromenade. Die urbanistische Bedeutung dieser Einschnitte ist dabei ein Element, ihre Funktion für die Wohnungsgrundrisse ein anderes. Sie belichten in den Normalgeschossen die Mittelzone der Wohnungen und ermöglichen damit einen neuartigen Grundrißtyp von großer Bautiefe (15,5 m), bei dem die Haupträume sich Z-förmig von dieser natürlich belichteten Mittelzone (Bad. Küche, WC) aus entwickeln. Dieser Zuschnitt schafft nicht zuletzt eine ständige ‹Präsenz› des Straßenraums beim Wohnen, mithin eine städtische Qualität.

some places they mark the public passageways between the street and the river promenade. The urban meaning of these openings is one element. Their function for the apartment ground plans is yet another. On the normal floors they let light into the central zone of the apartments. Thus they allow a new kind of ground plan type with a large building depth (15.5 m) in which the main rooms develop in a Z-shape away from this naturally lit middle zone (bathroom, kitchen, lavatory). This layout creates a constant ‹presence› of the street space within the living space which represents an important urban quality.

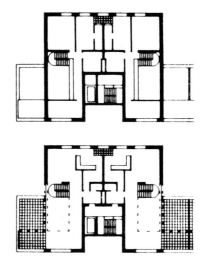

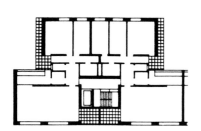

Grundrisse der Maisonette-Bekrönung und des Normalgeschosses 1:500 / Perspektive der Flußfassade / Querschnitt 1:1000 / Gesamtgrundriß 1. Obergeschoß 1:1000

Ground plans of the maisonette crowning and a typical floor 1:500 / Perspective of the river facade / Cross section 1:1000 / Overall ground plan: second floor 1:1000

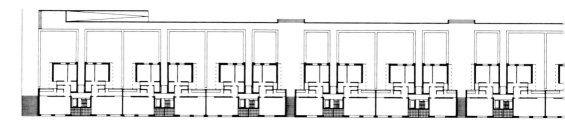

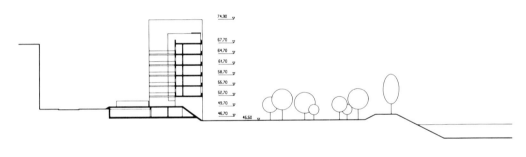

KNSM-Insel, Amsterdam
Mit Mario Ferrari und Bruno Jenni, Wettbewerb, 1995

Die KNSM-Insel ist ein schmaler Streifen im Hafengebiet Amsterdams, durch einen Damm mit dem Osthafen verbunden. Sie wird gegenwärtig als Wohngebiet aufgewertet; bereits gebaut ist u.a. ein Block des Architekten Hans Kollhoff. Das vorliegende Wettbewerbsgebiet liegt westlich des Verbindungsdamms, großenteils noch im Wasser, muß also erst noch aufgeschüttet werden. Snozzis Entwurf dokumentiert die Überzeugung, daß eine urbanistische Denkweise einen anderen Projektierungsperimeter als den vorgegebenen erfordere. Das Hauptaugenmerk des Vorschlags gilt der Stelle, wo der Damm auf die Insel trifft. Sie ist ungelöst, auch was die Beziehung zwischen den beiden Inselhälften Java (westlich) und KNSM (östlich) anbelangt. Um diese Teile klar zueinander zu definieren und dem Anschluß des Damms an die Insel eine Artikulation zu geben, führt der Entwurf als neues Element einen kleinen Bootshafen ein, der als Gelenk zwischen den beiden Inselhälften fungiert. Die Hafenöffnung wird von zwei Gebäuden definiert, dem bestehenden SHB-Gebäude, das nun aber durch die Hafenmauer eingebunden und städtebaulich wesentlich prominenter wird. Es definiert den Inselteil Java. Der andere Endpunkt ist ein Wohnbau mit Innenhof, der das südliche Pier abschließt und so als Molenbau in der Verlängerung der KNSM-Flucht die Hafeneinfahrt markiert. Die typologische Referenz für dieses ins Wasser gesetzte Hofgebäude ist das «Admiralty Storehouse» (1685) am Henrikkade (heute: Niederländisches Schiffahrtsmuseum). Dadurch, daß das Gebäude durch seine vorgeschobene Stellung Element der Insel ist und nicht die Verlängerung der vorhandenen Bebauung, bildet es den Eingang zur Insel. Es enthält in 8 Obergeschossen 139 Maisonette-Wohnungen und ist als Massivbau mit Sichtbacksteinfassaden entworfen. Sein zweigeschossiger Portikus enthält Restaurants, Läden usw. Der Platz nördlich des Hafens wird als Zäsur zwischen den beiden Inselteilen präzisiert. Die Endschleife der Straßenbahn wird als klare Kreisform vorgeschlagen. Östlich des neuen Hafens sieht der Entwurf einen schlanken Wohnbau auf Stützen vor, eine Skelettkonstruktion mit vorgehängter Fassade aus Holzpanelen (32 Wohnungen). Mit den verschiedenen Teilen des Entwurfs schafft Snozzi eine Art synthetischen Bezug zur Amsterdamer Architektur dieses Jahrhunderts: das Hofgebäude im Meer mit seiner Backsteinfassade bezieht sich dementsprechend auf die Amsterdamer Schule eines de Klerk; der langgestreckte Molenbau – als Stahlskelettkonstruktion – auf die frühere Industriearchitektur der Insel; das turmartige Wohngebäude im Park ist eine Huldigung an den Architekten Duiker.

KNSM Island, Amsterdam
With Mario Ferrari and Bruno Jenni, competition, 1995

The KNSM island is a narrow strip in the harbor area of Amsterdam, connected by a dam with the eastern harbor. It has been reevaluated in the course of the zoning policy as a housing area; a housing block by the architect Hans Kollhoff has already been constructed. The competition area in question is to the western side of the connecting dam and it is, for the most part, still under water – which means that it will first have to be filled. Snozzi's design documents the conviction that an urban way of thinking requires a projecting parameter different from the given one. The main attention of the proposal refers to the location where the dam meets the island. Its character remains unclear even when it comes to the relationship between the two halves of the island – Java to the west, and KNSM to the east. In order to define these parts clearly towards one another and to articulate the connection of the dam to the island, the design introduces a small boat harbor as a new element, which would serve as a joint between the two island halves. The harbor opening is defined by two buildings. First, the existing SHB-building which is now integrated by the harbor wall and gains in urban prominence. It defines the Java island part. The second end point is an apartment building with a courtyard which, limiting the southern pier, thus marks the harbor entrance as a pier building on the extension of KNSM. The reference for this yard building set into the water is the «Admiralty Storehouse» (1685) at the Henrikkade (today's Dutch Maritime Museum). Because the building is an element of the island due to its pushed-out position, and not an extension of the existing development, it forms the entrance to the island. It has 139 maisonette apartments on 8 floors and is designed as a massive construction with brick facades. Its two-story porticos contains inset restaurants, stores etc. The square north of the harbor is made more precise in its function as a caesura between the two parts of the island. The end loop of the tram is suggested as a clear circular shape. East of the new harbor, the design projects a narrow apartment building (32 units) on supports – a skeletal construction with a wood-paneled curtain wall. The various parts of the design create a kind of synthetic relationship to the predominant architecture of Amsterdam in this century: the yard building in the water, with its brick facade, relates on this level to the «Amsterdam school» of de Klerk; the long-stretched quay building – a steel skeleton construction – relates to the former industrial architecture of the island; the tower-like apartment building in the park is an homage to the architect Duiker.

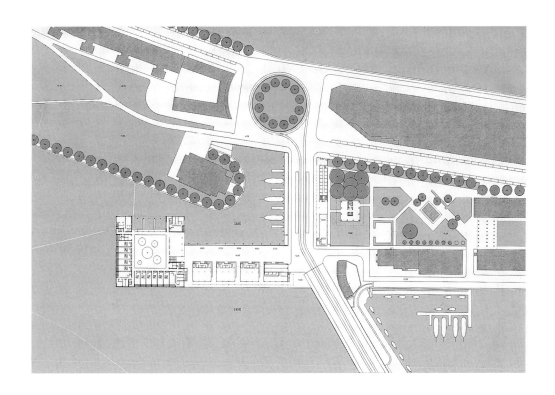

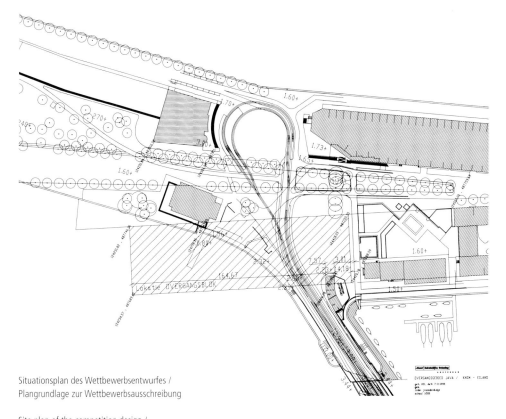

Situationsplan des Wettbewerbsentwurfes /
Plangrundlage zur Wettbewerbsausschreibung

Site plan of the competition design /
Planning basis for the competition invitation

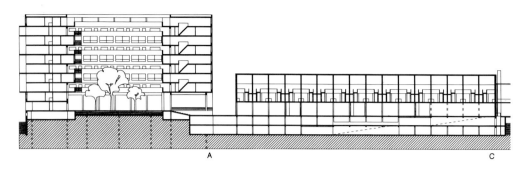

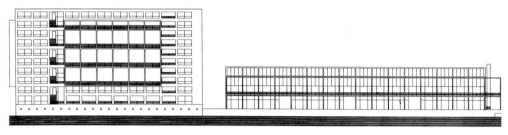

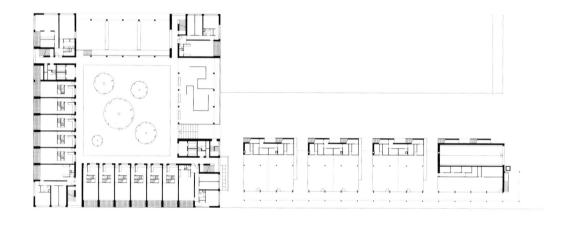

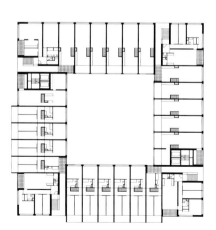

Schnitt / Fassade / Grundrisse von Obergeschoß und Erdgeschoß der Molenbauten, ca. 1:1000

Section / Facade / Ground plans: upper and first floor of the pier buildings, approx. 1:1000

Bürohaus mit Wohngebäude am Pariser Platz, Berlin

Mit Anne-Catherine Javet, Willfried Schmidt, Isabelle Valazza, Wettbewerb, 1995

Anlaß des Wettbewerbs war die Absicht der Stadt Berlin, den Pariser Platz in seinen historischen Begrenzungen wiederherzustellen und damit das seit dem Zweiten Weltkrieg freistehende Brandenburger Tor wieder zum Teil eines definierten Stadtraumes zu machen. Der Wettbewerb, zu dem Snozzi eingeladen war, wurde von einer privaten Grundstücksgesellschaft veranstaltet und betraf nur ein einzelnes Grundstück, war also nicht als städtebaulicher Wettbewerb ausgeschrieben. Das Programm verlangte umfangreiche Büroflächen und Wohnungen und setzte bei enormer Parzellentiefe zugleich eine sehr hohe Bebauungsdichte voraus. Snozzis Vorschlag ist von substantiellem Wert, was sein Verständnis vom Bauen angesichts der geradezu greifbaren Geschichtlichkeit dieses spezifischen Ortes betrifft. Ein Entwurf an einer Stelle weltpolitischer Zuspitzungen wie hier konnte für Snozzi nur bedeuten: kein bloßer Rückgriff auf vorhandene Formen und Typen, sondern die Geschichte als «Geschehenes» sichtbar zu machen. «Die vom Projekt heute geforderte hohe Bebauungsdichte verlangt neue typologische Lösungen, die sich von denen des 19. Jahrhunderts unterscheiden» (Snozzi). Die direkte Bezugnahme auf die morphologische Formel von ‹Vorderhaus – Hinterhäuser mit Lichthöfen› schien Snozzi falsch. Konstituierendes Element des Entwurfs sind die Brandmauern zu den Nachbargrundstücken, auf denen als Bezugselementen das Projekt beruht. Die Bedeutung der Brandmauern ist eine doppelte: sie prägen maßgeblich die bauliche Struktur Berlins, und sie sind Symbole geworden für Krieg und Zerstörung. Als primäre Elemente werden sie hier auf beiden Längsseiten in ihrer ganzen Ausdehnung visualisiert: die Vertikal- und Horizontalerschließungen sowie die technischen Installationen erstrecken sich hinter je einer durchgehenden Schildwand. Der Ort des Eingriffs ist durch diese beidseitige Ausfütterung definiert. Das Raumprogramm ist in fünf quergespannten Brückenbauten untergebracht (baustatischer Typus: Hängewerk). Snozzi streb-

Office Building with Apartment House at Pariser Platz, Berlin

With Anne-Catherine Javet, Willfried Schmidt, Isabelle Valazza, competition, 1995

The intention of this competition was for the city of Berlin to reestablish the Pariser Platz (Paris Square) with its historical borders thus making the Brandenburg Gate, which was free-standing since the end of World War II, once again a part of a well-defined urban space. The competition, which Snozzi was invited to, was initiated by a private property association and was concerned only with a single piece of property. Therefore, it was not published as an ‹urban competition›. The program asked for extensive office spaces and apartments and presumed both an enormous depth of the lots as well as a high density of buildings. Snozzi's proposal is of substantial value given his understanding of architecture in the face of the quite tangible historic nature of this specific location. The design for a location such as this, a site that was once the front line of world wide political confrontation, could mean only one thing to Snozzi: it could not be a mere fallback to the pre-existing forms and types, rather it would have to embrace all of this profound history and make it perceivable as a reality. «The high density of buildings demanded by the project today requires new typological solutions which are radically different from those of the 19th century» (Snozzi). The direct reference to the morphologic formula of ‹front house – back house with courtyards for light in between› seemed wrong and inappropriate to Snozzi. The fundamental component of the design is the existing fire walls abutting the neighboring properties. They are the reference points on which the project is based. The meaning of the fire walls is twofold: they decisively make their impression on the architectural structure of Berlin and they have become symbols of war and destruction. In this design, they are made manifest as primary elements in their entire expanse on both longitudinal sides: the vertical and horizontal developments as well as the technical installations each stretch out behind an uninterrupted masonry wall. The location of the operation is defined on both sides by this «lining». The spatial

Skizze zum Erläuterungsbericht / Sketch for the explanatory report

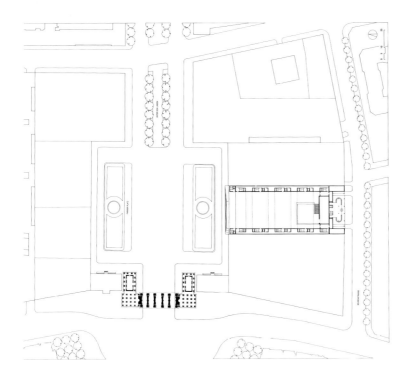

Gesamtsituation mit dem Brandenburger Tor / Längsschnitt und Grundriß Obergeschoß 1:850 / Perspektive der Halle, abgetiefter Bereich vor dem Saal

Site plan with the Brandenburg Gate / Longitudinal section and ground plan of the upper level 1:850 / Perspective of the lobby, lowered section outside of the hall

te eine konstante Bauhöhe an. In den glasgedeckten Zwischenräumen fällt von oben Tageslicht ein. Das stützenfreie Erdgeschoß und die Räume zwischen den Brücken erlauben das Erfassen des ganzen Grundstücks in seinen großzügigen Dimensionen (Länge 102 m, Breite 42 m, Höhe 20 m); sie machen den Ort zu einem außergewöhnlichen städtischen Innenraum, der, obgleich nicht ‹leer›, die Leere thematisiert. Ihn bezeichnet Snozzi als das Herz des Entwurfs. Entgegen dem vorgegebenen Programmpunkt, die Platzfassade möglichst geschlossen zu gestalten – jedoch in Übereinstimmung mit seinem Konzept – sieht das Projekt eine leicht zurückgesetzte, über die ganze Breite reichende Verglasung des Erdgeschosses vor. Die Halle enthält die Empfangsdesks der verschiedenen Nutzer und kann auch als Ort für Ausstellungen dienen. In ihrem hinteren Teil liegen um eine offene Vertiefung herum verschiedene Räume öffentlichen Charakters: Konferenzsaal, Versammlungsräume und die Cafeteria. Die Wohnungen (großzügige 1- und 2-Zimmer-Wohnungen) sind auf der Südseite in einem separat von der Behrensstraße aus erschlossenen Bauteil zusammengefaßt. Als Materialien schlägt der Entwurf Travertin für die Platzfassade und den Hallenboden vor sowie Sichtbeton für die Seitenwände und die Rückwand. Sie bilden den hohen Grad klaren Denkens und architektonischer Ordnung, von denen dieser Entwurf zeugt, auf der stofflichen Ebene ab.

program is accommodated by five transversely-stretched «bridge buildings» (stucture type: hanging truss). Snozzi was striving for a constant building height. The glass-covered interstitial spaces are lit by daylight from above. The support-free ground floor and the spaces between the bridges allow for the inclusion of the entire property with its generous dimensions (length 102 m, width 42 m, height 20 m); they turn the location into an unusual urban inner space which, although not ‹devoid›, makes the void a theme. And Snozzi describes it as the heart of the design. Contrary to the given program – to design the facade facing the square as closed as possible, yet in harmony with Snozzi's own concept – the project intends for a slightly set-back glazing of the entire width of the ground floor. The lobby contains the reception desks of the various users and may also serve as a place for exhibitions. In the rear, placed around an open depression, there are various rooms with a communal character – a conference hall, meeting rooms and the cafeteria. The apartments (generous 1- and 2-room-apartments) are contained in a part of the building developed separately from Behrensstraße on the south side. The design proposes travertine as a covering material for the facade facing the square and for the floor of the lobby, fair-faced concrete for the side walls and the back wall. This selection of materials gives testimony the high degree of clear thinking and architectural order illustrated in this design.

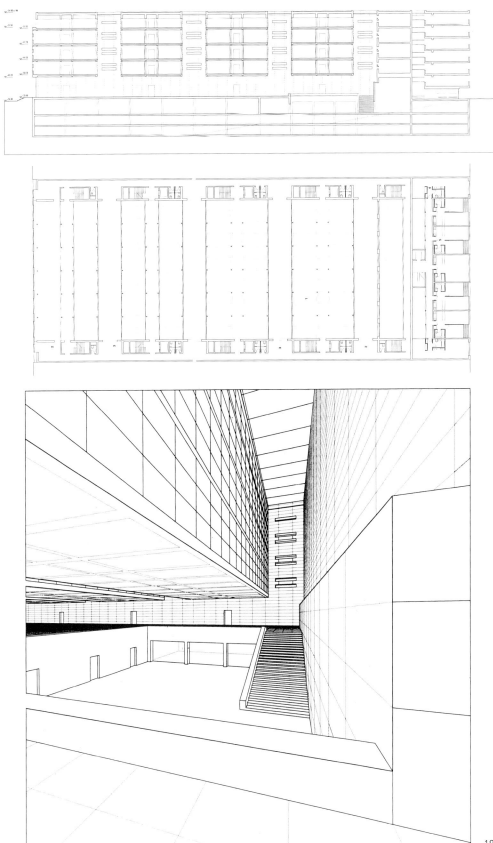

Biographie

1932	29. Juli: Luigi Snozzi geboren in Mendrisio, Schweiz
1952–1957	Architekturstudium an der Eidgenössischen Technischen Hochschule Zürich (ETH)
1957–1958	Praktika bei den Architekten Peppo Brivio (Locarno) und Rino Tami (Lugano)
1958	Eröffnung des eigenen Architekturbüros in Locarno
1962–1971	Bürogemeinschaft mit Livio Vacchini
1962–1974	Mitglied der Heimatschutzkommission «Bellezze Naturali» des Kantons Tessin; u.a. Erarbeitung von Gegenvorschlägen
1971	Mitbegründer des Partito Socialista Autonomo (PSA)
1973–1975	Gastdozent für architektonisches Entwerfen an der ETH Zürich
1975–1988	Zweites Architekturbüro in Zürich (mit Bruno Jenni)
1980–1982	Gastdozent an der Ecole Polytechnique Fédérale, Lausanne (EPFL)
1983	Wird Ehrenmitglied des «Bund Deutscher Architekten» BDA
1984–1985	Gastdozent an der EPFL
1985	Beton-Architekturpreis
1985–1997	Ordentlicher Professor für Architektur an der EPFL
1986–1988	Vorsitzender des von Johannes Voggenhuber geschaffenen «Gestaltungsbeirats» in Salzburg
1987	Gastprofessor an der SCI-ARC (Southern California Institute of Architecture), Vico Morcote (Kanton Tessin)
1988	Eröffnung eines Architekturbüros in Lausanne
1993	Beton-Architekturpreis. Monte Carasso erhält den «Wakker-Preis» für vorbildlichen Heimatschutz zugesprochen. Architekturpreis «Prince of Wales» der Harvard University, Cambridge, Massachusetts
1994	Mitglied der Akademie der Künste, Berlin Ehrenmitglied des Schweizerischen Ingenieur- und Architekten-Vereins SIA
1995	Stiftungsratsvorsitzender der SCI-ARC, Vico Morcote
1996	Schweizer Beitrag an der Architektur-Biennale in Venedig

Biography

1932	29 July: Luigi Snozzi born in Mendrisio, Switzerland
1952–1957	Studied architecture at the Swiss Federal Institute of Technology (ETH) in Zurich
1957–1958	Practical semester with the architects Peppo Brivio (Locarno) and Rino Tami (Lugano)
1958	Opening of his own architectural studio in Locarno
1962–1971	Office association with Livio Vacchini
1962–1974	Member of the Cantonal Preservationist Commission «Bellezze Naturali»; refinement of counter proposals
1971	Co-founder of the Partito Socialista Autonomo (PSA)
1973–1975	Guest lecturer for architectural design at the ETH in Zurich
1975–1988	Second architectural studio in Zurich (with Bruno Jenni)
1980–1982	Guest lecturer at the Ecole Polytechnique Fédérale, Lausanne (EPFL)
1983	Honorable member of the «Association of German Architects» (BDA)
1984–1985	Guest lecturer at the EPFL
1985	Award for concrete architecture
1985–1997	Professor for architecture at EPFL
1986–1988	Chairman of the «Design Council» in Salzburg, initiated by Johannes Voggenhuber
1987	Guest professor at the SCI-ARC (Southern California Institute of Architecture), Vico Morcote (Canton of Ticino)
1988	Opening of an architectural studio in Lausanne
1993	Award for concrete architecture. Monte Carasso receives the «Wakker-award» for exemplary regional preservation. «Prince of Wales» architectural award of Harvard University, Cambridge, Massachusetts
1994	Member of the Academy of the Arts, Berlin Honorable member of the Swiss Club of Engineers and Architects (SIA)
1995	Endowment chairman of the SCI-ARC, Vico Morcote
1996	Swiss contribution for the Architectural Biennale in Venice

Ausstellungen / Exhibitions

1975 Tendenzen. Neuere Architektur im Tessin (Gruppenausstellung/Group exhibition; ETH Zürich)

1980 Bauen 70/80 in der Schweiz (Internationale Wanderausstellung/International touring exhibition; Pro Helvetia)

1981 Panorama van de Avant-Gardes (Arnhem)

1982 Incontro con Alberto Sartoris (Stabio)

1983 La Moderne: un projet inachevé (Festival d'Automne, Paris)

1984 Luigi Snozzi (Architekturmuseum, Basel)

1986 Constructions et projets (Paris, Kopenhagen, Lausanne)

1987 Le città immaginate: un viaggio in Italia (Triennale di Milano)

1988 Luigi Snozzi: Bologna, Milano e Monte Carasso (Progetto Città, Padova)

Luigi Snozzi: Progetti e architetture (SCI-ARC, Vico Morcote)

1989 Luigi Snozzi: Architektuur-Tentoonstelling (Antwerpen)

Luigi Snozzi: Bauten und Projekte (Hochschule für Angewandte Kunst, Wien)

Monte Carasso: Un processo in atto (Monte Carasso)

Luigi Snozzi, Architekt (Pontresina)

1990 Galfetti – Snozzi – Vacchini (Helsinki)

1991–1993 Architetture recenti (Museo Vela, Ligornetto, Architekturforum Bern, EPFL Lausanne, Obec Architectu Prag)

1993 Analogie II (mit Niele Toroni. Galerie Knapp, Lausanne)

Monte Carasso (Harvard University, Cambridge, Mass.)

1994 Constructions et projets, 1972–1992 (Université du Québec Montreal; Columbia University New York)

1995 Un lugar – cuatro arquitectos: Botta, Galfetti, Snozzi, Vacchini (Caracas, Mexico-City, Buenos Aires)

1996 Auf den Spuren des Ortes (Zürich, Museum für Gestaltung)

Biennale d'architettura, Venedig

Werkverzeichnis / List of Works

1957	Semesterarbeit ETH: Hochhaus / Semester project ETH: High-Rise Building	1972	Studie Wohnbau und Bootshafen / Study for an Apartment Building and Boat Harbor Foce Sacromonte, Brissago
1958–59	Haus Lucchini / Lucchini House, Faido		
1959	Haus Stratmann / Stratmann House, San Nazzaro	1973	Wettbewerb Wohnbauten / Competition: Apartment Buildings, Celerina
1961	Projekt Haus Rotalinti / Project: Rotalinti House, Bellinzona	1972–76	Haus Kalman / Kalman House, Brione s/Minusio
1962	Projekt Haus Siodmak / Project: Siodmak House, Ascona	1973–78	Gemeindehaus und Primarschule / Community House and Primary School, San Nazzaro
1961–63	Haus Sargenti / Sargenti House, Vira	1974	Projekt Wohnbau / Project: Housing Development Verdemonte, Monte Carasso
1961–63	Apartmenthaus Verna / Verna Apartment Building, Muralto		
1961–63	Restauration Kirche / Church Restoration, Muralto	1974	Wettbewerb Wohnhäuser / Competition: Apartment Houses, Rancate (mit / with M. Botta)
1962–65	Sozialwohnbau / Social Housing, Locarno (mit / with L. Vacchini)	1974–79	Restauration Kloster Madonna del Sasso / Restoration of the Madonna del Sasso Monastery, Orselina
1962–65	Bürogebäude Fabrizia / Office Building Fabrizia, Bellinzona (mit / with L. Vacchini)		
1963–65	Häuser Taglio / Taglio Houses, Orselina (mit / with L. Vacchini)	1975–77	Haus Bianchetti / Bianchetti House, Locarno-Monti
1964–66	Haus Snider / Snider House, Verscio (mit / with L. Vacchini)	1975	Wettbewerb Schule / Competition: School Building, Minusio
1967–70	Wohnbau / Apartment Building, Carasso (mit / with L. Vacchini)	1976	Studie Brücke / Study for a Bridge, Golino
1969	Wettbewerb Schulhaus / Competition: School Building, Mesocco	1976	Wettbewerb Psychiatrische Klinik / Competition: Psychiatric Clinic, Münsterlingen
1969	Wettbewerb Hauptbahnhof / Competition: Central Railroad Station, Zürich (Kollektivarbeit / collective work)	1976	Wettbewerb Sportzentrum / Competition: Sports Complex, Tenero
		1976–78	Haus Cavalli / Cavalli House, Verscio
1970	Wettbewerb Primarschulhaus / Competition: Primary School Building, Locarno	1976–77	Planung Centro Storico / Planning of the Centro Storico, Locarno (mit / with T. Carloni, L. Vacchini)
1970	Wettbewerb EPFL / Competition: EPFL, Lausanne (mit / with M. Botta, T. Carloni, A. Galfetti, F. Ruchat)	1977–79	Ladengeschäft Costantini / Costantini Store, Minusio
		1977–79	Zentrums- und Richtplan / Center and Master Plan, Monte Carasso
1970–74	Projekt Überbauung / Project: Al Rabissale Development, Minusio	1978	Wettbewerb Primarschule / Competition: Primary School, Montagnola
1971	Wettbewerb Verwaltungszentrum / Competition: Administrative Center, Perugia (mit / with M. Botta, I. Gianola) (I)	1978	Wettbewerb Erweiterung Hauptbahnhof / Competition: Expansion of the Main Station, Zürich (mit / with M. Botta)
1971	Wettbewerb Golfclub / Competition: Golf Club, Ascona	1979	Wettbewerb Papierwerdareal / Competition: Papierwerdareal, Zürich
1971	Projekt Apartmenthaus Martinelli / Project: Martinelli Apartment Building, Lugano	1979	Braunschweig: Eine Utopie für die Stadt / Braunschweig: a Utopia for the City
1972	Projekt / Project: Bianchetti I, Locarno-Monti	1980	Wettbewerb Piazza del Sole / Competition: Piazza del Sole, Bellinzona

1981	Wettbewerb Klösterli-Areal / Competition: Klösterli-Area, Bern	1987–93	Restrukturierung und Umbau des Convento / Restructuring and Conversion of the Covento, Monte Carasso
1981	Wettbewerb Kunstmuseum und Bibliothek / Competition: Museum and Library, Chur	1987	Studie Überbauung Porta Genova / Study for the Development of the Porta Genova, Milano (Beitrag für / Contribution to the Triennale Milano) (I)
1981	Wettbewerb Kasernenplatz / Competition: Kasernenplatz, Luzern		
1981	Wettbewerb Centro Patriziale / Competition: Centro Patriziale, Losone	1987	Wettbewerb Dorfplatz / Competition: Village Square, S. Candido (I)
1981–84	Raiffeisenkasse / Raiffeisen Bank, Monte Carasso	1987–91	Wettbewerb und Weiterbearbeitung Bürogebäude Ilôt-Riponne / Competition and Continuation of an Office Building Ilôt-Riponne, Lausanne
1982	Wettbewerb Bibliothek / Competition: Library, Thun		
1982–84	Turnhalle und Garderobengebäude / Gymnasium and Locker Room Building, Monte Carasso	1987–88	Wettbewerb Spital / Competition: Hospital, Montreux
		1988	Haus Walser / Walser House, Loco
1982–84	Restaurant Haus Franzoni-Balli / Franzoni-Balli House Restaurant, Locarno	1988	Haus Morisoli / Morisoli House, Monte Carasso
1983	Wettbewerb Telecom-Bürohaus / Competition: Telecom Office Building, Bellinzona	1988	Wettbewerb Postgebäude / Competition: Post Office Building, Locarno
		1988–89	Haus Bernasconi / Bernasconi House, Carona
1983	Wettbewerb Bahnhof / Competition: Central Railroad Station, Bologna (I)	1988	Restrukturierung EPFL / Restructuring: EPFL, Lausanne
1983	Haus F. Guidotti / F. Guidotti House, Monte Carasso	1988	Wettbewerb Architekturmuseum / Competition: Museum of Architecture, Rotterdam
1983–93	Wettbewerb und Ausführung Pfarreizentrum / Competition and Realization: Parish Center, Lenzburg	1988	Wettbewerb Quartier / Competition for a Quarter, Scheveningen
		1988–90	Haus Diener / Diener House, Ronco
1983–84	Haus Heschl / Heschl House, Agarone	1989–90	Wettbewerb Piazza Grande / Competition: Piazza Grande, Locarno
1983/90	Ausbau Friedhof / Expansion of the cemetery, Monte Carasso		
		1989	Haus / House, Porza
1984	Schließfächer und Sportplatz / Locker Room and Sports Field, Monte Carasso	1989	Projekt / Project: Märki Shopping Center, Giubiasco
1984	Wettbewerb Wohnhausblock / Competition: Apartment Block, Wien (A)	1989	Projekt Umbau Haus Rapetti / Project: Conversion of Rapetti House, Monte Carasso
1984	Projekt Reihenhäuser / Project: Row Houses Büchel, Brione s/Minusio	1989	Projekt: Häuser Cerri/Joppini / Project Cerri/Joppini Houses, Roveredo
1984	Wettbewerb Strickmaschinenareal / Competition: Knitting Factory grounds, Schaffhausen	1989	Studie Quartier Semblanet / Study for the Semblanet Quarter, Martigny
		1989–91	Doppelhaus Guidotti / Guidotti Double House, Monte Carasso
1985	Haus Barbarossa / Barbarossa House, Minusio		
1985	Wettbewerb Theaterplatz / Competition: Theaterplatz, Frankfurt (D / G)	1989–97	Quartier Morenal / Morenal Quarter, Monte Carasso
1985–87	Apartmenthaus Bianchini / Apartment Building Bianchini, Brissago	1990	Projekt Wohnhaus Kirchgemeinde / Project: Church Community Apartment Building, Monte Carasso
1986	Wettbewerb Regierungszentrum des Département du Bas-Rhin / Competition: Government Center of the Département du Bas-Rhin, Straßburg (F)	1990–91	Wettbewerb Pfarreizentrum St. Florin / Competition: St. Florin Parish Center, Vaduz (FL)
		1990	Wettbewerb Geschäfts- und Wohnhaus / Competition: Office and Apartment Building, Sursee
1987	Wettbewerb Regierungsviertel / Competition: Government Quarter, Vaduz (FL)		
1987	Wettbewerb Marienhof Platz/ Competition: Marienhof Platz, München (D / G)	1990	Projekt Geschäftshaus Curti / Project Curti Office Building, Feldmeilen

1990	Studie Bahnhofplatz und Volkshochschule / Study for the Station Square and Adult Evening School, Pforzheim (D / G)
1990	Wettbewerb Schulhaus / Competition: School Building, Sementina
1991	Master Plan: Le Bouveret
1991	Projekt Bezirksspital / Project: District Hospital, Sully
1991	Projekt Haus Bläuer / Project: Bläuer House, Sissach
1991	Wettbewerb Lido / Competition: Lido, Brissago
1991	Wettbewerb Centre d'Art Contemporain / Competition: Centre d'Art Contemporain, Lausanne
1991	Projektstudie Häuser Morlana / Project Study for Morlana Houses, Bergamo (I)
1991	Wettbewerb Place Montcalm / Competition: Place Montcalm, Nîmes (F)
1992	Projekt Haus Veronese / Project: Veronese House, Malvaglia
1992–95	Haus Cassina / Cassina House, Bellinzona
1992	Projekt Verwaltungsgebäude Wohnbaugesellschaft / Project: Administrative Building for a Housing Corporation, Pforzheim (D / G)
1992	Wettbewerb Sulzer Quartier / Competition: Sulzer Quarter, Winterthur
1992–95	Doppelhaus Giannini / Salzborn / Giannini / Salzborn Double House, Cureglia
1992	Projekt Haus Cattani / Project: Cattani House, Jesi/Ancona (I)
1992	Studie Stadtviertel Ticosa / Study for a Quarter in Ticosa, Como (I)
1993	Umbau Haus d'Andrea / Conversion: d'Andrea House, Monte Carasso
1993	Systematisierung und Bebauungsstudie / Structuring and Development Study, Rekem (B)
1993	Haus M. Guidotti / M. Guidotti House, Monte Carasso
1993	Wettbewerb UEFA / Competition: UEFA, Nyon
1993	Projekt Wohnüberbauung «Céramique» / Project: Housing Development «Céramique», Maastricht (mit / with A. Galfetti) (NL)
1993	Wettbewerb Kantonale Verwaltung / Competition: Canton Administration, Bellinzona
1995	Studie Schulhaus / Study for a School Building, Bidogno
1995	Wettbewerb Fondachhof / Competition: Fondachhof, Salzburg (A)
1995	Wettbewerb Pariser Platz 3 / Competition: Pariser Platz 3, Berlin (D / G)
1995	Wettbewerb Klingelhöferdreieck / Competition: Klingelhöferdreieck, Berlin (D / G)
1995	Wettbewerb Wohnüberbauung KNSM-Insel / Competition: Housing Development KNSM-Island, Amsterdam (NL)
1995	Systematisierung «RT 1» / Structuring «RT 1», Monte Carasso
1996	Städtebaulicher Ideenwettbewerb / Urban Ideas Competition, Würzburg (D / G)
1996	Wettbewerb Museumseinbau Alter Hafen / Competition: Museum Installation Alter Hafen, Würzburg (D / G)
1996	Wettbewerb Kasernenareal / Competition: Barracks Quarter, Zürich
1996	Wettbewerb Klinik / Competition: Clinic Lavey-les-Bains

Auswahlbibliographie / Selected Bibliography

Hinweise:
- Vornamen von wiederholt erwähnten Autoren sind bei der ersten Erwähnung ausgeschrieben und ab der zweiten Erwähnung mit Initialen angegeben.
- Erscheinungsorte von Periodika werden nur einmal vermerkt.
- Hinweise ‹in spitzen Klammern› geben den thematischen Kontext an.

Notes:
- The first names of repeatedly mentioned authors are spelled out when first mentioned; after that they are indicated by initials.
- The location of the publication of periodicals is mentioned only once.
- Notes in ‹these parentheses› indicate the thematic context.

1. Veröffentlichungen von Luigi Snozzi / Publications by Luigi Snozzi

«Case Popolari der Gemeinde Locarno»,
 in: Werk (Zurich) 5/1967, pp. 264–265.
«Wiederherstellung der Pfarrkirche von Brissago»,
 in: Werk 9/1967, pp. 533–535.
«Verwaltungsgebäude Fabrizia SA, Bellinzona»,
 in: Werk 9/1967, pp. 539–41.
«Eigentumswohnungen via Caselle, Orselina»,
 in: Werk 9/1967, pp. 541–3.
«Case Popolari der Gemeinde Locarno: eine Reportage», in: Werk 5/1969, pp. 296–300.
«Progetto '31771' menzione speciale» ‹Perugia›,
 in: Controspazio (Milan) 1–2/1972,
 pp. 38–41 (with M. Botta, I. Gianola).
«Struttura portuale e residenziale alla foce del Sacromonte, Brissago», in: Rivista Tecnica (Bellinzona) 24/1973, pp.1157–1159.
«Presentazione di un corso di architettura»,
 in: Rivista Tecnica 9/1975, pp. 30–82.
«Entwurfsmotivationen», in: Tendenzen.
 Neuere Architektur im Tessin (exhibition catalogue, ETH Zurich 1975), pp. 46–50.

«Concorso per un insediamento abitativo a Rancate»,
 in: Casabella (Milan) 414/1976, pp. 36–37
 (with M. Botta).
«Case a Celerina», Lotus International (Milan) 15/1977, pp. 114–117.
«Zwei Wohnhäuser im Tessin»,
 in: Werk/Archithese (Zurich) 9/1977, pp. 55–58.
«Casa a Locarno-Monti e a Brione s/Minusio»,
 in: Rivista Tecnica 12/1977, pp. 18–23.
L. Snozzi et al.: «Hosianna – oder Barbarei»,
 in: Werk/Archithese 25–26/1979, pp. 37–47.
«Il complesso architettonico del Sasso nel suo sviluppo storico», in: G. Pozzi (Ed.): La Madonna del Sasso fra storia e legenda. Locarno 1980, pp. 269–333.
«La lecture d'un monument» ‹Madonna del Sasso, Locarno›, in: Archithese (Zurich) 1/1981, pp. 10–17.
«Leserbriefe: Architekten als Umweltzerstörer»,
 in: Tages-Anzeiger Magazin (Zurich) 17/1981, pp.2.
«Madonna del Sasso a Orselina. Sviluppo storico e lavori di restauro»,
 in: Rivista Tecnica 5/1981, pp. 35–46.
«Betrachtungen über die Solothurner Gruppe»,
 in: Werk/Bauen+Wohnen (Zurich) 7–8/1981,
 pp.14–16.
«Une heureuse trouvaille» ‹Bibliothèque des Pâquis, Genève›, in: Werk/Bauen+Wohnen 10/1981,
 pp.38–42.
«Überlegungen zu Ernst Gisels Werk»,
 in: Werk/Bauen+Wohnen 7–8/1982, pp.19–25.
«Municipio e scuole comunali a San Nazzaro»,
 in: Rivista Tecnica 10/1982, pp. 42–49.
«Il sito, la natura e le opere dell'uomo»,
 in: Abitare (Milan) 206/1982, pp. 96–111.
«Concorso per la nuova sedia amministrativa della Direzione dei Telefoni a Bellinzona»,
 in: Rivista Tecnica 3–4/1983, pp. 60–62.
«Progetti per il museo e la biblioteca cantonale – Coira», in: Rivista Tecnica 5/1983, pp. 60–63.
«Edificio residenziale a Monte Carasso», in: Rivista Tecnica 9/1983, pp. 42–47.
«Concorso per un centro parrocchiale a Lenzburg»,
 in: Rivista Tecnica 11/1983, pp. 50–55.
«Chiesa parrocchiale di Brissago», in: Rivista Tecnica

7–8/1983, pp. 65–69.
«*Schweizer Tendenzen*», in: H. & M. Bofinger (Ed.): Junge Architekten in Europa (Stuttgart 1983), p. 44.
«*Die Tendenza*», in: Aktuelles Bauen (Solothurn), 10/1983, p.78–82.
«*Der Ort oder die Suche nach der Stille*», in: Archithese 3/1984, pp. 23–27.
«*Il centro monumentale di Monte Carasso*», in: Rivista Tecnica 12/1984, pp. 38–49.
«*Promenade architecturale, Minusio*», in: L'Architecture d'Aujourd'hui (Paris), 236/1984, pp. 34–35.
«*Stazione di Bologna*», in: Rivista Tecnica 1–2/1985, pp. 56–57.
«*Casa a Gerra Piano-Agarone*», in: Rivista Tecnica 4/1985, pp. 42–45.
«*Palestra, depositi comunali e centrale termica, Monte Carasso*», in: Premio architettura Beton 85, Zurich 1985, pp. 27–35.
«*Casa d'abitazione, Locarno-Monti*», in: AS/Architecture Suisse (Pully/Lausanne) 69/1985, pp. 1–4.
«*Beton: Gespräch mit Aurelio Galfetti, Luigi Snozzi und Livio Vacchini*», in: Archithese 2/1986, pp. 4–14, 32.
«*Palazzo del dipartimento a Strasburgo*», in: Rivista Tecnica 4/1987, pp. 56–59.
«*Projeter pour la ville, leçon inaugurale*», in: Polyrama (Lausanne) 75/1987, pp. 57–65.
«*Area di progetto Porta Genova*», in: Lotus International 54/1987, pp.104–105 (with M. Arnaboldi, R. Cavadini).
«*Casa Franzoni-Balli in Locarno, Restaurant im ehemaligen Hof*», in: Detail (Munich) 2/1987, pp. 139–144.
«*Das Unding über den Geleisen*» (lecture) in: H-J. Rieger/Th. Zahnd (Ed.), «*Das Unding über den Geleisen. Zum Projekt HB Südwest in Zürich*» Zurich 1987, pp. 9–56.
«*Traum und Wirklichkeit einer Kommission*» ‹Salzburg›, in: Werk/Bauen+Wohnen 3/1988, pp. 26–37 (with Paolo Fumagalli).
«*Casa a Minusio, 1987*», in: Rivista Tecnica (Bellinzona) 11/1988, pp. 27–29.
«*Eine Stadt entwerfen*» ‹german translation of inaugural lecture 1986›, in: Du (Zurich) 11/1989, pp. 106–119.
«*Projekte für St. Pölten*», in: Internationales Architektursymposium der Landeshauptstadt St. Pölten, 1989, pp. 50–55.
«*Centro artigianale e commerciale a Giubiasco 1989*», in: Rivista Tecnica, 6/1990, pp. 20–22.
«*Riassetto di piazza Grande a Locarno*», in: Rivista Tecnica 7–8/1990, pp. 4–5.
«*Territorio, ambiente e istituzioni. Proposta per un piano regolatore*», in: Clessidra 1/1990, pp. 2–5.
«*Casa Walser*», in: AS/Architecture Suisse (Lausanne) 94/1990, pp. 11–14.
«*Due case a Roveredo/GR, 1989*», in: Rivista Tecnica 5/1991, (n.p.)
«*Intelligente Kompromisse*», in: P. Disch (Ed.): Architektur der Deutschen Schweiz 1980–1990. Lugano 1991, pp. 20–21.
«*L'architettura del lago. Piano di sistemazione di Le Bouveret 1991. Progetto per il lido di Brissago*», in: Rivista Tecnica 7–8/1992, pp. 29–31, 35–37.
«*Le Bouveret, projet de développement*», in: IAS/Ingénieurs et Architectes Suisses (Lausanne) 7/1992, pp. 117–123.

2. Veröffentlichungen über Luigi Snozzi / Publications on Luigi Snozzi

2.1 Monographien / Monographs

Pierre Alain Croset (Ed.): «*Luigi Snozzi, progetti e architetture 1957–1984*». Milan 1984.
Luigi Snozzi: «*Urban renewal at Monte Carasso*». Exhibition catalogue, 9 H Gallery, London 1986.
Hans-Jörg Rieger, Thomas Zahnd (Ed.): *Das Unding über den Geleisen*. HB-Südwest-Debatte. POCH-Verlag, Zurich 1987.
«*Luigi Snozzi und das Politische in der Architektur*», in: Du (Zurich) 11/1989 , pp. 11–119, (monographical issue, contributions by Dieter Bachmann, Ursula Koch, Helen Meier, Werner Oechslin, L. Snozzi, Vladimir Spacek, Johannes Voggenhuber).
«*Snozzi, Vacchini, Galfetti: Three Ticino Architects, 60–90*», Exhibition catalogue, Helsinki 1990.
C. Negrini, P.-A. Croset, G. Groisman (Ed.): «*Luigi Snozzi*», in: Rivista Tecnica 3/1990, pp. 9–70.
Peter Disch (Ed.): Luigi Snozzi. Costruzioni e progetti/Buildings and projects 1958–1993. Lugano 1994.
Luigi Snozzi: Monte Carasso. *La reinvenzione del sito/Die Wiedererfindung des Ortes.* Basel 1995.
Un lugar – cuatro arquitectos: Botta, Galfetti, Snozzi, Vacchini. Exhibition catalogue, Caracas/Venezuela 1995.
Claude Lichtenstein (Ed.): Luigi Snozzi. *Auf den Spuren des Ortes.* Ein Gespräch in und um Monte Carasso. Exhibition catalogue, Museum für Gestaltung Zürich, 1996.

Gabriele Basilico: Monte Carasso: *La ricerca di un centro.* Un viaggio fotografico di Gabriele Basilico con Luigi Snozzi. Exhibition catalogue, Biennale Venezia 1996, Baden 1996.

2.2. Zeitschriften und Sammelbände /
 Periodicals and survey publications

«Haus Snider, Verscio», in: Werk (Zurich) 12/1967, pp. 784–785.
Tita Carloni: *«Studien für einen Richtplan des historischen Zentrums von Bellinzona»*, in: Werk 3/1968, pp. 141–149.
Jul Bachmann/Stanislaus von Moos: New Directions in Swiss Architecture (New York 1969) pp. 30, 43, 44, 71, 75, 76.
«Gruppo Ticino: Botta, Carloni, Galfetti, Ruchat, Snozzi», in: Werk 10/1970, pp. 656–657.
«Concorso per un quartiere abitativo Celerina», in: Rivista Tecnica (Bellinzona) 20/1973, pp. 988–998.
«Concorso per una casa dei bambini e un centro comunale a San Nazzaro», in: Rivista Tecnica 4/1974, pp. 51–53.
«Snider House, Kalman House, Bianchetti House», in: a + u (Tokyo) 69/1976, pp. 52–69.
Mario Botta: *«Un' occasione mancata, analisi critica del concorso di Tenero»*, in: Rivista Tecnica 4/1977, pp. 27–33.
Bruno Reichlin/Martin Steinmann: *«Die Architektur der Landschaft»*, in: F. Achleitner (Ed.): Die Ware Landschaft. Eine kritische Analyse des Landschaftsbegriffs. Vienna 1977, pp. 49–57.
P. A. Croset: *«Dorigny: La question théorique de l'architecture»*, in: Habitation (Lausanne) 11/1978, pp. 3–8.
M. Botta: *«La signification de l'environnement construit et naturel»*, in: Werk/Bauen+Wohnen (Zurich) 12/1980, pp. 36–39.
Ulrike Jehle-Schulte Strathaus: *«Ausstellung: Heile Welt der Schweizer Architektur»*, in: Werk/Bauen+Wohnen 6/1981, p. 8.
Renato Magginetti: *«Concorso di Piazza del Sole: contributo per un dibattito»*, in: Rivista Tecnica 8/1981, pp. 35–46.
Frank Werner: Die vergeudete Moderne. Stuttgart 1981, p. 199.
Heinrich Helfenstein: *«Architektur der Schweiz. Synopsis der Architektur in der Schweiz nach 1950»*, in: Archithese 1/1982, pp. 7–11.

«Il viottolo fra casa e paese», in: Abitare (Milan) 206/1982, pp. 42–43.
G.P.: *«Progetto di concorso per museo e biblioteca a Coira»*, in: Casabella (Milan) 484/1982, pp. 34–35.
Mirko Zardini, *«Il concorso per il nodo ferroviario di Bologna»*, Casabella 497/1983, pp. 12–23.
T. Carloni: *«50 anni di architettura in Ticino 1930–1980»*, in: Quaderno della Rivista Tecnica (Bellinzona), 1983, pp. 4–11.
T. Carloni: *«Tra conservazione e innovazione. Appunti sull'architettura nel cantone Ticino dal 1930 al 1980»*, in: SIA/Schweizer Ingenieur und Architekt (Zurich) 10/1983, pp. 161–167.
Paulhans Peters: *«Experimente: zwei Veranstaltungen, die etwas über scheinbar alte und scheinbar neue Entwurfsmethoden aussagen»*, in: Baumeister (Munich) 8/1983, pp. 730–732.
M. Botta, S. von Moos, T. Carloni: *«Dibattito sulla ricerca»*, in: Rivista Tecnica 7–8/1984, pp. 27–28.
Kenneth Frampton: *«L'opera di Luigi Snozzi 1957–1984»/«Die Arbeit Luigi Snozzis von 1957–1984»*, in: P. A. Croset (Ed.): Luigi Snozzi 1957–1984 (Milan 1984) pp. 9–29.
Vittorio Gregotti: *«Sulle tracce dell'architettura»/«Auf den Spuren der Architektur»*, in: P.-A. Croset (Ed.): Luigi Snozzi 1957–1984 (Milan 1984) pp. 31–35.
Max Bosshard et al:: *«Die Quadratur des Ortes»*, in: Archithese 3/1984, pp. 28–32.
Raffaele Cavadini: *«Das Tessin und die Tendenza: einige Bemerkungen»*, in: Aktuelles Bauen (Solothurn) 7/1984, pp. 21–5.
T. Carloni, *«Für Luigi Snozzi»*, in: Werk/Bauen+Wohnen 1–2/1985, pp. 18–9.
R, Cavadini et al.: *«Dieci anni dopo Tendenzen»*, Rivista Tecnica 1–2/1985, pp. 26–41.
Gerardo Zanetti, *«Luigi Snozzi: Dreissig Jahre Widerstand»*, in: D. Bachmann/G.Zanetti (Ed.): Architektur des Aufbegehrens, Bauen im Tessin (Basel 1985) pp. 93–111.
Jacques Gubler: *«Conversation avec Luigi Snozzi»*, in: AS/Architecture Suisse (Lausanne) 69/1985, pp. 1–4.
Paolo Fumagalli: *«Eine Konfrontation, die nicht stattfindet»*, in: Werk/Bauen+Wohnen 7–8/1986, pp. 9–13.
Micha Bandini: *«An Architecture of Radical Beauty»*, and: *«Notes on a Design Process»*, in: Luigi Snozzi. Urban renewal at Monte Carasso. Exhibition catalogue, 9 H Gallery, London 1986.
Dieter Bachmann: *«Gründer, Schüler, Epigonen»*, in: Du (Zurich) 546/1986, pp. 62–67, 71–72.

Florence Kohler: *«Trois architectes au Tessin. Luigi Snozzi à Monte Carasso»*, in: AMC Architecture Mouvement Continuité (Paris) 12/1986, pp. 3–17.

Irma Noseda: *«Eingriffe. Casa Franzoni-Balli, Locarno»*, in: Archithese 6/1986, pp. 66–68.

Jonel Schein: *«Concours pour l'hôtel du département, Strasbourg»*, in: L'Architecture d'Aujourd'hui (Paris) 250/1987, pp. 15–18.

Claudia D. Berke: *«Luigi Snozzi: eine Architektur der Beziehungen»*, in: Der Architekt (Stuttgart) 12/1987, pp. 580–583.

M. Zardini: *«Il moderno va in città, una conversazione con Luigi Snozzi»*, in: Casabella 534/1987, pp. 16–17.

M-R. N.: *«Modernismi ja paikan henki»*, in: Arkkitehti (Helsinki) 3/1987, pp. 45, 64–67.

Darl Rastorfer: *«Architects of the Ticino»*, in: Architectural Record (New York) 4/1987 pp. 110–117.

Peter Buchanan: *«Constructing order Ticino Luigi Snozzi and Livio Vacchini»*, The Architectural Review (London) 1095/1988, pp. 35–45.

«Dibattito sulla ricerca. Tavola rotonda con Livio Vacchini, Luigi Snozzi, Claudio Negrini», in: Rivista Tecnica 7–8/1988, pp. 37–43.

Egbert Koster: *«Tendenzen in Tessin. Recente Tessiner architectuur»*, in: De Architect (s'Gravenhage) September 1988, p. 118–127.

T. Carloni: *«Il frammento»*, in: Abitare 263/1988, pp. 194–205.

Wim J. van Heuvel: *«Het werk van Luigi Snozzi. Hoogtepunt in Modulex-reis naar Tessin»* in: AB/Architectuur/Bouwen (Rijswijk) 6–7/1988, pp. 59–62.

Ruud Brouwers, Bernard Colenbrander: *«6 designs for the Dutch Architectural Institute»*, Rotterdam 1988, pp. 7, 68–79.

Frank Werner, Sabine Schneider: *«Neue Tessiner Architektur»*, Stuttgart 1989, pp. 17–18, 128–143, 170–171.

Piet Gellynck: *«Het Experiment Monte Carasso»*, in: Ruimte voor Kwaliteit (Brussels) 1990, pp. 42–74.

Sigrid Hanke: *«Die Natur erträgt nur die Wahrheit»* ‹Walser House›, in: das Ideale Heim (Zurich) 7–8/1990, pp. 40–45.

P. A. Croset: *«Architetture di Luigi Snozzi»*, in: Casabella 567/1990, pp. 4–22.

Giuseppe Curonici, Plinio Martini, Tita Carloni, Gerardo Zanetti: *«Die moderne Architektur in der italienischen Schweiz»/«Le mouvement moderne dans la Suisse italienne»*, in: Ca'nossa, Basel 1990, pp. 5–13.

«Element der Landschaft – Haus Diener in Ronco, Tessin», in: Architektur aktuell (Vienna) 137/1990, pp. 50–53.

«Casa con vista sopra Ascona», in: Abitare, 293/1990, pp. 114–123.

Carlo Negrini, P.-A. Croset, L. Snozzi, G. Groisman: *«La ricerca recente di Luigi Snozzi»*, in: Rivista Tecnica 3/1990, pp. 9–70.

Jean Goossens: *«Variaçoes sobre o tema da estrela»*, in: J. Geys, P. Coessens, J.Goossens: Jef Geys. Architectuur als Begrenzing. Bienal Sao Paulo 1991. Gent 1991, n.p.

«Luigi Snozzi: Bernasconi House, Diener House», in: European Masters 3 – Housing Architecture. Barcelona 1991, pp. 194–212.

Wolfgang Amsoneit: *«Switzerland-Schweiz-Suisse»*, in: Contemporary European Architects. Köln 1991, pp. 42–47.

Franco Patà: *«L'esperienza di Monte Carasso, intervista al sindaco Flavio Guidotti»*, in: Archithese 6/1991, pp. 62–64.

Nina Rappaport: *«Bellinzona. Nina Rappaport on a historic town that has embraced modern architecture»*, in: Architecture Today (London) 20/1991, pp. 8, 9, 12.

Vincent Mangeat, Aurelio Galfetti, L. Snozzi, Giovanni Bruschetti: *«Vincent Mangeat: Architetture. Dibattito: ... a proposito della città»*, in: Rivista Tecnica 11/1992, pp. 5–7.

B. O.: *«Gestaltung des Sulzer-Areals in Winterthur»*, in SIA Schweizer Ingenieur und Architekt (Zurich) 47/1992, pp. 896–902.

Alberto Sartoris: *«L'architettura creativa in Ticino»*, in: G.Bonalumi, S. Caratti: L'almanacco 1993. Bellinzona 1992, pp. 112–120.

Bruno Jenni, Martin Steinmann, Peter Zumthor: *«Umbau der Innenstadt»*, in: Irma Noseda (Ed.): Bauen an Zürich (Bauamt II, Zurich 1992), pp. 21–29.

Ursula Koch, Hans Kollhoff, Luigi Snozzi: *«Das Hochhaus in Zürich – ein Gesprächsthema»*, in: I. Noseda (Ed.): Bauen an Zürich (Bauamt II, Zurich 1992), pp. 48–57.

«Modernidad clàsica. Mirador arquitectonico», in: Architectural Houses – Casas en la montana (Barcelona 1992), pp. 148–159, 178–185.

«Premio Wakker 1993 al comune di Monte Carasso», in: Rivista Tecnica 3/1993, pp. 84–85.

P.-A. Croset: *«Luigi Snozzi a Monte Carasso 1978–1992»*, in: Anastasia Gilardi (Ed.): Monte Carasso 1912–1992. Bellinzona 1993, pp. 155–176.

Klaus Kinold: *Ich will Architektur zeigen, wie sie ist.* Düsseldorf 1993, pp. 137–144.

A. Sartoris: *«L'architettura creativa in Ticino»*, in: Controspazio – Architettura Urbanistica (Milan) 3/1993, pp. 62–69.

Nico Ventura: *«Stazioni ferroviarie per la città di oggi»*, in: Casabella 606/1993, p. 21.

Ana Luiza Nobre: *«Snozzi, Galfetti, Krähenbühl: paisagens do Ticino»*, in: AU – Arquitetura Urbanismo 51/1993, pp. 46–57.

«Percorso diagonale» in: Abitare 316/1993, pp. 127–135, 208.

«Iniziative culturali degli Ordini delle province di Potenza e di Bolzano» in: Casabella 610/1994, p. 34.

P.-A. Croset: *«L'architettura è l'urbanistica di Luigi Snozzi»/«The Architecture and Town Planning of Luigi Snozzi»*, in P. Disch (op. cit 1994), pp. 32–73. «Luigi Snozzis Architektur und Stadtbau»: pp. 417–430.

Roger Diener: *«La seduzione dell'architetto»/ «The Seduction of the Architect»*, in P. Disch (op. cit. 1994), pp. 24–31. *«Die Verführung des Architekten»* pp. 414–416.

Alvaro Siza: *«Impressioni di un viaggio in Ticino, visitando le case di Luigi Snozzi»/«Impressions of a Trip in the Ticino, Visiting the Houses of Luigi Snozzi»*, in: P. Disch (op. cit. 1994), pp. 20–23. *«Eindrücke von einer Reise in das Tessin, die Häuser von Luigi Snozzi betreffend»*, p. 413.

«Seminario a Monte Carasso», in: Casabella 612/1994, p. 40.

«Seminari estivi: Vienna e Bergamo», in: Casabella 613/1994, p. 42.

Casabella 630/1996, p. 109 ‹Berlin, Pariser Platz›.

Mitarbeiterinnen und Mitarbeiter / Collaborators

1958–1996

Aguet, Anne-France
Andina, Angelo
Andina, Luca
Andina, Renato
Aubry, Marie-Christine
Arnaboldi, Michele
Baehler, Matteo
Barblan, Luca
Beretta, Alfredo
Bonetti, Mirko
Bonny, Laurent
Boetschi, Patric
Bosch, Gian Marco
Cavadini, Raffaele
Corradi, Massimo
Croset, Pierre-Alain
Domenighini, Elis
Duyne, Pleij Wendy
Flammini, Luca
Gaggini, Michele
Groisman, Gustavo
Guggisberg, Manuel
Guidotti, Livio
Lutz, William
Kamm, Christine
Ktenas, Nikos
Manzoni, Mirko
Mariani, Laura
Mazzi, Magda
Monassero, Silvia
Moor, Stefano
Moro, Paolo
Müller, Ruedi
Nilson, Carine
Pasteris, Nicola
Peters, Margareta
Plum, Rainer
Polli, Stefano
Quattrini, Fausta
Rayon, Jean Paul

Ros, Loredana
Rovetta, Croset Chiara
Ruggiero, Daniel
Schmidt, Willfried
Snozzi Groisman, Sabina
Snozzi, Sandra
Stula, Darko
Vicedomini, Maurizio
von Euw, Walter
Vuilleumier, Vincent
Zürcher, Christoph

1997

Buetti, Claudio
Bianda, Francesco
Ferrari, Mario
Fontana, Mitka
Javet, Anne-Catherine
Maggini, Luisa
Mazzi, Giuliano
Valazza, Isabelle
Vidotto, Marisa

Partner / Associate

Jenni, Bruno

Bildnachweis / Illustration Credits

Sergio Auelli (Milano):
123

Stefania Beretta (Giubiasco):
153, 180 unten/bottom

A. Carpi (Giubiasco):
29 unten/bottom

Italo Colombo (Torino):
17 unten/bottom

Alberto Flammer (Losone):
21, 22, 23 oben/top, 24, 25, 27, 29 oben/top, 30, 31, 33, 34, 35, 51 unten rechts/bottom right, 65

Betty Fleck (Zürich):
87, 135 oben/top, 144, 155, 180 oben/top

Heinrich Helfenstein (Zürich):
48, 51 oben rechts/top right, 97, 113 oben/top

Peter Horn (Stuttgart):
119 unten/bottom

Eduard Hueber (New York):
51 oben links/top left, 51 unten links/bottom left, 52, 54, 55, 57, 59, 61, 74, 75, 77, 101, 115

Cathy Karatchian (Genève): 141, 167

Klaus Kinold (München):
101 unten links/bottom left, 101 unten rechts/bottom right, 103

Claude Lichtenstein (Zürich):
133 unten rechts/bottom right, 174, 175

Giovanni Luisoni (Morbio Superiore):
119 oben/top, 121

Photoswissair (Zürich):
43

Filippo Simonetti (Brunate-Como):
111, 113 Mitte/center, 127 unten/bottom, 131, 133 oben/top, 135 unten links/bottom left, 135 unten rechts/bottom right, 137, 147, 149, 159

Studio Snozzi (Locarno):
17, 18, 19, 37, 38, 45, 69, 70, 71 Mitte/center, 79, 83 unten/bottom, 89, 91, 105, 110, 117, 156, 162, 169

Vladimir Spacek (Zürich):
Umschlag hinten/backcover

Sulzer AG (Winterthur):
171

Walter Wachter (Schaan, FL):
127 oben/top

Große Architekten in der erfolgreichen Studiopaperback-Reihe:
The Work of the World's Great Architects:

Alvar Aalto
Karl Fleig
4. Auflage. 256 Seiten,
600 Abbildungen
ISBN 3-7643-5553-0
deutsch / französisch

Tadao Ando
Masao Furuyama
2. Auflage. 216 Seiten,
397 Abbildungen
ISBN 3-7643-5437-2
deutsch / englisch

Architektur im Widerspruch
Bauen in den USA von
Mies van der Rohe bis
Andy Warhol
H. Klotz und J. W. Cook
2. Auflage. 328 Seiten,
197 Abbildungen
ISBN 3-7643-5552-2

Mario Botta
Emilio Pizzi
2. Auflage. 256 Seiten,
666 Abbildungen
ISBN 3-7643-5438-0
deutsch / französisch

Johann Bernhard Fischer von Erlach
Hellmut Lorenz
176 Seiten, 172
Abbildungen
ISBN 3-7643-5575-1

Walter Gropius
Paolo Berdini
256 Seiten, 580
Abbildungen
ISBN 3-7643-5563-8

Herzog & de Meuron
Wilfried Wang
2. Auflage. 160 Seiten,
313 Abbildungen
ISBN 3-7643-5589-1
deutsch / englisch

Philip Johnson
Peter Blake
256 Seiten, 270
Abbildungen
ISBN 3-7643-5393-7
deutsch / englisch

Louis I. Kahn
Romaldo Giurgola,
Jaimini Mehta
4. Auflage. 216 Seiten,
423 Abbildungen
ISBN 3-7643-5556-5
deutsch / französisch

Le Corbusier
Willi Boesiger
7. Auflage. 260 Seiten,
525 Abbildungen
ISBN 3-7643-5550-6
deutsch / französisch

Adolf Loos
Kurt Lustenberger
192 Seiten, 332
Abbildungen
Deutsche Ausgabe:
ISBN 3-7643-5586-7
Englische Ausgabe:
ISBN 3-7643-5587-5

Richard Meier
Silvio Cassarà
208 Seiten, 264
Abbildungen.
ISBN 3-7643-5350-3

Ludwig Mies van der Rohe
Werner Blaser
6. erw. Auflage.
248 Seiten, 180
Abbildungen
ISBN 3-7643-5619-7
deutsch / englisch

Richard Neutra
Manfred Sack
2. überarbeite Auflage.
192 Seiten, 291
Abbildungen
ISBN 3-7643-5588-3
deutsch / englisch

Jean Nouvel
Olivier Boissière
300 Seiten, 300
Abbildungen
ISBN 3-7643-5356-2
deutsch / englisch

J. J. P. Oud
Umberto Barbieri
200 Seiten, 340
Abbildungen
ISBN 3-7643-5567-0

Andrea Palladio
Die vier Bücher zur
Architektur
A. Beyer und U. Schütte
4., überarbeitete Auflage.
472 Seiten
ISBN 3-7643-5561-1

Richard Rogers
Kenneth Powell
208 Seiten, 481
Abbildungen
ISBN 3-7643-5582-4
deutsch / englisch

Aldo Rossi
Gianni Braghieri
4., erweiterte Auflage.
288 Seiten, 290
Abbildungen
ISBN 3-7643-5560-3
deutsch / französisch

Hans Scharoun
Christoph J. Bürkle
176 Seiten, 182
Abbildungen
Deutsche Ausgabe:
ISBN 3-7643-5580-8
Englische Ausgabe:
ISBN 3-7643-5581-6

Karl Friedrich Schinkel
Gian Paolo Semino
232 Seiten, 330
Abbildungen
ISBN 3-7643-5584-0

Gottfried Semper
Martin Fröhlich
176 Seiten, 192
Abbildungen
ISBN 3-7643-5572-7

José Luis Sert
Jaume Freixa
2. Auflage. 240 Seiten,
500 Abbildungen
ISBN 3-7643-5558-1
deutsch / französisch

Alvaro Siza
Peter Testa
208 Seiten, 300
Abbildungen
ISBN 3-7643-5598-0
deutsch / englisch

Mart Stam
Simone Rümmele
160 Seiten, 167
Abbildungen
ISBN 3-7643-5573-5

Luigi Snozzi
Claude Lichtenstein
208 Seiten, 400
Abbildungen
ISBN 3-7643-5439-9
deutsch / englisch

Louis Henry Sullivan
Hans Frei
176 Seiten, 208
Abbildungen
ISBN 3-7643-5574-3
deutsch / englisch

Giuseppe Terragni
Bruno Zevi
208 Seiten, 490
Abbildungen
ISBN 3-7643-5566-2

Oswald Mathias Ungers
Martin Kieren
256 Seiten, 406
Abbildungen
ISBN 3-7643-5585-9
deutsch / englisch

Otto Wagner
Giancarlo Bernabei
2. Auflage. 208 Seiten,
330 Abbildungen
ISBN 3-7643-5565-4

Frank Lloyd Wright
Bruno Zevi
3. Auflage. 288 Seiten,
575 Abbildungen
ISBN 3-7643-5557-3
deutsch / französisch